A TIME
TO EVERY
PURPOSE

A TIME TO

MICHAEL KAMMEN

EVERY PURPOSE

The Four Seasons in American Culture

The University of North Carolina Press *Chapel Hill & London*

© 2004 The University of North Carolina Press
All rights reserved
Set in Galliard and Mantinia types by Eric M. Brooks
Manufactured in the United States of America

This book was published with the assistance of
the William R. Kenan Jr. Fund of the University of
North Carolina Press.

The paper in this book meets the guidelines for
permanence and durability of the Committee on
Production Guidelines for Book Longevity of the
Council on Library Resources.

Library of Congress Cataloging-in-Publication Data
Kammen, Michael G.
A time to every purpose: the four seasons in American
culture / by Michael Kammen.
 p. cm.
Includes bibliographical references and index.
ISBN 0-8078-2836-X (cloth: alk. paper)
1. United States—Civilization. 2. Seasons—Social
aspects—United States. 3. United States—Social life
and customs. 4. Popular culture—United States.
5. United States—Intellectual life. 6. Art, American—
History. 7. American literature—History and criticism.
8. Seasons in art. 9. Seasons in literature. 10. Seasons—
Social aspects—Europe—History. I. Title.
E169.1 .K295 2004
700'.4273—dc22 2003013734

Excerpt from "Winter Trees" from *Twelve Moons* by Mary
Oliver. Copyright © 1972, 1973, 1974, 1976, 1977, 1978, 1979
by Mary Oliver. Used by permission of Little, Brown and
Company, Inc.

08 07 06 05 04 5 4 3 2 1

For

JOAN & ERICH GRUEN

and

JANE & BERT LAZEROW

delightful companions
and devoted Californians

A book's an inn whose patrons' praise
Depends on seasons and on days,
On dispositions, and—in fine—
Not wholly on the landlord's wine.
—Richard R. Kirk, *A Book's an Inn*

CONTENTS

Prologue 1

INTRODUCTION: Seasonal Cycles and Sequences 11

 The Circle of the Seasons as a Persistent Trope 12

 Continuity and Change in Seasonal Responses 16

 Perceptions of the Seasons: Cultural Constructions of Nature? 21

 Seasonal Processions as Measuring Rods for a Citified Society 25

 Places with Significantly Variable Seasonal Cycles and Motifs 30

 On Bringing the Motif to the New World, and Seasonal Anxieties 31

CHAPTER 1. From Antiquity to the Eighteenth Century in Europe 37

 The Genesis of Seasonal Motifs in Antiquity 38

 The Revival and Evolution of the Motif in Medieval Times 45

 Seasonal Labors and Calendars: The Humanistic Motif in Renaissance Europe 48

 The Seasonal Flourish in Renaissance Art and Beyond 50

 James Thomson and His Poem's Impact at Home and Abroad 63

CHAPTER 2. The American Reception and Adaptation of the Four Seasons Motif 73

 Adaptations and Modifications of the Motif in Early America 73

 Seasonality and Slavery: African American Lives in Early America 75

 Thomson's Influence and the Uses of Seasonality in the Young Republic 77

 Natural Theodicies and the Compatibility of Divine Purpose with Science 86

 Creative and Adaptive Responses by American Artists 91

 Americanization of the Motif: Rejecting Thomson and European Vistas 96

 Seasonal Art and Literature: Divergent Tensions 101

 The Four Seasons in Native American Culture 104

CHAPTER 3. Nostalgia, Nationalism, and the American Seasons, 1854–1914 108

 Seasonal Responses to Urbanization and Social Change at Midcentury 109

 Growing Affluence, Conditions of Life, and Seasonal Sensibilities 113

The Appeal of Sentimental Seasonality in the Wake of the Civil War 115

The Broad Appeal to All Taste Levels 120

American Seasonal Art in the Victorian Era 122

Complexities of Competition among the Seasonal Sages 128

At Century's End: Seasonal Cultivation, Wildness, and Persistent Nostalgia 133

CHAPTER 4. American Transitions:
The Seasonal Sense of Place, Time, and Imagery 140

Seeing Seasonal Sentiment and Diversity in America 141

Modes of Metaphor in Writing about the Seasons 151

Artistic Modernism and the Seasonal Motif, 1912–1961 155

Eugenics: Seasons of Birth and Human Fertility 164

Literary Modernism, Seasons of the Mind, and the Waning of Creativity 166

"Demopiety"?: Dialogical Responses to Seasons in the City 171

CHAPTER 5. Nature Writers, Reader Response, and the
Ambivalence of Urban America 175

A Collegial Cohort of Seasonal Writers, 1941–1978 175

Seasonal Receptions: How the Reviewers Responded 186

Seasonal Receptions: How the Readers Responded 191

City Readers and Country Writers: Connecting the Distance 199

Changing Attitudes and Continuities: The Flux of Stable Cycles 204

CHAPTER 6. The Four Seasons and American Popular Culture:
Calendars and Consumerism 209

Seasonal Cycles and Singular Lives in a Society Still Diverse 209

Norman Rockwell: Marking Seasonal Time with Youngsters and Codgers 218

Using the Seasons to Sell Things 224

Places to Go, Things to See, and Vicarious Seasonal Travel 227

Seasonal Films and Music 230

Seasonal Journalism and Cartoons 235

CHAPTER 7. The Four Seasons in Contemporary American Art and Poetry 240

 Landscape Responses, ca. 1964–1999 241

 Life Cycle Responses, ca. 1977–1996 245

 Symbolic Serialism as a Structured Response to a Disorderly World 252

 Urban Responses, ca. 1982–2000 256

 Versed in the Seasons: Confessional Moods and Contemporary Poetry 260

CONCLUSION: Science and the Seasons, Retrospection, and Reprise 265

 Contemporary Science, Seasonality, and Human Cycles 266

 Continuities and Change: The More Things Change . . . 268

 Noticing the Nuances of Seasonal Variability 272

 Seasonal Creativity and Spheres of Civil Life 275

Acknowledgments 281

Notes 283

Index 321

To every thing there is a season, and a time to every purpose under heaven. A time to be born, and a time to die; a time to plant, and a time to pluck up that which is planted.

 Ecclesiastes 3:1–2

These regular phenomena of the seasons get at last to be—they were *at first*, of course—simply and plainly phenomena or phases of my life. The seasons and all their changes are in me.

 Henry David Thoreau, *Journal* (October 26, 1857)

I have been comparing in my mind our life to the four seasons.

 Adaline Cleveland Hosmer, Mecklenburg, New York,
 unpublished journal entry (November 11, 1860)

The course of the seasons never does run smooth, owing to the unequal distribution of land and water, mountain, wood, and plain.

 John Burroughs, "The Falling Leaves" (1919–20)

And the seasons, they go round and round,
and the painted ponies go up and down.
We're captives on a carousel of time.
 Joni Mitchell song, "The Circle Game" (1970)

There is a bit of every season in each season.
 Annie Dillard, *Pilgrim at Tinker Creek* (1974)

Cycles are circles that travel in straight lines. The seasons come in cycles,
yet each season marks the passage of another year. We receive our names,
plant, harvest, marry, dance, sing, and are buried in concert with the
[seasonal] cycles.
 Anthony Dorame, Tesuque Pueblo, near Santa Fe (1980s)

No one, to my knowledge, has observed the minute differences in
the seasons. . . . A Book of the seasons, each page of which should
be written in its own season & out-of-doors, or in its own locality
wherever it may be—
 Henry David Thoreau, *Journal* (June 11, 1851)

A TIME
TO EVERY
PURPOSE

PROLOGUE

Why has fascination with the four seasons been so remarkably dominant in Western art as well as literature, and more particularly for our purposes, in American culture? There are numerous reasons, and this book seeks to reveal a great many of them. Most obviously, seasonal change suffuses the environment in which much of humankind has sought to survive for millennia. Seasonality provides both challenges and opportunities for existence beyond the level of mere endurance. For well over two centuries, however, seasonal change in the United States and elsewhere has made fewer demands than it once did, and become less of an imperative in purely practical terms as people have achieved an unprecedented degree of mastery over nature—by no means complete, to be sure, but nonetheless separating the circumstances of modern life from all that has gone before. Yet the motif not only persists, it truly flourished during the second half of the twentieth century and the beginning of the twenty-first, more visible than ever and arguably more creative, albeit clichéd at times because of commercialization and sheer overuse.

Images evoked by the seasons long ago achieved certain conventional forms, so that a visual vocabulary became familiar to most members of society. From antiquity through the nineteenth century, spring has been associated with childhood or with plowing and planting fields, with garlands of flowers or with fishing if the artist's mood favored leisure over labor. Summer has commonly meant courtship for young couples, or the harvesting of hay and wheat along with the necessary implements, or sheep shearing if that had not yet been done in late spring, or bathing (frequently by semi-nude women). Autumn has customarily been connected with maturity and adult responsibility, with harvesting fruits and vegetables, above all grapes for making wine, often with Bacchus, the god of high spirits, presiding. And winter's most affective associations have involved the need to keep warm (gathering firewood, huddling close to a brazier of some sort, wearing multiple layers of clothing), hunting for meat, and simply being able to function despite wind, snow, storms, and the forbidding sight of barren trees. Human symbols of winter have most often been an elderly couple nearing the end of their lives together or else one venerable survivor alone. Only since the eighteenth century have winter sports, sleighs, snowmen, and such largely supplanted the more menacing aspects of the season long regarded as mankind's meanest nemesis.

There has also been a gradual and subtle overall shift, however, in terms of

gendered associations with seasonal icons. From antiquity until the early modern era, meaning approximately the seventeenth century, personifications of seasonality were more likely than not to appear in displays of manly strength and agricultural labor. Thereafter the visual trend shifted toward beauty rather than strength, and most notably female beauty—a trend clearly evident in the work of painters like Boucher, Gérôme, Cézanne, and Mucha on the European side, and artists like Frank Benson and John LaFarge on the American.

The iconography of the seasons connects well with the desire to decorate calendars and almanacs, devices that people have long found useful in order to recall when to observe certain festivals and undertake an array of essential agricultural tasks. Consequently, calendrical books of all sorts have accommodated seasonal motifs quite nicely. The connection between calendars and seasonal images has been close for many centuries, from religious books of hours that endured into the Renaissance through Norman Rockwell's bemused designs for wall calendars in the mid-twentieth century. Seasonal motifs have also been highly useful as ancillary decorations: as an elaborate border on one of Raphael's biblical tapestry designs for the Vatican in 1516, in the upper corners of castle rooms where walls meet the ceiling (such as in the Esterhazy summer palace at Fertod in Hungary or the Bernadotte "apartments" in Sweden's royal palace), at pavilions associated with fairs and festivals, and on the sides of fountains situated in civic spaces and elegant gardens, such as the Bethesda Terrace in Manhattan's Central Park or the *Fountain of the Four Seasons* at Iowa State University in Ames (plate 27).

Perceived parallels between the human life cycle and the four seasons made the latter irresistible as images in literature as well as in physical spaces that people occupy. Rooms customarily have four walls and four corners, and gardens may also. The four humors, the four elements, and the four directions have all been deployed as cultural motifs, but none of those "sets" lends itself quite so readily for decorative purposes as activities associated with the seasons. Therefore seasonality long ago became a familiar trope that artists and writers could engage for allegorical purposes. Sometimes an especially successful use of nature's cycle will spark a flurry of interest by creative individuals who wish to follow suit. That occurred after the Antwerp artist Pieter Bruegel made his marvelous seasonal paintings (1565) and engravings (1567), after the Scot James Thomson's much-admired long poem, *The Seasons*, was completed in 1730, and after Currier and Ives published their varied sets of seasonal lithographs between 1855 and 1870.

The seasons can be employed for sentimental purposes, as a vehicle for the expression of national pride, or to convey a sense of spiritual growth, especially by means of a metaphorical pilgrimage, as in Chaucer's *Canterbury Tales*. Some creative individuals have used the motif because seasonality itself was a personal passion for them: Susan Fenimore Cooper, Henry David Thoreau,

the American artists Jasper Cropsey and Charles Burchfield, and many of the mid-twentieth-century conservationists, like Hal Borland, come to mind immediately. Still others fall back upon the seasons because they require a clear structural framework for their concerns, ranging from problematic human relationships to the close observation of nature. The French filmmaker Eric Rohmer, writers like Joseph Wood Krutch, Aldo Leopold, and W. D. Snodgrass, and such artists as Jasper Johns and Jennifer Bartlett provide obvious examples. The four seasons motif supplies the focus for a remarkable array of artistic endeavors.

For many individuals, concentrating upon the course of a single year, even when the events or phenomena described actually took place over a longer span of time, provides a narrative device that permits the compression of complexity into a cohesive "package" more readily perceived or followed by others. *The Pioneers* by James Fenimore Cooper (1823) and Thoreau's *Walden* (1854) unfold as though they occurred during the course of one year. Countless authors, writing both fiction and nonfiction, have followed in Cooper and Thoreau's footsteps in order to describe what life was (or is) like in a particular community, or on an island, or in some remote location well-liked by an individual feeling alienated from contemporary and excessively commercialized life.

For bird-watchers, of course, like John Burroughs and later John Kieran, avian migrations have been reliably wondrous markers of seasonal change, so it is not surprising just how often such migrations figure in the writings of those naturalists who have contributed to the rich genre of books with an explicitly seasonal structure. The same pattern obtains for those who prefer botanical benchmarks. Doing so is symmetrical and sequential, with a beginning, middle, and end, regardless of whether the artist or writer wishes to start with winter or spring. Both options have proven equally attractive, more so than starting with summer or autumn, although there are individuals in our own time (since the 1960s) who have experimented with the latter two and explained why: usually because the tourist season offers a useful vehicle for those who favor summer, and the start of the school year does the same for those preferring fall as their point of departure.

We cannot ignore the commercial imperatives: much of modern cultural production reliant upon the four seasons motif has had entrepreneurial objectives in view. That is actually true even when we think of "fine artists" who produced work of museum quality like Bruegel or Jean-François Millet or, in the United States, a worthy impressionist like Willard Leroy Metcalf or a skilled designer in the decorative arts like Louis Comfort Tiffany. They all required commissions in order to survive and pursue their careers. The fact that we now have an astonishing array of marketable products with "four seasons" somewhere on the label only means that there has been a marked proliferation of a motif that has been a signal aspect of civilization for a very long time. Norman

Rockwell and the popular naturalist Edwin Way Teale prospered by doing what they loved to do best and being remunerated rather handsomely in the process. Not many people undertake four seasons suites just for the fun of it. Some may simply strive for creative achievement; but most would more gladly receive praise if it's accompanied by cash. Currier and Ives, based in New York City, did not print all of those seasonal images because they were nature lovers. They were businessmen who dominated their field because they had a keen sense of what would please the people. Their public happened to love fire companies fighting blazes in urban places as well as pastoral scenes of seasonal idylls.

We should also acknowledge that some of the finest and most important masterpieces of four seasons writing and art occurred by serendipity. When young James Thomson composed a poem titled "Winter" in 1726, he had no idea that it would become a great popular success. What does an aspiring writer with no independent means do next? Write more seasonal poems! The next thing he knew he had a quartet, and a runaway hit that eventually, in 1801, would prompt Haydn to compose his great oratorio, *The Seasons*. (Haydn learned about Thomson's *Seasons* by way of a German poet who had been inspired by the poem.) In 1985 Jasper Johns initially just wanted to paint a picture that he called *Summer*. Then came a commission to illustrate a limited edition of the poems of Wallace Stevens, which caused him to read "The Snow Man," which led him to paint *Winter*. At that point he was halfway done, so by 1987 he completed the best-known set of seasonal works by an American artist. It all happened by chance. Peter Blume, the Russian-born magic realist, began his four seasons suite in 1964 and finished it in 1989. Did he know that it would become a complete set when he painted *Winter* in 1964? I don't think so. When Annie Dillard was writing her prize-winning *Pilgrim at Tinker Creek* (1974), she experimented with many structural devices and finally settled on the four seasons by default. It simply worked better than any alternative she contemplated.

With Jasper Johns, Norman Rockwell, Eric Rohmer, and many others, seasonal projects were undertaken in the autumn of their lives. Consequently their rendering of fall had special and poignant meaning for them. Intimations of mortality figure significantly, albeit discreetly, in a great many of the projects considered here. It is pertinent to recall a sonnet that John Keats wrote in 1818 and sent to a friend. Someone gave it a title posthumously, "The Human Seasons," but its first line has become its enduring title.

Four seasons fill the measure of the year;
 Four seasons are there in the mind of man.
He hath his lusty spring, when fancy clear
 Takes in all beauty with an easy span:
He hath his Summer, when luxuriously
 He chews the honied cud of fair spring thoughts,

Till, in his soul dissolv'd, they come to be
 Part of himself. He hath his autumn ports
And havens of repose, when his tired wings
 Are folded up, and he content to look
On mists in idleness: to let fair things
 Pass by unheeded as a threshold brook.
He hath his winter too of pale misfeature,
Or else he would forget his mortal nature.[1]

Having collected and lived with this material for close to twenty years now, I have come to see that quite a few of the finest and most memorable works about the four seasons make use of them in idiosyncratic or, at the very least, highly unpredictable ways. In so many of the most impressive achievements, "topicality overrides seasonality," so that Thoreau's *Walden*, which moves through the seasonal cycle from spring to spring, is not only concerned with many things other than the seasons, but includes chapters that contain imagery from *all* of the seasons. Thoreau is not a stickler for compartmentalization because, as he and other notable nature writers like Annie Dillard and Ann Zwinger have asserted, "There is a bit of every season in each season."[2] John Burroughs, perhaps the most beloved of all American naturalists, at least during his own lifetime and for several decades afterward, had a penchant for contemplatively suggesting one season while in the midst of another, deliberately intermingling his imagery. Here is a typical passage from his essay called "A River View" from the early 1880s.

A dweller upon its banks, I am an interested spectator of the spring and winter harvests which its waters yield. In the stern winter nights, it is a pleasant thought that a harvest is growing down there on those desolate plains which will bring work to many needy hands by and by, and health and comfort to the great cities some months later. When the nights are coldest, the ice grows as fast as corn in July. It is a crop that usually takes two or three weeks to grow, and, if the water is very roily or brackish, even longer. Men go out from time to time and examine it, as the farmer goes out and examines his grain or grass, to see when it will do to cut. . . . When there is an abundant harvest, after the ice-houses are filled, they stack great quantities of it, as the farmer stacks his surplus hay.[3]

The more conventional (sometimes even banal) books and works of art are the most formulaic, observing predictable things at predictable times. They shun surprises because they cater to the modern, middlebrow, and urbanized assumption that the seasonal cycle is normatively routinized rather than unreliable or even capricious. One of the great challenges for those who contribute to

this genre, be they writers or artists, is avoiding the trap of tradition and fulfill-
ing trivialized expectations rather than innovating, as Jean-François Millet did
when he accepted a commission from a wealthy merchant and dared to make
peasants and their labors the focus of his wonderful four seasons suite in
1868–75 (figure 1).[4]

I contemplated, though not for long, making this project quite literally,
meaning structurally, a four seasons book. I might have begun with a section
designated as Winter, the long period of gestation foreshadowing the Renais-
sance, and explored therein the relevant materials from antiquity until about
1500, considering that span (incorrectly) to have been a barren period making
way for the maturation of a motif. Then Spring might have followed, ca. 1500
to about 1725, with a great flowering from the beautiful secular illustrations of
Simon Bening in the Low Countries through Nicolas Poussin in France during
the middle of the seventeenth century to the eve of simultaneous production by
Vivaldi in Venice and Thomson in England of their respective seasonal master-
pieces in 1726. Then we would have turned to Summer, ca. 1730 through the
close of the nineteenth century, a period when there was a lush proliferation in
painting, poetry, statuary, and the decoration of private homes and public
buildings with seasonal motifs. That might have taken us from the spectacular
floral still lifes of Netherlandish artists to William Morris, Oliver Wendell
Holmes Sr., and Alphonse Mucha in the later Victorian ambience of England,
America, and France. Finally we would arrive at Fall in the twentieth century,
when the entire motif somehow achieves a brilliant presence adorned by au-
tumn leaves, yet gradually dissipates its vitality because so much of the popula-
tion appears to be losing touch with the natural world. Why? On account of
their predominantly urbanized existence and owing to so much contestation
over man's optimal relationship to nature as a result of the conservation move-
ment that got its impetus from people like Aldo Leopold and Rachel Carson,
who wrote such influential four seasons books during the 1940s.

It was not difficult to resist that temptation. In addition to being mechani-
cal and arbitrary, it would not have served my intent to write an account that is
primarily American but with sufficient comparative context, rather than a com-
pendious narrative that would have lumbered through many more centuries
and cultures than I am competent to discuss adequately. What interests me
most in this book is what the historical evolution of the four seasons motif can
reveal about American culture: how the motif was brought to the New World,
how it was initially received and used in derivative ways until the middle of the
nineteenth century, and then how the motif became symptomatic of American
nostalgia and national chauvinism in the later nineteenth century and well into
the twentieth.

Those two concerns, nationalism and nostalgia, are the paired engines that
provide this project with explanatory momentum: nationalism because Ameri-

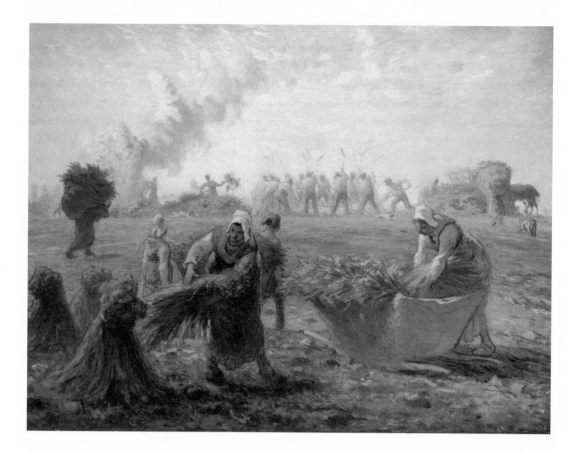

cans came to believe that manifestations of nature were more beautiful in the United States than anywhere else, and nostalgia because the advent of industrialization and urbanization prompted them to feel increasingly remote from the natural world and the lifestyle of their forebears. Consequently we will be tracing, among other things, not only the persistence of nostalgia, but a profound nostalgia for persistence. In an unpredictable, disorderly world of flux, the seasonal cycle offers reassurance that at least some fundamentals in this life are eternal.

During the twentieth century, and especially the second half thereof, appreciative Americanism became much less prominent as a stimulus for seasonal art and writing in the United States. Nostalgia, on the other hand, remained remarkably constant, and quite possibly became more important than ever as a stimulus for popular consumption of seasonal enterprises of all sorts. The more people felt disconnected from nature, and as growing numbers actually became so, the more they were attracted to seasonal imagery. In the half-century following World War II, however, many Americans also moved beyond nostalgia, both as producers and as consumers of seasonal markers. They remained attentive to seasonality, to be sure, but instead of looking primarily to nature to

FIGURE I
Jean-François Millet, Buckwheat Harvest, Summer *(1868–74), oil on canvas. Gift of Quincy Adams Shaw through Quincy Adams Shaw Jr. and Mrs. Marian Shaw Haughton. Courtesy, Museum of Fine Arts, Boston.*

define what the seasons are and mean, they turned increasingly to social institutions and relationships that have more to do with the modern, urban, and festive ways in which we live—the human practices and habits that presently demarcate our annual existence: back to school in late summer; Halloween, Thanksgiving, and Christmas; Easter break and spring cleaning; and finally summer vacation. Hence some of the most prominent seasonal provocations and novelties that we will encounter in chapters 6 and 7.

What kinds of issues does the history of seasonal change and its variable meanings allow us to raise? What kinds of questions does it require us to ask? Beginning with chapter 2, we will explore the changing role and voice of naturalists in American society, along with the visions of nature perceived and offered by different kinds of artists. That leads us to information about how and where Americans saw natural beauty in the land; and, perhaps most important of all, when we reach the close of the nineteenth century and then move into the twentieth, we should be able to enhance our understanding of how Americans responded to industrial innovations and to diminished differentiation among the seasons overall. Once canned foods began to be available in the later nineteenth century, for example, people found an array of metaphors to convey the "deseasonalization" of customary foodways. Innovative technologies succeeded in "inverting the order of the seasons," or as one writer put it, the new technological order "naturalizes spring and summer in winter" and "fixes the seasons so much so that spring, summer and autumn live in bottles."[5] Technological improvements were perceived as an astonishing "plus," yet were accompanied by a poignant sense of something else gone forever.

Americans felt increasingly disengaged from their native environment, and modern naturalists writing in the decades following World War II told them that they were "alienated" from nature. Writers continue to do so right up to the present moment. As Diane Ackerman remarked in 2001: "We've worked hard to exile ourselves from nature, yet we end up longing for what we've lost: a sense of connectedness."[6] How have people reacted to hearing that concern raised time and again, and how has it affected their interest in the American seasons? A short answer can be summed up in two ways: during the second half of the twentieth century the four seasons motif became paradoxically more pervasive than it had ever been, and it gained a centrality in popular culture previously unknown. By the end of the century it achieved a prominence in American art, music, and even poetry that virtually no one could have envisioned two or three generations earlier. Looking back, we find that sometimes artists and writers interested in the seasons seemed to be on the same wavelength, but at other times not. There was a great outpouring of important seasonal writing from about 1941 to 1978 (see chapter 5), but not as much in the way of seasonal art. Since the later 1970s, however, there has been an astonishing burst of seasonal art (see chapter 7), but considerably less writing than was produced dur-

ing the third quarter of the twentieth century. We will look at those changing rhythms and try to make sense of them.

Owing to all of that creativity, which actually had its genesis with modernism earlier in the twentieth century (chapter 4), there could very well have been a fourth "N" included with nature, nationalism, and nostalgia as central concerns in my analysis: Novelty. Over the course of the past century Americans have sought new ways to image and express seasonality, or to use the four seasons as an explicit metaphor for messages deemed socially significant or personally meaningful. Because farming has come to be so much less important experientially to most Americans, they now think about the seasons in nontraditional, nonagricultural ways, often only loosely linked to nature. That seems nearly as true in small-town America as it does in major cities.

Given the geophysical diversity of the United States, the seasons are inevitably quite variable in different regions. Nevertheless, there seems to be some feeling or sense of normative seasonal change that is widely accepted. Though much of California and the Southwest have "only" three seasons in the eyes of many, Christmas decorations must look wintry there, just as they do throughout the entire land, even if that means pasting artificial snow in shop windows in Los Angeles, Phoenix, and Santa Fe. In the Northeast people often wear Easter outfits that are really a month too early for the actual climate. Some of the hats look rather silly with unexpected snow on top when Easter occurs late in March. Summer is celebrated and appreciated in those parts of the Northeast and upper Great Plains even though it is comparatively briefer than elsewhere and can even be treacherous. The first time I visited Yellowstone National Park, in August 1976, it snowed. But just try telling folks in Wyoming and Montana that they do not have four full seasons. The lodges in and near Glacier National Park on the Canadian border feature four seasons post cards, and Yellowstone has four seasons snack shops. The length and character of the seasons may vary all across the United States, but what matters, at least for our purposes, is the widely shared attraction to seasonal change, the attitudes that people have about it, and their responses to creative uses of seasonality by people from other parts of the country. Edwin Way Teale and Hal Borland, the most beloved nature writers in the country between the 1940s and the close of the 1970s, both lived in remote parts of rural Connecticut, but their deeply appreciative fan mail, which they received in great abundance and saved, came from all across the land.

I do not share the view that American culture became utterly homogenized during the second half of the twentieth century. Regional and local identities continued to matter a great deal to people in deeply personal ways, despite increased mobility and the development of vast national chains of hotels, eateries, movie theaters, and bookstores, to say nothing of nationwide programming dispensed by means of television. Yet information about the seasons and imag-

inative interpretations of them in art, literature, and film have been shared by a vast audience. What people actually received, and what they made of it in turn, intrigues me and will be central to chapters 4–7. The excitement generated each time Teale published a new book about the seasons was truly palpable. A nationwide contest in 1957 that elicited tens of thousands of seasonal drawings by school children tells us a lot, especially because the hundred best entries toured the country for four years. When Andrew Wyeth issued a four seasons portfolio in 1964 with twelve reproductions of his hitherto unseen dry-brush drawings made between 1941 and 1961, that became a cultural event, and the portfolio remains an affordable collector's item (look for it by way of eBay on the Internet). When people clamored for Norman Rockwell's four seasons calendars, and deluged him with fan mail about them for many years, their enthusiasm really mattered. (Just try bidding for one of those original calendars on an Internet auction!)

Among the many fascinating things I have learned from this enterprise is that serious nature lovers are more often engaged by seasonal *transitions* than they are by seasonal peaks, and I have gradually swung toward that persuasion myself, perhaps as a result of things that I have observed in the process of working on this book. Since 1965 I have enjoyed the pleasures of watching the seasons change in and around my home (plate 1) near Ithaca, New York. For some years now, the most popular local bumper sticker here reads, "Ithaca Is Gorges." For me, however, Ithaca is equally the site of sharply contrasted and highly unpredictable seasons. As a colleague once quipped when I asked him whether he had any travel plans: "No. When you're tired of Ithaca, you're tired of living."

I have also found that dedicated students of nature tend to say that the season they like best is the season they are in. I understand that now in a way that I previously did not, perhaps because I appreciate that they are speaking about the season of their life as well as the season of the year. Thoreau put it very well toward the end of his own life, when mortality had become more than a matter of intimations: "These regular phenomena of the seasons get at last to be—they were *at first*, of course—simply and plainly phenomena or phases of my life. The seasons and all their changes are in me."[7]

INTRODUCTION
SEASONAL CYCLES AND SEQUENCES

Seasonal changes, seasonal differences, seasonal consequences. Seasonal significance. The inevitable yet unpredictable presence and implications of these phenomena are surely among the oldest and most familiar motifs in the cultural experience of humankind, at least throughout the temperate zones that girdle the globe's northern and southern hemispheres. During the three millennia for which we have visual and recorded information, seasonal modes of expression have been emblematic of agricultural practices and religious beliefs, mythological meanings, and emotional yearnings—all manifest in art and literature, festivals and social celebrations. The overall arc of these modes has spanned, with overlaps, from attempting to demystify the wonders of the natural world with mythologies, to ascribing seasonal change to a "natural theodicy" (God's design for our environment), to being a meaningful metaphor for the human life cycle, to providing allegorical ways of explaining personal experience, to contemplating the consequences of empirical knowledge newly derived from natural science. The seasons have always been with us, but with variable meanings for diverse people at different times in human history.

Consequently, quite a few remarkable and important works of art, poetry, and nature writing have either been inspired by the seasonal cycle or structured according to it or both. Many of them have been brilliantly innovative and profoundly influential, such as Virgil's *Georgics* (written 36 to 29 B.C.), Pieter Bruegel's seasonal paintings (1565), James Thomson's book-length poem *The Seasons* (1726–46), Henry David Thoreau's *Walden* (1854), Aldo Leopold's *Sand County Almanac* (1949), and Jasper Johns's intriguingly personal suite of paintings, *The Seasons* (1986–87). Those creations, and so many others that comprise the dramatis personae of this project, combine close observation of nature with astute commentaries about human nature, and concern the constants as well as the capricious elements in our relationship with the physical universe. They have not previously been considered together as an interconnected genre spanning many centuries, with special attention to their numerous manifestations in the New World, and the United States in particular.

The four seasons motif has been dynamic, adaptable, evolutionary, and en-

during as a stimulus to visionary creativity in the arts. Remarkable writers and artists keep finding fresh ways to present the seasons and to use them as a context for cultural values: how we live, how we *should* live (admonitions from Virgil to Thoreau and beyond), who we are at each stage of the human life cycle, how best to apprehend and appreciate the natural world, and how best to understand significant transitions in life and art. Ralph Waldo Emerson, whose influence on American nature writing has been immense, captured some of that intertwined complexity in passages such as this one: "The heart has its sabbaths and jubilees, in which the world appears as a hymeneal feast, and all natural sounds and the circle of the seasons are erotic odes and dances."[1]

The Circle of the Seasons as a Persistent Trope

As fresh and arresting as Emerson's assertion may sound, "the circle of the seasons" had already become a familiar phrase in the vocabulary of vocal people sensitive to cyclical changes and influences. "We contemplate with quiet joy the circle of the seasons," wrote Thoreau in 1838, at the age of twenty-one, "returning without fail eternally." Three years later he observed in his journal that "our work should be fitted to and lead on the time, as bud, flower, and fruit lead the circle of the seasons." More than a decade later, in April 1852, another journal entry suggests that he had just discovered the nexus of image and natural reality. "For the first time I perceive this spring that the year is a circle—I see distinctly the spring arc thus far." Thoreau's journals can be extremely enigmatic. Perhaps he meant only that for the first time *that spring* he was reminded of the notion on that particular day. Or, since he had invoked the same image several times much earlier, perhaps he meant that his vision of the seasonal year as a circular phenomenon was becoming more vivid and complex in its implications. He was, after all, revising his manuscript of *Walden* in 1852–53, and the concept of cyclical seasons would soon become the dominant ordering principle of his masterpiece.[2]

In any case, the concept has certainly persisted in American art and literature. Eugene F. Savage's *Bacchanal (The Four Seasons)*, painted around 1920 (plate 26), is an allegory in which stylized figures are arranged in a circular pattern of action. The picture deliberately represents a fairly boisterous round of the seasons. Autumn is rather abruptly displacing Summer from the scene. Winter, represented by an old man, is preparing a shaft to be shot into the back of Autumn. And Spring is plotting her ways of superseding Winter. Edwin Way Teale published his *Circle of the Seasons* (1953) as a journal that runs from January through December. In 1990, three years after Jasper Johns completed his four large oil paintings of the seasons (plate 38) followed by a limited edition of the quartet in print format, he prepared a single-image cruciform print version of *The Four Seasons* (figure 2) so that they would be viewed in a *cyclical*

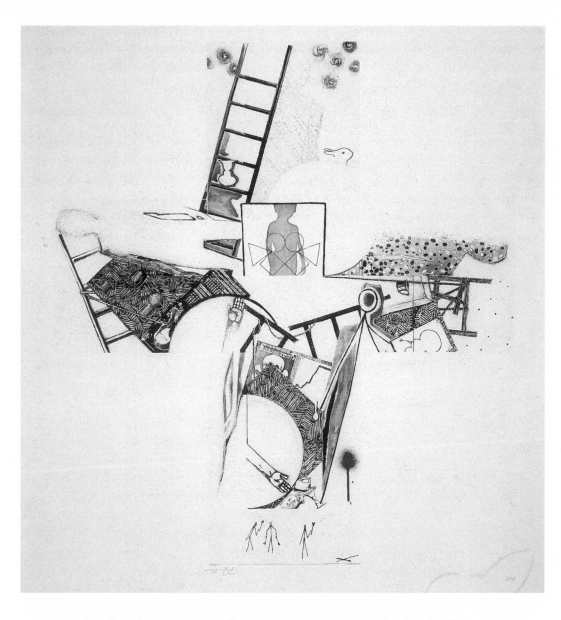

manner rather than simply sequentially, spring to winter, which implies finality rather than eternal repetition.

Even the most familiar ways of observing and describing the seasons can be highly creative or at least heuristic—a useful means of enabling novices to contemplate nature and begin to access its wonders. However hackneyed the seasons may become in the hands of less imaginative writers and journeyman artists, it is essential that we keep in mind the inspirational excitement felt by creative individuals who incorporated seasonal change into enduring works of art. On September 8, 1854, four weeks following the publication of *Walden*, Thoreau (figure 3) recorded his "autumnal madness" while gathering grapes,

Introduction 13

FIGURE 3
Samuel
Worcester
Rowse,
Henry David
Thoreau
(late summer
1854), crayon.
Courtesy of
the Concord
Free Public
Library.

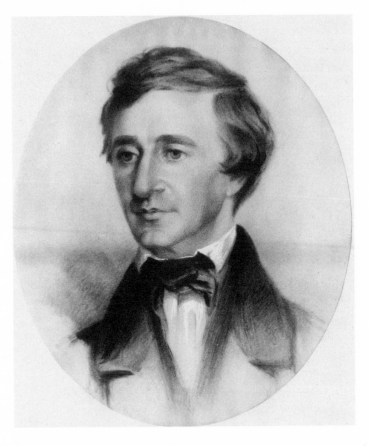

his anticipation of the "ripening year," and three days later he felt that he was beginning to "throw off" his "summer idleness."[3] Considered as cultural phenomena, then, the seasons matter so much because of the remarkable spontaneity they have generated and despite the derivative or uninspired work that has waved along in the wake of genius.

Certain themes and types of projects concerned with seasonality may *seem* derivative simply because they address or even embrace the most essential aspects of the phenomenon. Without the sun, for example, and the earth's annual orbit around the sun, there would be no seasons. Thomson's Augustan poem, *The Seasons*, devotes a long sequence of lines to the sun's intensity in "Summer." Thoreau referred to the sun as his "mistress." John Burroughs (figure 4) carefully noted that our mechanistic calendars were not actually in phase with reality. "The season is always a little behind the sun in our climate. . . . According to the calendar, the summer ought to culminate about the 21st of June, but in reality it is some weeks later." When Elihu Vedder painted *The Sun and Four Seasons* (figure 5) in Rome (1893), he was providing a high Victorian variant of ancient mosaics from the Roman era. Wallace Stevens's seasonal poetry in the late 1940s is quite obsessed with the sun as a primal force. Fredric Klees, author

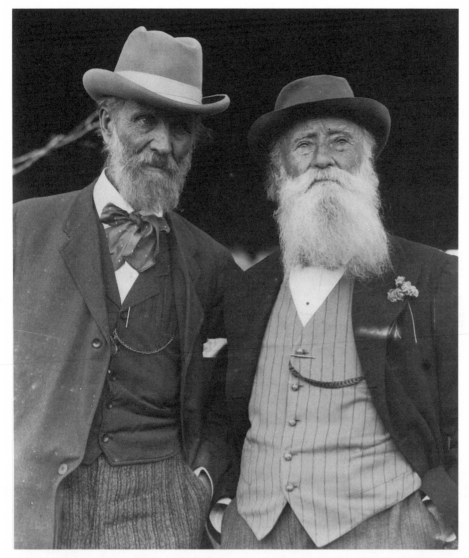

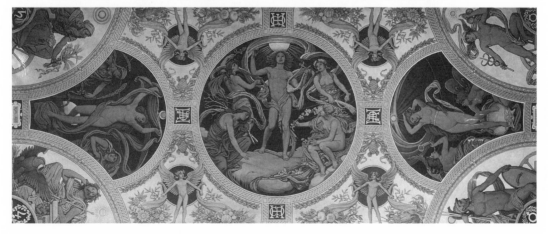

of *The Round of the Year* (1963), a typical four seasons book by an amateur American naturalist, often called attention to "the sun this morning a great ball of fire as it came up."[4]

Continuity and Change in Seasonal Responses

Despite differences and discontinuities in seasonal variation according to geography, historical time, and cultural values (such as religion versus secularism), the most characteristic seasonal symbols persisted. They remained remarkably constant in key respects, from ancient times at least until the Victorian era in America. The customary and familiar iconic symbols were fully developed by the twelfth century, although the prominence of classical deities associated with particular seasons waxed and waned according to the variable potency of Christian doctrine and pantheism. According to pre-Christian personification, when Persephone (the daughter of Ceres) returns from months of banishment in the underworld with Pluto, she signifies the end of winter and the advent of spring. Ceres, the goddess of growth and harvest, comes and goes periodically. Pomona, goddess (or nymph) of fruitfulness, appears most prominently in sixteenth- through eighteenth-century European art (along with her disguised suitor Vertumnus, late Roman god of vegetation and the changing seasons) because fruits and the harvest are heavily featured in baroque and rococo European painting (figure 6). Significantly, however, the prevalence of ancient mythology in European seasonal art from the mid-seventeenth to the mid-nineteenth centuries did not carry over to the New World. American artists and writers knew Virgil's *Georgics* and Ovid's *Metamorphoses*, abundant sources of classical mythology, but did not visualize or invoke those stories as their Old World predecessors had.[5]

Europeans have been more inclined than their American counterparts to begin seasonal sequences with winter. A slender volume published in Dublin in 1818 seemed almost apologetic at the outset because it started with January: "The ancients began their year in March [i.e., spring], and it may appear singular, that modern civilized nations should choose to commence their year, at a period when nature lies almost dormant, in preference to that season, when the race of vegetables and animals is actually renewed." In 1836 the Reverend Henry Duncan, a versatile Church of Scotland clergyman, published *Sacred Philosophy of the Seasons; Illustrating the Perfections of God in the Phenomena of the Year*, a four-volume compendium that was adapted in 1839 for the first of several American editions. Volume 1 is devoted to winter, and the author explained why in his preface:

> Winter is not the death of Nature, neither is it merely the season of Nature's sleep after the labors of the vegetable world are finished. A thousand secret

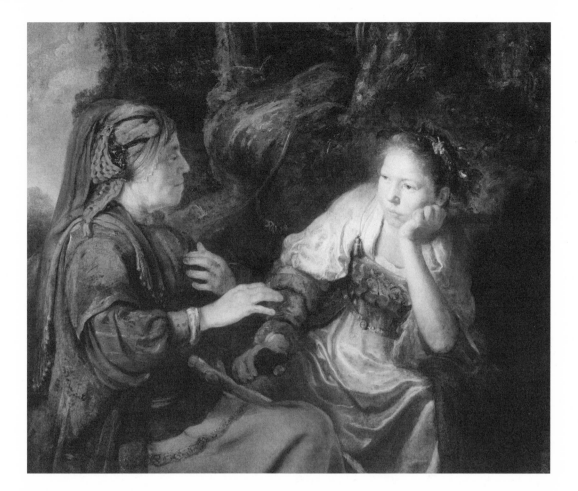

operations are in progress, by which the seeds, buds, and roots, of future plants and flowers, are not only preserved but elaborated, that, when the prolific months of Spring arrive, they may burst into life in all the freshness and vigor of a new birth. This, which is both a more important and a more interesting view than that which is commonly entertained, represents Winter as the first stage in the processes and developments of the revolving year.

He stated in the preface to volume 4 that autumn provides an "epitome" of the entire year in "inverted order" because it really includes aspects of summer, spring, and winter.[6]

Victoria Sackville-West, widely recognized in Great Britain as an authority on gardening, published a book-length poem in 1926 in blank verse titled *The Land* that achieved immense popularity (reprinted twenty times). She, too, began with winter; but more important, perhaps, was her obvious debt to Virgil's *Georgics* and Hesiod's *Works and Days*, the main progenitors of seasonal writing from antiquity. *The Land* reveals the lingering impact in England of

FIGURE 6 *Govaert Flinck,* Vertumnus and Pomona *(ca. 1650), oil on canvas. Memorial Art Gallery of the University of Rochester. Gift of Dr. and Mrs. Frank W. Lovejoy Jr.*

classical writing about the four seasons well after the virtual disappearance of that influence among nature writers in the New World. Sackville-West differed from the "models" she so admired by being more descriptive than didactic. Her poem offers proud homage to English country life as much as it does to Virgil, but she is determined to convey a sense of connectedness:

> Hesiod and Virgil knew
> The ploughshare in its reasonable shape,
> Classical from the moment it was new.

On the very last page Sackville-West speaks to Virgil directly.

She also devotes four full pages (40–44) to bees, a sure indication of her esteem for Virgil, who devoted one book in *The Georgics* to bees as socially cooperative creatures. Bees and beekeeping provide yet another recurrent motif in seasonal writing because cold weather can be devastating to them; but even more important, as pollinators they play a vital role in the reproduction of plants. James Thomson devoted many lines to bees, especially in "Autumn," and so did Edwin Way Teale in books written throughout four decades beginning in the 1930s. Sue Hubbell, the American author of *A Country Year: Living the Questions* (1986), is a beekeeper whose vocation provides the organizing theme of her four seasons book. Although she never mentions Virgil, she certainly perpetuates that familiar fascination from *The Georgics*.

Hubbell begins and ends her work with spring, like so many of the finest American writers. Doing so, regardless of an author's preferences for the other seasons (Thoreau adored both autumn and winter), provides the most hopeful emphasis upon procreation, rebirth, and the continuity of life. Ending a book or a series of paintings with winter is more likely (though certainly not inevitably) to be austere yet, paradoxically, also more traditionally Christian. For American artists and writers attentive to season-based creativity there has been no singular or dominant way of sequencing the seasons, except that they are *least* likely to begin with summer or with autumn (exceptions to the latter include Henry Beston's classic *The Outermost House: A Year of Life on the Great Beach of Cape Cod* [1928] and Robert Jessup's fantasy sequence of seasonal paintings [plate 40]).[7] The roster of American writers whose works start with spring and stop with winter is considerable, beginning with Susan Fenimore Cooper's *Rural Hours* (1850), James Buckham's *Afield with The Seasons* (1907), Rachel L. Carson's *Under the Sea-Wind* (1941), Teale's best-selling quartet (1951–65), and no fewer than three of Hal Borland's collected columns from the *New York Times* and *The Progressive*.[8]

Finally, there are also what might be called "calendrical" books and almanacs by American naturalists, works that are quite concerned with seasonal change but organized on a monthly basis beginning with January. (The almanacs often have day-by-day entries, commonly clustered by months or even by seasons.)

The best-known among these are Leopold's *Sand County Almanac* (1949), Joseph Wood Krutch's *Desert Year* (1952), Teale's *Circle of the Seasons* (1953), Hal Borland's *Twelve Moons of the Year* (1979), and Verlyn Klinkenborg's *Rural Life* (2003).[9] But here we must pause to sort through a puzzle, because most creative works with seasonal motifs were not meant to be calendars, and some almanacs and calendars are not primarily concerned with the seasons; or if they are, they do so in a manner that is much too literal-minded or else perfunctory.

In medieval times (and subsequently), calendars served to remind people about special days and requisite religious observances. In the eighteenth and nineteenth centuries, farmers kept daybooks to record the weather, and they purchased almanacs in order to "know" the latest possible date for freezing temperatures in the spring, or else the earliest in the fall. Relying upon such records assumed a certain degree of regularity and predictability from year to year.[10] Somewhat inexplicably, Thomas Jefferson insisted that planting be determined according to the calendar, arbitrarily, rather than by the realities of weather conditions at any given time. A few of our naturalists, mostly the earlier ones, shaped their seasonal books based upon such assumptions of regularity. Writing in 1907, for example, James Buckham insisted upon reliable precision.

> Many seasons of bird observation in different parts of New England have led me to anticipate with peculiar delight the coming of the tenth of May. For some occult reason known only to the birds that date seems to be the spring day of jubilee, the "old-home day" of the feathered pilgrims. They may be entirely ignorant of the Gregorian calendar, but they certainly do have some system of their own for marking times and seasons, even down to the days thereof, as their regular arrival in certain localities, year after year, on certain calendar days (or so near them that the variation is not worth computing) conclusively proves.[11]

Most naturalists who write about the seasons have done so based upon observations gathered over many years. Necessarily, they seek to make plausible and persuasive generalizations. Nevertheless, most of them acknowledge that seasonal change and activity vary from one year to the next. So we encounter in the literature a curious phenomenon: some rigid assertions about what will happen at very particular times mingled with a more prudent insistence upon variability. John Burroughs warned his readers to be aware of regional differences: "The course of the seasons never does run smooth, owing to the unequal distribution of land and water, mountain, wood, and plain." Edwin Way Teale put it even more succinctly in 1953, citing Burroughs and his friend John Kieran, a noted ornithologist: "No two years are alike."[12]

So almanacs and books about the seasons may be cousins, at best, but not exactly siblings. Partial blame for the confusion may be placed upon nineteenth-century reviewers of the "almanacker's art," who sometimes tended to conflate

the two types. Part of the explanation may also be found in the fact that both genres include considerable concern with meteorology: the study of climatic changes and their causes. And responsibility also lies with a few of the naturalists themselves, especially the most creative. In August 1851, for example, Thoreau called his journal (so aptly!) a "meteorological journal of the mind." He intended to describe and document not merely the seasons, but seasons of feeling and perception *within* the seasons. He correctly observed in 1850 that the "year has many seasons more than are recognized in the almanac," yet envisioned his journal as a "Kalendar" of both the natural and human seasons.[13]

After years of dickering with publishers during the 1940s over how best to collect his essays into a book, Aldo Leopold wrote to a friend in 1944: "I have been flirting with the almanac idea myself as a means of giving 'unity' to my scattered essays." By 1948 he was calling his now famous project the "Sauk County Almanac." We do not know how "Sauk" gave way to "Sand" within a year. But we do know that Leopold, like all modern naturalists, kept factual "field notes" which he then recorded in his "Shack Journal." Thoreau's forty-one volumes of journals, published posthumously in 1906, comprise an even greater achievement in terms of seasonal observation than *Walden* and *A Week on the Concord and Merrimack Rivers* (1849).[14]

Because writers like Teale, Borland, and Donald Culross Peattie occasionally published journal notes in revised form as popular almanacs, they have made it that much easier for us to fall into the trap of regarding almanacs and books about the seasons as mates, which they are not despite the fact that astute observations about the seasons certainly do appear from time to time in the almanac volumes. Here is just one example from *An Almanac for Moderns* by Peattie:

> There is something classic about the study of the little world that is made up by our first spring flowers—all those which bloom not later than April. They are delightfully easy to learn, in case you do not already know them, for there are so few of them that any local manual of the spring flowers will swiftly make you friends for life with them. . . . Characteristic of the northern hemisphere, these give us blossoms that turn up to us the dainty face upon the delicate stalk. They mean to us all that is brave and fresh and frail in the name of spring. Summer flowers distract us with well upon a hundred families, with a strong tropical element; autumnal flowers are confined almost wholly to the tall rank composites. But something in the spring flora, perfect in its simplicity and unity, carries us back to Arcady.[15]

One of the most striking distinctions among American artists and writers is the preference of many for describing or showing seasons at their absolute peak (such as Jasper Cropsey's display of brilliant fall foliage [plates 16 and 18]) while others have felt more fascinated by the transitions from one season to the next

(a preoccupation of Charles Burchfield exemplified by his *Coming of Spring* [plate 28] and Emily Clayton Bishop in her allegorical sculpture titled *The Passing of the Seasons: Winter into Spring* [1908]). As the poet Wallace Stevens wrote to a friend in 1951: "It is the dead of summer here. People are beginning to say how fast the summer is going by. In the park the great leaves of the water-lilies are beginning to shrivel. This is always one of the first signs that the season is passing—even though it is not actually mid-way."[16]

Among the many notable manifestations of Thoreau's role in this narrative is that he combined an enthusiasm for the seasons at their most characteristic peaks and a fascination with transitions. He was enamored of the whole grand concept of the redemptive cycle of the seasons. As he wrote in his journal on June 11, 1851, while *Walden* was still in gestation: "No one to my knowledge has observed the minute differences in the seasons. . . . A book of the seasons—each page of which should be written in its own season & out of doors or in its own locality wherever it may be—[.]"[17] In a very real sense, naturalists like Teale, Borland, Dillard and others eventually wrote such books more than a century later—not exactly as Thoreau would have done, yet each author's achievement is distinctive and noteworthy.

Perceptions of the Seasons: Cultural Constructions of Nature?

In a society or culture of hunter-gatherers, people moved on a seasonal basis in search of sustenance. Seasonality has never meant more than it did to prehistoric humankind. It was not a socially constructed phenomenon in their lives. But at some point in ancient times it became so, in a certain sense. According to Greek mythology, in the Golden Age there was perpetual spring (plate 5). Then came the Silver Age, when spring shrank to a single season, so that summer, autumn, and winter came into being. Although the genesis of that myth cannot be pinned down, we do know that somewhere in the deeper recesses of time, perhaps the second millennium B.C., people in the temperate zones identified only two seasons by name: summer and winter, because both of them enjoy considerable climatological consistency throughout, first favorable and then unfavorable to growing things.

At some point during the first millennium B.C., at the latest, acute observers began to suspect that seasons might conceivably be determined by the position of the earth on its journey around the sun (though the vast majority would follow the view of Ptolemy, indicating just the opposite). The axis of the earth, on which the globe spins, is tilted 23½ degrees away from vertical to the plane of the earth's orbit around the sun, and always points in the same direction. Consequently the northern hemisphere is inclined toward the sun in summer and away from it in winter. That fact, combined with the curvature of the earth's surface, results in uneven heating at various latitudes. During autumn, the

FIGURES
7–10
Frances F.
Palmer and
Charles R.
Parsons for
Currier and
Ives, The
Four Seasons
of Life
(1868), toned
lithographs.
Division of
Prints and
Photographs,
Library of
Congress.

FIGURE 7
Childhood.

northern hemisphere tilts progressively farther from the sun; and in spring, of course, the reverse takes place. When these fundamental determinants came to be more fully understood in the seventeenth and eighteenth centuries, the seasons no longer needed to be socially constructed and rationalized by myths and metaphors, although they continued to be by many people, especially artists, for various reasons.

One of the most important ways in which the cycle of the seasons has been culturally constructed involves the concurrence that societies have tended to draw between seasonal progression and the human life cycle. The parallel dates back as far as a poem of Pythagoras praising what he referred to as "The Four" and to Ovid's *Metamorphoses* at the end of the first century B.C.[18] Occasional analogies appeared in the thirteenth and fourteenth centuries. They became commonplace in European art during the seventeenth century and pervasive in American art and writing during the mid- and later nineteenth century, ranging from immensely popular lithographs by Currier and Ives (figures 7–10), to sentimental fantasies by a widely read New Englander with the peculiar pseudonym Ik Marvel, to Thoreau and his contemporary Wilson Flagg. Like Jasper Johns when painting *The Seasons*, Thoreau regarded *Walden* as a ripened prod-

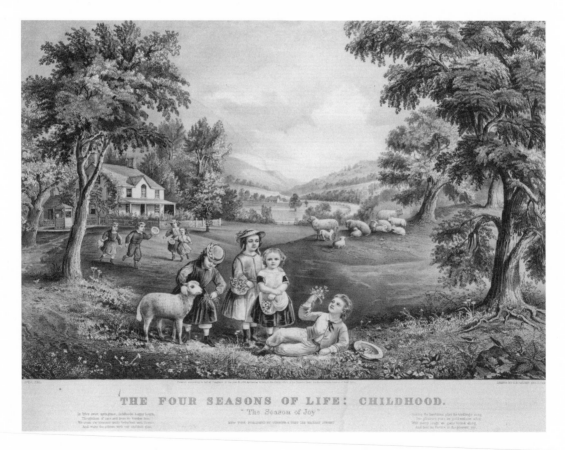

THE FOUR SEASONS OF LIFE: CHILDHOOD.
"The Season of Joy"

uct of his autumn years, but clearly hoping that it was still early in that season for him rather than late. Although he usually tried to be upbeat about autumn as a season of maturity, the circumstances of his delicate health by the later 1850s caused him considerable concern.[19]

The persistence of this inevitable analogy for more than another century would prompt Hal Borland to devote one of his seasonal columns in 1969 to the problem of misleading parallels.

> We live with it. It is a part of our consciousness, and it is so deep in our unconsciousness that we know without stopping to argue it out that life itself is cyclic, and so is thought, and fashion, and even the trends of human behavior, both private and public. The comparison of life to the year, with the springtime of youth and the hoary winter of old age, is just a bit too glib, but even it is not really false. There are the rhythms, the cycles, the way life and everything else in our cosmos changes, coming around to similarity time and again but never coming to quite the same ever again.

Despite Borland's cautionary wisdom, serious social scientists along with popularizers of social commentary have persisted in publishing books and essays

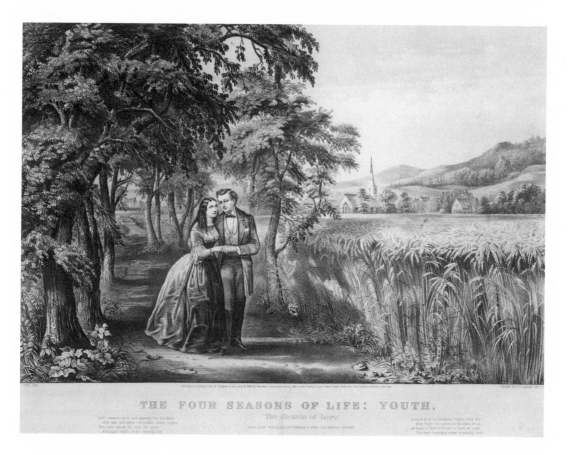

THE FOUR SEASONS OF LIFE: YOUTH.
The Season of Love.

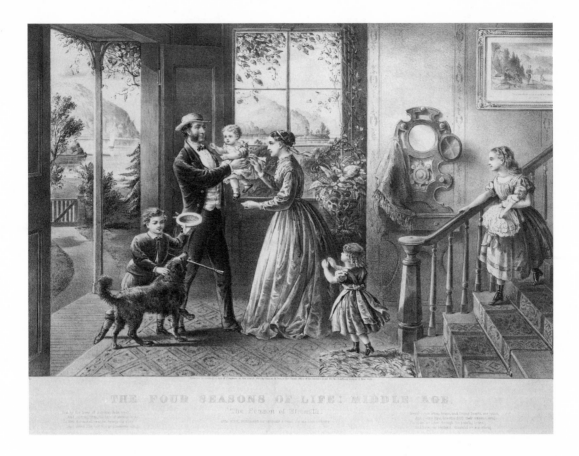

THE FOUR SEASONS OF LIFE: MIDDLE AGE.
"The Season of Strength."

FIGURE 9
Middle Age.

that push the seasonal analogy to extremes of pseudoscientific empiricism. The best-known of these works, perhaps, are Daniel J. Levinson's *Seasons of a Man's Life* (1978) and Gail Sheehy's *Passages: Predictable Crises of Adult Life* (1976).[20]

Compounding this penchant for similarities between cycles of nature and the human life cycle, we also find in ancient symbolism an inclination to correlate the four seasons with four segments of the day. That analogy would persist in European art and thought right through the nineteenth century. Prime examples are provided by Poussin's *Four Seasons* (1660–64); by Nicolas Lancret, another French artist, whose *Four Times of the Day* (1739–41) quartet is located in London's National Gallery; and by occasional work done by Jean-Baptiste Corot (ca. 1858). Among American artists, the analogy is evident in Thomas Cole's *Four Times of the Day in Italy* (1830s). Roughly two decades after Cole's composition, an obscure New York State farmwife wrote in her diary: "As I have . . . compared our life to the four seasons I will now represent it by the hours of the day."[21]

Which brings us to yet another central concern of quite a few artists who paint the seasons: contemplation of time and its long-term passage. A contemporary American artist, James McGarrell, painted *Spots: Near Distance* (1984–

24 *Introduction*

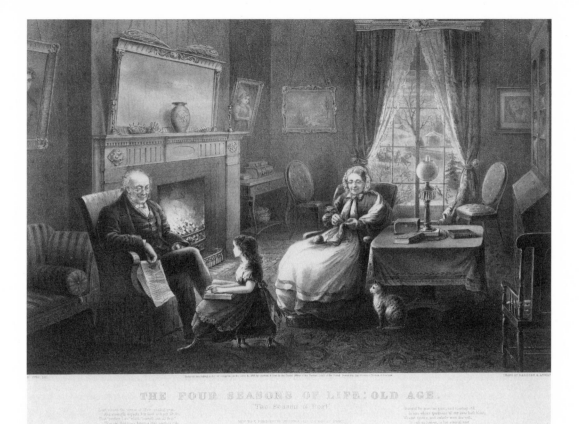

85), which views the same scene both seasonally and sequentially at different times of the day. McGarrell has also painted at least three major (and very different) sets of four seasons images: *Tendril Nights* (*The Four Seasons*) (1983), *River Run* (1990, plate 44), and most recently murals titled *Redwing Stanza* in the spacious dining room of his own home in Newbury, Vermont (plate 45). In the year 2000, when McGarrell turned seventy, he wrote that he continued "to be occupied by the 4 seasons subject, in fact, and in the larger context of time—hours of the day, months of the year and times of a life," a statement that is representative of quite a few other artists and provides a succinct reprise of themes that have just been introduced.[22]

FIGURE 10
Old Age.

Seasonal Processions as Measuring Rods for a Citified Society

The presentation or use of seasonal motifs frequently occurs in discussions of progress or social change, and more often than not is accompanied by a tone of nostalgia if not regret. Nature, of course, has increasingly come to be viewed as diminished, even threatened, by technological progress and social desires in a self-indulgent postmodern society. What needs to be kept clearly in mind, how-

ever, is that these sentiments are not new, though they most certainly intensified during the twentieth century. As early as the mid-nineteenth century, possessing a country home became important for affluent people who worked in cities but wanted to retain intimate contact with nature and seasonality. By 1875 the *New York Times* was publishing articles and editorials on the "walking mania" that seemed to be sweeping eastern seaboard cities. Affluent members of the growing middle class, noticing industrialization, wanted somehow to "get back to nature." Like Thoreau, John Burroughs burgeoned as a strident advocate of walking; in essays that appeared from the 1870s onward he not only sounded a critical alarm against the sedentary urbanization of America but also lamented that machinery had significantly reduced the picturesque aspects of farm life. His antimodernism and nostalgic tone did not diminish his popular appeal because so many of his readers shared those sentiments.[23]

Naturalists half a generation younger than Burroughs, writing at the turn of the century, tended to be less overtly critical or iconoclastic. Although their books were principally aimed at urban dwellers and sought to reconnect and familiarize them with nature, the authors identified with the emotional needs of their readers. As Frances Parsons put it in 1902, "we, with city lives but country loves" should recognize that there is seasonality to be enjoyed despite the confines of urban life. "In the city as in the country there are marks of the changing seasons pregnant with suggestions to the nature-lover." Similarly, Samuel C. Schmucker indicated repeatedly in his *Under the Open Sky* (1910) that while man had been steadily encroaching upon nature, and that certain wild creatures and flowers seemed to be disappearing, the purpose of his book was to assist people who felt a longing for contact with "Nature in her simpler manifestations." Schmucker tended to be predictably sentimental and romantic, and like Parsons frequently anthropomorphized nature, including plants as well as animals. His prime objective, however, was to bring city folk back into informed contact with traditional seasonal settings.[24]

Less than half a century later, when a remarkable and broadly appreciated generation of naturalists produced a considerable amount of seasonal writing, their tone and most frequent subtext became quite different. Henry Beston, the eldest of the group and one who had already produced *The Outermost House*, epitomized one aspect of the new cri de coeur with the closing paragraph of *Northern Farm* in 1948: "What has come over our age is an alienation from Nature unexampled in human history." If that sounds hyperbolic, Beston was undoubtedly the most antimodern member of this Thoreauvian cohort. Few others rang out with quite so shrill a tone. But one year later a reviewer of Joseph Wood Krutch's *Twelve Seasons* told readers that the book addressed "mankind's divorce from nature." Within a decade that sentiment started to be linked ever more explicitly to disaffection from city life.[25]

In Hal Borland's seasonal column for *The Progressive* early in 1967 he insisted

that even in an urbanized environment, mankind needs "the vital stimulus . . . the changing of the seasons." He would reiterate that theme repeatedly until he died. In 1971 Charles Seib lamented that "city life insulates us from the elements." And in 1988 journalist Rick Marsi railed at "how far humans have removed themselves from the cycle of the seasons."[26]

In several respects, Borland's views were most symptomatic of the naturalist critics; but before we listen to his (customarily) gentle homilies we must introduce a major development that will become central to the final chapters of this book: namely, the "flattening" of the seasons in nineteenth- and twentieth-century life. The phenomenon gets started in the eighteenth century, of course, but accelerates rapidly thereafter, when weddings as well as the conception of children ceased to be seasonal phenomena to anything like the extent they once had been. Urbanization and the accompanying changes in how people live played a major part. Today most of us can be warm and well-fed in winter, but that was not always so. For animals, autumn is a time for planning ahead, for gathering and putting up provisions. For most of human history that was true for people as well; but it has been much less so for more than a century now. Since World War II, especially, many Americans have been able to do what only a tiny elite once did: change their location, climate, and environment to suit their comfort levels. In Florida and the Southwest these people are referred to, somewhat disparagingly, as "snowbirds." They can migrate. As historian George W. Pierson put it in 1972, "Americans have pretty thoroughly scrambled their seasons."[27]

Fundamentally, for more than a century now people have been living much more independently of seasonal change than their ancestors did. When ownership of automobiles became democratized during the 1920s, for example, that contributed to the "deseasonalization" of American cities. The need for swift snow removal suddenly seemed urgent, and essential equipment became available. In 1927 a Caterpillar Tractor Company brochure declared that "life in Winter soon will go on much as in July." The very notion of plowed roads being open all year round became normative well before midcentury. When we look at the responses of writers and artists to such realities, we encounter an intriguing split. Artists and poets who choose to use the four seasons motif become more subjective, personal, and often exuberantly creative in their projects, as we shall see in chapter 7. The naturalists, in contrast, become increasingly distressed and critical. For Hal Borland (figure 11) life without seasonal change and the challenges it presents was virtually inconceivable. He explained why quite forcefully in *Homeland*.

Remembering all this now, this quiet rural autumn morning, I wonder what we have gained and what we have lost as we, a nation, have become so largely an urban people, not only living apart from the land but alien to it.

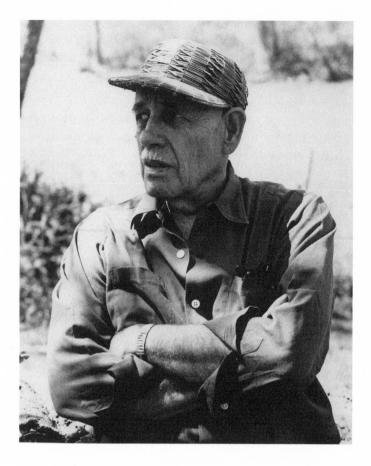

FIGURE II
Hal Borland
(ca. 1973).
Photograph
by Les Line,
courtesy of
Alfred A.
Knopf, Inc.

We haven't achieved certainty, about our selves or even about our purposes. Man has become one of the most unpredictable creatures on earth, and for that reason one of the least reliable. . . . Lacking the continuity of the seasons and the certainty of the great rhythms inescapable on the land, he has achieved a strange arrogance that mistakes data for knowledge and makes gods of his machines.

Nobody in his right mind would argue that isolated life on the land, wholly dependent on the seasons and made comfortable only by individual effort, represented the ultimate of human achievement. But it is debatable whether automated, group-dominated urban life, almost wholly isolated from the natural environment, represents that ultimate either.[28]

Five years later Borland felt provoked by the arrogance of an urbanite whose "seasons of the mind" (meaning the pleasures of popular culture, mainly) was a very far cry from Thoreau's desired "meteorological journal of the mind." So Borland snapped back in a manner that almost seems intemperate for such a calm, semireclusive soul.

Just recently I read a complaint about critics of urban life by a man who was so insular that he was almost incredible. Yet he said, "There is an abiding sense of isolation, insularity, and anachronism about rural life and rural people," and he went on to proclaim that in the city "spring occurs every time there's a new museum exhibit or hit show or pennant race. The seasons of the mind do not wait upon the equinox—the bloom of a new fashion and the eclipse of a celebrity's glow are small parts of a man-made world spinning far faster than the leisurely pace of our planet." And so on through as myopic a demonstration of imperception as I have ever read.

Borland's screed virtually echoed one of Thoreau's most prescient journal entries more than a century earlier, in 1859: "Why do you flee so soon, sir, to the theaters, lecture-rooms, and museums of the city? If you will stay here a while I will promise you strange sights. You shall walk on water; all these brooks and rivers and ponds shall be your highway. You shall see the whole earth covered a foot or more deep with purest white crystals . . . and all the trees and stubble glittering in icy armor."[29]

Thoreau penned another remarkable passage during the 1840s in which he commented that a village is not complete unless it has trees to mark the seasons suitably. He then specified willows for spring; elms for summer; maples, walnuts, and tupelos for autumn; evergreens for winter; and oaks for "all seasons."[30] I am unaware of any other passage like that in all of the literature; yet I do find it intriguing to notice how many urban parks and cemeteries contain man-made counterparts to Thoreau's seasonal trees: namely, four seasons statuary, sometimes in marble, sometimes in concrete, occasionally even in the guise of fountains with figures representing the four seasons. The urban flâneur can stroll to Madison Avenue and 25th Street in Manhattan and find the female four seasons surmounting the Appellate Court House, designed and placed there late in the 1890s (plate 21); to Rockefeller Park in Cleveland, where painted cement sculptures of four female figures in classical dress have resided since the mid-1960s (moved there from Gates Mills, Ohio); to Westhampton Memorial Park in Richmond, Virginia, where four seasons putti have gamboled since 1978 in the Garden of the Four Seasons; and to the Greenwood-Mount Olivet Memorial Park in Fort Worth, Texas, where seasonal putti were dedicated in 1961.

Last though hardly least, one should go to Salt Lake City, where Janet Shapero's work, titled *Seasons of Our Story*, was installed on the grounds of the Triad Center in 1993. Made of Utah red sandstone and cast glass, this is surely one of the most innovative pieces of seasonal sculpture. The design was developed in collaboration with the Uintah and Ouray Ute tribes of eastern Utah; and the images that are etched into the glass honor those Indians by recalling aspects of their history copied from petroglyphs. The title of this stunning work

refers to the seasons of Ute history as much as it does to the seasonal cycle in nature.

The prevalence of four seasons statuary, sculpture, fountains, even benches situated in public spaces in American cities clearly indicates a willingness if not a desire to perpetuate the traditional symbols of seasonal change, particularly for the "benefit" of urban dwellers—perhaps as a reminder of their roots, or at least their families' roots in an earlier, more rural and agrarian era. Yet another and, I believe, a related reminder to be found in private or domestic spaces takes the form of beautiful coffee-table books with stylish texts and splendid photographs of the seasonal cycle. These eye-pleasing depictions of places rank among the most popular items purchased at tourist-site gift shops.

Places with Significantly Variable Seasonal Cycles and Motifs

The four season motif may well be ubiquitous, but it is certainly not universal. In most parts of Africa it is more common to perceive the year in terms of three seasons. Along the Nile the seasons are called *Akbit* (the inundation), *Perit* (the going-out), and *Shemon* (the harvest). In 1993 a Nigerian artist named Obiora Udechukwu painted a major three seasons sequence. *Udummili* (*Rainy Season*) shows the abundance of nature resulting from heavy rainfall. *Okochi* (*Dry Season*) highlights a very intense sun brightening the sky. And *Ugulu* (*Harmattan*) depicts the time just before the dry season when dusty winds from the Sahara blow relentlessly across West Africa. The area called Kakadu in northern Australia is said to have six seasons.[31]

Naturalists who write about Vermont also like to say that it has five or six seasons. One of them calls the fifth season "mud March," being neither winter nor spring. According to Noel Perrin, however, six should be recognized: "First comes unlocking, then spring, summer, fall, locking, and finally winter. What begins in March is unlocking. Its enemies call it mud season, because what unlocks first is the ground, but that's not a fair name. There *is* considerable mud, but there is also much beauty of kinds never to be seen in warmer or drier climates." Another writer calls the dry season in California "the fifth season"; yet Edwin Way Teale asserted that the redwood belt of California had only two seasons: dry in the summer and wet in the winter. In Mary Austin's classic work about the Southwest, *Land of Little Rain*, she declared, "This is a country of three seasons." The late American artist, Peter Hurd, who lived on a ranch in New Mexico, painted at least two pictures titled *The Rainy Season*.[32]

When English colonists came to the Caribbean islands in the seventeenth century, they felt perplexed by the absence of seasons as they had been known at home and reported accordingly with a mix of delight and dismay. Their peculiar and ill-informed ideas about the psychological and behavioral consequences of seasonal "absence" were almost as misplaced as those expressed by

Hippocrates, the ancient Greek physician (ca. 400 B.C.) traditionally regarded as the "father of medicine," who declared: "The chief reason why Asiatics are less warlike and more gentle in character than Europeans is the uniformity of the seasons, which show no violent changes. . . . For there occur no mental shocks [to the people] . . . which are more likely to steel the temper and impart to it a fierce passion than is monotonous sameness. For it is changes of all things that rouse the temper of man and prevent its stagnation. For these reasons, I think, Asiatics are feeble. Their institutions are a contributory cause, the greater part of Asia being governed by kings."[33]

Hippocrates could not have been more mistaken. The seasons are every bit as variable in Japan and most of China as they are in Western Europe and the United States. In the second century B.C., a Chinese philosopher observed that "the concentrated essences of the yin and yang became the four seasons, and the scattered essences of the four seasons became the myriad creatures of the world." During the T'ang Dynasty (618–899 A.D.) seasonal poetry flourished, though the annual rhythm often included what they called an interlude between summer and autumn.[34] The East Asian countries, moreover, have an extremely rich tradition of four seasons art: in scroll paintings dating back to the fifteenth century, at least; on ceramic bowls and vases (plates 8 and 9); in Chinese seasonal pavilions arranged symmetrically around a small lake; and in elegant Japanese folding screens (figure 12). Seasonal scrolls painted in Japan during the nineteenth century range from traditional landscapes reflecting an enduring Chinese influence to more nationalistic works rendered in what artists considered an indigenous style (figures 13 and 14).

The labors characteristic of each season do not figure prominently in the East Asian tradition, as they do in the European. In that respect the former is closer to the customary American emphasis upon pure (or "naturalized") landscapes. In southern China, large armoires were made of lacquered wood (with gold and encrustations) on which seasonal poems and lavish seasonal designs were inscribed in circular medallions. In addition, Chinese and Japanese art of the seasons tends to favor certain seasonal flowers: above all the peony or iris for spring; the lotus, especially, but sometimes the peach and the rose for summer; chrysanthemums or red maples for fall; and usually pink or white plum blossoms for winter, though occasionally the prunus or apricot as very early harbingers of spring. They also visualize trees, and especially bamboo (a traditional emblem of gentlemanly virtues), under different weather conditions, and birds that are most conspicuous at particular times of the year.[35]

On Bringing the Motif to the New World, and Seasonal Anxieties

Whereas Hesiod and Virgil had lessons to teach, mainly about when to do what in the agricultural cycle, American didacticism has differed somewhat in

FIGURE 12
Kano School,
Birds and
Flowers of
the Four
Seasons *(later*
sixteenth cen-
tury), mineral
pigments on
gold-leafed
paper. One of
a pair of six-
fold screens
(showing
Winter and
Autumn).
The Metro-
politan
Museum of
Art, Purchase,
Mrs. Jackson
Burke and
Mary Living-
ston Griggs
and Mary
Griggs Burke
Foundation
Gifts, 1987.
(1987.342.1,2).

its emphases, ranging from Thoreau (how a man should live simply, in accord with nature) to the ecological and conservationist messages of Muir, Carson, Leopold, and Borland. With Annie Dillard and more recent artists there is a return to the mysteries, wonders, and awesome power of the seasons—themes that were central to Thomson's seminal poem *The Seasons* but stripped of his religious utterances and attributions that seemed essential to disciples of Isaac Newton and of Newton's God as well. The American writers customarily replaced religion with careful empirical notations of natural phenomena, often romanticized by touches of pantheism. In sum, the seasonal motif would come to be Americanized in the century and a half following 1850. One mission of this book is to demonstrate that process in some detail.

It needs to be noted that American artists as well as writers were increasingly attracted to "process" and "procession" in thinking about seasonality. It became symptomatic of the very syntax of their seasonal perceptions and depictions, and gradually supplanted the "circle of the seasons" as an especially appealing metaphor. Because Hal Borland was so engaged by what he believed to be eternal verities, he penned such passages as "so long as there is an earth and a procession of the seasons," which exactly replicates a phrase that painter Charles Burchfield inscribed in his journals more than once. When writer Laura Lee Davidson decided to spend a year living alone on an island in 1920, she explained that she planned to "watch the procession of the seasons." Procession and progression provide recurrent watchwords in later American conversations about the seasons.[36]

In terms of a unique "processional" collaboration, however, it should also be noted that in 1844 Thomas Cole, considered the founder of the Hudson River School, painted a work titled *Autumn* that George Austin of New York City

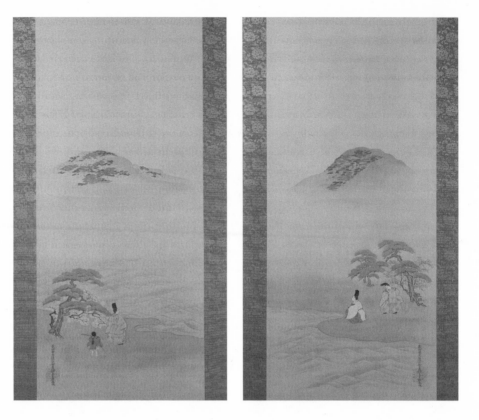

purchased. According to a review that appeared in the *Literary World* on June 5, 1847, a cycle of seasonal paintings had been completed because Austin also commissioned works from three other prominent American artists in order to make a quartet: *Summer* by Asher B. Durand, *Winter* by Regis Gignoux (a specialist in winter scenes), and *Spring* by Jasper Cropsey. "The works were distributed with discrimination," according to this account: "Cole's rich autumnal foliage; Durand's warm, dreamy atmosphere; Cropsey's tender greys and greens; Gignoux's fleecy snow storms are familiar to all lovers of art."[37] Alas, that series disappeared long ago; but it certainly sounds like the progenitor of many four seasons sets that we will encounter, mainly those painted between the middle and the end of the nineteenth century. From the surviving account, that collaborative set may very well have served as a major stimulus to the romantic imagination at midcentury.

Ever since Gilbert White commented in his classic *Natural History of Selbourne in the County of Southampton* (1789) that birds sing less in late summer, similar remarks about the seasonality of bird songs have become commonplace in the writing of naturalists. Artists do not customarily paint what we can and cannot hear. Composers, on the other hand, can and do; and works devoted to the seasons give us the sounds of storms, rustling leaves, thunder, and even avian

melodies. So we turn to Vivaldi, Haydn, Verdi, Tchaikowsky, Glasunov, Delius, and modern folksingers for seasonally specific music.

We should not be surprised that Thoreau made so many negative references to art that attempted to represent nature. "Men will go further and pay more to see a tawdry picture on canvas, a poor, painted scene, than to behold the fairest or grandest scene that nature ever displays in their immediate vicinity." And once again in his journal four years later, in 1857, after reading part of John Ruskin's *Modern Painters* (1843–60): "He does not describe nature as nature, but as Turner painted her. Although the work betrays that he has given close attention to nature, it appears to have been with an artist's and critic's design. How much is written about nature as somebody has portrayed her, how little about nature as she is and chiefly concerns us."[38]

Thoreau's close attention to Ruskin's thoughts on art, however, reminds us of the complexities and differences that we find when we move not only back across the Atlantic, but also back in time. In Europe, art frequently influenced poetry just as poetry could have a powerful impact upon music. We know, for example, that Thomson's *Seasons* was influenced by Nicolas Poussin's great series of paintings devoted to the four seasons (1660–64): the Virgilian gravity, the idealized landscapes, the human forms resembling antique statues, and so on. Scholars have found especially striking parallels between Poussin's *Summer* and Thomson's. And William Wordsworth's interest in Thomson's famous poem helped to perpetuate the image of Thomson as a painter-poet.[39]

On the other hand, a significant shift in attitude may have occurred on both sides of the Atlantic by the close of the nineteenth century. In George Gissing's seasonal novel, *The Private Papers of Henry Ryecroft*, initially published in *The Fortnightly* in London (1902–3), the narrator remarks that "through my youth and early manhood, I found more pleasure in Nature as represented by art than in Nature herself."[40] Perhaps at some point Gissing had somehow found occasion to heed Henry Thoreau!

Gissing completed that novel just before his premature death in 1903 at the age of forty-six; and scanning the rest of our dramatis personae there is an inescapable inclination to wonder whether a fascination with the four seasons motif is perhaps an older person's interest, if not concern. At the very close of his *Almanac for Moderns* (1935), as Donald Culross Peattie approached the vernal equinox, he wrote that "it touches a man that his tears are only salt, and that the tides of youth rise, and, having fallen, rise again. Now he has lived to see another spring, and to walk again beneath the faintly greening trees."[41]

Wallace Stevens had reached his sixty-eighth and sixty-ninth years when he composed "Credences of Summer" (1947) and "The Auroras of Autumn" (1948). He was clearly contemplating an irreversible progression (and ultimate finality) in both poems. "The season changes," he wrote. "A cold wind chills the beach." And then,

The scholar of one candle sees
An Arctic effulgence flaring on the frame
Of everything he is. And he feels afraid.[42]

Eugène Delacroix's last project, not quite completed at the time of his death in 1863, was his large set of the four seasons using mythological motifs. Jean-François Millet had not yet finished "Winter" in his four seasons suite when he died in 1875. The American artist Thomas Doughty was only halfway through his four seasons project when he died in 1856. Late in their lives both Willard Metcalf and Charles Burchfield envisioned a suite of seasons (Metcalf in 1924–25). Burchfield referred to his vision as "A Symphony of Seasons." Bernd Heinrich, a naturalist and scientist, was fifty-four when he published his account of *A Year in the Maine Woods* (1994). In closing a discussion of summer's end he acknowledged the realization "quite palpably now that it is life that has passed, but I feel content that I have lived it."[43]

Late in his life, though fully a decade younger than Heinrich was when he wrote those words, Thoreau observed in his journal that "it is in vain to write on the seasons unless you have the seasons in you." As a highly self-aware individual, Thoreau was clearly referring to the seasoning that comes with age because he had been writing *about* the seasons since his late teen years. Thoreau was only thirty when he left Walden in 1847. Annie Dillard was twenty-nine when she published *Pilgrim at Tinker Creek*, and Edmund Spenser was twenty-seven when his equally well received *Shephearde's Calender* appeared in 1579. A pastoral and allegorical poem, it offers a systematic description of all four seasons as well as the twelve months. December, with its bitter blasts of approaching winter, contains a reprise of the entire year, whose seasons are closely compared to the sequential stages of human life. Much would change between Spenser's Elizabethan poetry and Dillard's contemporary prose; but the legacies and resonance of all that lies between them seem equally worthy of pursuit.[44]

CHAPTeR I

FROM ANTIQUITY TO THE
EIGHTEENTH CENTURY IN EUROPE

Even a cursory glance at physical survivals from ancient Rome until the dawn of modern Europe reveals quite clearly the enduring cultural appeal of the four seasons motif, despite major innovations that involved organized religion, scientific understanding, aesthetic values, and the devolution of political power. One section of a floor mosaic depicting the seasons (plate 2) has survived largely intact from Antioch in Roman Syria (early third century A.D.). The winged boys, or putti, are actually play-acting by impersonating the seasons. Spring carries a container of flowers; Summer holds a sheaf of wheat in one hand and a sickle in the other; Autumn bears a basket of fruit; and Winter, wearing a warm cloak, poses alongside a bowl of fruit on a stand. This mosaic would have been part of a hallway floor in the home of an affluent family.[1]

Between 1575 and 1585 Jacopo Robusti, better known as Tintoretto, painted an *Allegory of Spring and Summer* and an *Allegory of Winter and Autumn*. Spring and Summer are shown as women. The first, in the foreground, holds a few flowers, and her hair is gaily decorated with white blossoms. The second, in the middle distance, is cutting wheat. In the companion piece Winter is represented as a nude old man seated on a waterfall with water rushing past him. He is watching a younger man, also nude, who appears to be somehow exercising in a tree. Although these oil paintings are large, they were very likely studies done for the weavers of grand tapestries. In any case, all four figures have a classical look, and each one is located in a setting that is well suited to the season. Spring is surrounded by wildflowers. Summer appears warm and dry. The tree in Autumn has sere leaves, and the trees in Winter are bare.[2]

Just beyond the famous Ponte Vecchio, spanning the Arno River in Florence, Italy, stands the Ponte Santa Trinita, originally constructed by the Frescobaldi family in 1252. Rebuilt in the sixteenth century, it is guarded at each end by two of the four seasons, with figures designed by Pietro Francavilla. Hence one side of Florence is sometimes referred to by locals as Spring and the other

side as Autumn. Michelangelo is believed to have provided a drawing for re-constructing this bridge.[3]

In the Palazzo Vecchio in Florence a room dedicated to the goddess Opi (the mother of Jove) includes four panels depicting the seasons. In the Estense Cas-tle at Ferrara the ceiling of the Aurora Room (once the bedroom of the Duke of Este) is handsomely decorated with the four seasons in the life of man. In the Venetian palace known as Ca' Rezzonico a grand room on the "first floor" (that is, the first level above the canal) has the seasons prominently painted where the walls meet the ceiling, an increasingly popular location for such motifs in seventeenth- and eighteenth-century palaces throughout Europe. Spring is represented by an uncommon acknowledgment of transition: a woman holds not only the inevitable flowers but an incense burner as well. Summer is sym-bolically reliable: a woman holds a crayfish in her right hand and a hat filled with grains in her left. Fall is only partially predictable: a woman bearing grapes and apples, with a cornucopia, a cow, and a book below her. And for Winter, a rather penetrating scene: a woman with a bow and arrow facing an old man with an arrow piercing his head.

The Genesis of Seasonal Motifs in Antiquity

During the later Middle Ages and Renaissance, many other Italian artists pro-duced personal variations on this enduring motif. But before turning to those works we must ask about the genesis of the motif, which clearly started in the central Mediterranean at least as early as the second millennium B.C. and un-derwent a series of transformations before emerging as the well-defined (though flexible) four-part sequence that we have been describing. We recall numerous scriptural references to the seasons, of course, the most familiar, perhaps, being the passage from *Ecclesiastes* (3:1–8) that begins, "To every thing there is a sea-son, and a time to every purpose under heaven."

Other biblical passages, however, serve to remind us that the characteristics we associate with certain times of the year differed in the ancient Near East. We associate the harvest with autumn, but *Jeremiah* 8:20 reads, "The harvest is past, the summer is ended." And *The Song of Solomon* 2:11–12 reads: "For lo, the winter is past, the rain is over and gone. The flowers appear on the earth, the time of singing has come, and the voice of the turtledove is heard in our land." The rainy season occurred in winter, not in April, when Americans are more likely to experience it.

Ancient Egyptians envisioned a system of three seasons that reflected cli-matic conditions in their land. Evidence suggests that people in Minoan Crete (second millennium B.C.) also used a concept of three seasons—winter, spring, and summer harvest—that suited its climate. In preclassical Greece, as reflected in the writings of Hesiod and Homer, there were only three *horae*, female

figures representing the seasons, with none for winter. The three were believed to promote the growth of vegetation. In classical Greece (sixth to fourth centuries B.C.), the four seasons were rarely represented in art despite the emerging appeal of four rather than three in literature. By 300 B.C., however, neo-Attic reliefs showed Dionysus leading a dance of the four seasons, an intriguing preview of Poussin's famous painting *A Dance to the Music of Time* (figure 15). The four seasons calendrical system apparently gained general acceptance during the early Hellenistic period, ca. 300–150 B.C.[4]

The Greek word "hora" denoted the seasons as well as certain female powers or spirits. By the time of Aristophanes (ca. 450–380 B.C.), the *horae* had clearly become goddesses of climate and vegetation. Euripides (fifth century B.C.) regarded Helios as the ruler of the *horae* and envisioned a team of four horses drawing the sun's chariot across the sky, an image that would become commonplace in Renaissance art, such as Poussin's *Dance*. Eventually, the *horae* were straightforwardly equated with the seasons of the year, frequently holding flowers and fruits. They also gave their name to the hours, which in a later era they also came to represent. Hence the close connection in seasonal iconography with "four times of the day."[5]

In Hellenistic and early Roman antiquity the seasonal figures stood primarily for good fortune, or happiness, or the passage of time. In later Hellenistic centuries the seasons served as symbols for the existence of an orderly universe. By the third century A.D. they had also been well established as parallel indications of change in the human life cycle. For Christians, however, the seasons ultimately indicated the promise of resurrection—hence their early appearance in the Roman catacombs. In the third-century Catacomb of the Pretestato, for example, there are four scenes in which putti are actively at work: making garlands for spring, harvesting in summer, at the vintage in autumn, and gathering olives in winter.

Depiction of the seasons as decoration for houses gradually spread uniformly throughout civilized centers of the Roman Empire, and ultimately the motif had considerable appeal simply because it replicated a fashion established by the Roman court and aristocracy. Starting in the early years of Hadrian's rule, around 119 A.D., imperial coinage tended to highlight the blessings of the seasons. The earliest preserved busts of seasonal figures date from the first century A.D., and the series of painted four seasons busts from Pompeii is believed to be the only certain example on Italian soil of a representation in which busts of the seasons appear together with those of the planetary gods of the week. A great many Roman mosaics display the seasons alone (without gods or other figures). Their apparent meaning? Symbols of prosperity and happiness. They seem to be saying, "May this house enjoy all good things throughout the year."[6]

Rome originated the use of the seasons in sepulchral iconography and became both its place of origin and the most central location for its development.

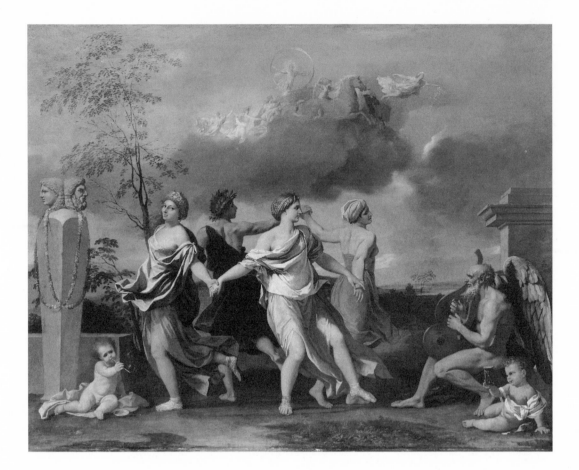

More than eighty pagan and thirty Christian designs have been found in sepulchral contexts. Four seasons sarcophagi started to appear between 222 and 235 A.D. during the reign of Emperor Alexander Severus. Among the eighteen Roman architectural sarcophagi extant, one of the finest and most carefully studied, known as the Dumbarton Oaks Sarcophagus (figure 16), probably dates from the first half of the fourth century. It seems to have been a very special commission, carved from a single block of grayish-white marble. Its subject matter clearly indicates that the sculptor must have been pagan, but it was created at a moment when overtly pagan and mythological motifs were being adapted for use on newly appearing Christian sarcophagi as well. Beneath the human figures of the seasons on the Dumbarton Oaks Sarcophagus, smaller figures appear to be symbols of fertility: a man milking a ewe for spring; a man carrying a sheaf of grain for summer; a vintage scene for autumn; and winter represented at the extreme left by a panther and at the right by a boar.[7]

Although there are clear patterns of repetition among Roman sarcophagi—quite a few extant ones apparently originated in the same workshop—there is also a fair amount of variation because each artist created his own version in

consultation with the commissioning family. So winter often might have a hare to which a dog vainly aspires, or the picking and pressing of olives, or a god shown with a boar, the animal so often featured in medieval and Renaissance iconography being butchered in November or December to provide meat for the cold season. In imperial Rome the seasons might be represented as female by *horae* or as male putti (plate 2), but most often, on the tombs of the wealthiest Romans, as adult males. Seasonal figures might be standing, walking, running, jumping, or even dancing.[8]

For a while, mainly from the third to the fifth centuries, the seasons were regarded by Christians as a symbolic promise of rebirth in conjunction with the Millennium. Unlike some other pagan motifs that were adopted or modified in Christian iconography, however, the seasons as personified forces were never endowed with a sufficiently significant theological meaning to insure their survival into Christian funerary culture. Representations of the seasons began to dwindle in number following the writings of Augustine (354–430). According to the late archaeologist and classicist George M. A. Hanfmann, once God was "removed to eternity, when [distinctive] Christian ritual and scriptural symbolism had crystallized, the [traditional] argument lost much of its conviction; it seems not to be a matter of chance that the representation of Seasons dwindle in number after the time of Augustine."[9] Consequently, interest in seasonal imagery waned from the time of the early church fathers until the Middle Ages.

Antiquity to the Eighteenth Century 41

Beginning with the Carolingian era in the ninth and tenth centuries, however, that creative contact with nature would begin to revive, though not for burial purposes.

Judaism followed a similar pattern of borrowing from Hellenistic culture. Rather early the reading of Scripture (the Torah) became associated with annual changes of the seasons. So life in the fields and cyclical change were depicted on tombs and in synagogues, perhaps suggesting aspirations for eternal life. Because these ideas would eventually find no place in normative rabbinic Judaism, at least not as embodied in borrowed pictures and symbols, they did not endure. Nevertheless, manifestations of the images we have been describing certainly became a part of Hellenized Judaism. Figures of the seasons on Jewish sarcophagi in Rome were "harmonized" in various ways, such as the placement of a menorah flanked by the seasons.[10]

The Dura Europos Synagogue (third century A.D.), located on the Euphrates River in what is now Syria, was decorated with wall paintings depicting biblical scenes. Ceiling tiles featured dates, wheat, grapes, and pomegranates. The synagogue known as Beth Alpha (sixth century A.D.), located west of the Jordan River and just south of Galilee, had a mosaic floor made with cut stones and mortar. The sun god Helios appears in his chariot surrounded by the twelve signs of the zodiac and by personifications of the four seasons. Rabbinic discussions from that early period indicate that pagan decorative imagery was permitted so long as it was not worshiped. As Erwin R. Goodenough has written, "Meaningless as representations of the zodiac might have become in synagogues and prayer books a thousand years later, their original invasion into popular Jewish symbolism, obviously never approved by the talmudic rabbis, must have had a great deal of meaning indeed."[11]

It is also clear that Stonehenge and other ancient monuments served religious purposes related to the seasonal cycle. These massive megaliths were undoubtedly designed to "record" with exactitude the changing seasons of the year, though the actual observances associated with them have long since become shrouded by the mist of legend.

Intriguingly, therefore, it is the Greek and Roman pantheon of deities and myths that survived and even flourished during the Renaissance and early modern period of European history. The Neoplatonists relied upon a tetradic correlation to demonstrate the yearly "unity" of the gods. Zeus was associated with spring, Helios with summer, Dionysus with autumn, and Hades with winter. For the Romans a comparable quartet became Venus (or Flora), Ceres, Bacchus, and Boreas (or Vulcan). Handsome mosaics using Greco-Roman four season motifs continued to appear in parts of North Africa, such as Tunis, and in Egypt where colorful tapestries were elegantly woven that depicted human figures in sets of four panels to decorate tunics or hanging fabrics for domestic use.[12]

We find occasional traces of all this in the material culture and decorative arts of Victorian America. The Romanesque Cupples House in St. Louis, built in 1890, has a large stained-glass window by Louis Comfort Tiffany derived from a drawing of the four seasons by the Pre-Raphaelite Sir Edward Burne-Jones. In this sequence, however, Mars as a young warrior serves as spring, Venus as summer, Apollo (unusually) as autumn, and Saturnus as old man winter.

Two, or perhaps three, ancient texts were particularly significant in transmitting the Greco-Roman seasonal tradition to subsequent centuries, even eras: Hesiod's *Works and Days*, Virgil's *Georgics*, and brief segments of Ovid's *Metamorphoses*, written after the Roman Republic had collapsed but before the Empire emerged. When Thomas Cole compiled a list of subjects that he had addressed over the course of his career, he cited "The Golden Age—The Age of Iron &c from Hesiod & Ovid."[13] *The Georgics* were Thoreau's favorite classical work, and, a century later, Henry Beston's as well. In his journals Thoreau cited Hesiod and Virgil as a linked pair, referred to Virgil frequently, and as early as 1840, when he was only twenty-three, quoted from *The Georgics* at considerable length in praise of husbandry. So did John Burroughs, on countless occasions, but especially when he was observing the behavior of bees.[14]

Hesiod's poem from the eighth century B.C., the Archaic era in Greece, describes agricultural work in a peasant community and follows the course of the seasons, although less than one-third of its 800 lines (383–617) actually treat the farmer's year and concentrate mainly upon the growing of cereals. Hesiod does provide vivid vignettes of summer and winter (lines 504–53 and 582–96) and describes in practical detail the kind of work appropriate and necessary to each phase of the year. Above all, he offered what would become widely recognized as basic rural precepts by praising the necessity of strenuous and persistent field labor. Hence the poem has always been perceived as didactic, hortatory, and homiletic.[15]

Although Virgil's *Georgics* do not highlight an arcadian world of love and song, like his *Bucolics*, and they do at least imply an ethos of work, their main message comes from the sheer pleasure found in vivid imagery and accumulated detail generated by landscape scenes of agrarian activity. The four books in praise of the farmer's life cover basic needs: tilling the land for field crops; growing woody plants, especially olive and grape vines; raising livestock; and beekeeping. Although Virgil concentrated his attention on the three seasons of growth and productivity, like so many later writers, he did detail the tasks that can occupy a farmer in winter. Book 2 closes with a lengthy eulogy of country life (lines 458–540).[16]

In four directly accessible lines of poetry, Virgil schematized what would remain for two millennia the quintessential visual presentation of the seasons. He delineated their procession as a tableau in the Palace of the Sun.

Young Spring was there, wreathed with a floral crown;
Summer, all unclad with garland of ripe grain;
Autumn was there, stained with the trodden grape,
and icy Winter with white and bristly locks.

It is easy to appreciate Virgil's immense appeal to nationalistic writers like James Thomson and the nineteenth-century American naturalists: a major theme in *The Georgics* is straightforward praise of the poet's native land, which meant that the set pieces expressing love of country eventually became more highly emphasized than Virgil's agricultural lore. Americans, moreover, found especially appealing his notion that the "natural" life lies in the springtime of the race. Philosophically the poem could provide knowledge of what people might observe in the workings of a dependable universe as the basis for ordering their own lives in conformity with nature's laws and rhythms.[17]

We find *The Georgics*' influence in ninth-century German poems describing rural life and the possible uses of various plants. During the Middle Ages *The Georgics* were spiritualized so that husbandry became an allegorical trope for tending and developing the Christian soul. During the Renaissance *The Georgics* were frequently cited from Petrarch onward to serve multiple purposes. Politian composed his *Rusticus* in 1483 in 570 Latin hexameters for recitation as a prologue to his lectures on Hesiod and *The Georgics*. By the sixteenth century, Italian vernacular began to supplant Latin in long poems like Giovanni Rucellai's on bees (1539) and Luigi Alemanni's on cultivation (1546). The latter, with its strictly seasonal organization and emphasis starting with "Lavori di Primavera [labors of spring]," would be the first true *Georgics* of the Renaissance era. In the American colonies, predominantly agricultural, *The Georgics* were eagerly read by educated people, either in the Latin original or in John Dryden's 1697 translation. By the last decade of the eighteenth century they had become widely specified as a college text.[18]

Unlike Hesiod and Virgil, who devoted poems primarily to the agricultural year and its requisite activities, Ovid, in *The Metamorphoses*, had a great many other concerns. But book 2 begins with a detailed description and story concerning the sun god's palace, which swiftly leads to a young man's confrontational vision of the "blinding rays."

With lustrous emeralds shone the chair of state,
Where Phoebus, robed in regal crimson, sate;
And Days, Months, Years, and Centuries had place
To left and right, with Hours of equal space;
and youthful Spring, with flowery garland bound;
Summer light-clad, whom harvest chaplets crowned;
And Autumn, stained with trampled grapes, stood there,
and Icy Winter, with his long white hair.[19]

More than merely an echo of Virgil, of course, the passage actually verges on plagiarism. But it did much to reinforce Virgil's visual imagery, helped make it memorable, and insured that those particular pictorial associations would endure for a very long time to come. Actually, Ovid had also been influenced by a Hellenistic poem that described individual attributes of the four seasons. The "Hours of equal space" more than confirm our suspicion that Hellenic *horae* had become Ovid's four seasons as well as an allusion to the quadripartite division of the day. A cultural heritage had been transmitted and virtually codified by the very beginning of the Common Era.[20]

The Revival and Evolution of the Motif in Medieval Times

The Middle Ages brought both changes and continuities, just as one might anticipate. Although spring and autumn are more critically important to the farmer, references to winter and summer actually preceded the other two in Germanic and Norse pagan poetry, presumably for two reasons: winter and summer are better defined seasons in terms of their persistent qualities, and winter in northern Europe can be very harsh. Winter required both preparation and stoicism, so references to its brutality appear well before ones to the benevolence of summer. Even so, the four seasons motif appears fairly early in medieval times in the context of a creation cycle, and spring provided the ideal and logical way to introduce the cycle. In the Manual of Byrhtferth of Ramsey (1011 A.D.) a circular figure divides the year into its four seasons, accompanying these with the four ages of man as well as the twelve months, each with its customary zodiac sign. A similar pattern (but literarily more elaborate) appeared in Provençal verse beginning in 1288. In a Monte Cassino codex from 1023 there are symbolic figures representing the labors of the seasons: one person holding up two green branches, a second cutting grain with a sickle, a third gathering grapes in a basket, and others killing a pig and chopping wood with an axe, typical harbingers of winter.[21]

Although seasonal renewal served as an important metaphor for continuity in medieval centuries, the iconography of the time tended to be allegorical in fairly simplistic ways: summer foretold heavenly bliss; winter foreshadowed the end of earthly life. In thirteenth- and fourteenth-century England the seasons were frequently drawn upon to symbolize the mutability of secular existence. By the thirteenth century, references to the seasons in vernacular poetry often became formulaic. Medieval students were required to write about the seasons in Latin, and therefore predictable ways of doing so emerged. In Middle English poetry seasonal conceits hardened into conventional forms, so that parallels between the four seasons, the four humors, and the four elements appeared frequently in semipopular and semididactic material as well as numerous calendar treatises.[22]

Although Chaucer's treatment of the seasons in *The Canterbury Tales* (1388), above all in the Prologue, was rooted in Anglo-French literary traditions, his poetry was so vividly innovative and imaginative that he literally transcended and transformed those well-worn phrases and devices. In the Franklin's Tale we are told, "His meals would always vary, to adhere / To all the changing seasons of the year." And there are numerous passages like this one:

> And this was, say the books, as I remember,
> The cold and frosty season of December.
> The ageing sun, dull copper in colour,
> That in the heat of summer earlier
> Had gleamed with glittering rays of burnished gold,
> Is now descended into Capricorn,
> And there, I think, his beams but palely shine.
> How have the bitter frosts, with sleet and rain,
> Destroyed the green in every garden yard!
> Janus sits by the fire with double beard,
> He's drinking wine out of his great ox-horn,
> And set before him is the tusked boar's head.
> "Sing Noel!" is the cry of every man.

In Chaucer's *Troilus and Criseyde* (ca. 1385) the seasons are carefully and consistently employed as functional, organic elements that contribute to the structure of the poem as well as its imagery and tone. Chaucer devised an entire set of references to the seasons in similes that illustrate the moods of the principal actors in his drama.[23]

European writers who reinforced or echoed the seasonal qualities and descriptions of Chaucer (and the French poets whose work he helped to popularize in England) were likely to mingle the traditions casually, though not so skillfully as he had. Curiously, according to Nils Erik Enkvist, a leading authority on medieval English poetry, English words for the seasons really did not "crystallize" into their present forms until the sixteenth century. In part that was because winter and "somer" were the first seasonal words used in poetry. "Lenten" and "hoerfest" were borrowed from the continent and then popularized as ways of referring to the "other" two seasons. Chaucer's initiative in borrowing "autompne" did not mature for more than a generation, when the word finally became commonly accepted. "Somer" was frequently used in reference to spring, actually, and "spring" did not come into general use until the sixteenth century. "Harvest" remained the most common word for autumn until that century also. What may have helped to delay these developments was the importance of debating in medieval rhetoric. A favorite conflict paired winter and summer, just as the *ludi* (medieval games) staged fights between the two seasons. "The Owl and the Nightingale" is a late twelfth- or early thirteenth-

century literary classic in this genre—the owl representing late fall or winter, and the nightingale late spring or summer, as well as clerics versus knights.[24]

Students actually played quite a creative role in adapting seasonal conceits in earlier medieval literature and left a significant legacy. Goliardic songs were Latin poems written by goliards (wandering students or ecclesiastics) during the tenth to thirteenth centuries. The most famous of these collections is the *Carmina Burana* (named for the monastery of Benedict-Beuren in southwest Germany where the manuscript was preserved). Allusions to the seasons in the introduction to the work tended to be elaborate rhetorical devices and initiated a sophisticated tradition. Thus the *Carmina Burana* might invoke Philomena where the English tradition would simply use a nightingale. That is why it is almost impossible to find in the season introductions of the goliardic songs many sources for the early English tradition of seasonal allusions.[25] These secular songs and poems were integral parts of a culture becoming more pervasively and more intensely Christian as the medieval centuries passed. Festivals and rituals were determined by a peculiar seasonal blend, partially inherited from the laboring requirements and practices of the pre-Christian past, but increasingly affected by events commemorating the lives of Jesus, Mary, and a great many saints.[26]

Despite the widely recognized significance of the Christian calendar during the high Middle Ages, imperatives of work never ceased to be primary determinants and always remained as visual reminders of requisite labors as well as devotions. During the fourteenth and fifteenth centuries, major book artists depicted events in the narrative of Christ's life with suitable seasonal settings. James C. Webster, a leading authority on medieval art, found the labors of the months depicted in the most intensely ecclesiastical texts: the Martyrology of Wandalbert and the Calendar of St. Mesmin in the Vatican Library; the mosaic pavements in Aosta Cathedral; sculptured slabs in the Ferrara Duomo; reliefs on the portal of Ste. Madeleine in Vézelay, south of Paris; and baptismal fonts in English churches.[27]

Even the sumptuous and justly famous medieval books of hours, whose purpose was purely devotional (though they surely served as status symbols as well) contained calendars and were frequently referred to as *horae*. So the pictorial vignettes for February might simply show people keeping warm (with "I burn wood" written in Latin); August might show wheat being threshed by a youth stripped to his premodern underwear; in September workers carry full baskets of grapes to vats where they dump them for stomping; and the task for October–November was typically fattening the hogs with acorns shaken down from oak trees. During the fifteenth century, artists and their courtly patrons took a growing interest in displaying secular activities, which therefore increased in pictorial size and importance even on the lustrous pages of devotional works.[28]

The balanced blending of seasonal labors with devotional reminders, yet tipping steadily toward the secular during the fifteenth century, can be seen in two roughly contemporary masterpieces, one from Italy and the other from France. In 1450 Piero de Medici commissioned Luca Della Robbia to decorate the ceiling of his study in the Florentine Palazzo Medici with tin-glazed terra-cotta works showing the labors of the months. Done in the blue, white, and yellow hues popular at the time, the motifs are drawn from both contemporary agricultural practice and from classical texts. That seasonal ceiling was completed in 1456.[29]

Less than twenty-five years later Jean Colombe completed the *Très Riches Heures* that had been begun earlier in the 1400s for Duc Jean de Berri by the Limbourgs. Derek Pearsall and Elizabeth Salter have supplied an admirable description of this expanded, "updated" treasure that has been so universally acclaimed.

> In the *Très Riches Heures*, seasonal landscape achieves that status which earlier Calendar painters had tentatively proposed for it. Not quite independent, it respects old contexts, old affiliations. The twelve phases of the year rest beneath the arc of the zodiac and are dominated by the golden chariot of the sun; the deep blue of the sky of France merges into the deeper tones of the unchanging heaven of the constellations; man, beast and nature observe and conform. But, given this restatement of an ancient pattern, the Calendar of the *Très Riches Heures* quietly confirms that the pattern allows for a wider range of interpretative skills than had been suspected. It neglects nothing that tradition could supply, but it claims the right to adjust, expand and add according to personal taste and individual observation. Most important, it confirms not only the seriousness of Calendar themes, but their virtually untried artistic potential. If the April and May miniatures are still influenced by garden imagery, if winter, in February, is still a shade prettier than experience registers, the last contribution of the Limbourgs, the October miniature, moves in a direction which can only lead to Bruegel. Thoughtful, robust, confidently and minutely observed, this version of autumn and its appointed labours marks the arrival of the Calendar on the threshold of high art.[30]

Virtually all of the late medieval books of hours included calendars, often placed separately at the front. Calendars made by the Limbourgs were among the most intricate and inventive, adapting older motifs into pictorial unity with fresh interpretations of traditional themes, so that, for example, their landscapes become more elaborate and detailed. And by the very first decades of the sixteenth century, pictorial influences from the Italian Renaissance could be

found in French books of hours. Depicting the mowing and gathering of hay in early summer, for instance, artists were more likely to emphasize the grace and mobility of the workers, rather than the actual labor being performed. By 1515, when the last great Flemish illustrator, Simon Bening, did his full-page calendar cycles, seasonal landscapes had become the dominant focus of such work, rather than being aides-mémoire for devotional prayer.[31]

The use of seasonal motifs on calendars actually dated back to ancient Rome, when rustic scenes, usually depicting agricultural activity, became common during the late Republic and very early Empire (the time of Virgil and Ovid). Anticipating a problem that persists in twentieth-century American almanacs and "books of days" (by Peattie and Borland, for example), Roman calendars did not exactly coincide with Roman thinking about the seasons, because the former began in January, the latter with spring. In *Daphnis and Chloë*, the pastoral work by Longus (ca. fifth century A.D.), a love story involving the couple unfolds against the backdrop of the four seasons, and changes in nature along with the work of farmers and shepherds are lovingly described. A poetic connection is clearly established between the cycles of nature and the activities and emotions of the young couple, who are the children of a goatherd and a shepherd. Daphnis would become the legendary hero of Sicilian shepherds and the reputed inventor of bucolic poetry.[32]

The culmination of this literary romance and related traditions came in 1579 when Edmund Spenser wrote *The Shephearde's Calender*. A systematic description of all four seasons (winter and spring receive more space than summer and autumn, however), the *Calender* is also an allegory that operates at several levels. Although ostensibly telling shepherds how to feed their sheep, it is primarily concerned with accepting a dedicated life in the world—meaning the life of a poet in service to his queen as a high heroic calling. It starts in January, "the sad season of the year," even though Spenser acknowledged that the New Year is normatively located late in March. In his prefatory "General Argument" Spenser offered the clearest explanation for resolving the venerable calendar dilemma by beginning in January for Christian reasons: "We maintain a custom of counting the seasons from the month of January," he wrote, "upon a more special cause than the heathen philosophers ever could conceive, that is, for the incarnation of our mighty Saviour, and eternal Redeemer, the Lord Christ." By December in this extended poem, when bitter blasts of winter approach, there is a review (or reprise) of the entire year, whose seasons are compared to the sequential stages of human life. Colin, Spenser's shepherd, having grown weary of his former ways, "proportioned his life to the four seasons of the year": youth, manhood, ripest years, and later age with "winter's chill."[33]

The poem was extremely well received in its day, despite Enkvist's later observation that its plan and structure had been suggested by the *Kalendrier des Bergers* with few new topics or fresh elements. From Enkvist's continental per-

spective, the Elizabethan pastoral had simply inherited a host of stock devices from earlier centuries, and the seasons appear very much as they had in the late Middle Ages. Be that as it may, *The Shephearde's Calender* heralded the final assimilation of diverse styles, idyllic and satirical, that had divided continental pastoralists into two camps. Admiring Chaucer greatly, Spenser created a pastoral poem that was also allegorical; and it became the point of departure for mature English pastoral writing. In *A Discourse on Pastoral Poetry* (1711), Alexander Pope observed that because Spenser really could not meaningfully describe nature separately for each month, he basically portrayed the seasons: "The year has not that variety in it to furnish every month with a particular description, as it may every season."[34]

The Seasonal Flourish in Renaissance Art and Beyond

Earlier references to illustrated calendars and books of hours carrying forward to the great Antwerp artists, Bening and Bruegel, lead us into the intriguing complexities of art devoted to the seasons during the Renaissance and subsequently. Before considering the remarkable achievements of artists in the Low Countries, Italy, and France during the sixteenth and seventeenth centuries, however, we must briefly acknowledge a particular legacy from antiquity and the Middle Ages. In an astronomical poem by Aratus (ca. 315–245 B.C.), Zeus explains when the seasons are propitious for planting saplings, sowing all sorts of seeds, and so forth. The poem inspired numerous works of art, most notably what is called "The Leiden Aratea," a ninth-century work that transmitted attractive but familiar motifs: spring with a flourish of flowers, summer with sheaves of grain, fall with a wreath made from grape leaves, and a glum-looking man wearing a cloak for winter.[35]

Hans Wertinger (ca. 1465/70–1533), a productive German painter and woodcarver who was born at Landshut and became the court artist at the Duke of Bavaria's residence there in 1518, is instructive for our purposes because he painted two sets of handsome pictures, of the months and of the four seasons, influenced especially by what he saw during his travels in the Tyrol in 1523. All of the scenes are totally secular. The months must have been placed as wall paneling in an aristocratic room. Using bright, local colors, the scenes are encircled by golden festoons. The activities shown are typical rather than allegorical. People seem to be going about their business in a carefree way. The seasonal paintings are more innovative and compelling. *Summer* (ca. 1525) not only shows sheep shearing, hunting, and fishing, but a mix of social classes as well. In *Deerhunting and Hayharvesting*, knightly and peasant pastimes are strictly segregated by a fence with nets on it. And Wertinger's winter scene (ca. 1525–26), which was most likely commissioned by Duke Ludwig X, depicts a fox hunt and a stag hunt.[36]

Meanwhile the artistic work of the Bassano family (actually named da Ponte, but so-called after their provincial city in the Veneto) spanned the fifteenth through the seventeenth centuries, starting with pictures of peasants and animals that became bustling depictions of seasonal labor and abundance. Francesco da Ponte (1547–92) painted *Summer* (ca. 1578) and Leandro da Ponte (1557–1622) *September* and *October*. So the months and the seasons continue to intermingle, in part because these works were based upon compositions by Francesco and Leandro's father, Jacopo. *September* is noteworthy because a master is clearly supervising his peasants. *October* is especially engaging because in addition to intense activity with the vintage, fall plowing is underway with a team of sturdy oxen front and center (figure 17). Here innovation is nicely integrated with tradition.[37]

Seasonal art had been flourishing in Italy since the high Middle Ages, initially, of course, in ecclesiastical settings. The most famous and significant Renaissance work of this nature, however, began with Raphael's "cartoons" for *The Charge to Peter*. Their borders display both the hours of the day and the seasons of the year. Based upon those paintings, Pieter Coecke van Aelst designed tapestries in Brussels made of silk and wool with silver gilt threads (ca. 1516–19) that hang in the Sistine Chapel at the Vatican. They display embracing figures with new leaves (fertility?) in spring, a nude woman with a sheaf of wheat (the sustenance of life) in summer, putti climbing on grape vines in autumn, and a shrouded figure and Juno born aloft by clouds and peacocks in winter. Classical and secular motifs commonly appeared in sacred places. But the great achievement in these tapestries lies not with the commonplace character of the designs; it resides instead in the exquisite beauty of their execution, especially their conversion from cartoons into tapestries.[38]

A unique and quite spectacular work known as the "Throne Baldachin" is comprised of eight separate tapestry components completed in 1561 to celebrate the marriage in 1559 of Charles III, Duke of Lorraine, and Claude, the daughter of Henry II of France and Catherine de Medici. The central imagery, designed by two Flemish artisans, features the four seasons (figure 18). That masterpiece and the collaboration between Raphael and a Flemish master are crucial because they shift our attention northward to the Low Countries, where seasonal art flourished for well over a century starting in the 1560s. Works by Dutch and Flemish artists would be collected at royal courts all over Europe. Equally important, they would stimulate similar and derivative art throughout the continent, but above all in France and Germany in the seventeenth century and in England, Spain, and the Austro-Hungarian Empire during the eighteenth.

The seminal figure in this flowering, and certainly the most famous, is Pieter Bruegel the Elder. Pieter van Aelst's wife taught the art of painting in tempera on cloth to Bruegel, her son-in-law. Much of Pieter van Aelst's work was de-

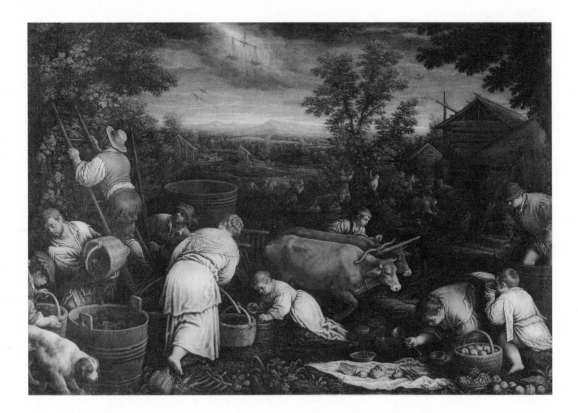

stroyed during the iconoclastic riots around Brussels and Antwerp in the 1560s, just as Bruegel was conceiving and painting his own great seasonal series. When Bruegel made his hegira to Rome, he may very well have seen the tapestries that resulted from the collaboration between Raphael and van Aelst. In any case, he certainly knew about their partnership on such a remarkable seasonal project because of his father-in-law's role. In 1565 Bruegel received a commission from Nicolaes Jongelinck II, an Antwerp merchant and humanistic patron, to paint the months, presumably to decorate an elegant villa. Bruegel chose to do six rather than twelve, however (one has been lost), and they are thematically seasonal in notably unusual ways, rather than being conventionally monthly. The surviving five are titled *Gloomy Day* (*Early Spring*); *Haymaking* (*Early Summer*); *The Wheat Harvest* (*Summer*) (plate 3); *Return of the Herd* (*Autumn*); and *Hunters in the Snow* (*Winter*). "Spring" would seem to be the missing sixth. They are spectacular and justly famous.[39]

Bruegel (ca. 1527–69) was aging prematurely when he made this set. It is conceivable that he did not complete the sixth, but he did finish two exquisite seasonal drawings in 1565 and 1567, simply called "Spring" and "Summer." They were to have been part of a cycle of four. At the request of Hieronymous Cock, Hans Bol completed and printed the set in 1570, a year after Bruegel's death; and thereafter works inspired by Bruegel's versions of the seasons proliferated,

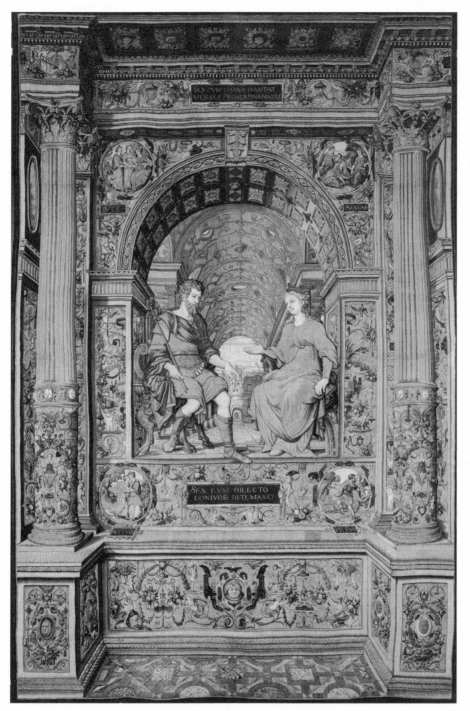

(opposite)
FIGURE 19
Jacob
Hoefnagel,
Winter
(end of the
sixteenth
century),
watercolor
bordered
with gold on
vellum, laid
down on
panel. The
Pierpont
Morgan
Library,
New York.
Gift of Sally
Sample Aall,
1998.13.
Photograph by
Joseph Zehavi.

both in oil painting and engravings. Pieter van der Heyden did several (1570) highlighting architecture more than Bruegel had. Bruegel the Younger (1564–1638) did his own seasonal works, including *Spring*. But the most critical stimulus from his father's genius involved the concentration on peasant activities, often selecting unusual seasonal labors and themes not found, for example, in Simon Bening's cycle of the seasons earlier in the sixteenth century, such as the return-of-the-herd motif.[40]

Some of the Flemish masters seem to have preferred painting seasonal pairs rather than quartets. Jacob Grimmer created *Spring* and *Autumn* in spectacular colors prior to his death in 1590, and Jan van Goyen (1590–1656) executed roundels of *Summer* and *Winter* in 1625. Jacob Hoefnagel of Antwerp (1575–1630) created a set of four roundels in 1595. *Winter* (figure 19) shows a bearded old man sitting beneath a bare tree. Below him is a pile of tools that would have been used during all four seasons: a sieve for casting seeds, a basket, a wood axe, and a pitchfork. All of the astrological symbols for the winter season are also present: Capricorn, Pisces, and Aquarius.[41]

Beginning in the 1590s a veritable plethora of four seasons engravings appeared, which suggests that something close to an avid market must have developed during the golden age of Dutch culture. Jan Saenredam did multiple sets that featured young people at play, work, and courtship, based upon paintings by Hendrick Goltzius (1601). Hendrick van Schoel soon did landscapes busy with people, based upon Bol's work. And Abel Grimmer (1592–1619) painted a seasonal suite in cheerful roundels as well as *Summer* and *Winter* as a colorful pendant pair.[42]

One of the most intriguing, and possibly the most popular, of all sets prepared during the first quarter of the seventeenth century came from Adriaen van de Venne (1589–1662). Born in Delft and dying in the Hague at a ripe age, he found totally fresh ways to deal with the seasonal theme by emphasizing social stratification and class differences more than previous artists in this genre. The dominant figures in the foreground are wealthy bourgeois or even local nobility; but diminutive humble figures are also present, such as beggars or peasants watching the gentry ice-skating. The images almost seem to be more concerned with socioeconomic distinctions than with nature. Alternatively, one might say that van de Venne was more interested in the pleasures than in the labors of each season. His preliminary studies for this enchanting set began in 1622; the oil paintings date from 1625; and engravings based on the paintings were included in Jacob Cats's *Houwelick*, a treatise on family life that became one of the essential books of seventeenth-century Dutch culture. The book was organized into four sections devoted to the life cycle of women: spring for courtship, summer for the role of wife, autumn for motherhood, and winter for widowhood. Spring shows a courting or newly married couple strolling in a vernal landscape (figure 20).[43]

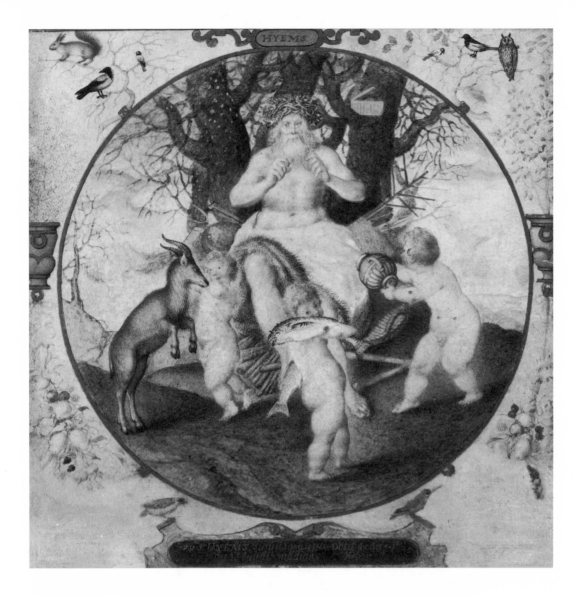

Seasonal books with other sorts of motifs also enjoyed great appeal in the Netherlands during the same period. *Hortus Floridus: The Four Books of Spring, Summer, Autumn and Winter Flowers* first appeared at Utrecht in Latin in 1615, and then a year later in London translated into English. Crispin van de Pass (1593/94–1667), a highly skilled copperplate engraver, created this masterpiece of plant engravings utilizing flowers appropriate to seasonal differences between northern and Mediterranean countries. Spring starts with hepatica, crocus, narcissus, many types of hyacinth, anemones, and a large array of tulips. Summer begins with the peony, then an array of iris, roses, pinks, and carnations. Autumn features purple clematis, musk rose, sunflowers, double hollyhocks, several types of mallow, and cyclamen. For winter there is an elaborate

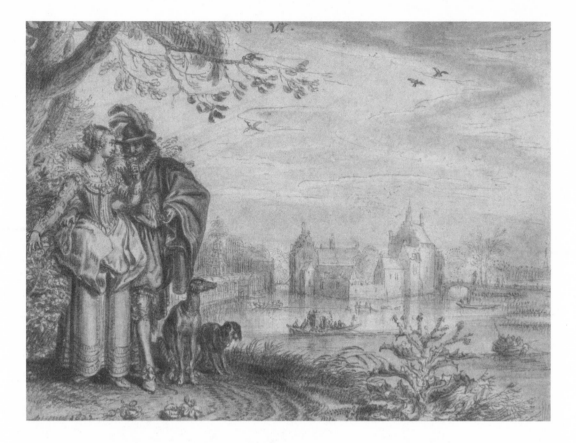

formal garden with black hellebore (the Christmas rose), then three kinds of snowdrops, and finally early spring flowers: daffodils, dog's tooth, and hyacinths once again.[44]

Ambrosius Bosschaert (1573–1621) painted *Bouquet of Flowers on a Ledge* (1619), featuring flowers that bloom at different times of the year but in a single still life: iris, flame tulips, lilies of the valley, roses, etc., thereby launching yet another Dutch four seasons tradition that would culminate during the second quarter of the eighteenth century in the spectacular still lifes of Jan van Huysum (1682–1749). His vases of voluptuous colors (plate 6) required that each flower be painted from "life" when it was actually in season. In the meantime, Bosschaert's son, Ambrosius the Younger (1609–45), helped to develop this trope along with Balthasar van der Ast (1593–1657).[45]

Their contemporaries chose to pursue the seasonal theme in every imaginable motif and manner. Hessel Gerrytsz (1581–1632) did etchings of *The Seasons: Views of Castles in the Vicinity of Amsterdam*. Hendrick Avercamp (1585–1634) had a penchant for winter scenes along the canals. J. van Blarenberghe's approach presented the four seasons as a procession of people in the foreground, with appropriate seasonal activities behind them: planting in spring, crops growing (as a poor beggar doffs his hat to the passing aristocracy) in summer,

leaves turning in autumn, and skaters and sleighs on the ice in winter. Van Blarenberghe's interest in the socioeconomic hierarchy was clearly comparable to van de Venne's.[46]

Other Dutch and Flemish artists would produce less predictable four seasons suites during the mid- and late seventeenth century. Jan Griffier (1652/56–1718) gave spring a literally fantastic landscape; autumn has a gorgeous garden at a grand villa in the middle distance, with a noble family in the foreground; and winter has a wonderful use of white "frosting" for snow and ice on the trees, many people skating on a canal or river, and an enchanting castle sitting in the middle. Jan van Almeloven (born ca. 1652; worked at Utrecht 1678–83) did diamond-shaped engravings of the seasons after work by H. Saftleven.[47]

Meanwhile, by 1630 a Bohemian artist from Prague, Wenceslaus Hollar (1607–77), had made etchings of the four seasons depicted as views of Strasbourg and also as four attractive women of indeterminate age. All of them appear to be affluent and are elegantly costumed in Van Dyck–era fashions. Spring holds a bunch of tulips and points to a lush vase of mixed blossoms. Summer is demurely veiled and holds a fan half-open beneath her chin. Autumn places her hand on a very large salver weighted down with fresh fruit. And Winter is well warmed by a cloak, long gloves, and an immense fur muff. A second set, made in 1643–44, shows the same strikingly winsome models outdoors at full length rather than, as before, from the hips upward; and *Winter's* woman now wears a mask, perhaps more for Carnival cover-up than for protection against the cold.[48]

In 1636 Hollar joined the retinue of Thomas Howard, Earl of Arundel, and five years later he married Mistress Tracey, a waiting woman at Arundel House. In 1641 his seasons were engraved and published in London, and then a few years later they were published again in France when the Earl retired there with the Royalists once civil war broke out. Although many customary symbols of the seasons are presented, they appear in fresh configurations rather than in formulaic ways. Hollar certainly seemed to be conflating the seasons with the stages of a woman's life, especially in *Autumn*.[49]

This flurry of well-noticed Flemish, French, and English seasonal prints produced by the early 1640s brings us to Pietro Testa (1612–50), a renowned draftsman and printmaker born in Lucca, who worked mainly in Rome. Between 1638 and 1644, exactly contemporary with works by Poussin, Cornelis Galle, Magdalena de Passe, Hollar, and quite a few others, Testa created a series of etchings and then engravings of the four seasons. Contemporaries who knew and admired Testa considered *The Seasons* to be his finest and most important works, describing them as poetic fictions richly ornamented with all sorts of unusual "inventions, including all earthly creatures subject to time and the order of the heavens." Although traditional seasonal imagery can be found in these elaborate prints, all of that is subordinated to a grand philosophical

(opposite)
FIGURE 20
Adriaen van de Venne,
Spring *(1622), brown ink, gray wash, and white gouache, incised, with a framing line in black ink, on off-white antique laid paper. Courtesy of the Fogg Museum, Harvard University Art Museums, The Maida and George Abrams Collection. Photograph by Allan Macintyre. © 2002 President and Fellows of Harvard College.*

theme that Testa derived from his reading of Platonic philosophy, especially the *Phaedrus*: on earth the individual human soul is so governed by time and change that it is imprisoned by the senses and the passions.[50]

What seems most remarkable about the seasonal imagery that flourished following the 1560s is the variety, ubiquity, and creativity of what appeared in painting and the decorative arts. Around 1610, Bartolomeo Manfredi (ca. 1580/87–1621), painted his single-canvas *Allegory of the Four Seasons*. Four figures are somewhat crowded together: Spring with roses and a lute; breast-exposed Summer with wheat and a mirror; Autumn with grapes; and Winter, huddled somewhat to the right and rear, wearing a big fur hat and a tightly wound cloak. Spring and Autumn are embracing and kissing passionately. Only Summer, a little aloof from the other three, makes eye contact with the viewer; and Winter regards his three companions with a twinge of regret, perhaps, for opportunities lost forever. Although the painting is distinctive, it reminds us stylistically of work by Manfredi's more famous contemporary in Rome, Caravaggio. The allegorical seasons suggest the life cycle, to be sure, but done in a manner like no other—a striking contrast to the engraved *Four Seasons* (1607) by Otto Van Veen (1556–1629), also presenting the stages of life, in which a procession up an incline is led by a child, followed single file (seen from the rear) by a virile young man carrying a plant, a mature man whose hat is covered with autumnal fruits, and finally an elderly man, well-robed and relying upon a walking stick.[51]

In the innovative vision of Giuseppe Arcimboldo of Milan (1527–93) the seasonal *became* the human. Arcimboldo painted idiosyncratic yet influential portraits (ca. 1563–72), showing men's heads and shoulders constructed—in one instance—entirely of flowers and leaves for Spring; grains for Summer; fruits and vegetables (with a mushroom ear) for Autumn; and mostly withered roots, vines, and a few lingering lemons for a grotesque old man Winter. For another set he paired the seasons of the year with the four elements (air, fire, earth, and water) for presentation to Emperor Maximilian II in 1569 as an allegory of imperial power over the natural world. Because of their sheer novelty, these distinctive images have been made into modern greeting cards, enhancing their widespread visibility.[52]

Representations of the seasons in the decorative arts flourished in France, especially, intensifying in the later seventeenth century, fostered in part by an unusually rich national tradition of four seasons folklore that has been elaborately documented by the Belgian ethnographer and folklorist, Arnold Van Gennep.[53] During the mid-seventeenth century Abraham Bosse (1602–76), engraver to Louis XIV, made his elaborately conceived plates of *Les Quatre Saisons*. That is when many houses built in Paris began to have mascarons—heads representing the seasons, with predictable decorations in their hair—

placed above doors and some windows. And that is when the four seasons fountains were completed at Versailles.[54]

Above all, perhaps, at that time the Gobelins Manufactory in Paris created the spectacular tapestries known as *The Seasons of Lucas* (because the design was wrongly attributed at some point to the great Flemish artist Lucas van Leyden). Woven from wool, silk, and metallic wrapped threads, they were apparently based upon a sixteenth-century set woven in Brussels. In *Autumn* (plate 4) women are bringing grapes into a yard where they are being pressed by foot in a vast container. Wine is also being poured into casks at the right-hand side. In *Winter*, where brilliant reds and blues, along with beige, predominate, there are six prominent pairs of couples, one of them quite elderly. People are skating along a river (or canal) in the middle; trees are entirely bare in the background; children carry bundles of faggots; and people wearing very warm clothes are also strapping on overshoes.[55]

Seasonal art and décor had long been entrenched as a French tradition. It served a pedagogical purpose during the late 1480s, when Jean Poyet, the court "illuminator," decorated a book for the young Charles VIII with a simple but charming design of the four seasons to accompany a page of text. Poyet's masterpiece, *The Hours of Henry VIII* (made in Tours, ca. 1500), is filled with monthly and seasonal scenes, designed as much for visual delight as for spiritual inspiration. Stained-glass roundels of the seasons became frequent favorites in sixteenth-century France. April might show courtship, for example, whereas October would feature a middle-aged couple at dinner. Jean Androuet du Cerceau created a sculpture group for the Hôtel de Sully in 1624. Above and flanking the front door (courtyard side), he placed Autumn and Winter. Spring and Summer flank the back door to the garden.[56]

The four seasons motif came to central Europe and Britain with less intensity and ubiquity prior to the eighteenth century, yet there are notable examples distinctive for particular localities that are unlike anything described thus far: earthenware plates from seventeenth-century Switzerland, decorated with colorful human figures in the center surrounded by grapes, plums, pears, and pomegranates around the flat outer edges. A tall, square, blue-and-white ceramic vase showing Hollar's full-length portraits of courtly women wearing seasonal costumes (1643) was made in Frankfurt during the mid-1670s, indicative of a transcontinental migration of the motif. A spectacular nautilus goblet featuring the four seasons was made in Vienna with shell and silver gilt by Christoff Neumayr in 1680 (figures 21 and 22).[57]

Salzburg, Austria, has been especially receptive to the motif. The Mirabelli Garden there, associated with the residence of the prince archbishop, received large four seasons statues made of marble and stone in 1685. The prince, who had studied in Rome, "modernized" Salzburg and had the Mirabelli Garden designed for his pleasure, and that of his wife and fifteen children. In the

baroque grand dining room on the second floor of the Schloss Leopoldskron in Salzburg, large painted roundels of the four seasons surmount the very tall entry doors. Once again, three women and a man are depicted. Spring faces us garlanded with flowers. Summer holds huge sheaves of wheat across her lap, almost like a pietà. A bosomy Autumn shares a big bunch of grapes with a child (or else a dwarf). And Winter, a white-bearded old man, hovers behind a studious young man working at a desk: presumably, knowledge and wisdom will be passed along to the next generation.[58]

Colored-glass roundels similar to the ones in France described above appeared in England during the first half of the sixteenth century, except that they are explicitly the months with representations of agricultural labor (mainly done austerely in yellow and grey). For March a man attaches vines to a pole. In June he trims plants. In July he applies the scythe to corn, and in September he cuts wheat. In October two men are planting seeds, and November is for butchering hogs. Not being a country conducive to the grape, England occasionally had a different emblematic rhythm of the year. Early in the reign of King James I, but sometime prior to 1611, however, a large set of seasonal tapestries featuring shields was made for the Marquess of Salisbury at Hatfield House. In *Autumn* Bacchus is at the center with an abundance of grapes, some of which discreetly cover his loins. Apples are also being harvested from trees.

60 *Antiquity to the Eighteenth Century*

John Donne struck a more sobering (yet hopeful) note in his Sermon III from 1625: "Now God comes to thee, not as in the dawning of the day, not as in the bud of the spring, but as the sun at noon to illustrate all shadows, as the sheaves in harvest, to fill all penuries, all occasions invite his mercies, and all times are his season." In *Paradise Lost* John Milton made frequent references to seasons repeatedly returning.[59]

After the Restoration in 1660, it became common for English country homes to have four adjacent windows decorated with seasonal motifs; and poems in praise of country life became increasingly popular. The owners of country houses were frequently represented as people making a point of participating in agricultural work, which then would be described season by season in a manner reminiscent of Virgil. A splendid tin-glazed earthenware dish, reminiscent of the Swiss ones described previously but much more intricately designed, was made at Southwark, London, in 1660 (figure 23). Captioned "The Dream of Jacob," seasonal symbols surround the central image of a ladder reaching to heaven with angels ascending it.[60]

In 1636 a burial structure was erected in Largs, Ayrshire, Scotland, for Sir Robert Montgomerie and his wife, Dame Margaret Douglas. It was originally attached to the old church of Largs. When the church was demolished in 1802, the "aisle" (burial place) was left to stand alone. Now listed as one of the Ancient Monuments of Scotland, it is regarded as a notable and representative example of decoration fashionable in Scottish houses during the first half of the seventeenth century. On either side of the couple's coats of arms are symbolic and biblical figures. Above the tomb, to the right and left, are Justice and Fortitude. Overhead, Isaac, Jacob, and Esau are on one side, with the temptation of Adam and Eve opposite. Above some biblical texts are signs of the zodiac and allegorical scenes, and in the corners the four seasons. Summer and Autumn have village scenes, and Summer is regarded by Scots with special veneration because it shows the building before the demolition of the old church.[61]

The Song of the Plough, an old Scottish favorite, includes the familiar phrase: "Turn, Turn, the Seasons Turn." When the late Northrop Frye attempted to devise a theory of literary myth that would encompass everything from epic to folklore, he turned to the seasonal metaphor as his structural device. He acknowledged, reminiscent of Giuseppe Arcimboldo's grotesque busts, that the "vegetable world" supplies us with the cycle of the seasons, "often identified with or represented by a divine figure which dies in the autumn or is killed with the gathering of the harvest and the vintage, disappears in winter, and revives in spring." A page later he suggests that "the Ptolemaic universe provides a better framework of symbolism, with all the identities, associations, and correspondences that symbolism demands, than the Copernican one does. Perhaps it not only provides a framework of poetic symbols but *is* one, or at any rate be-

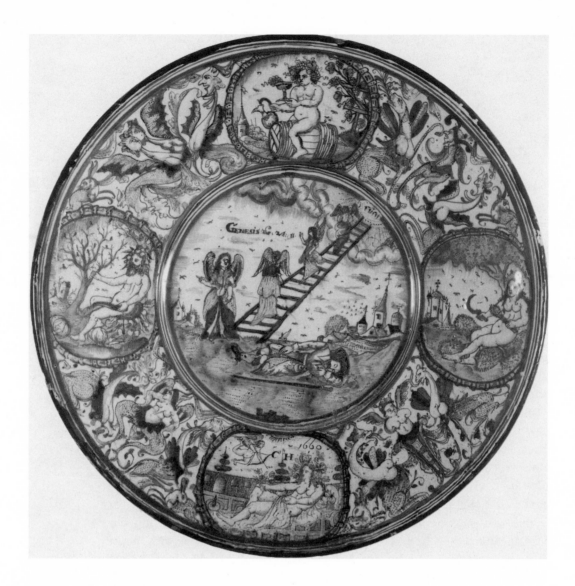

FIGURE 23
"The Dream
of Jacob" plate
(Southwark,
London, 1660),
ceramic. The
British
Museum.

comes one after it loses its validity as science, just as Classical mythology became purely poetic after its oracles had ceased."[62]

That succinct perspective offers much to contemplate and much that seems useful. However well a Ptolemaic conception of the universe served those cultures that have been covered thus far, I find no evidence in the materials lying ahead for the eighteenth century onward that a Copernican conception served any less well. For the American naturalists to be examined in chapters 3 through 5, the Copernican system undoubtedly served even better, because their objective was not mythmaking but scientific as well as cultural understanding. When Northrop Frye launched into his mythos of spring (comedy), summer (romance), autumn (tragedy), and winter (irony and satire), he actually echoed some, though by no means all, of the tropes that we have been tracing thus

far.[63] He may very well assist the student of literature to formulate a metastructure for purposes of categorization. But his schema notably suggests just how fully the seasonal has become naturalized as a trope in Western culture.

James Thomson and His Poem's Impact at Home and Abroad

During the eighteenth and nineteenth centuries the four seasons motif in literature and the arts continued to be linked with spiritual impulses on occasion. More often than not, however, references to God became largely a matter of lip service rather than serious redactions of religious belief. Which is not to say that the motif waned either in visibility or as a cultural artifact and significant symbol. The motif not only remained linked to legendary traditions of long standing, it even generated some new mythic tales. As humankind felt a growing sense of control over the environment, sometimes even verging upon illusions of mastery, the mysteries of seasonality came increasingly to be connected to cultivation and gardens, to the life cycles of communities and nations. The four seasons had been utilized as a decorative device for many centuries, as we have seen; but now it was employed for that purpose more than ever before. It also remained linked, to a greater degree than in the past, with ruminations concerning the human life cycle. In Great Britain and in France, especially, some creative artists and writers seemed even more inclined than previously to pursue parallels between the seasons and times of the day.

What American society would inherit from Europe concerning the seasons as a mode of expression, as a means of articulating attitudes, and as a vehicle for cultural nationalism became especially clear between the 1790s and the 1830s. During the 1820s, for example, American artist Thomas Cole visited the Louvre and saw a set of four seasons paintings by Pierre-Antoine Patel (1648–1707), a Parisian from a family of artists who specialized in landscapes. That encounter in the Louvre inspired Cole to contemplate seasonal art very seriously even though he never completed a full set identified as such—*The Voyage of Life* suite (1839–42) being a partial exception.[64]

What else would be "inherited" or influential? From about 1745 through the 1790s numerous sets of four seasons engravings were published in London, often with captions that included lines from *The Seasons* by James Thomson (figure 24). Those prints, many of them rather second-rate artistically and quite clichéd symbolically, enjoyed considerable popularity in the young republic. By 1800 American copies based on English prototypes were being sold, particularly in Philadelphia. In fact, Thomson's poem itself went through countless American editions, sometimes reproducing English illustrations but increasingly incorporating simpler ones designed by American woodblock artists.[65]

One of the most prominent aspects of Thomson's *Seasons*, frequently noted by scholars, is the poet's apparent ambivalence about the relative merits of city

FIGURE 24
John Vanderbank, James Thomson *(1746), oil on canvas. The Scottish National Portrait Gallery, Edinburgh.*

and country living. Thomson offered endless praise for pastoral innocence and the virtues of rural "retirement," all the while denouncing urban life because of its obsessions with fashion and luxury. Exurban nature provided a tranquil retreat, he insisted, and even solace from the ills of densely clustered society. Nevertheless, Thomson also celebrated commercial progress and improvement, idealized a productive economy and abundance, and admired city life because the city was where learning and polite society were most readily found. Thomson managed to extol progress as well as simplicity and rustic virtue. The vast impact of his poem transmitted that complex ambiguity to both his English readership and American admirers. Either they somehow found ways to reconcile these opposing values or they internalized only those parts of Thomson's message that appealed to them. Typical of the conflicting passages that appear in Thomson's "Autumn" are the following, beginning with a negative assessment of city life:

This is the life which those who fret in guilt
And guilty cities never knew—the life
Led by primeval ages uncorrupt.

Connecting with this, but developing more specific complaints:

> The city swarms intense. The public haunt,
> Full of each theme and warm with mixed discourse,
> Hums indistinct. The sons of riot flow.

But then:

> Hence every form of cultivated life
> In order set, protected, and inspired
> Into perfection wrought. Uniting all,
> Society grew numerous, high, polite,
> And happy. Nurse of art, the city reared
> In beauteous pride her tower-encircled head;
> And stretching street on street, by thousands drew,
> From twining woody haunts, or the tough yew
> To bows strong-straining, her aspiring sons.[66]

Edward Cave, founding editor of the widely read *Gentleman's Magazine* begun in 1731, assumed a highly symptomatic pseudonym, Sylvanus Urban. Perhaps that is a benchmark for the genesis of nostalgia by city dwellers in Britain for those features of rural life that seemed lost or else threatened—a symptom of cultural ambivalence. The city may be the optimal setting to get things done, a springboard for commercial or cultural ambitions. But the country is the best place to be in touch with one's "better nature."

Between 1726 and 1730, when he completed the initial version of his poem, Thomson became increasingly influenced by scientific ideas—at a time when the Copernican view of the heliocentric universe had achieved very broad acceptance in the Anglo-American world. In 1728 Samuel Edwards's *Copernican System* exploited scientific material for poetic purposes. And Thomson seems to have experienced a sense of awe on account of the steadily circling planets. By accepting and admiring Newtonian science in such an enthusiastic manner, Thomson was embracing the Copernican system *tout court*. And it was clearly embraced among French *érudits* by the 1720s as well. John Milton summed up Copernican sentiments most succinctly in *Paradise Lost*, book 3 (lines 94–96):

> O Sun!
> Soul of Surrounding worlds! In whom best seen
> Shines out thy maker![67]

The appeal of Thomson's poem also owed much to the way in which he interpolated stories concerning mythical characters—episodes rich with human interest. The somewhat salacious story of Damon and Musidora ("Summer," lines 1279–1370) narrates the way a stoic devoted to "false philosophy" is humanized by the sight of a woman's beauty. In the initial version Musidora

(opposite)

FIGURE 25
Thomas Sully,
Musidora
(1835), oil on
wood. The
Metropolitan
Museum of
Art, Gift of
Louis Allston
Gillet, in
memory of his
uncles, Sully
Gillet and
Lorenzo M.
Gillet, 1921.
(21.48).

comes to bathe in a stream, seeking a cool retreat from the heat of summer. Undetected, her suitor Damon should have "retired," but being smitten by her beauty he lingered to watch her wash. Whether it was love, lust, or both that kept him glued to the spot is not entirely clear, but love apparently trumps lust in the 1744 version. In that revision the sensuous aspect of the tale gets toned down, and thereafter this romance remained a playful piece of rococo decoration, used by many subsequent graphic artists, ranging from Thomas Gainsborough in England (1727–88), whose bare-breasted beauty is sensuously attractive, to the American Thomas Sully, who painted a much less erotic, chastely nude Musidora (figure 25) in 1835 after a version by Benjamin West.[68] William Wordsworth remarked that the Musidora episode became the most frequently read passage from *The Seasons,* though he did not specify which version!

Another tale narrated by Thomson—this one tragic—had almost the same impact, and perhaps even a stronger one in the young United States. It concerned lovers named Celadon and Amelia and first appeared in 1727 in "Summer" (lines 1169–1222). The two are walking through the woods when an electrical storm bursts upon them and Amelia is struck and killed by a bolt of lightning. Thomson's "inspiration" for this story came from newspaper reports of rustic lovers actually struck dead by lightning in July 1718 in Oxfordshire. Thomson's purpose in relating his version was to illustrate not only God's absolute power, but man's incomprehension of God's purposes. References to this sad incident became common in antebellum America, and William Sidney Mount made an oil painting in 1828 titled *Celadon and Amelia* (figure 26).

The most extraordinary impact of Thomson's poem in the arts, however, occurred not in painting or prints but in the decorative arts, more specifically in porcelain figures of the seasons that were made in many different forms, sizes, and qualities. They started to appear around 1755, when the Chelsea Porcelain Works produced soft-paste candlesticks with flowers accompanied by allegorical figures of the four seasons. Between 1756 and 1800 Derby Porcelain Manufacturing offered similar sets with predictable motifs: two couples, each with a child and flowers for spring, then harvest, next grapes, and finally an old man representing winter. Variations of these seasonal ceramic pieces continued to appear in the young United States at the start of the nineteenth century, quite often featuring children (figure 27). Diverse designs were apparently derived from sets first made in the mid-eighteenth century in Meissen, Germany, a sign of close Anglo-German cultural ties under the Hanoverian monarchs.[69]

The enthusiastic response to Thomson's *Seasons* continued on the European continent well into the nineteenth century. In France, for example, we find a direct impact in the derivative and lengthy (235 pages) *Saisons: Poème* by Jean-François, Marquis de Saint Lambert, initially published in 1769 and already in its fourth edition by 1771. The young writer responded to Thomson's nationalistic

boasting by declaring that the details of nature and life in the French country-side had not yet been adequately rendered. After citing Virgil, Ovid, Horace, and other classical writers, he followed Thomson by indicating his knowledge of natural science as well as the shared experiences of "popular" country life. His own national pride is tempered by a lament that the French ignored the wonders of nature ("une nation qui l'ignore ou la regarde avec l'indifférence").

FIGURE 26
William Sidney Mount, Celadon and Amelia *(1828), oil on canvas.
The Long Island Museum of American Art, History and Carriages,
Bequest of Ward Melville, 1977.*

As for particulars of the seasons, he observed that spring starts out somber and majestic but then becomes friendly and humorous. Nature is expansive and beautiful in summer, melancholy in autumn, sublime and terrible in winter. Curiously, winter receives his most sustained attention: 66 pages as opposed to 42, 46, and 47 for the first three seasons.[70]

Eighteenth-century French art certainly supplied an exuberant though excessively saccharine response to the seasonal motif, which achieved a high degree of visibility. Most important in terms of sheer quantity as well as notoriety, yet somehow sentimental and insipid to modern eyes, is the work of François Boucher (1703–70). In 1745 he painted several seasonal sets titled *Spring* and *Autumn*, followed by *A Summer Pastoral* and *An Autumn Pastoral*, clearly inspired, directly or indirectly, by Thomson's *Seasons*. In 1755 he painted a modestly sized four seasons quartet highlighting courtship and feminine beauty. *Summer* features three females in various states of dishabille, and in *Autumn* a young woman is offered grapes by an ardent swain. In *Winter* a woman rides in a sleigh while a boy skates; it cannot be too cold because her bosom is partially exposed.[71]

Shifting our attention to Spain we turn to one last example from among numerous possibilities: the fascinating *Four Seasons* of Francisco Goya. Called cartoons, they actually are major paintings that he made as preparatory designs for tapestries. He completed them in 1786–88 at the request of the Prince and

FIGURE 27
*Derby
figures of the
Four Seasons
(ca. 1800),
soft-paste
porcelain.
Colonial
Williamsburg
Foundation.
Abby Aldrich
Rockefeller
Folk Art
Museum,
Williamsburg,
Va.*

Princess of Asturias, who wanted seasonal tapestries to hang in the dining room at the Palacio del Pardo. The series represents Goya's most mature effort in the tapestry "cartoon" genre. By 1790 he refused to continue his work at the Royal Tapestry Factory because he believed that doing so constrained his "genius." In fact, the ten completed tapestries made from Goya's designs were never hung in El Pardo. Instead, they were randomly scattered through different rooms at the Escorial Palace.[72]

Those cartoons are now located in the Prado Museum. Although there are certain familiar elements present, they are delightfully fresh and contain messages concerning class, social status, and human relations that may have been disturbing if members of the royal court bothered to pay attention and look closely. For spring, titled *Las Floreras* (the flower girls), a young, well dressed mother and daughter are buying or at least receiving flowers from a young woman on her knees, presumably as an indication of her inferior status. Her smiling male accomplice stands behind the mother holding a baby rabbit aloft with a finger to his mouth, suggesting some sort of conspiratorial silence in his relationship with the flower vendor. He appears to be as cheerful as the mother is quizzical or condescending. Summer, titled *La Era* (the threshing floor, plate 7), is much the largest of the set. Workers, with their wives and small children, arranged in a kind of pyramid, are mostly taking a break from their labors, enjoying rest, wine, and gleeful conversation while being greeted by four newly arrived laborers. In the background, balancing the bales of wheat, we see part of a vast palace, not fully colored so that it seems a ghostly stronghold of power to these presumably powerless peasants. *La Vendemia* (the vintage) has a young royal couple prominent in the foreground with a large basket full of grapes. A peasant girl with another huge basket balanced on her head attends to them and awaits their command. Behind them in the fields male peasants are hard at work, and one of them has paused to stare back at the noble couple enjoying their leisure. The colors are attractive but dominated by cool blues, whereas *La Era* is warmed by the bright yellow bundles of wheat, and the open shirts of the workers also suggest a season of intense heat.

La Nevada (the snowfall) seems quite a different composition from the other three, which is frequently the case with winter motifs. A hunter with his gun and dog plod uphill through snow, followed by a donkey with an enormous boar tied securely across its back. Behind the hunter but preceding the donkey are three miserable-looking peasants with inadequate pieces of cloth wound around their heads and shoulders to provide some sort of cover against the bitter cold. Last comes a well-wrapped man ascending the hill wearing what seems to be a black tricorn hat. Whether he is a person of higher status than the others is unclear, but unlike the rest, he has no burden to bear. Whatever the relationships among these five men, the wretchedness of their midwinter weather is abundantly evident. In this suite Goya has achieved an element of mystery

and engaging provocativeness that had not often been seen since Bruegel's extraordinary seasons in 1565.[73]

Given all of this enthusiasm for seasonal art and literature in eighteenth-century Europe, then, the intriguing issue arises: what happened to the genre, especially its British protocols and manifestations, when they were transported to Britain's colonies overseas? The answer varies depending upon time, specific geographical location, and the very nature of any particular tradition under scrutiny. Take, for example, the changing seasonality of marriage and conceptions in early modern England and its North American possessions. Weddings had once been banned in England during the seasons of Lent and Advent, which affected almost 30 percent of the year. Couples in New England, however, where the Anglican Church exercised virtually no control, were free to schedule their marriages for almost any day or season.[74]

But what occurred when English colonists (and convicts who would become colonists) went to Australia during the first half of the nineteenth century? That turns out to be an intriguing question. The seasonality of marriage in England had not merely (or simply) been bound by the ecclesiastical calendar. The latter, in turn, converged conveniently with agricultural imperatives. Lent coincided with the season for intensive plowing and planting in late winter–early spring. And Advent coincided with final phases of the harvest. It's not just that everyone was preoccupied with work at such times. What mattered most was that those were extremely inconvenient (if not impossible) times for travel to and from festivities. So the English had long been accustomed to late spring and summer marriages, or else midwinter ones after the Christmas season had finished. Given those deeply entrenched traditions, would colonists in Australia follow the customary calendar and marry in the particular months when British men and women had always married? Or would they adapt to the realities of weather conditions in the southern hemisphere where the "world" they had always known was turned upside down?[75]

Because parish records happen to be very good indeed for Van Dieman's Land (known as Tasmania after 1856), we have an answer to that question. By the 1840s the settlers in this new venue had come to terms with the "inverted" seasons. They opted for meteorological realities over tradition, so marriage rates rose during their late spring and summer, and once again during their early "winter" (such as it was). Not just necessity, but expediency as well, is the parent of invention.[76]

CHAPTER 2

THE AMERICAN RECEPTION AND
ADAPTATION OF THE FOUR SEASONS
MOTIF

Adaptations and Modifications of the Motif in Early America

During the first two centuries of the European experience in North America, the challenges of seasonal change would be an ever-present and frequently harsh reality. Confronting all manner of meteorological and geophysical difficulties, as the colonists did, the seasons as motif and metaphor, expressed in literature and the arts, would develop slowly among them and, at first, rather predictably. For a small number of literati, clergymen, and other members of the educated social elite, the seasons could be viewed through classic writers such as Virgil and, by the eighteenth century, major British poets such as Chaucer, Spenser, and above all, Thomson. For the vast majority of colonists, however, seasonal rituals and festivals followed the Christian calendar pretty much as they had "at home," although there were some regional variations along the Atlantic seaboard, especially in New England, and by the 1740s and 1750s in the backcountry as well.* Authorities on New England culture during the later seventeenth century have observed that "the very nature of farm life, with its settled routines and seasonal rhythms, offered at least the illusion of social stability and continuity."[1]

*In 1751 Great Britain finally decided to catch up with continental Europe and shift from the Julian to the Gregorian calendar, a conversion that began in Rome in 1582 and gradually spread to most Christian countries. Because of a miscalculation by Roman astronomers in 45 B.C., a very gradual slippage eventually resulted in calendars no longer coinciding with the solstices and equinoxes. By 1751 the difference was eleven days in the Anglo-American world. The new calendar officially went into effect on September 2, 1752, which meant skipping to September 14. Riots ensued in England because people felt cheated, and the slogan of the rioters was "Give us back our eleven days." At the same time, in September 1752, the commencement of the new year was shifted from March 25 to January 1.

By the later eighteenth century, however, American farmers, responding to a chronic shortage of labor, arranged their workload so that the sequence of harvest peaks happened "at seasons differing from each other much more than in England." By the early nineteenth century, owing to climatic variations from Europe, planting and harvesting in the mid-Atlantic and New England occurred at times that varied by as much as a month from northern European norms. Combined with the need to make optimal use of scarce labor resources, that meant significant changes from English custom in the American calendar.[2] Several travelers to and from the British Isles commented explicitly on these differences. Harriet Martineau's lengthy 1838 account of her travels in the United States devoted a chapter called "Hot and Cold Weather" to seasonal phenomena. When Thomas Jefferson made a tour of English gardens in 1786, he noticed transatlantic variations as well. But most Americans simply accepted the conditions they knew as being normative. Elizabeth Drinker, a Philadelphian, recorded these lines of poetry in her diary in 1795.

> I stay much at home, and my business I mind,
> Take note of the weather, and how blows the wind,
> The changes of Seasons, The Sun, Moon and Stars,
> The Setting of Venus, and riseing of Mars.[3]

Because there were so many regional (even subregional) variations in climate, and because of the need to establish local norms for various kinds of essential activities, "seasons" and "seasonable" were casually used as nouns and modifiers to define or clarify an array of imperatives. People in Pennsylvania wanted their state bill of rights to protect their liberty to "fowl and hunt in seasonable time on the lands they hold." In 1787–88 Federalists lampooned Anti-Federalists with "seasonable" caricatures, thereby suggesting a very strong sense that certain activities were most appropriate (and likely to occur) at particular times. In point of fact, however, state elections for the next seventy years occurred at many different times of the year: every month except January, February, and July. Consequently, campaigning took place in quite variable phases. Americans became accustomed to a curious dualism in their lives: some things were reliably seasonable while others remained quite variable.[4]

Both situations were operative when it came to weddings. In Puritan New England, Congregational as well as Presbyterian, the "marrying time" took place most intensively late in the calendar year, well into autumn but especially in November and December. In Anglican Virginia, however, the favorite season for marriage occurred between Christmas and Lent. Quakers living in the Delaware Valley followed yet another pattern, preferring to marry at two annual peak times, spring and autumn. In the backcountry, however, being rapidly settled by the mid-eighteenth century, the dominant season for marriage

ran from April through July, when clergymen could actually reach remote communities. Two-thirds of all recorded marriages took place in the spring and summer. Fall turns out to have been the least active period.[5]

Because marriage remained a seasonal occurrence in seventeenth- and even eighteenth-century America, so was the birth of children, first ones especially, but subsequent ones as well. At a time when birth limitation was highly unreliable, seasonal variations in climate, diet, and hence nutrition combined with the rhythmic intensity of the work cycle in ways that affected fertility. Among Quakers, for example, conceptions were most likely to occur in spring (April and May) and in November, whereas conceptions were least likely to occur in September, February, and March. In New France (French Canada) at the beginning of the eighteenth century, conceptions ebbed dramatically during late winter, rose to a notable peak in June, and then declined steadily until September, when they leveled off except for a brief increase between Christmas and Epiphany. Other than that surge during the holiday season, the conception graph was in almost perfect accord with the temperature. The warmest weather occurred in mid-July. As the daily comfort level began to increase significantly in midspring, so did conceptions.[6]

Seasonality and Slavery: African American Lives in Early America

We have already noted that in a wide variety of ways, going back to antiquity and beyond, agricultural life and labor were intensely seasonal. So, inevitably, was life for black slaves throughout the colonial period and right up through the Civil War, but in several respects even more so than for white workers, and in ways unknown to most whites. A great many slaves, for example, had no knowledge of their actual birth dates. As Frederick Douglass wrote at the outset of his autobiography: "I do not remember to have ever met a slave who could tell of his birthday. They seldom come nearer to it than planting-time, harvest-time, cherry-time, spring-time, or fall-time."[7]

In 1760 George Washington described the workday of his slaves as being "only" from "sun to sun"; but the actual length of a workday, especially for a field slave, would have varied with the seasons. During the summer, when the sun rose soon after five o'clock and set between eight and nine, his slaves were commonly at work for at least fourteen hours a day. And because several of the most important grain crops in Virginia were harvested during summer, that became a brutal season for the Africans. For those slaves who worked as general laborers, their tasks would have varied somewhat according to the season. Weekly work reports from Mount Vernon dating to the mid-1780s indicate that in spring and summer male slaves plowed, rolled, and harrowed the ground; seined for fish; sowed and weeded crops; cut straw and brush; heaped and tied

hemp; cradled and bound the grain harvest; shocked wheat and oats; gathered splits for basket making and tanned bark; cut hay, clover, and cornstalks; cut fence rails and posts; cleaned swamps; and filled gullies.[8]

When fall brought cooler weather, men harvested corn and peas, sowed winter grains, and made livestock pens and feeding racks. Women cut and piled cornstalks, chopped and began to process flax, threshed rye, cleaned oat and wheat seed, and dug carrots. Although winter is customarily considered a slower time in the agricultural calendar, Washington's slaves were kept as busy as possible. Male slaves worked on the mill race; dug ditches; cut rails, posts, and firewood; slaughtered hogs; filled the icehouse; built new roads; framed a barn; made baskets and horse collars; tanned leather; and tended the stable. Women helped at the icehouse, beat out hominy, cleaned the stable, salted the slaughtered hogs, stripped tobacco, packed fish, and made basket splits.[9]

Solomon Northup's narrative of his life and labors on a plantation called Bayou Boeuf in Louisiana conveys a clear sense of seasonal rhythms in the Mississippi Delta region. He describes the cotton cycle from planting in March and April to hoeing in midsummer and picking from August through the end of the year. During early autumn dogs were used to run hogs out of the swamps so that they could be confined in pens, fattened, and then slaughtered on a chilly morning sometime around New Year's. Northup described sugar cultivation in monthly stages. In winter his tasks ranged from canal construction (or restoration) to "numerous calls to play on the violin."[10]

Charles Ball worked on plantations in South Carolina and in Maryland near the Patuxent River and Chesapeake Bay. When his master discovered that he had worked at a fishery on the Patuxent for several springs, he was shifted from the cotton fields to making a seine. If Ball successfully caught fish in late winter when the plantation's food supply was low, he received strong praise. He observed in retrospect that "the fishing season was always one of hard labor, it is true, but also a time of joy and hilarity. We then had, throughout the time of fishing, plenty of bread, and at least bacon enough to fry our fish with." For Ball the "fishing season" spanned a very specific time period, and he used that designation for a prominent part of the annual work cycle described in his memoir, *Fifty Years in Chains*.[11]

Eventually, when his master aged, Ball was sent to work on the plantation of the master's daughter in Georgia. His account of winter activities seems representative for a slave who had been entrusted with considerable responsibility:

We passed this winter in clearing land after we had secured the crops of cotton and corn, and nothing happened on our plantation to disturb the usual monotony of the life of a slave, except that in the month of January, my master informed me that he intended to go to Savannah for the purpose of purchasing groceries, and such other supplies as might be required on the plan-

tation in the following season; and that he intended to take down a load of cotton with our wagon and team, and that I must prepare to be the driver.

Ball escaped and made his way slowly through the Carolinas. He commented that "the month of November is, in all years, a season of clouds and vapors," but that particular year in North Carolina it was worse than usual. In December, his sixth month of freedom, "the wind blew from the south, the snow melted away, the air became warm, and the sun shone with the brightness, and almost with the warmth of spring."[12] John Brown, who also became a fugitive slave and achieved his freedom, had been the property of a tobacco distiller in Georgia. His narrative included an account of the specifically seasonal nature of his work. Brown remembered vividly when he was first separated from his biological family. "It was a bright, sun-shiny morning, in the autumn season, at about the commencement of tobacco-cutting time."[13]

Slaves who managed to make their way north to freedom, achieve an education, and write memoirs that abolitionists could use in their crusades interchanged the use of particular months, conventional names of the seasons, and meaningful phrases like fishing season, planting season, and "season of clouds and vapors" to describe the weather as well as their work routines. For less fortunate slaves, who are frequently mentioned in these memoirs, the seasons provided the principal means of measuring and marking their lives. Most of the "festivals" observed by African Americans were closely linked to the cycle of cultivation. As Charles Ball comments in *Fifty Years in Chains*, "After the feast of laying by the corn and cotton, we had no meat for several weeks; and it is my opinion that our master lost money by the economy he practiced at this season of the year."[14]

Within half a century, however, the more fortunate members of a younger generation of freedmen and women who studied at the Hampton Institute in Virginia took classes in geography in which each one held a small globe, while a heliocentric diagram designed to explain the science behind the seasons was drawn on the blackboard. Photographer Frances Benjamin Johnston captured such a moment in 1899 (carefully posed, in all likelihood) and it was published with the caption, "Geography: Studying the Seasons" (figure 28).[15]

Thomson's Influence and the Uses of Seasonality in the Young Republic

What antebellum slaves, no matter how dutiful, did not receive were certificates like those called "rewards of merit" that were printed (with blanks left for a person's name and a skill, like spelling, to be filled in) for distribution to white students who excelled in the private secondary schools of New England during the second and third decades of the nineteenth century. Across the top, occupying more than half of the entire certificate, were roundels with symbolic

depictions of the seasons; or, in the most elaborate of these handsome achievement awards, images of seasonal rural labor were surmounted by "The Seasons" in scroll-surrounded script, directly beneath which appeared the favorite one-line quotation from James Thomson's beloved poem ("These as they change Almighty Father, these are but the varied God"), which achieved the peak of its American appeal during the early decades of the nineteenth century.[16]

We know that educated and well-informed Americans were reading and enjoying Thomson's poem with gusto as early as the mid-eighteenth century. In 1745 Benjamin Franklin wrote to a London correspondent: "Your authors know but little of the Fame they have on this side of the Ocean. . . . Whatever Thomson writes, send me a Dozen Copies of. I had read no Poetry for several years, and almost lost the Relish of it, till I met with his *Seasons*. That charming Poet has brought more Tears of Pleasure into my Eyes than all I ever read before." Within three years Franklin was incorporating lengthy extracts from Thomson's poem into *Poor Richard's Almanack* and thereby disseminating awareness of it to significant numbers of readers in the colonies. Early in the 1760s young Thomas Jefferson copied lengthy passages from *The Seasons* into his commonplace book; and we know that John Paul Jones read and greatly admired the poem.[17]

Two American images created soon after independence had been won provide another clear indication of Thomson's appeal. When Charles Willson Peale painted a portrait of Mrs. Elias Boudinot IV (Hannah Stockton, whose brother Richard had signed the Declaration of Independence), she chose to hold and prominently display for the viewer Thomson's poem, visibly open to "Winter" (figure 29). Because it clearly could not have been the winter of her life, the picture must have been made in the winter of 1784. In Samuel Jennings's popular painting titled *Liberty Displaying the Arts and Sciences* (1792), in the lower left-hand corner Jennings placed a blue-gray book. The spine reads "Thomson's The Seasons."[18]

London imprints of the poem were still being imported as late as 1788, but American editions were printed in Philadelphia (1777, 1778, 1790 and 1795), Newburyport for Boston (1790), Albany, New York (1801), and Brookfield, Massachusetts (1807 for Isaiah Thomas). All of these editions were without illustrative plates, but Stafford's Philadelphia edition of 1797 contained four illustrations, including "Celadon and Amelia" as the graphic to introduce "Summer," with a huge flash of lethal lightning menacing in the background as the distraught young lover bends over his stricken sweetheart. The Philadelphia editions of 1795, 1801, and 1802 carried a false title page dominated by a curious configuration of the seasons separated into quadrants by a very tall tree: summer and spring are represented at the top left and right, while winter and autumn are directly beneath them respectively. For purposes of creating a genuine *cycle* of the seasons, this arrangement does not work, whether one follows it clockwise or counterclockwise. (Most likely the process of engraving had reversed the source drawing. The configuration does make sense if reversed.)[19]

Editions printed at Philadelphia in 1804 and 1814 and at New York in 1817 include engravings made by English artists. We would know that even if "R.A." (Royal Academy) did not appear after the artists' names because the principal figures are costumed elaborately, because peasants labor while gentry couples court, and because "Summer" has one breast prominently bared with a caption taken from Thomson below her: "the sultry season glow'd." American illustrators did not call attention to class differences and did not ordinarily expose breasts. The 1814 printing, made for distribution in "Georgetown (D of C)," has a discreetly half-naked female, presumably Musidora, stepping in a stream to bathe. Beginning with Philadelphia editions in 1805 and 1826 and a Boston edition in 1822 we find less sophisticated illustrations of the four seasons, woodblock prints rather than engravings and rustic figures performing seasonal chores, although the Boston version does emphasize leisure for the seasonal emblems: a man lazily fishing, three lads preparing to swim, a courtship scene for autumn (against a backdrop of workers cutting wheat), and the usual bleak scene for winter—one man alone trudging into the forest to face his fate in rough weather.[20]

Editions printed at Philadelphia between 1826 and 1857 include portraits of Thomson facing the title page, loosely based upon the portrait by John Vanderbank (figure 24). The 1857 printing has an intriguing false title page featuring a graceful male skating self-assured and alone, reminiscent of a famous oil painting by Sir Henry Raeburn of *The Reverend Robert Walker Skating on Duddingston Loch* (ca. 1784), thereby calling attention to Thomson's Scottish origins. The illustrations by an obscure artist named Schmolze are not unlike some of the rural scenes by Currier and Ives that began to appear in 1855.[21]

Special editions printed at Philadelphia in 1811 and 1828 are distinctive and important because they are tiny (less than 4¼ inches high and 2½ inches wide), clearly intended as "pocket books" to be taken on trips by travelers or by

suitors intent upon serious literary courtship maneuvers. The 1811 edition has no plates, but a frontispiece precedes the title page. Notably, the copy located at the Library Company of Philadelphia has a plate pasted on the front board. It reads: "The Reward of Merit. A Premium, Presented by D. Jaudon, to his amiable young friend and pupil Miss Hester Cooper." The 1828 edition, published by Edwin T. Scott, contains a frontispiece and five plates, including one for Thomson's concluding hymn done by an English artist and engraver. These pocket-sized printings, bound in leather, with a clever tab inserted for closure to protect the delicately thin pages, enjoyed considerable popularity.[22]

Thomson's poem permeated early American culture in yet another way: via material culture and the graphic arts going well beyond book illustrations. A large number of the porcelain representations of the seasons referred to in the previous chapter were imported to the colonies and the young republic between the 1770s and the 1830s.[23] During the 1750s, moreover, hand-colored line engravings of seasonal figures placed in sequence and intended to be framed together were printed in London. Between 1745 and 1765 mezzotint engravings of attractive women, invariably shown two-thirds length (to about where the knees would be if they were not so well covered by billowing skirts), were printed and sold in London as representations of the four seasons. The models for the set sold by Henry Overton were particularly fetching, with bosoms considerably exposed(except for Winter, who is well cloaked). Sets printed and sold by Robert Sayer between 1760 and 1785 became especially well known among the landed gentry in the American South, as did a set printed for Carrington Bowles in 1760–65. We know that these sets were inspired by Thomson because they invariably have four lines selected from *The Seasons* beneath the image. Most of them were left in black and white, but some were hand colored, usually to the detriment of the image.[24]

By the 1790s multiple sets, most of them unattractive to modern eyes, were being offered by printers in London. And by 1800 copies of those second-rate English originals were being made and sold in New York by Luzerder and Westfield. The seasonal motif even appeared on copperplate-printed cotton textiles (tabby weave) made in England around 1790.[25] At exactly that time, American women began doing seasonal scenes in needlework. Initially they seem to have closely followed the format of familiar English engravings. Isabella Hall, for example, a woman from New Jersey or Pennsylvania, used silk embroidery on a silk ground to stitch a pictorial "Spring" clearly inspired by Thomson's poem. Between approximately 1810 and 1825 anonymous artists, mainly in New England and especially Massachusetts, began producing seasonal images using watercolor and pencil on wove paper. These have a much simpler appearance than their English counterparts, featuring rustic costumes

FIGURES
30 & 31
*Statuettes
of the four
seasons
(Spring,* left,
and Winter,
right), *artist
unknown
(Boston area,
ca. 1790–1810),
wood. The
Metropolitan
Museum of
Art, Bequest
of Flora E.
Whiting, 1971.
(1971.180.83
and 86).*

and rural landscapes rather than country estates of landed gentry. The earliest bears the word "Summer" below a woman raking hay. Another shows a family (parents and three children) picking apples from several trees, which can symbolize either autumn or simply the joys of country life. The details are handled crudely, and the work may very well have been executed by a talented but untrained youngster.[26]

In any case, these representations signify both the Americanization and the democratization of James Thomson's influence. The people depicted are not peasants; but neither do they belong to the elite. They are husbandmen and their wives, "middling folk" as they would have been called at the time.

Between 1790 and 1810 carved wooden statuettes of the four seasons and other seasonal figures began to appear in New England (figures 30 and 31). The symbols are fairly standard: women with flowers, sheaves of grain, fruit, and a fur muff. But the carving is careful and graceful, marred only by faces that seem a bit crude, or perhaps more generic than individualized. A charming statuette of a young boy skating, carved from American black walnut, may very well have been based upon a Bristol or Chelsea porcelain figure from England. But in any

event the boy certainly represents winter. He wears over his shoulder a pouch with a dead rabbit in it; his jacket is fur lined; and his head is bent slightly forward as he skates into the wind.[27]

By the early decades of the nineteenth century there seemed to be no limit to American ingenuity in placing seasonal motifs as decorative designs on practical and functional artifacts. Richard Brunton of Connecticut engraved about a dozen different family registers listing births and deaths, and several of them have seasonal figures placed in the four corners. Between 1810 and 1825 parts for tall case clocks were made in Birmingham, England, and shipped to New York, where mahogany cases were made for them with symbols of the four seasons painted on the dial. By 1830 large cotton kerchiefs were being made in the vicinity of Chester County, Pennsylvania—some in brown and white, some in red and white, but all displaying highly detailed depictions of seasonal activities (figure 32). They were actually made in four sections and stitched together.[28]

Nor did these objects and motifs emanate solely from Anglo-American sources. The four seasons are illustrated in a splendid example of a *bauernschrank*—a tall German standing cupboard for storing earthenware and other objects (related to cooking and dining) on interior shelves of variable height—produced in Bavaria in the late eighteenth or early nineteenth century, combining rough carpentry and some very fine carving (figure 33). The two front doors each bear a pair of paintings. On top a boy is sowing seed, and opposite him a man holds a scythe. On the bottom a young woman is raking leaves. Opposite her a man wears heavy clothes in a rather desolate setting; winter (and perhaps life itself) has been hard on him.[29]

For well over a century, beginning in George Washington's era, it was not unusual for the homes of socially prestigious and affluent Americans to have a four seasons decoration handsomely situated, as much to give pleasure to the owners as to show visitors that they were able to perpetuate a tradition dating back to Italian palazzi, French châteaux, and British country homes. Colonel Fielding Lewis and his wife Betty, Washington's kinswoman, had installed in Kenmore, their home near Fredericksburg, Virginia, what has been designated as the "most elaborate decorative plasterwork in America." The ceiling of the first floor bedroom is molded plaster (called "ornamental stucco") with the four seasons prominent in the corners. The symbols chosen are somewhat unusual for this Virginia venue: palm leaves for spring, grapes for summer, oak leaves and acorns for autumn, and mistletoe for winter. When George Eastman built his Rochester, New York, mansion early in the twentieth century, he also opted for the four seasons in molded plaster, but even more opulently displayed on the ceiling of his very capacious main sitting room.

The mansion at Montgomery Place, located near Kingston on the west bank of the Hudson River, was built in the Federal style in 1804–5 by Janet Livingston Montgomery, the widow of Revolutionary War hero and martyr Richard

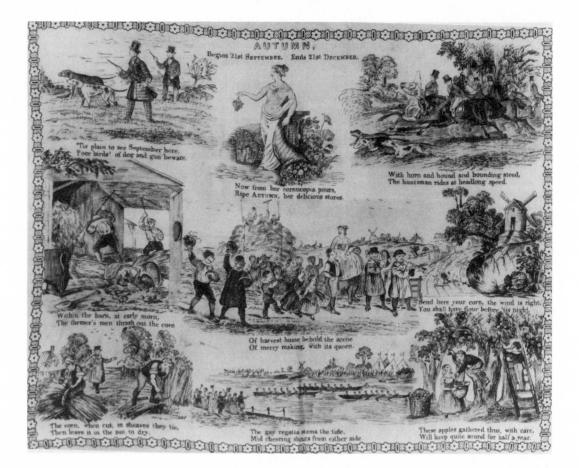

FIGURE 32
*Four seasons
kerchief,
detail of
Autumn,
(southeastern
Pennsylvania,
ca. 1830).
Private
collection.*

Montgomery. At some point, most likely during the early 1850s, her grandchildren placed in the front hall four large plaster and wood roundels representing the four seasons that were copies of a famous set carved by the Danish sculptor Bertel Thorvaldsen (1768–1844), considered along with Antonío Canova as the two most representative exponents of the classical revival in sculpture. "Winter" shows a very elderly couple in antique robes. "Spring" has a female figure flanked by an infant at her left hand and a youth at her right. A bouquet of autumn flowers is prominent, but also a tall basket of spring flowers. Emblems of both generations in the life cycle are thereby present. For "Summer" a classically dressed young couple are in a wheat field, with a second female figure on her knees cutting wheat—a clear acknowledgment of status differentiation between proprietors of the estate and their laborers. And "Fall" displays a classically draped couple of mature years, the man bringing grapes and a hare to a woman with a suckling infant. She could be either his daughter or his young wife. All of the roundels are strikingly elegant, suitable exemplars of the gentry's taste preferences at that time.

The placement of these sophisticated symbols, and some other decorative

FIGURE 33
Bauern-
schrank (rural
Bavaria, later
eighteenth
century),
wood.
Courtesy of
Professor and
Mrs. George
Kimball
Plochmann.
Photograph
by Jeremy
De Weese,
Murphysboro,
Ill.

decisions made in the mid-nineteenth century in the United States, is indicative of a confluence of classical and neoclassical sources familiar to educated Americans. In Virgil's *Georgics* fishing is a well-described springtime activity, and a fishing scene was introduced in Thomson's "Spring" when he made his major 1744 revision. Late in life, the Pennsylvania artist Thomas Doughty (1798–1856) undertook a four seasons series that he never completed. His *Spring Landscape* (figure 34), however, is a fishing scene in which the figures wear clothing appropriate to American gentlemen of the period rather than classical drapery.[30]

Still other strands of continuity persisted from the 1820s through midcentury. James Fenimore Cooper's *Pioneers* (1823), which long enjoyed considerable appeal, describes the social life of a village called Templeton. Using cyclical movement during the course of a single year, Cooper begins in 1793 with winter and the Christmas season, following very much in the European pattern, and continues on through spring and summer. He called it a "descriptive tale" and included genre scenes from everyday life, such as the making of maple sugar during the transition from winter to spring. Chapter 1 opens with an epigram from Thomson:

> See, Winter comes, to rule the varied year
> Sullen and sad, with all his rising train;
> Vapors, and clouds, and storms—

Chapter 27 begins with yet another epigram from Thomson, this time having to do with river flooding. American readers would have responded knowingly to these references, as did the British.[31]

Casual yet increasingly muted or even unflattering references to Thomson continued to appear well into the 1850s. Asher B. Durand, the prominent American landscape painter, was referred to in 1852 as a "Thomson on canvas— always soothing, never inspiring, sure to please, equally sure not to surprise." *The Crayon*, a prominent journal of art and literature in which Durand had a major hand, simply noted in an early issue that "Mr. Wordsworth dates the dawn of the modern era in Poetry from the appearance of the 'Seasons,' which were first published in 1726." Casual and rather noncommittal or neutral references to Thomson's views about the contemplation of nature continued to appear during *The Crayon*'s six-year life span.[32]

Natural Theodicies and the Compatibility of Divine Purpose with Science

In order to understand why, at midcentury, the weight of American opinion began to shift away from admiration for Thomson, we need to look back at the relatively sparse amount of American literary effort concerned with the seasons prior to that time. The earliest such work had been composed by Mistress Anne Bradstreet, an English-born Puritan who emigrated early to the Massachusetts

Bay Colony and composed "The Four Seasons of the Year," a poem of 260 lines, during the 1640s. It is gracefully written albeit rather conventional, and sustains a predictable parallel between the seasonal sequence and the human life cycle. There are, to be sure, some engaging touches, as when in her "Autumn" she affirms the consumption of wine—though in moderation.

> The vintage now is ripe, the grapes are pressed,
> Whose lively liquor oft is cursed and blest;
> For nought so good, but it may be abused,
> But it's a precious juice when well it's used.[33]

There is little else to mention until just after independence when America's most prominent poet of the time, Philip Freneau, wrote five stanzas titled "The Seasons Moralized," quite possibly a commentary on Thomson. Once again the seasons become a metaphor for the human life cycle.

> They who to warmer regions run,
> May bless the favour of the sun,
> But seek in vain what charms us here,
> Life's picture, varying with the year.
>
> Spring, and her wanton train advance
> Like Youth to lead the festive dance,

FIGURE 34
Thomas Doughty, Spring Landscape *(ca. 1853–56), oil on canvas. The Metropolitan Museum of Art, Gift of George F. Shelton and Mrs. F. H. Markoe, in memory of their father, Theodore B. Shelton, 1917. (17.66).*

All her scenes are mirth and play,
And blushing blossoms own her sway.

The Summer next (those blossoms blown)
Brings on the fruits that spring has shown,
Thus men advance, impelled by time,
And Nature triumphs in her prime.

Then Autumn crowns the beauteous year,
The groves a sicklier aspect wear;
And mournful she (the lot of all)
Matures her fruits, to make them fall.

Clad in the vestments of a tomb,
Old age is only Winter's gloom—
Winter, alas! shall spring restore,
But youth returns to man no more.

Important here, and innovative, is the poet's explicit didacticism. Such moralizing would continue after Freneau but take on a different tone and varied colorations by the time of Emerson and Thoreau more than a generation later. Freneau had clearly read Thomson and reflects the remarkable vitality of his influence in the 1780s and even as late as 1809, the date of the revision of the poem that is quoted here. But the ways in which Freneau's moralism combined with a kind of pantheistic secularism anticipate the mainstream American treatment of the seasons after the mid-nineteenth century. Resurrection and rebirth are not emphasized by Freneau.[34] Nor do they figure in Washington Allston's rather affected thirty-four-page poem titled "The Sylphs of the Seasons, A Poet's Dream" (1813).

But they certainly were by a significant number of Americans during the 1830s and 1840s. Religious revivals flourished among evangelicals in those years; and a successful revival was commonly referred to as a "season of refreshing." When a new Presbyterian church was erected on Long Island in 1844 as a result of spasmodic revivals there, a local historian observed, "Under the present pastor, the years 1831 and 1842 have been distinguished as seasons of refreshing; and the congregation is probably in as prosperous circumstances, as at any previous period of its history." Among evangelicals the life cycle's parallel to the seasons received a new specificity because children were perceived as figures embarking on a religious journey that should lead them to spiritual wisdom. In the 1840s, moreover, an evangelical Christian in the United States would expect to grieve for a dead child "through a complete change of seasons."[35]

In 1831 an English Quaker named William Howitt (1792–1879) wrote *The Book of the Seasons; or The Calendar of Nature*, published simultaneously in London and in Philadelphia by the prominent printing firm of Carey and Lea. Al-

though Howitt's project was initially rejected by four of the principal publishers in London, it proved to be immensely popular and ran through no fewer than another six large editions in 1836, 1839, 1840, 1842, 1850, and 1856. Howitt was actually a chemist and druggist in Nottingham. More important, he seems to have been what contemporaries called a "Seeker," one who quests for religious experience and undergoes a kind of purification odyssey. By the 1850s and 1860s he had become a Spiritualist. The title of his project is a bit misleading, and the work is in several respects a "throwback" because it is organized by the months despite its seasonal emphasis and concerns. It is a deeply religious enterprise written by a man impassioned by his love and concern for nature. Americans liked to make the book a gift for their spouses and sweethearts. It clearly enjoyed a significant impact on both sides of the Atlantic.[36]

The Reverend Henry Duncan (1774–1846), a Church of Scotland clergyman who ministered at Ruthwell in Dumfriesshire from 1798 until his death, was an entrepreneurial character who published cheap popular tracts and instituted savings banks in his locale. While he sided with the evangelical wing of his church, he combined his extensive knowledge of literature and natural history to complete a four-volume work called *Sacred Philosophy of the Seasons; Illustrating the Perfections of God in the Phenomena of the Year*, published in Britain in 1836. F. W. P. Greenwood prepared an American edition that appeared in Boston in 1839 with some cuts, adaptations, interpolated observations, and illustrations intended to make it more appropriate and attractive to readers in New England. By 1842 its availability was being advertised by a bookseller in the village of Ithaca, New York, indicating that it enjoyed a fairly broad geographical distribution.[37]

At the very outset Duncan declared that no work concerned with "Natural Theology" had ever been devoted to the seasons. In volume 3 he proclaimed that a valid analogy existed between the world of Nature and the world of Grace; and in volume 4 he insisted that the progress of mankind ("society") sprang from differences among the seasons or climate—a distinction made rather blithely, although it is unquestionably true that climate does much to determine characteristic qualities of the seasons. Duncan had a particular interest in the details of "progress" by which society arrived at its "present state of improvement." He deliberately devoted volume 1 to *Winter* for customary Christian reasons (a season of potential rebirth and "gestation" rather than one of irrevocable death); he then identified spring with reproduction and summer with growth and, somewhat unusually, with "the manhood of the year" (more often attributed to autumn). He quoted from Thomson's concluding hymn in *The Seasons* (and also alluded to Musidora) without feeling any need to mention Thomson by name. He simply assumed that every reader would recognize the reference.[38]

What seems most significant, once again, is that in his introduction to each

volume the thorough and painstaking American editor commented on differences between the seasons in Britain and the United States that had either necessitated adjustments or else required the reader to be alert for asymmetrical developments. Winter and spring both begin earlier in Great Britain. Ultimately, however, those adjustments pertain to particulars. The editor was fundamentally in sympathy with Duncan's declarations that God determines the seasons and everything related to them because of His "beneficent design." God is clearly not understood as some sort of clockmaker who created the world and then sat back to watch, or who simply left it to its own devices: "The natural operations which are silently proceeding around us, are the work of a present Deity, and a reflection of his attributes."[39]

In 1845 Edward Hitchcock, president of Amherst College and professor of natural theology and geology there, delivered a lecture called "The Coronation of Winter," which was later published as the fourth and final chapter of *Religious Lectures on Peculiar Phenomena in the Four Seasons*. Finding it extremely well received, he added three more lectures in 1847, 1848, and 1849, completing the cycle with the inclusive volume appearing at Amherst in 1850. Although these lectures seem a logical extension and culmination of Henry Duncan's more compendious and also more Linnaean (because of their obsession with enumerating and categorizing) volumes, they seem to have been the last of their breed, so to speak. Other naturalists during the second half of the nineteenth century might be Christian believers, but never again would anyone elaborate a seasonal case that "by bringing before the imagination the most brilliant objects of the natural world, we get some faint conception of its magnificence; or rather, we learn that the most splendid scenes of earth are only faint emblems of the New Jerusalem and the Glory of God which forms its light." For Hitchcock, plants arose from the earth at "Divine Command."[40]

In discussing "The Euthanasia of Autumn," he acknowledged the customary analogy between the human life cycle and the seasons but stressed the ephemeral quality of human existence. Rather than lauding autumn's natural beauty, he stressed its "shriveled and decaying aspect." When describing an ice storm that apparently occurred on January 17, 1845, he perceived a "sea of glass" and a fairyland but then added that "a more Christian designation would be, a celestial land." Because Hitchcock devoted considerable discussion to atmospheric changes, it is clear that meteorology figured prominently in his fusion of natural and theological phenomena. He also made reference to the "journey of life," indicating his familiarity with Thomas Cole's famous set of four large paintings called *The Voyage of Life* (1839–40), so remarkably popular that Cole created a second, almost identical series in 1842. Numerous engravings of the suite were published soon after Cole's death in 1848. Cole was also an evangelical Christian, and his notable set has a very strong seasonal aspect.[41]

In 1849–50, exactly when Hitchcock was compiling his lecture series and seeing it through publication, a skilled Pennsylvania artist named John F. Francis was painting a strikingly handsome set of tabletop still lifes representing the four seasons. His symbols for spring are raspberries and cream, ready for the palate, with all essential implements at hand (figure 35). For summer there is an abundance of melons, peaches, and pears; for autumn, an upturned basket offering an appealing array of apples and chestnuts; and for winter, a warming display of champagne in three well-filled flutes, with cheese, biscuits, and a bottle of cognac (plate 11). Where and how this highly mobile portrait painter acquired the skills to create such a stunning series is not clear. We do know that his wife was English-born and that they lived in Philadelphia for periods of time when he may have had contact with such prominent American artists as Thomas Sully and the sons of Charles Willson Peale.[42] But we have no assurance. What matters most, however, is that these elegant images are rather European in their style and subject matter. They bring to mind, for example, still lifes painted by Chardin, and give barely a hint of the dominant trend that would soon emerge in American art of the four seasons: namely, landscape painting.

If the iconographic destiny of seasonal art in the United States did not lie with the likes of John F. Francis, then where and with whom did it wait? The answer would not be fully apparent until the 1850s and beyond. During the first half of the nineteenth century, conquering the landscape and achieving successful cultivation of the best crops in optimal places, assisted perhaps by scientific agriculture (disseminated in journals that proliferated for farmers by the 1830s and 1840s), were dominant priorities. By midcentury, although people living in the Northeast could not yet expect a full variety of foods throughout the year, they no longer anticipated seasonal scarcity, and their perception of their yearly diet was not haunted by anxiety about securing sufficient supplies. Although notable progress had been made during the preceding century, American pastoralism, the unreserved appreciation of nature in its serenely pristine state, would have to wait—at least in the eyes of most. The prime desiderata aimed at achieving mastery over the land in order to maximize agricultural production.[43]

That, for Americans, nature needed to be tamed and controlled explains the relative paucity of seasonal writing between Freneau and Thoreau, and the relatively modest amount of seasonal art prior to 1855, except for illustrations that appeared in the many and varied editions of Thomson. Only when agricultural mechanization began to take hold and make a discernible difference during the 1850s and 1860s did some Americans, especially in the East, begin to feel wistful, nostalgic, or moralistic about the enchanting nature and glories (rather than the challenges) of seasonal change.

What, then, appeared in the arts of a seasonal nature prior to 1855? A great many of Edward Hicks's versions of *The Peaceable Kingdom* and of *Penn's Treaty with the Indians* actually highlight autumnal foliage and other signs of seasonal change. Occasional paintings and prints of individual seasons appeared. Someone from the school of sculptor William Rush in Philadelphia carved from pine a large bust of *Winter* (ca. 1825) wrapped in an American flag, all polychromed. Much more important, however, an English-born painter named George Harvey, who emigrated to the United States in 1820 and settled in Hastings-on-Hudson, painted an attractive set of North American four seasons, in which he tried to render the quality of light characteristic of different seasons of the year and also times of the day. For those reasons he called the set "Atmospherical Landscapes." In 1841 William Bennett, a New York City printmaker, engraved aquatints of the paintings and published them under the title *Harvey's Scenes of the Primitive Forest of America, at the Four Seasons of the Year*. The landscape for spring is called "Burning Fallen Trees in a Girdled Clearing, Western Scene" (figure 36), and that for summer depicts "A Road Accident. A Glimpse Thro' an

FIGURE 36

George Harvey, Burning Fallen Trees in a Girdled Clearing, Western Scene *[Spring], (1841),
engraved aquatint from Harvey and William James Bennett,* Harvey's Scenes of the Primitive
Forest of America *(1841). Division of Prints and Photographs, Library of Congress.*

FIGURES
37–40
Frances F.
Palmer for
Currier
and Ives,
American
Country Life
(1855), toned
lithographs.
Amon Carter
Museum,
Fort Worth,
Texas.

FIGURE 37
May
Morning.

Opening of the Primitive Forest, Thornville, Ohio" (plate 10). The autumn scene, with attractive colored leaves, shows "Gigantic Sycamores. Owl Creek, Ohio." And finally the winter image presents "Impeded Travelers in a Pine Forest, Upper Canada [i.e., Ontario]." Obviously, the landscape was still perceived as a source of problems and obstacles as late as the 1840s.[44]

An interesting case has been made that storms and summer harvest scenes emerged as the dominant images of nature in mid-nineteenth century American landscape painting. Jasper Cropsey, who later became the most prolific creator of four seasons landscapes, painted *American Harvesting* (1850 or 1851), which was engraved for members of the American Art-Union in 1851 and replicated by Cropsey in oil in 1864. Asher B. Durand offered *First Harvest in the Wilderness* (1855) and Jerome Thompson, *The Haymakers: Mount Mansfield, Vermont* (1859). These artists seem to have been strongly influenced by a series of books on closely related themes that appeared in the preceding decade, such as Charles Lanman's *Essays for Summer Hours* (1841; third edition, 1853); Margaret Fuller's *Summer on the Lakes in 1843* (1844); and George William Curtis's *Lotus-Eating: A Summer Book* (1852).[45]

AMERICAN COUNTRY LIFE.
May Morning

In 1855 Currier and Ives produced the first of their many four seasons sets—this one called *American Country Life* (figures 37–40)—which enjoyed wide appeal and were reprinted numerous times. That same year George Henry Durrie painted at least three of the seasons: *Winter* (plate 12), *Spring*, and *Autumn*. And at just about this time Alfred Jacob Miller made a series of watercolors on paper. Titled *Snake Hill*, presumably after the locale of that name in New Jersey, *Summer* shows an indigo blue hill with very white clouds above it; *Autumn* has drying hay with small fir trees in the lower left corner; and *Winter* presents blowing snow, snow clouds, and dried hay covered with snow. The topographical view of Snake Hill remains constant throughout, and there are birds in the sky in all four scenes.[46]

Between 1845 and 1855 figured glass flasks, most likely made to hold liquors, were produced in New Jersey. Bearing seasonal motifs, one had leafless trees in raised relief with "WINTER" forming an arc over the tree and another had a tree with full foliage accompanied by "SUMMER." Most of them are colored aquamarine, but some are deep amber. The production of these flasks may well have continued into the 1870s.[47]

FIGURE 38
Summer's
Evening.

AMERICAN COUNTRY LIFE.
Summers evening

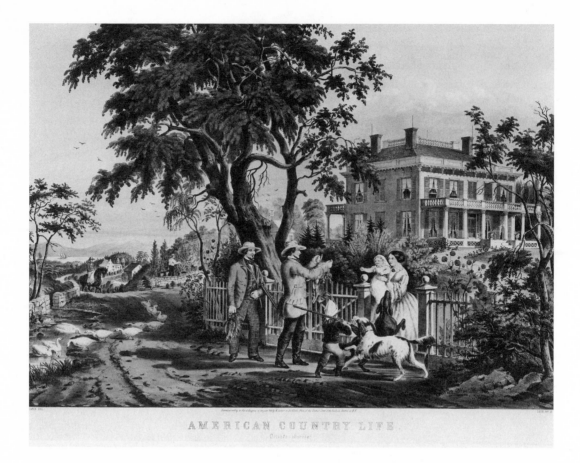

AMERICAN COUNTRY LIFE

Americanization of the Motif: Rejecting Thomson and European Vistas

To the extent that Americans of the mid-nineteenth century were intrigued by storm scenes and by summer haying in their landscapes, it might appear that they were still in accord with James Thomson. But a pronounced shift in sentiment about their native scenery and their own distinctive seasons became evident by the early 1850s and started a striking departure in representations of the seasons and feelings about them. This dramatic transformation was actually anticipated by Timothy Dwight, an articulate clergyman who also became known as one of the "Connecticut Wits." In 1778 or 1779 he read the "Autumn" section of *The Seasons* and observed that Thomson "had entirely omitted" what to a New Englander was "often among the most splendid beauties of nature." Dwight seems to have been one of the first Americans to celebrate the superiority of fall foliage in the United States. Many years later, when Dwight finally published his four volumes of *Travels*, he elaborated upon that observation in a manner that foretold the growth of American chauvinism on the subject a generation later.

(above)
FIGURE 39
October
Afternoon.

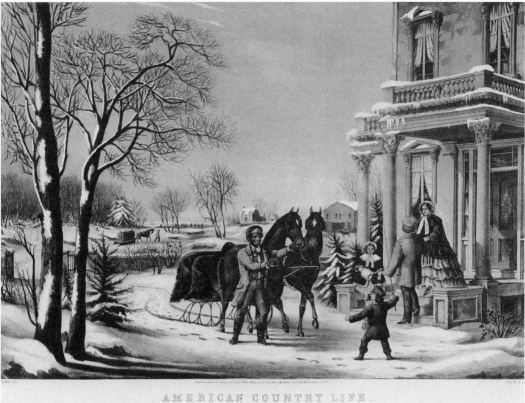

AMERICAN COUNTRY LIFE.
Pleasures of Winter

Of the effects of this change it is perhaps impossible for an inhabitant of Great Britain, as I have been assured by several foreigners, to form an adequate conception without visiting an American forest. When I was a youth, I remarked that Thomson had entirely omitted in his Seasons this fine part of autumnal imagery. Upon inquiring of an English gentleman the probable cause of the omission, he informed me that no such scenery existed in Great Britain. In this country it is often among the most splendid beauties of nature. All the leaves of trees which are not evergreens are by the first severe frost changed from their verdure toward the perfection of that color which they are capable of ultimately assuming, through yellow, orange, and red to a pretty deep brown.[48]

In 1794, when Dwight published his well-received long poem, "Greenfield Hill" (mostly written in 1787, actually), his "Prospect" praised the distinctiveness of nature in the New World and admonished readers: "Look not to Europe." Stressing the healthfulness and fruitfulness of the American seasons, he wrote his way through the entire cycle, starting with spring and ultimately re-

FIGURE 40
Pleasures of
Winter.

turning to it following a "Recollection of the Winter" and "The Pleasures of Winter." When Thoreau wrote "A Winter Walk" in 1843, he too would reject the customary European emphasis upon the harshness of winter.[49] More often than not, American visions of winter would invoke calm rather than calamity.

That attitude gradually became a distinctive aspect of seasonal writing in the United States. Late in 1836 a lengthy essay appeared on page one of the *Ithaca Herald*. Titled "Reflections on the Change of Seasons," its author ("Clericus") rejected the classical notion of a golden age of perpetual spring (plate 5) and called attention to "that insatiable demand of new gratifications, which seems particularly to characterize the nature of man." In his fourth paragraph he launched into this panegyric: "Every season has its particular power of striking the mind. The nakedness and asperity of wintery nature always fills the beholder with pensive and profound astonishment; as the variety of the scene is lessened, its grandeur is increased, and the mind is swelled at once by the mingled ideas of the present and the past, of the beauties which have vanished from the eyes, and the waste and desolation which are now before them." He then touched upon another, related theme that would also be elaborated upon by many American writers a generation later: namely, that winter concentrates the mind and consequently is a better time for serious thinking and creativity than spring and summer, which are more sensuous but less cerebral seasons. In October 1851 Thoreau entered this observation in his journal: "The alert and energetic man leads a more intellectual life in winter than in summer. In summer the animal and vegetable in him are perfected as in a torrid zone—he lives in his senses mainly—In winter cold reason & not warm passion has her sway—he lives in thought and reflection—He lives a more spiritual and less sensual life." In 1870 James Russell Lowell wrote a long essay, "A Good Word for Winter," in which he embellished that notion in considerable detail.[50]

Lowell's widely noticed essay gave a rather snide assessment of Thomson, calling him "turgid, no good metrist, and his English is like a translation from one of those poets who wrote in Latin after it was dead; but he was a man of sincere genius. . . . He was the inventor of cheap amusement for the million, to be had of All-out-doors for the asking." Thoreau, who had read Thomson on several occasions, certainly shared that poet's emphasis upon the importance of "retirement and solitude." But when Thoreau wrote "Autumnal Tints" in the mid-1840s (quite possibly while living at Walden Pond), he began the essay by attacking Thomson for his limited appreciation of just how sensational fall foliage can be: "What is the late greenness of the English elm, like a cucumber out of season, which does not know when to have done, compared with the early and golden maturity of the American tree?" Thoreau actually opens with an encomium for American exceptionalism in terms of seasonal change. "Europeans coming to America are surprised by the brilliancy of our autumnal foliage. There is no account of such a phenomenon in English poetry, because the trees

acquire but few bright colors there." After singling out Thomson for his inadequacy, however, he acknowledged that "the autumnal change of our woods has not made a deep impression on our own literature yet. October has hardly tinged our poetry."[51]

In June of 1853 Thoreau made a revealing entry in his journal. Following lavish praise for the evening song of the woodthrush, and scorn for men who laud the thrasher and other birds, he asserted that "there is as great an interval between the thrasher and the wood-thrush as between Thompson's [sic] 'Seasons' and Homer." Five years later Thoreau took aim at Thomson for presuming in "Summer" to know about remote places he had never seen: "With the utmost industry we cannot expect to know well an area more than six miles square; and yet we [meaning Thomson] pretend to be travelers, to be acquainted with Siberia and Africa."[52]

Early in 1852 Thoreau recorded an observation that, in its essence, recurred with increasing frequency in his journals during the decade that followed: "In few countries do they enjoy so fine a contrast of summer and winter. We really have four seasons, each incredible to the other. Winter cannot be mistaken for summer here." By 1859, having read some of his fellow naturalists, but especially literati who had been to Europe, he lamented that "American scholars, having little or no roots in the soil, commonly strive with all their might to confine themselves to the imported symbols alone." When an English source made a comment comparable to Thoreau's, it was likely to be picked up and reprinted in the American press. Jasper Cropsey's spectacular painting *Autumn on the Hudson* (1860), for example, was first exhibited in London and elicited this generous observation from a reviewer there: "They who know the aspect of Nature in the autumn in England only, have no notion of the glorious garb she elswhere [sic] puts on at that time. In America, the woods are all ablaze." The comment would promptly be quoted in *The Crayon* in May 1860.[53]

The growing divergence between American perceptions of the seasons and James Thomson's involved more than climate zones, meteorology, and native plants and trees. Thomson had responded with considerable frequency to seasonal changes in cultivated gardens, however expansive they might have been, and therefore to landscapes meticulously managed by man as well as historically by the painter's equally controlled eye (such as Claude Lorrain's and Salvator Rosa's), whereas American writers and artists were responding with such enthusiasm to what they liked to regard as "wild" nature. In 1743 Thomson made his first visit to Hagley Park, the estate of his friend and patron, Lord Lyttelton. It was there in 1744 that Thomson enlarged and made his most important revisions to *The Seasons*. The park figures directly, for example, in one of the major expansions of Thomson's text ("Spring," lines 904–62). Yet another addition concerned a landscape garden, Lord Cobham's Stowe, that was added to the text of "Autumn" (lines 1037–81). Thomson imagined himself walking

and talking with the Elder Pitt among the gardens there. Looking at William Kent's illustrations for the first quarto edition of *The Seasons* (1730), the domed building that he designed for "Autumn" roughly resembles Lord Burlington's Palladian villa at Chiswick.[54]

In 1746 Thomson and Lyttelton visited William Shenstone's garden at The Leasowes, where they passed through "Virgil's Grove." By that time, finalizing his poem, Thomson had become a connoisseur of the finer points of garden art. Finding the schematized character of a garden useful to him as a contemplative poet, he celebrated the "goodly prospect" that greeted him at Richmond Hill. In fact, the entire Thames Valley seemed to become for him one highly expansive landscape garden. Thomson even revealed his historical knowledge of English landscaping through his citation of James Harrington's retreat, Petersham Lodge, where the "pendant woods" were part of one of the very earliest landscape gardens. Ultimately, the special appeal of a garden for Thomson lay in its "Order in variety," which is a phrase that few nineteenth-century Americans would have used.[55]

American artists and illustrators who visualized Thomson's sad tale of Celadon and Amelia did not depict it merely as a tragic walk in the woods. They placed it in a wild, totally untamed setting (figure 26), more like George Harvey's seasonal scenes from 1835–41, which take place in forests. By the time Samuel Lancaster Gerry painted his four seasons landscapes in the 1860s and Jasper Cropsey did his between 1859 and 1883, however, what appears are neither gardens on aristocratic estates nor untamed and awesome forests but rather scenic views of beautiful valleys and wooded areas, infrequently under cultivation. A vision of unsullied nature revealing the absolute perfection of each season. Note the locations of Cropsey's 1879 suite (plates 14–17): *Spring*, Todt or Grymes Hill, Staten Island; *Summer*, the Hudson Valley, near Piermont, New York; *Autumn*, the Ramapo River, New York; and *Winter*, perhaps the Warwick Valley, New York.[56]

Another distinction that must be kept in mind when comparing European and American art of the four seasons is how they dealt with matters of social class. In Old World seasonal art, of the early modern period especially, but continuing well past the eighteenth century (because traditions die hard), the intermingled presence of affluent people and peasants, with no ambiguity about who is in charge, must have been very satisfying to the aristocracy and bourgeoisie. It visibly affirmed their wealth and social power. There is nothing quite comparable to those figures and socioeconomic relationships in American art of the seasons. In fact, it is often devoid of people, or else those that do appear are fairly diminutive. The glories of nature and the landscape itself are what matters most. That pattern would *begin* to be modified in seasonal art by Grant Wood and Thomas Hart Benton during the 1930s, especially in their prints dating from 1937–39; and by the 1960s people started to appear in seasonal art by

Peter Blume, Paul Cadmus, and others. But as late as 1974, turning to literary representations, in Annie Dillard's *Pilgrim at Tinker Creek*, the reader is confronted with a microcosmic universe where barely any human beings seem to be present.

Seasonal Art and Literature: Divergent Tensions

As art historian Angela Miller has astutely observed, Americans referred to their country with warm regard as a "great book of Nature." By extension, Miller continues, "art was a form of scriptural commentary on nature's book." Articulate painters like Asher B. Durand viewed nature and its reproduction on canvas or paper, or in stone, as a series of visual texts to be read, appreciated with awe, and understood. Some of the nation's seminal and leading naturalists, however, insisted that art rarely, if ever, could improve upon or surpass nature. Henry Thoreau declared repeatedly that nature would inevitably "prevail" over art. In praising the great drama of winter sunsets, for example, he insisted that art could neither reproduce nor compete with the real thing.[57] He did not seem to envision that an artist might have objectives that transcended the mere replication of nature, such as rendering meanings and perceptions *about* nature, or enhancing our appreciation of it by focusing the viewer's eye upon particular effects of atmosphere and light. Because Thoreau did not feel the need for any special assistance in contemplating the world, he sometimes assumed that no one else did either.

Writers and artists diverged in various ways in viewing and re-creating seasonal effects and changes. Around 1860, for example, an obscure American painter named Kost produced an attractive (if overly symmetrical) still life titled *Fruit of the Seasons* (figure 41). The mix of sheer quantity and variety is a bit much; but it must have pleased the artist, who clearly wanted to make a statement about American abundance. Compare Kost's "naïve" picture, however, with Thoreau's journal entry for October 21, 1855: "I have never liked to have many rich fruits ripening at the same season." The stark contrast is not simply between Kost and Thoreau, but between Thoreau and so many other artists (including John Francis) who also became excessive in displaying large amounts and varieties of fruit as symbols of summer and autumn. We must never lose sight of the fact that Thoreau was the advocate of "Economy" and simplicity.[58] One can imagine how he would have reacted to the masses of flowers and petals painted by Severin Roesen (1815–71). Following in the tradition of Van Huysum (plate 6), Roesen, who emigrated to the United States from Germany in 1848, liked to show an extravagant diversity of flowers, all in full bloom at once despite their differing seasonal growth cycles. Thoreau surely would have said something along the lines of: "Let each season offer its own distinctive display. Don't force matters, never mind forcing flowers."

Wilson Flagg (1805–84), a New England naturalist and Thoreau's contemporary, was best known as a remarkable botanist and ornithologist who wrote many essays and books devoted to seasonal qualities and changes. His descriptions of the phases of the year, first printed in the *Boston Weekly Magazine* in 1839–40, were reprinted in the *Salem Gazette* and subsequently gathered into book form in 1857. There is an intriguing sequence where he does something that no visual artist can do, and that Thoreau infrequently did: namely, record what he called "sounds from inanimate nature."

Each season of the year has its peculiar melodies, besides those proceeding from the animated creation. In the opening of the year, when the leaves are tender and pliable, there is a mellowness in the sound of the breezes, as if they felt the voluptuous influence of spring. Nature then softens all the sounds from inanimate things, as if to avoid making any harsh discords with the anthem that issues from the streams and woodlands, vocal with the songs of millions of happy creatures. The echoes also repeat less distinctly the multitudinous notes of birds, insects, and other creeping things.

Flagg sustained his symphony of seasonal sounds through the entire year, concluding with the waning of winter.

But when the sun gains a few more degrees in his meridian height, and the snow begins to disappear under the fervor of his beams, then do the sounds from the dropping eaves, and the clash of falling icicles from the boughs of the orchard trees, afford a pleasant sensation of the grateful change which

has already commenced; and the utterance of these vernal promises suddenly awakens all the delightful anticipation of birds and flowers. The moaning of the winds has been plainly softened by the changes of the season, and the summer zephyrs that occasionally pay us a short visit from the south, and signalize their coming by the crimsoned dews at sunrise, let loose a thousand rills that make a lively babbling music, as they leap down the hillside into the valleys.[59]

What makes these passages intriguing is not merely the fluid grace of Flagg's language, but the sheer artistry. He has created an *audible* picture with words, thereby supporting the claim made by several nineteenth-century naturalists, including Thoreau, that they could paint better in prose than many artists did with their brushes.

One of Flagg's contemporaries, Henry Carmer Wetmore, wrote a peculiar novel (under the pseudonym Harry Penciller) titled *Rural Life in America; or, Summer and Winter in the Country* (1855), set in eastern Pennsylvania. One leitmotif that permeates the book is a curious obsession with death, curious because the author's message is not entirely clear. At one point Wetmore seems to be saying that the *year* may be mortal but not nature itself—nor, perhaps, good Christians: "The road keeps the river bank for a mile or two and then enters the woods. How beautiful are the cedars and hemlocks, clothed as in winding sheets! Now and then a limb bursts through its shroud, emerging, as it were, into life again, and seeming to say—" 'Oh year! we are immortal, we die not with thee.'" Later, however, when the author contemplates the mutability of life and friendship, we encounter a passage that is less hopeful: "The lapse of three years makes sad changes, not only over all the world, but in the little sphere immediately around us. The seasons, with their attributes of fruits and flowers, sunshine and snows, have gone their accustomed round: friends with whom we were familiar, the loving and the loved, have passed away: some like the fragile flowers of spring—others like old forest trees, sapless, and broken by the weight of years."[60]

We know that a "culture of death" emerged during the 1840s, stimulated in part by the rural cemetery movement, and that it persisted through the era of the American Civil War.[61] Rural cemeteries were compatible with widely shared beliefs and rituals associated at that time with seasonal change and the human life cycle—the notion prevalent among evangelicals, especially, that life springs up again from death, as plants do from the soil in the cycle of the seasons. The New York State census for 1855 included a very large and carefully tabulated page devoted to "Deaths Classified by Months and Seasons." The figures are given for every county. The aggregate totals indicate that the greatest number of deaths occurred in summer and the fewest in winter. When the Reverend T. H. Stockton offered his prayer at the dedication of the Gettysburg Cemetery

on November 19, 1863, he compared the death of heroes to the certainty of seasonal renewal: "As the trees are not dead, though their foliage is gone, so our heroes are not dead, though their forms have fallen."[62]

Within a year after the Civil War ended, mid- to late spring became the chosen season for commemorations of those who had died during the conflict. The season of nature's rebirth and the resurrection of Christ would be the logical, "natural" season in which memories of the dead might contribute to the "resurrection" of the nation. Throughout the United States it became the custom to dedicate monuments on or close to Memorial Day. By then, flowers were abundantly available for wreaths and placement by gravesites. Spring could be a season of ritualized wistfulness as well as joy.[63]

The Four Seasons in Native American Culture

Our understanding of seasonal symbols and meanings in Native American culture is much less developed than it ought to be, but we do know that elements of animism and what might be termed pantheism (for lack of a better word in this case) historically played an important part in Indian folklore, culture, and spiritual customs.[64] What is certain is that, even from earliest times, Indian life was profoundly affected by seasonal changes, as one would expect, and that Native Americans responded accordingly but with significant tribal variations and even with different names for the seasons as well as the months in, say, southern and northern New England. As historian William Cronon has observed, "Just as a fox's summer diet of fruit and insects shifts to rodents and birds during the winter, so too did the New England Indians seek to obtain their food wherever it was seasonally most concentrated. They learned to exploit the seasonal diversity of their environment by practicing mobility. As one early European visitor observed: 'They move . . . from one place to another according to the richness of the site and the season.'"[65] The phrase "Indian summer" may have its origin in references to the Native American practice of leaving village communities in late autumn for winter locations that would be more favorable, especially for hunting.

Cronon has given us the most specific account of seasonal survival by the New England Indians during the colonial period.

Bird migrations made their biggest contribution to Indian food supplies in April, May, September, and October, when Canada geese, brants, mourning doves, and miscellaneous ducks passed through; other birds albeit in few numbers could be caught during the summer as well. By July and August, strawberries, raspberries, and blueberries were ripening, providing food not only for Indians but for flocks of passenger pigeons and other birds which nested in the area. In addition to birds, various coastal mammals—whales,

porpoises, walruses, and seals—were hunted and eaten. Nuts, berries, and other wild plants were gathered as they became available. In all ways, the summer was a time of plenty.

Things changed in September. Toward the middle of the month, Indian populations moved inland to the smaller creeks, where eels could be caught as they returned from their spawning in the sea. From October through March, villages broke into small family bands that subsisted on beaver, caribou, moose, deer, and bear. Men were responsible for killing these animals, while women maintained the campsite and did all hauling and processing of the slaughtered meat. If snows were heavy and animals could be easily tracked, hunting provided an adequate food supply; if the snow failed to stay on the ground, on the other hand, it was easy to starve. Northern Indians accepted as a matter of course that the months of February and March, when the animals they hunted were lean and relatively scarce, would be times of little food.[66]

How the Indians of North America identified, measured, and recorded seasonal change varied considerably from one region of the country to another. In 1903 Mary Austin wrote of the Paiute "calendar system" in the Southwest: "They have no stamp of heathen gods nor great ones, nor any succession of moons as have red men of the East and North, but count forward and back by the progress of the seasons; the time of the 'taboose,' before the trout begin to leap, the end of the piñon harvest, about the beginning of deep snows. So they get nearer the sense of the seasons, which runs early or late according as the rains are forward or delayed." The Paiute developed a connection for every craft and event with the season in which it occurred or appeared.[67]

At the Detroit Institute of Arts there is a remarkable "document," a Yankton Sioux "winter count" completed around 1910–12, with cotton cloth, ink, and pigment. A winter count is a calendared history in pictorial form. Every summer, actually, the "count keeper," in consultation with his community, selected a single prominent event that epitomized the entire year and depicted it on a buffalo hide or, later, on a piece of muslin. The resulting "calendar," serving as the annals of the community, functioned as an aid to tribal memory. This particular "winter count" spans at least two generations of history concerning the Upper Yanktonai. Beginning in the lower right corner and moving counterclockwise in a spiral fashion, each image corresponds to one year between 1823 and 1911. Written captions giving the title for each entry were probably added sometime after 1877 during the reservation period when transliterations of Nakota words were standardized.[68]

Returning to seasonal rituals in southwestern cultures, in 1915 the pioneering anthropologist Elsie Clews Parsons was allowed to witness the winter solstice celebrations of the Zuni. She described two major Kachina dance se-

FIGURE 42
*Susan
Fenimore
Cooper
(mid-1850s),
photograph by
W. G. Smith.
Courtesy of
Hugh C.
MacDougall
and the James
Fenimore
Cooper
Society.*

quences dramatized by the Zuni, spectacular dances that celebrated the winter and summer solstices in February and September.[69]

Mabel Dodge Luhan's *Winter in Taos*, easily her finest book, was inspired by her perception of ritualized life cycle observances at the Taos Pueblo. Her narrative, structured according to the seasons, also progresses from morning to evening of one winter day, interweaving memories of her life during other seasons in Taos. She recalls autumn, for example, when her mother visited; or the main road obscured by dead leaves in summer; and her yearning for spring, when D. H. Lawrence and his wife, Frieda, will return. In fact she repeatedly revels in the coming of spring to Taos, refers to the "melancholy of spring" but later glories in the vital beauty of early spring. Because building her house became such an important, ongoing preoccupation, she discusses the variable functions of thick adobe walls in different seasons. Similarly, she is enchanted by the changing appearance of the Sacred Mountain "all through the seasons"; and she is equally intrigued by seasons at their peak and by transitions from one to the next.[70]

In the Taos Pueblo Church of St. Jerome, statues of the Virgin Mary and her "friends" (local *santos*, as it were) stand prominently on the altarpiece, highly visible as one enters the church. Their attire is changed seasonally by the congregation: green in spring, pink in summer, yellow in autumn, and white in winter.[71]

Finally, a text written in the 1980s by Anthony Dorame, a member of the Tesuque Pueblo in New Mexico, says much about seasonality for Native Americans. It is inscribed on a plaque in the Museum of Native American Arts in Santa Fe: "Cycles are circles that travel in straight lines. The seasons come in cycles, yet each season marks the passage of another year. We receive our names, plant, harvest, marry, dance, sing, and are buried in concert with the cycles."

At the midpoint of the nineteenth century, rural Americans—the majority of Americans at that time—still lived according to the cycle of the seasons, despite the fact that increasing numbers of households enjoyed a far more varied diet throughout most of the year because of more careful planning than half a century earlier. Anxiety about scarcity in late winter and early spring had greatly diminished, and people looked forward eagerly to the appearance of new foods in each season.[72] Nevertheless, at midcentury large numbers of urban dwellers

continued to resonate to the same seasonal rituals and symbols as those living in the rest of the country. On January 1, 1849, for example, the newspaper carriers who hawked and delivered *The Sun* in New York City brought along to their patrons an oversized supplementary sheet titled "New Year's Address by the Carriers of The Sun." In the center there is a lengthy poem filled with chauvinistic proclamations of the nation's distinctive destiny. Surrounding that text there are bold woodcuts that intermingle urban sites, ranging from the Park Fountain and City Hall to the "Sun Establishment and Printing Vault," with scenes of the four seasons that are utterly rustic and look like fugitive illustrations from *The Seasons*: spring plowing with a bit of social mixing on the side, summer harvesting and dairying in a bucolic setting, people of all ages gathering fruit and grain in autumn, and feeding livestock on a snow-covered farm for winter. City life and country life *could* be visualized as proximate rather than distant and discrete from one another, especially in the realm of popular culture.[73]

What cannot be overemphasized when considering the United States at midcentury is the intensity of national pride in the natural landscape, particularly when viewed through the prism of the seasons. As Susan Fenimore Cooper (figure 42) noted in her *Rural Hours* (1850): "Our native writers, as soon as we had writers of our own, pointed out very early both the sweetness of the Indian summer, and the magnificence of the autumnal changes." They demonstrated, she declared, "the precise extent of the difference between the relative beauty of autumn in Europe and in America: with us it is quite impossible to overlook these peculiar charms of the autumnal months," whereas in Europe "they remained unnoticed, unobserved, for ages." Henry David Thoreau echoed that sentiment in countless ways: "Our Indian summer, I am tempted to say, is the finest season of the year. Here has been such a day as I think Italy never sees."[74] These emerging perceptions of difference and impassioned views of distinctiveness are central to the ways in which Americans have blended nature, nationalism, and nostalgia in understanding the seasons.

CHAPTeR 3

NOSTALGIA, NATIONALISM, AND THE AMERICAN SEASONS, 1854–1914

During the second half of the nineteenth century, seasonal perceptions and sentiments were readily apparent in relation to major developments and concerns in American culture. The most important in terms of their long-range implications, even though not yet fully noticeable, were the lessening of seasonal differences in the daily lives of many people, particularly because of increasing urbanization and the gradual influence of physical improvements in housing, heating, and the distribution of food supplies. Henry David Thoreau astutely took note of these changes in his journal on February 5, 1854.

> The animal merely makes him a bed, which he warms with his body in a sheltered place. He does not make a house. But man, having discovered fire, warms a spacious apartment up to the same temperature with his body, and without robbing it, so that he can divest himself of cumbersome clothing— not keeping [to] his bed—maintain a kind of summer in the midst of winter, and, by means of windows, even admit the light. . . . Thus he goes a step or two beyond instinct and secures a little time for the fine arts.[1]

As the nation started to become less rural, traditional labors of the seasons impinged somewhat less upon the monthly and yearly routines of many Americans. The relentless urbanization (and suburbanization) of the United States during the twentieth century would notably accelerate the process of diminishing seasonal imperatives and their attendant manifestations for more and more people.

In response to the realization that certain irreversible social changes were altering American lives as well as familiar landscapes, nostalgia and romanticization emerged as prominent patterns in literature and art that were seasonal in character or emphasis. Moreover, such sentiments would be found throughout the entire culture, ranging from fine art to forgettable poetry to popular lithographs that were prized at the time even though they may now seem "sappy." National pride, often expressed as intense chauvinism, was also evident in

many different ways as writers and artists sought to proclaim the distinctively superior beauty of Mother Nature in North America, manifest in especially notable patterns when seasonal transitions took place. Toward the close of the century, when city life and consumerism became ever more prominent, people tended to "telescope" the seasons, which meant an inclination to begin blurring traditional seasonal differences and lines of demarcation. In addition, as holidays such as Easter, Thanksgiving, and Christmas started to undergo commercialization, they achieved a new and different kind of prominence on the annual calendar, thereby diminishing familiar notions of seasonal phasing. Their rhythms were less clearly defined in relation to customary agrarian work linked with seasonal demands. The shifts at this stage, however, were more subtle than stark.

If the four seasons were gradually being "flattened" in terms of human needs and activities, one still had to pay close attention in order to discern related symptoms of change in American culture. Perhaps the single most striking feature of seasonal art and literature during the second half of the nineteenth century was its resistance to change. Those who continued to use the traditional motifs, ranging from individuals who created cultural artifacts to those who promoted them (such as magazine editors or people who commissioned works of art), seemed to desire and deliberately emphasize the eternal seasonal verities rather than adapting them to changing circumstances. The latter development, with certain exceptions, would largely have to await the twentieth century. For the most part, where seasonal representations were concerned, it can truly be said that the more things changed, the more they remained the same. Victorian America was neither the time nor the place for intensive iconoclasm, seasonal or otherwise.

Seasonal Responses to Urbanization and Social Change at Midcentury

A closer look at particular developments during the 1850s confirms that artistic innovation did occur but within well-established traditions, reinforced by a degree of discomfort with change. That look might begin with a cluster of related yet rather different cultural "events" that took place in 1854–55. The first occurred in August 1854, when Henry David Thoreau (figure 3) published *Walden*. He had actually lived in the cabin he built at Walden Pond for two years and two months from 1845 through 1847. He then wrestled, on and off, for almost seven years with the problem of finding an optimal mode of presentation that would highlight the social and environmental messages that he hoped to disseminate. Finally, in 1852–53, he found a solution: compress his "narrative" to a single year spanning the cycle of the seasons from spring to spring. We get the clearest premonition of this breakthrough in a journal entry that he made in October 1853: "It is surprising how any reminiscence of a different season of the year affects

us. When I meet with any such in my journal, it affects me as poetry, and I appreciate that other season and that particular phenomenon more than at the time. The world so seen is all one spring, and full of beauty."[2]

Walden is so permeated with seasonal references, allusions, and connections to human feelings and behavior that it eventually became the most influential book about seasonality ever written by an American. Part of its inimitable genius, of course, is that it concerns many matters that transcend seasonality, such as self-reliance, simplicity, economy, friendship, solitude, the rhythms of human life in relation to the cycles of nature, and so forth. Every naturalist in the century and a half since *Walden* has felt obliged to pay obeisance to the master of this genre or, at the very least, come to terms with him and his texts. Consequently we encounter endless citations to such passages as this one, referring to his cabin and its carefully chosen site, which appears early in the chapter titled "Where I Lived and What I Lived For": "There I did live, for an hour, a summer and a winter life; saw how I could let the years run off, buffet the winter through, and see the spring come in." Three chapters later, in "Solitude," he voiced the refrain that became an inspiring maxim for every American naturalist who followed in Thoreau's footsteps as a seasonal writer: "While I enjoy the friendship of the seasons I trust that nothing can make life a burden to me."[3]

The length and breadth of Thoreau's legacy have been sufficiently notable that they deserve some notice here. In reviews of books by twentieth-century nature writers there are constant references to and comparisons with Thoreau. Often they will acknowledge that a later writer is the superior naturalist, yet notably lacking in some intangible way when compared with Thoreau, such as the possession of profound insight. Frequently the reviewer finds it difficult to pinpoint just what gives Thoreau his special place in the pantheon. After Henry Beston published *The Outermost House*, his four seasons book, in 1928, a review appeared in the *New York Herald Tribune* under the headline "A Walden of the Beach." When Donald Culross Peattie, another literary naturalist, published *An Almanac for Moderns* in 1935, he gladly devoted July 12 and 13 to Thoreau's birthday, designating him a poet rather than a man of science, but above all "the father of all American nature writers." When Edwin Way Teale published *North with the Spring* in 1951, Rachel Carson praised the book lavishly: "It establishes you in the direct line of Thoreau," she told him. After Leonard Hall published *A Year at Possum Trot Farm* in 1957, one reviewer called him "the Thoreau of the Ozark Mountains." And, indeed, Hall often touched base with Thoreau in his text. When Charles Seib published *The Woods* in 1971, he acknowledged at the outset that Thoreau had exerted the greatest influence upon his outlook. And when Maxine Kumin's *In Deep* appeared in 1987, she declared that Thoreau "has been my special mentor" and noted that she reread *Walden* every year or two. In an early poem she called him "my quotable friend."[4]

Although *Walden* would eventually become a canonical as well as pro-

foundly influential work, its immediate impact was modest, and its limited supply had been exhausted by 1862, the year the young author died. Quite a different reception met Currier and Ives's very first set of four seasons prints less than a year later. *American Country Life* (figures 37–40) achieved immediate and widespread appeal. The lithographs are carefully designed—in key respects the finest among the many seasonal sets that Currier and Ives published during the subsequent three decades—and the reasons for their swift success would seem to be numerous. First and most simply, the four seasons motif enjoyed one of its moments of peak popularity in the mid-1850s. Second, the images certainly *appear* to be distinctively American at a time of strident nationalism, despite numerous signs of cultural adaptation or direct borrowing from Europe. Note the architectural diversity of the homes featured in each print: Italian villa style in *May Morning*, cottage Gothic in *Summer's Evening*, rustic Greek Revival in *October Afternoon*, and a blend of neoclassical with late Federal in *Pleasures of Winter*.[5]

Note also the ways that conventional symbols associated with phases of the year have been incorporated yet subordinated by Currier and Ives's artists to the dominant theme: contented families enjoying the salubrious pleasures of each season's special blessings and bounties. A hired hand is plowing unobtrusively, so we can be sure that it is spring. Only slightly more prominent in the next composition, hay is being loaded on a venerable wagon, a certain sign of midsummer. The genteel menfolk have been successfully hunting, but the absence of brilliant fall colors on the trees (barely any tinted leaves at all, in fact) make the October scene seem more European than American. That autumnal ambiguity is only partially remedied by the inconspicuous cornhuskers in the background. The sleigh-ride motif makes winter unmistakable but, once again, it is distinctively American only because the cheerful groom defending himself against a snowball at point-blank range is black.

One other characteristic of this highly popular set betrays its debt to the European tradition in seasonal art. The most prominent figures are notably well dressed and prosperous, but within each image there are also working-class men performing seasonal chores at a distance. The existence of a leisured gentry dependent upon a laboring class is candidly (almost innocently) acknowledged, just as it was in so many paintings and prints of the four seasons made in early modern Europe. Are there any significant differences then? In art created in the Low Countries during the sixteenth century, laborers are usually working under the close and careful scrutiny of those they serve, whereas the American farmhands seem to require no supervision. And in seventeenth-century European art, members of the underclass (including beggars) look on as envious observers while the more affluent picnic, play, court, or enjoy the delights of ice-skating. In this widely appreciated set by Currier and Ives from 1855, there is barely any communication or apparent relationship between those

who toil and those who are liberated from manual labor. But at least there are numerous flesh-and-blood people in these lithographs. Human beings would virtually disappear from American landscapes illustrating the four seasons during subsequent decades—in marked contrast to comparable European art during the final third of the nineteenth century (see figure 1).

In the same year that *American Country Life* appeared, Walt Whitman published "Song of Myself" as the primary portion of his *Leaves of Grass*. In stanza 16, where he describes ordinary people pursuing their daily lives all across the United States, he included these two lengthy lines: "Seasons pursuing each other the indescribable crowd is gather'd, it is the fourth of Seventh-month, (what salutes of cannon and small arms!) / Seasons pursuing each other the plougher ploughs, the mower mows, and the winter-grain falls in the ground." These lines are significant because Whitman was deliberately intermingling observations about urban and rural life—if anything, with greater emphasis upon the former. A few lines farther down he observed: "The city sleeps and the country sleeps."[6]

In May and June of 1855 *The Crayon* printed several essays that insisted upon seasonal delights to be found not only in rural areas but also in urban locations large and small. To "our friends in the country" an author living in New York City explained: "you do not enjoy exclusively the glory and the beauty of the Spring season. . . . You possess not all the beauty in the world! We of the city have a portion, and we too can boast of our Spring floral delights. We have pleasant walks, made so by the taste of those who dwell upon the way-side. We can walk our streets, and turn our steps to where flowers grow, warming the fronts of our stone houses as well as our stony hearts."[7]

Those assertions are meaningful because they were made at about the same time as the earliest laments I have found indicating that urban dwellers felt disconnected from the wonders of nature, by which the anonymous author of an 1857 essay in *Putnam's Monthly Magazine* meant seasonal change and scenic variety in particular. "How few among us, on the other hand, watch still, with simple, faithful wonder, the marvelous changes that the seasons work in the world around us! Thousands, we fear, are never aware of the charms of spring, and boast that they know not the 'rigor of winter.' To them, all the year is but one busy scene of city turmoil or study's unbroken silence."[8]

Such assertions and regrets would remain a persistent yet minor refrain for almost a century, though they certainly helped to condition and define what prominent naturalists would write about the four seasons during the last decades of the nineteenth century and earliest ones of the next. Unlike the outlook of their successors during the third quarter of the twentieth century, who commonly chided city dwellers for being out of touch with nature, John Burroughs and his late Victorian cohort in the 1880s and 1890s made an earnest effort to bring the glories of nature and the seasons to a rapidly growing urban

readership. Rather than scolding, they offered information and insight to compensate for environmental deprivation.

One of the earliest to do so was the well-informed, keenly observant writer Wilson Flagg. His *Studies in the Field and Forest* (1857) received a warm welcome in important venues like the *North American Review* because of its clarity and because it seemed less subjective and antisocial than Thoreau's *Walden*. Although Flagg has long since been overshadowed by his Concord contemporary, his ruminations conveyed a sense of homely wisdom that was more accessible albeit less provocative than the insights of Walden's rustic philosopher. Representative of Flagg's observations is the following:

> Though we are accustomed to regret the lapse of summer, and to dread the coming of winter, there is a providential wisdom in these revolutions of the seasons; and although our enjoyments are greater in the balmy summertime, than during any other period, yet their average is greater than it would be if this delightful season were to remain with us throughout the year. There is an influence breathing from all nature in the autumn that leads one to reflect on the charms of the seasons that have flown, and prepares us by the regret thus awakened to realize their full worth, and to experience the greater rapture, when we meet them once more.[9]

To most readers in the 1850s and 1860s, that voice sounded more direct and encouraging than Thoreau's.

Growing Affluence, Conditions of Life, and Seasonal Sensibilities

Making seasonal attributes and changes meaningful for ordinary readers may very well have been easier in the mid-nineteenth century than subsequently because so many routine events and occurrences were far more seasonally specific than they would be less than a century later. So long as churches were unheated, for example, the duration of sermons varied with the seasons: much shorter in winter and considerably longer in the warmest months. People who lived far from the center of town often complained about going to church at the worst times of climatic discomfort. They explicitly referred to "the extreme difficult seasons of heat and cold." Spring was traditionally the "moving season," when mobile families who were so inclined packed up for a fresh start in a new community. That was also when laborers searched for work in opportune places to hold them through the next harvest. Caring for private patients in hospitals was also a seasonal business. Right through the beginning of the twentieth century, hospitals tended to be sparsely populated during the summer months when patients as well as some physicians fled the heat of urban areas for rural comfort. In nineteenth-century medical practice, moreover, purges were routinely administered in the spring and fall because of the widely

held belief that they would facilitate physiological adjustment to the changing seasons.[10]

During the later nineteenth century it also became commonplace for upper-class and wealthy Americans to move about from home to home on a seasonal basis. This involved considerably more than simply going to summer resorts in the White Mountains of New Hampshire or to "cottages" at Newport. Alice Forbes Perkins Hooper, the daughter of Charles Elliott Perkins, a railroad magnate, summered in Milton, Massachusetts, and wintered in Boston. In addition, her family spent spring and autumn at their home called "The Apple Trees" in Burlington, Illinois. As a young man, William Sumner Appleton, founder of the Society for the Preservation of New England Antiquities, made the seasonal rounds between Boston, southern Maine, Squam Lake in New Hampshire, and Cape Cod. From the perspective of a New Englander, those were seasonally variable locations.[11]

Henry Adams explicitly identified his birthplace, Quincy, with summer and Boston with winter. Those designations transcended the delights of youthful pleasures and the more somber challenges of teaching, writing, and seeking a vocation. Boston became his dark symbol for State Street, which meant the powerful banking interests that he reviled. The seasonal differences between these two venues emerged in his autobiography as defining metaphors for dualisms that loomed large in his life and cultural milieu.

> Winter and summer, then, were two hostile lives, and bred two separate natures. Winter was always the effort to live; summer was tropical license. . . . Summer was the multiplicity of nature; winter was school. . . . The bearing of the two seasons on the education of Henry Adams was no fancy; it was the most decisive force he ever knew; it ran through life, and made the division between its perplexing, warring, irreconcilable problems [and] irreducible opposites. . . . From earliest childhood the boy was accustomed to feel that, for him, life was double. Winter and summer, town and country, law and liberty, were hostile. . . .[12]

Although very few Americans could voice their values and feelings with Adams's virtuoso imagery, surely quite a large number of them would have shared his sentiments. The polarity between summer and winter—particularly given the late nineteenth-century range of rapid social changes—was such a logical way of contrasting leisure and labor, home and work, light and dark, comfort and commerce, indolence and industry. Seasonal similes could epitomize worlds of difference between ways of living.

Some of Adams's abilities and sensibilities were shared by another American Victorian who also underwent a notable odyssey in search of a vocation, and in the process actually created one: landscape architecture. During the later 1850s, when Frederick Law Olmsted was planning Central Park in Manhattan, he was

deeply concerned about the vistas—how they would appear and be perceived through the changing seasons—and that preoccupation remained with him during his many subsequent projects. The Bethesda Terrace, envisioned as the park's "drawing room" (a formal site where people would forgather), blended architectural features into the landscape, and Jacob Wrey Mould designed whimsical motifs of the four seasons to ornament its banisters. Such symbols were becoming ubiquitous by the start of the 1860s.[13]

That appears to have been especially true in the realm of decorative arts and material culture. Between 1858 and 1860 Ruggles Morse built a handsome Italianate mansion in Portland, Maine (now known as the Morse-Libby House and open to the public as a survival of Victorian opulence in northern New England). Images of the four seasons were painted in the corners of the so-called green bedroom. They took the form of women's faces, and the representation of winter remained a mystery to the staff until quite recently. Instead of the conventional symbol, an old woman warmly cloaked, preference was given to a much younger woman, not warmly dressed but wearing a mask. The solution to the mystery? Morse had extensive investments in New Orleans and spent considerable time there. The woman was meant to evoke Mardi Gras and its masked balls, which occur in late winter. In addition, the upstairs sitting room is graced by a spectacular center table hand-carved entirely from rosewood (plate 13). Made around 1860 in Boston or New York, probably by artisans from Europe, it features the heads of four women as caryatids adorning the tops of the elaborately sculpted legs. Each woman wears a headdress, variously decorated with flowers for spring, wheat for summer, grapes for fall, and pine cones for winter.[14]

Many European artists of the later nineteenth century who painted sets of the four seasons, particularly members of the Barbizon school and then French impressionists, did so in response to commissions from bourgeois patrons who chose the subject to illustrate the life of leisure that resulted from affluence and early exurbanization. Their interest was not so much in nature per se, or even the essential work that needed to be performed within natural settings. Instead, the seasonal suites of Delacroix, for example, treated mythological motifs, and those done by Cézanne at the age of twenty-one used elongated depictions of young women as a decorative device. Only Jean-François Millet was able to violate the wishes of his patron and present peasant labor in a manner faithful to the agrarian spirit of literature and art from Virgil's *Georgics* through the sixteenth-century emphasis upon human efforts to wrest a living from the land.

The Appeal of Sentimental Seasonality in the Wake of the Civil War

Were seasonal motifs only for the affluent wishing to flaunt their wealth and newly acquired social status? Hardly. In 1860 Felix Octavius Carr Darley (1822–

88), an artist whose audience was the middle class, designed his *American Farm Scene* series featuring horses, hay wagons, harvesting, and other predictable images associated with the seasons. These lithographs were artistically superior to much of the work produced by Currier and Ives, and they prompted European artists to make copies or variations of them. Darley's carefully composed and clearly rendered work seems to have appealed to urban and small-town purchasers nostalgic for a way of life that appeared to be waning. Darley created another set of four seasons lithographs in 1869 for the *Art Supplement to Appleton's Journal*. With the emerging novelty of production in color, these popular chromolithographs displayed youths in spring, with plowing in the background; courtship in summer, with a man bedecking his sweetheart with flowers; a woman picking fruit in autumn, with two other harvesters behind her; and an elderly couple walking through snow in winter, the husband solicitous of his wife's slow pace. Darley's work in this genre remained in demand for years.[15]

His commercial success, alongside the appearance of four seasons paintings during the 1860s by such "serious" painters as Samuel Lancaster Gerry, William Trost Richards, and William Hart, surely motivated Currier and Ives to find new and varied ways of following up on their initial effort of 1855. For a while they seemed only to be "dabbling" in the market, with prints titled *Summer Fruits* and *Autumn Fruits* (1861) or *The Season of Blossoms* (1865), as well as a quartet called *The Farmer's Home* in 1864, one of the most rustic of all their sets. But in 1868 they produced a major series, traditional in emphasis yet thematically fresh in terms of the American market, titled *The Four Seasons of Life* (figures 7–10), mainly designed by Frances F. Palmer, one of their best artists, assisted by Charles R. Parsons. Each of these images conveys to our eyes, metaphorically as well as literally, a kind of overbearing sweetness: stiffly posed children for *The Season of Joy*, a courting couple in a country lane with a church for marrying close at hand in *The Season of Love*, parental pride in a burgeoning family for *The Season of Strength*, and an aged, bespectacled couple serenely transmitting knowledge and perhaps wisdom to a child in *The Season of Rest*. Although these may seem to ignore or trivialize the disorder and disruption of life in the American 1860s, it was precisely the idealized tranquility of rural life that carried such a strong appeal in the immediate wake of a horrendous civil war.[16]

So Currier and Ives lost no time in the winter and spring of 1868–69 in producing the most widely circulated of all their seasonal sets, this one simply titled *American Homestead: Winter, Spring, Summer, and Autumn*. Produced in large quantities, hundreds of thousands at a time for distribution to dealers, and mostly in black and white but sometimes hand-colored, these lithographs are undoubtedly the most popular series of small folios that Currier and Ives ever published. Once again the dominant motifs are rusticity, nostalgia, and na-

tionalism. Each image depicts a home whose architecture is now unmistakably American. Blossoming trees and sheep ready for shearing dominate spring. Contented cattle grazing while vegetables are brought in characterize summer. A family harvesting huge apples and pumpkins tells autumn's tale. And children sleighing while their father carries firewood to his wife waiting at the house sets the winter scene. It's ever so pastoral, domesticated, and uncomplicated: exactly what the newspapers indicated that American life was *not* in 1868–69. But the very point of these beloved lithographs is that they represented an escape from the harsh realities of public life. Hence they would hang in vast numbers of middle- and working-class homes. The firm's slogan read: "The Cheapest and Most Popular Pictures in the World." Indeed, the prices for Currier and Ives prints ranged from twenty cents to four dollars at most.

Those images remained available for decades to come. The company could do nothing to improve upon them or their commercial success. In 1870–71, for example, Currier and Ives produced a ghastly set using young women woefully overdressed, with clichéd symbols of the seasons covering their hair and an excess of unattractive jewelry. The firm published many other seasonal prints as singles or in pairs; but their apogee had been achieved in 1868–69, years that marked a convergence of incredibly intense interest in American seasons in print media as well as in oil paintings and lithographs.

An attractive publication called *The Atlantic Almanac for 1868* appeared early in that year, followed by a sequel for 1869. The former included a lengthy essay by Oliver Wendell Holmes Sr., titled "The Seasons," and another one called "A Talk About the Year" by Donald Grant Mitchell (figure 43), the antiurban author of *Dream Life: A Fable of the Seasons*, which created a small sensation as an escapist fantasy after it was published in 1851; a miscellany of mediocre poems explicitly about the seasons (e.g., "The Varying Year"); and convivial illustrations of woodland scenes. It ended with a sheet of music, a song called "All the Year Round," which began with the lines:

> All the year round!
> All the year round!
> What are the seasons to you or to me?

My own response to that rhetorical question may explain why this efflorescence of visible interest in the four seasons was peaking so intensively in 1868–69. First, there was the postwar homecoming mood and the desire for normal, domestic lives. Second, the realization that urbanization was changing life as it had been known, and that something precious from the American past was slipping away. Hence this surfeit of sentimentalism and nostalgia.

Holmes's long and delightful essay, formally divided into four sections, one for each season, managed to touch all of the key chords. He begins by lamenting that too few people pay sufficient attention to the wonderful seasonal trans-

1822–1908

formations in the United States, and he does seem to be addressing primarily urban dwellers like himself, a Bostonian. In the section devoted to spring he observes that "one must go to the country to find people who care enough about these matters, and who are constantly enough in the midst of the sights and sounds of the opening year to take cognizance of the order of that grand procession." When he reaches autumn, the predictable chauvinism becomes mildly puzzled if not agnostic: "The reason why American woods should be so much more brilliant in the autumn than those of the Old World is not obvious." (Wilson Flagg had explained in 1857 that it was because summer lasted longer in England.) Several columns later Holmes's nationalism takes a more literary turn: "Sleigh-bells," "shagbarks," and "pumpkin-pie" are evoked. "These belong to the New World vocabulary," Holmes writes. "It is a great misfortune to us of the more elderly sort, that we were bred to the constant use of words in English children's books, which were without meaning for us and only mystified us." In his transition from the section on autumn to the one on winter, Holmes devised a charming image to convey the confused sentiments of national identity that plagued his generation but now were being overcome: "What a mess,—there is no better word for it,—what a mess was made of it in

our young minds in the attempt to reconcile what we read about with what we saw. It was like putting a picture of Regent's Park in one side of a stereoscope, and a picture of Boston Common on the other, and trying to make one of them. The end was that we all grew up with a mental squint which we could never get rid of."[17]

Donald Grant Mitchell's contribution was considerably more conventional, yet highly symptomatic nonetheless. He began by commenting that notions of urban life and customary almanac imagery were virtually incompatible. "I don't think I ever chanced to see the picture of a city lamp-post in an Almanac, or of an omnibus, or street corner, or the portrait of an alderman,—outside of *Punch*. The book of all other books which makes us count our time, and change our dates, and reckon the seasons,—I mean the Almanac,—gives us flight into the country." Living as he did on his rural estate well outside of New Haven, Mitchell rather patronizingly warned the city dweller not "to affront spring-time in the country till the ground is fairly settled, and he finds firm footing on the lawn." Numerous remarks follow—certainly snide-sounding to twenty-first-century ears—in which he regretted the seasonal inadequacies of urban folks. Speaking of spring fruits and vegetables, for example, he asked—and answered—rhetorically: "You have them better in the cities? Doubtful." And then a bill of particulars appears, beginning with radishes! Interspersed with Mitchell's essay are poems submitted by such prominent writers as Thomas Bailey Aldrich ("Autumn Days"). How Mitchell's prejudices would have been received by city people who bought the *Atlantic Almanac* is difficult to say; but the editors were shrewd to pair and balance Mitchell with Holmes, giving two complementary perspectives as well as literary styles: one sprightly and the other somewhat wistful. They may have agreed that nature and the seasons were more readily appreciated in the country, but Holmes's emphasis was positive and proudly American, while Mitchell's was critical of social change and avid on behalf of rusticity.[18]

The *Atlantic Almanac for 1869* was prepared by Mitchell alone, and the illustrations seem rather ordinary by comparison with those for the preceding year. I suspect that without another engaging essay by Holmes, the project was doomed, and in fact it did not continue. Indeed, the October 1869 issue of another magazine proclaimed, "The present age is eminently practical. The palmy days of Ik Marvel [Mitchell's pseudonym as a novelist], the good old dreamer, are over. Men have no time to read *Dream Life* now. They who linger with fond delight over its pages in childhood, soon find its poetry fading in the dull realities of life." Well, perhaps. Even so, that seasonal fantasy in prose, not poetry, went through fifty editions in the United States by 1922 and achieved translation and notable circulation in several Western European languages. Mitchell did not like to believe that the book's immense success depended solely upon its sugary sentimentalism about life and the changing seasons, yet that appears

to have been exactly the cause of its cometlike blaze across the horizon during the mid-Victorian era. Mitchell's name and career have long since been relegated to dim obscurity, but the impassioned fan mail that can be found among his surviving papers indicates just how radically tastes have changed over the past century and a half. Emily Dickinson found his book impressive and intriguing. It might be added that the published notices of *Dream Life* were not consistently favorable even when the book was first reviewed in 1852; its popular appeal continued nonetheless, and as late as 1893, when a new edition appeared, one reviewer expressed astonishment that there were still readers eager for fictional fantasies by Ik Marvel.[19]

However remote Mitchell may be from Americans' consciousness today, he was, despite his antiurban conservatism, highly representative of his own era in the depth of his feelings of national chauvinism. In *Dream Life*, for example, he insisted upon the vast superiority of American farmers over their British and French counterparts—and John Burroughs and many other late nineteenth-century naturalists would provide their own variants on that theme. As Burroughs put the matter in his *Signs and Seasons*, "The Americans are—or were— the best mowers. A foreigner could never quite give the masterly touch."[20] The American sense of *difference*, though without any acknowledgment of superiority, would receive affirmation in a variety of ways from foreign observers over the years. Tolstoi, Proust, and Yeats, for example, all admired *Walden* immensely and called explicit attention to its "Americanness."

Following the burst of seasonal writing and images that appeared during the late 1860s, a great deal of trivial poetry and illustrative material filled the popular press. Countless poems, for example, commonly titled "The Four Seasons," appeared in *Punchinello*, or *The Galaxy*, or *The Living Age*. What no one knew at the time, of course, because they were not published until many decades later, is that between the 1860s and the 1880s, Emily Dickinson was writing quite a few seasonal poems that have now become both memorable and canonical. They lack titles because she wrote them on scraps of paper and tucked them away. So they are simply known by their first lines, such as "There's a certain slant of light" and "Apparently with no surprise," which comments on the effects of sun and frost upon flowers. Dickinson observed meteorological effects as well as seasonal transitions and peaks, most notably in her garden.[21]

The Broad Appeal to All Taste Levels

Irrespective of quality or level of cultural aspiration, certain seemingly timeless themes recur throughout the poetry, essays, and magazine art of postbellum America: above all, delight in the anticipation and excitement of seasonal change. Thoreau was especially fascinated by seasonal shifts and variations, commenting upon them endlessly in his journals as well as in *Walden*. For

lesser writers among his contemporaries the enthusiasm for transitions had more to do with romance, the sheer fecundity and variability of nature, and the promise of renewal. Hence "Harry Penciller" praised the passage from spring to summer because of its association with love and impending marriage. The transition from summer to autumn meant that "the sheen of ripeness is over woods and fields and gardens." And a saving grace of winter would be found in the recognition that the calendar year might die, but hemlocks do not.[22]

Popularity, mediocrity, and universality made perfectly compatible bedfellows. During these decades Louis Prang and Company produced an extraordinary array of calendars, greeting cards, valentines, and trade cards, all aglow with seasonal motifs. After Prang turned to chromolithography in 1866, his business did not flourish until he adopted sentimental and nostalgic themes, more often than not seasonal. "Summer by the Sea," "Coming of Autumn," "Winter by the Sea"—those were the kinds of motifs that members of the public wanted to see and send to one another during the last three decades of the nineteenth century. At least part of the stimulus came from the growing commercialization of holidays and festivals. Sending mass-produced cards rather than handmade ones gradually became socially acceptable, and there was a marked increase in the realm of seasonal observance tied to special occasions.[23]

Inevitably, I suspect, we are inclined to wonder what parallels existed, if any, between popular and "fine" art pertaining to the four seasons. The answer lies not so much in sentiment as in style and the actual rendering of subject matter. Those who painted one-of-a-kind images in oil on canvas were concerned with aesthetic issues, subtlety, European traditions, and appropriately American innovations. The artists who worked for Currier and Ives, or someone like F. O. C. Darley, were generally less concerned with such matters. But when Thomas Cole compiled a sketchbook between 1827 and 1840, making an inventory of subjects that he might wish to paint, no fewer than three items on his list referred to the seasons, and one of them provides an uncanny anticipation of the Currier and Ives series titled *The Four Seasons of Life* (figures 7–10) from 1868. Here is Cole's entry: "Four seasons—series. Spring with children playing in a beautiful scene—flowers and blossoming trees—winter—old people sitting in a room by the fire reading—a view of a wintry landscape through a large Gothic window." His prospective images drew heavily upon literary sources combined with appealing scenarios in visually appropriate American settings. That is also true of the work of lithographers, who proceeded to sentimentalize their scenes to a degree unimaginable for painters. Otherwise, their sources of inspiration were closely connected.[24]

The American painters of the Victorian era who are remembered as fine artists depicted numerous seasonal landscapes. Although they ranged across "the procession of the seasons," autumn was very clearly the most favored, perhaps because it lent itself to the most brilliant colors or because it conveyed the passage of time so clearly or possibly because it could be used to evoke a mood of melancholy that might win plaudits if it prompted spiritual feelings. Frederic E. Church did at least six major paintings and numerous sketches with "autumn" in their titles. Winslow Homer and Albert Pinkham Ryder seem to have been equally partial to spring and autumn, especially during the 1870s. George Inness, most notably during his later years in the 1880s, did countless versions of autumn at different times of the day and in different months, hither and yon. And Jervis McEntee seemed to specialize in images of late fall to serve allegorical ends. One, for example, is titled *And the Year Smiles as It Draws Near Its Death* (1877). With notable consistency, seasonal art in the United States during these decades depicted largely unpeopled landscapes as locations in which mankind is but a small part of nature's nation.[25]

Jasper Cropsey stands out among American Victorians as the preeminent artist engaged by the four seasons motif. He may have painted as many as twelve documented sets, although only some have survived. Most of them were commissioned (by English as well as American patrons), most celebrate the beauties of nature in the New World, and some seem to suggest the existence of a divine order. Perhaps that is a distinctive quality of series, suites, and sets of paintings: they lend themselves to notions of "order." Cropsey was clearly captivated by then-current theories of cyclical growth and regeneration—not exactly new and profound ideas, but ones that were much discussed in his day. His first efforts seem to date from 1855 and 1856, but the earliest group to survive was composed between 1859 and 1861, with the seasons set in England, the Mediterranean, New York State, and Switzerland. For almost four decades, beginning in 1849–50, he also painted spectacular seasonal scenes as "singles," such as *American Harvesting* in 1851, with a classic hay wagon crossing a field, and *Autumn—On the Hudson River* in 1860, with a roughly picturesque wilderness in the foreground, a more settled and serene middle ground, and towns and riverside ports in the light-filled distance.[26]

In 1879 Cropsey painted a particularly beautiful set, with all of the seasons notably located in New York State (plates 14–17). Like most of his suites these are diminutive, measuring six by eleven inches each. In 1883 he composed what may well have been his last set, also small but reverting to the cosmopolitanism of the 1859–61 series. This time he reversed the order of the first two locales, placing spring along the Italian coast; summer in Stoke Poges, England; autumn in New York (most likely along the Susquehanna River); and winter at

the Simplon Pass in Switzerland (plate 18). Although there are human figures, they are tiny. (Cropsey had clearly read William Wordsworth's autobiographical poem *The Prelude* [1850], in which he described with ambivalent feelings of awe and dismay his experience of crossing the Simplon Pass.) Cropsey lived in England between 1856 and 1863, when he came home because of pro-southern sympathies that he encountered there. One can see some influence from J. M. W. Turner in his work; but clearly Thomas Cole remained his single most important source of inspiration. Cropsey also owned more than a dozen books of botanical science, which may help to explain why his trees and shrubs are highly individualized.[27]

Although there is no reason to suspect any direct connection or pattern of influence, it should be noted that during this pre-cinema period scene painters also created elaborate moving tableaux depicting the succession of the seasons. Matthew Somerville Morgan (1836–90), for example, a British scene painter, designed a multiple transformation scene, "The Fleeting Seasons—From Winter's Ice-Bound Home to Autumn's Golden Bower," for an 1867 production in New York of *Babes in the Woods, or, Harlequin Robin and His Merry Men*, a costly and imposing stage spectacle. Parlor theatricals with such titles as "Summer and Winter" also enjoyed considerable appeal within the home at that time. So here again is diverse evidence of high culture and popular culture running along parallel tracks.[28]

By the 1880s and especially the 1890s, Cropsey's pattern of creating four seasons suites of paintings for patrons had expanded and proliferated in numerous ways—the size of the projects, the media used (including murals and stained glass), and their geographical distribution all across the United States—in the work of other artists. In 1892 Charles Freer, a wealthy Detroit industrialist, commissioned Dwight William Tryon to create a large seasonal cycle for his new home. Because the scenes were painted for particular locations in the home, the set varies in size from 38 by 83 inches for *Springtime* (plate 19) to 28 by 61 for *Winter*, the last one completed, in 1893. The process of envisioning a contemplative group that would satisfy Freer's very keen eye is said to have exhausted Tryon, yet in 1893 he also collaborated with Thomas Wilmer Dewing on a triptych for Freer's flamboyant neighbor and fellow tycoon, Frank J. Hecker. Tryon painted *Spring* and *Autumn*, while Dewing provided *Summer*. The artists may well have ignored winter at Hecker's request. I find it intriguing that Dewing painted numerous other landscapes of spring and summer, but never of autumn or winter. Most artists had favorite seasons.[29]

Decorating American homes with seasonal motifs became a veritable "rage" during the last quarter of the nineteenth century and the early years of the twentieth. Moreover, this enthusiasm was neither confined to the elite nor did it invariably take predictable forms. The owners of the Decatur House on Lafayette Square in Washington, D.C., imported a quartet of paintings from

Japan made by Kunitsuru Utagawa early in the 1870s, almost certainly the first four seasons set painted in the Japanese style for an American home. In 1880, when federal employee Eben Loomis bought a home near Rock Creek in Washington, his daughter Mabel painted a beautiful four seasons frieze for her father's study. In 1889 George Starrett, a carpenter and architect, built a handsome home in Port Townsend, Washington. Otto Chapman painted a fresco of the four seasons to cover the entire ceiling above a two-tiered, free-floating staircase. When John D. Rockefeller Sr. built a home in Pocantico Hills, New York, at the turn of the century, he had its facade adorned with motifs of spring, summer, and autumn. The house was not originally intended for winter residence. Using seasonal motifs was very much in vogue, obviously, and those who used them were aware that such decoration had been a tradition in European domiciles of all sorts for at least half a millennium. They also served quite well as means of making a statement: "I am not out of touch with the natural world."[30]

Whether these designs were accomplished as oil paintings to be hung, as plasterwork on walls or ceilings, or as frescoes applied directly, it is notable that including the four seasons, more often than not, was carefully planned as an integral part of the décor from the outset. By the close of the nineteenth century, artists skilled in painting glass or working with stained glass were able to add yet another medium. The two most notable figures to do so were John LaFarge and Louis Comfort Tiffany. The latter created four seasons windows for at least four homes, including his own; and LaFarge prepared spring and autumn windows in 1896 for a home on Lake George that eventually belonged to Adolph Ochs, publisher of the *New York Times*. LaFarge designed yet another pair on an immense scale when commissioned by William Whitney for his country home at Old Westbury, on Long Island. Executed in 1901–2, *Spring* (plate 22) features a winged angel, nude from the waist up, floating in space and surrounded by brilliant blue skies and bright green foliage with white blossoms. All of these windows are stunningly beautiful, and most were created during the decade following 1892. As early as 1883–84, however, the firm of J. & R. Lamb in New York City advertised "Artistic Stained Glass for Church and Household Decoration." Its ads featured images of windows designated "Summer" and "Autumn," with a winsome young woman in each, one gathering flowers and one harvesting fruit.[31]

The appeal of seasonal motifs would predictably be manifest in public spaces, civic as well as domestic. During the 1890s statues representing the four seasons appeared in the garden of the Valentine home in Richmond (now a municipal museum) and in the garden of Yaddo, which became a colony for artists and writers in Saratoga Springs, New York. The latter quartet was sculpted from white marble by an unknown Italian craftsman and brought to Yaddo by a financier, Spencer Trask, as a gift to his wife, Katrina, sometime between 1899 and 1905. The four statues show young women holding the usual

symbols: flowers, wheat, grapes, and pine cones with evergreen branches. Whether they were made in Italy or the United States is not clear, but most likely the latter. In any case, the setting for the statues was carefully intended to be bicultural. The Trasks based the plan for their rose garden on Italian classical gardens they had seen on visits abroad, but the contiguous rock garden was meant to be an expression of indigenous American landscape design. They wanted the best of both worlds. Ardent nationalism did not determine aesthetic decisions concerning seasonal design in every instance at the turn of the century.[32]

When the Library of Congress was erected in the mid-1890s, the interior of what is now known as the Jefferson Building, opposite the U.S. Capitol, was intended to be brilliantly ornate and pay tribute to as many classical writers, scientists, musicians, and traditional motifs as possible. Inevitably the four seasons are featured—in not one but three locations. At the entrance to the rotunda, on the left and right of a life-size bronze rendering of Father Time, there are figures of maidens with children, also in bronze, representing the seasons. On the west side of the upper level there are four handsomely designed plaster roundels featuring women with neoclassical garb engaged in customary activities appropriate to each season. These seem to echo the well-known roundels executed in Rome sixty years earlier by the great Danish sculptor Thorvaldsen. Because the Washington versions are white and positioned quite high where the walls meet the ceiling, they are easily missed.

On the east side of the upper level there are more roundels, in which the prominent artist Frank Benson painted four attractive women in 1895. Although he had been influenced by Abbott Thayer, best known for his paintings of idealized, often angelic women, Benson wanted his to appear as fresh and real examples of American beauty. In his set of murals nationalism and realism are combined, at least compared to Thayer's ethereal and otherworldly women. Whereas Benson's representations of spring and summer engage the viewer's glance directly, we see Autumn in profile, in the manner of classic Italian Renaissance portraits; and the figure for winter is curious because there is little more than wintry wind affecting her appearance or her light drapery. The great wreath that covers this roundel, like the other three, ends with an open cornucopia threatening to spill the abundance of America down upon the observer. Benson's beauties manage to be literally pretty yet unimaginative in terms of seasonal iconography.[33]

Among the American impressionists who were Benson's contemporaries, two require our attention because of the sheer number of seasonal paintings they completed during this period, even though neither of them seems to have deliberately created a unified suite of seasonal images. John Henry Twachtman (1853–1902) is unquestionably the more important of the two and is best remembered for his pleasingly benign winter scenes. But he painted all of the sea-

sons, mostly during the 1890s, with titles such as *Springtime, Summer, Hemlock Pool* (plate 20, an autumn scene), and *Winter Harmony*. J. Francis Murphy (1853–1921), who is considerably less well known, built his studio in Arkville, New York, and achieved many honors beginning in 1893. His *Fall Landscape* and *Winter Landscape*, both from 1897, make a pendant set, and his undated *Spring Landscape* along with *Summer, Summer Time*, and *Late Summer* all indicate that he was certainly attuned to landscape motifs that enjoyed broad appeal at the turn of the century. Although his impressionism resembles Inness's technique more closely than it does Twachtman's, what these exact contemporaries share in common most of all, beyond their interest in seasonal transitions, is the fact that their landscapes are utterly unpeopled. Once again, compared with so many of their European contemporaries who were engaged by seasonality, Twachtman and Murphy seem unmistakably American.[34]

The "Americanness" of these artists presents an interesting and complex twist, however. Their preferred subject matter during their mature years was their native land and its distinctive vistas. Nevertheless, each of them had not only studied in Europe but also lived there for considerable periods of time. Dwight Tryon sailed for Paris in 1876 and returned home in 1881 when his money ran out. Twachtman made at least three important trips: first to Munich and Vienna in 1875–78, back to Europe for travel and painting in 1881–82, and then to Paris and Vienna in 1883–85. Murphy spent six months in France in 1887 and traveled extensively in western Europe in 1909–10. Europe represented the "source" of the Western tradition in art, and these painters never repudiated the influences that shaped them there, even though they were determined to render and represent the American scene in all of its seasonal splendor and subtlety. Perhaps they can correctly be called cosmopolitan nationals.

Art historian Angela Miller has offered a thoughtful way to explain why landscape and nature painting did not fully come into its own in the United States until well into the 1850s. Nature, she suggests, "presented a solution to regional and later sectional diversities by offering a non-specific and expansive symbol of nationalism." In looking at the later nineteenth century, I would add the following coda: regional and sectional diversities persisted along with troubling memories of their consequences. But in addition, American nationalism, which gained intensity and potency as the century neared its close, was moderated in the arts so long as Europe remained the fount of aesthetic values and inspiration. Hence on the cosmopolitan side we have Elihu Vedder in 1893 painting in Rome for an American patron a very large work titled *The Sun and Four Seasons* ("The Huntington Ceiling," figure 5), and yet we have an obscure artist like George Wilmont Gustin painting at the very same time the four seasons as observed in Wayne County, Pennsylvania. Regionalism, nationalism, and cosmopolitanism all remained very much "in play" during this period, and seasonal motifs lent themselves readily to the imperatives of each.[35]

FIGURE 44
*Four seasons
pitcher
(ca. 1879),
sterling silver,
Gorham Man-
ufacturing
Company.
The Museum
of Fine Arts,
Houston.
Gift of Eleanor
Freed in
memory of
her parents,
Esther and
David W.
Kempner.*

Gustin's very vertical pictures were actually painted on the panels of elegant folding screens, a fact that serves as a useful reminder of just how ubiquitous the four seasons motif became in the decorative arts during the later nineteenth century. A handsome "album quilt" at the Oneida Community Mansion House in upstate New York features, prominently placed among an array of symbols, squares devoted to tulips, fruit, grapes, and holly. Meanwhile, as a counterweight to that rustic, country piece, the Gorham Manufacturing Company in Providence, Rhode Island, created a spectacular, sterling silver Four Seasons Pitcher around 1879 (figure 44). Embossed on the sides are women gathering flowers, cutting and binding sheaves of wheat, harvesting fruit from trees, and warming their hands by a fire. Twenty-five years later Gorham made an equally stunning, indeed sensuous, four seasons centerpiece bowl that is twenty-seven inches long. On the repoussé sides are allegorical female figures and putti representing the seasons.[36]

Interest in the vagaries of seasonal change, and especially in surprises whose timing was capricious, captivated writers as well as artists. Thoreau, as we have noted, boasted that Indian summer was most glorious in the United States. When Oliver Wendell Holmes wrote his lengthy essay on "The Seasons" for *The Atlantic Almanac for 1868*, he devoted a paragraph to the delights of Indian summer.

> In October, or early in November, after the "equinoctial" storms, comes the Indian summer. It is the time to be in the woods or on the sea-shore,—a sweet season that should be given to lonely walks, to stumbling about in old churchyards, plucking on the way the aromatic silvery herb everlasting, and smelling at its dry flower until it etherizes the soul into aimless reveries outside of space and time. There is little need of trying to paint the still, warm, misty, dreamy Indian summer in words; there are many states that have no articulate vocabulary, and are only to be reproduced by music, and the mood this season produces is of that nature.

In 1898 John Muir wrote to a friend: "If nothing untoward happens I'll be East in August or September. Will make a trip southward along the Alleghenies with Sargent & Canby. Then if you are free we will make a trip in the midst of the Indian Summer color in the lake region." Even this devoted Californian wanted to witness the heartwarming quality of Indian summer in the northeast. Along with composers like Charles Ives, many artists certainly felt inclined to capture those same qualities on canvas. Jasper Cropsey painted a large *Indian Summer* in 1866, and William Trost Richards did the same in 1875. As for writers, we need only recall the title of chapter 24 in *The Education of Henry Adams*, "Indian Summer," referring to a phase later in his life yet preceding the analogical winter of his age.[37]

As we observed earlier, quite a few nature writers, such as Thoreau, felt certain that they were able to paint "word pictures" of the seasons more effectively than visual artists could. They surely did enjoy the advantage of being able to discuss, and not merely allude to, other seasons while concentrating upon one in particular. But on occasion the naturalists' self-assurance proved overweening or just plain wrong. Wilson Flagg, for example, declared that American landscape painters ignored winter, a season that he found most attractive and interesting. A mere glance at the art of George Henry Durrie (plate 12), Regis Gignoux, John Henry Twachtman, Willard Leroy Metcalf, and many others can serve as a corrective. American artists as well as writers tended to be rather upbeat about winter, certainly compared with their European counterparts. The only distinction that I would be prepared to make, and then rather tentatively, is that painters were usually more inclined to sentimentalize or romanti-

cize winter by softening its representation. Quite a few writers, at least, were more likely to acknowledge the harshness of winter, because great storms can facilitate dramatic episodes. Nevertheless, we must keep in mind James Russell Lowell's 1870 essay, "A Good Word for Winter," in which he observed that winter provided the ideal time to study the anatomy of trees and that he found winter more interesting than summer for related reasons as well. Robert Frost, Donald Hall, and other writers would echo Lowell a century later.[38]

I know of only a few instances when Victorian artists actually sought to join with contemporary writers on seasonal landscape projects, believing that collaboration would succeed because their perspectives converged. In 1879 J. Francis Murphy wrote a letter to John Burroughs, explaining that he had read and admired many of the naturalist's articles and indicating that he was a professional artist who had studied landscape "closely and earnestly." Murphy then added that he had submitted drawings to the editor of *Harper's*, who responded positively, and therefore proposed that Burroughs collaborate with him by writing an essay on "weeds," suggesting "any day's walk in the Summer along one of our country roads or over some of our fields." Burroughs apparently agreed to the plan, and his observations on weeds are found in the essay "A Bunch of Herbs." A few years later Burroughs would remark that "birds not of a feather flock together in winter. Hard times or a common misfortune makes all the world akin." He and Murphy were not exactly birds of a feather, but they did share a mutual interest in Hudson River Valley flora. Their brief cooperation, however, seems to have been unusual among writers and artists with seasonal enthusiasm. Most often they went their separate ways, even while being quite aware of one another.[39]

Because John Burroughs was the best known and best loved naturalist in late-nineteenth-century America, and one who wrote so explicitly about the seasons, we should pause to notice the sources that shaped his writing and then consider his own influence and legacy as a seasonal writer. We know that early in the 1860s Burroughs read Wilson Flagg's *Studies in the Field and Forest* (1857) and other writers' essays that appeared in journals. His two great heroes were Emerson and Whitman, both of whom he met, and with the latter of whom he became pen pals. During the mid-1870s Whitman sent Burroughs a letter containing lavish praise for an essay that had just appeared in *Galaxy*. When Burroughs sent Whitman the draft of an essay about Emerson, Whitman returned a very critical response: it was too "Emersonian," meaning "indecisive," and Whitman urged Burroughs to find his own voice. In 1877 Whitman sent Burroughs a letter that lauded his recent book, *Winter Sunshine*, which happened to include a warm essay about Whitman![40]

Among Burroughs's papers is an incomplete and unpublished manuscript, only seven pages in length, discussing Thoreau, whom Burroughs had eclipsed by the later 1870s. "Recently while reading Thoreau's Journals," he remarked, "I

wondered why his natural history notes with which the Journal abounds interested me so little. On reflection I saw that it was because he contented himself with making out a bare statement of the fact—he did not relate it to anything else or interpret its meaning. There is a great deal of bold dry natural history of this kind in journals which he never wove together into a living texture." Another typescript among his papers consists of Burroughs's answers to a set of questions posed to him by an unknown source. When they were posed is unclear, though it may have been well into the early decades of the twentieth century when Thoreau had been fully "rediscovered" (his journals were not published until 1906). The person inquiring observed, "I have noticed a steadily increasing interest in Thoreau, and his writings," and asked "Is this due, in your opinion, to any outstanding element of thought, or to his definite expression of ideas?" Burroughs replied: "To his real merits as a writer," meaning *not* to his abilities as a naturalist.[41]

Was Burroughs jealous of Thoreau? Did he feel competitive with him? Burroughs most certainly felt competitive with his great California contemporary, John Muir. Those two (figure 4) at least maintained friendly relations on the surface and occasionally visited and camped together despite a semicovert rivalry as the paramount American naturalists at the turn of the century. (Thoreau, by the way, was Muir's favorite author. He loved to hold forth on the wonders of *Walden* and frequently urged the book upon his friends.) Twenty years younger than Thoreau, Burroughs did not seem to understand that the journals were deeply personal and were literally field notes and ruminations that Thoreau might well have converted into essays and books had he not died at the age of forty-four (whereas Burroughs lived into his eighty-fifth year). Nothing that Burroughs wrote was as profound or as provocative as Thoreau's two books and his journals, but almost everything that Burroughs wrote was more lyrical for the ordinary reader than Thoreau's efforts. After *Winter Sunshine* appeared late in 1875, Henry James described Burroughs as "a sort of reduced, but also more humorous, more available, and more sociable Thoreau." To deny Thoreau's merits as a close observer of nature, however, is inexplicable, especially considering that John Muir was Burroughs's real rival, and not the curious man from Concord. Despite his reputation among contemporaries as a kind of "saint," Burroughs, as we now know, was neither so idealistic nor so altruistic as people assumed, and his apparent modesty barely concealed a very large ego. He thrived on adulation.[42]

Burroughs received it because his customary emphases seemed to be so in touch with the mood of the times. "The change of the seasons," he observed, "is like the passage of strange and new countries." On occasion he rehearsed age-old motifs but in American settings: such as threshing and flailing buckwheat in summer—the subject, even as Burroughs wrote, of Jean-François Millet's painting of summer in his four seasons quartet (figure 1)—or the killing of hogs

in late fall, an activity often depicted in medieval and Renaissance art. At other times he called attention to the perils faced by North American wildlife: how difficult it was for animals to find food during a really harsh winter, or the dangers of long distance migration for birds, with many of them dying en route each season. In "The Spring Bird Procession" he reminded readers that not only did birds return to the United States from warmer climates in the south, but birds that had wintered in the United States also began migrating to their summer breeding grounds in Canada. As a mature naturalist he even slipped in a gentle correction aimed at his earliest source of inspiration. Emerson, he wrote, "is happy in his epithet 'the punctual birds.' They are nearly always here on time—always, considering the stage of the season; but the inflexible calendar often finds them late or early." Burroughs loved to call attention to the calendar's unpredictability. The seasons may follow one another in unrelenting succession, but just exactly when in any given year could not be depended upon. Referring to a late spring, he noted that "the cold, wet weather, of course, held up the bird procession also."[43]

Burroughs's marriage was not a happy one. He fathered a child by a young woman from a nearby farm and then used subterfuge to persuade his wife to adopt the baby boy as their own from an orphanage in New York City. During his later years Burroughs was doted upon by an adoring disciple named Dr. Clara Barrus, and the nature of their relationship beyond her role as editor and biographer remains unclear. All of which may or may not help to explain his fascination with gender roles and seasonality among birds. In 1917, for example, he wrote that "it is highly probable, if not certain, that the matches made in the North endure but for a season, and that new mates are chosen each spring. The males of most species come a few days in advance of the females, being, I suppose, supercharged with the breeding impulse."[44]

Burroughs's cordial friendships with purposeful and prominent men like Henry Ford, Jay Gould—who had been a childhood playmate in the village of Roxbury, New York, overlooking beautiful vistas of the northern Catskills—Thomas Edison, Harvey Firestone, and Theodore Roosevelt seem almost as curious as his odd relationship with Clara Barrus. The explanation for their warm friendships lies partially in the fact that Burroughs was really not so rustic and otherworldly as he appeared. He enjoyed visiting New York City and attending meetings of the American Academy of Arts and Letters, to which he was elected in 1898. And he also enjoyed the advantages that accrued from the admiration of wealthy men. Henry Ford gave Burroughs a car in 1912, for example, made others available to him on special occasions, and helped to arrange several delightfully comfortable camping trips for the aging naturalist in places ranging from the Green and White Mountains of northern New England to the Great Smokies and the Everglades. Burroughs admired Edison immensely and found Ford a lively companion apart from his frequent anti-

Semitic tirades, which deeply disturbed Burroughs.[45] What matters most, however, is that these powerful men admired Burroughs because his essays fed the nostalgia that prompted them to collect Americana, build museums, and rusticate themselves in settings that highlighted the seasons.

Burroughs's rich correspondence reveals the extent of his influence and the vast number of admirers who wrote to tell him what his books and essays meant to them. On occasion, however, he received mail from fans who felt troubled by his apparent blend of agnosticism and natural science, or what one reader referred to as his "Pantheism." Another wanted Burroughs to know that Nature was quite compatible with Scripture, and even with miracles mentioned in the Bible. James Thomson had dealt with that issue successfully in *The Seasons* by making God explicitly responsible for all of nature's wonders; but by the twentieth century this matter became something of a barrier between many seasonal writers and their more devout readers.[46]

Burroughs's posthumous reputation is remarkable because there were (and still are) many keepers of the flame, ranging from the worshipful Vassar students who came over from Poughkeepsie to visit him at Riverby, his home overlooking the Hudson, to Miss Ethel Doolittle, an Oneonta, New York, woman who corresponded with Burroughs for years and compiled a kind of almanac comprised of pithy seasonal quotations taken from her hero's writings. Soon after his death in 1921 the John Burroughs Memorial Association was formed, with its headquarters located at the American Museum of Natural History in New York City. The organizational disciple there was Miss Farida Wiley, a self-taught naturalist and ornithologist who led thousands of people over the years on bird-watching rambles through Central Park. In 1951 she edited a handy volume titled *John Burroughs' America*, a selection of his writings at the heart of which is a lengthy section devoted to extracts concerning the four seasons and seasonal change in the United States. In so doing Wiley replicated (within a more compressed framework) a similar labor of love undertaken by H. G. O. Blake, who, between the later 1870s and 1892, extracted and organized lengthy passages from Thoreau's journals into four companion volumes each of which bore the name of a season. Thoreau thereby achieved in death what he had so often yearned for in life, a systematic survey of the seasons in his "neighborhood," written daily and often out of doors.[47]

Perhaps because John Muir was responsible for founding the Sierra Club, which remains a significant organization to this day, and possibly because Muir's 1911 book, *My First Summer in the Sierra*, has become a minor classic that is now better known than any of Burroughs's books, Muir's reputation has surpassed that of his East Coast compatriot. If we are interested in comparing their posthumous reputations, it is instructive to look at Donald Culross Peattie's *Almanac for Moderns*, published in 1935. In his entries for April 3 and 4 he celebrated Burroughs's birthday but damns the naturalist with faint praise.

"Burroughs modeled himself throughout upon the lines of genius and succeeded in giving a good imitation of it," he wrote. "If he was never seriously rated as a naturalist in scientific circles, that is simply because he discovered nothing new—except as it was new to him. But John was honest; he never pretended even to himself that he was a scientist. He was an appreciator, and in a wide sense, a poet of science, but a poet who would take no license."[48]

On April 21 Peattie celebrated Muir's birthday with more positive praise and comparisons.

> As Burroughs was the people's poet of birds, so Muir took his delight in every continent's green mantle of vegetation. John Burroughs in the east, John Muir in the west, birdsman and plantsman, they are a pair that the mind inevitably links. Burroughs was the philosopher (if a bewildered one) and the bearded sage whom all conditions of people sought. Far more than Muir was he lionized, and successful with his pen. But Muir was the genuine explorer, humble of heart, iron of frame. He was immeasurably closer to the Nature that both of them loved, and to the scientific frame of mind which does not humanize or sweeten what it must report.[49]

I am not at all convinced that Burroughs was "bewildered" in any sense of the word. I am confident that he always knew his own mind and exactly what he hoped to achieve. Moreover, the range of his enthusiasms and expertise extended well beyond his beloved birds; but otherwise Peattie was correct in identifying Burroughs as a determined popularizer who wanted to make the natural world feel as comfortable and comforting as possible to his rapidly growing urban readership.

At Century's End: Seasonal Cultivation, Wildness, and Persistent Nostalgia

Burroughs's success was symptomatic of his sensitivity to what American readers needed and wanted. Between 1894 and 1910 a flurry of seasonal books appeared, written by naturalists who are almost entirely forgotten today but whose names were well recognized by contemporaries because their works were widely read and appreciated. What they shared in common with Burroughs, above all, were an affection for the value of nature, especially plants and birds, closely observed in a well-defined locale, and a manner of presentation that presumed little knowledge on the part of their audience but did not patronize the reader in any way. They brought people who felt increasingly out of touch with the natural world vicariously back to elements that had been familiar to their parents and grandparents—or so they believed, at least.[50]

In that sense, these works once again capitalized on varied versions of nostalgia for a way of life that seemed to be waning. Some of the key texts in this fin de siècle swell of genteel seasonal cycles, gently presented in order not to

foster feelings of loss owing to urbanization, include *According to Season: Talks about the Flowers in the Order of Their Appearance in the Woods and Fields* by Frances Theodora Parsons (1894 and reprinted in 1902); *The Friendship of Nature: A New England Chronicle of Birds and Flowers* by Mabel Osgood Wright (1894), dynamic leader of the Audubon Society in Connecticut; *The Brook Book: A First Acquaintance with the Brook and Its Inhabitants Through the Changing Year* by Mary Rogers Miller (1902); and *Afield with the Seasons* by James Buckham (1907). Let a single passage from Wright's insightful and delightful book indicate the sorts of messages from all of these authors that readers so admired and appreciated.

> Earth, wedded to the Sun, gave birth to four daughters, and confided the shaping of vesture to their keeping. Winter, the eldest, silent, ermine-cloaked . . . Spring, the youngest, is the heart flower, with curving pale gold hair bound by the moon's slim crescent . . . Summer has an ampler mien; full-lipped is she, with red-gold hair, crowned in roses, and a generous body . . . Autumn, the wayward daughter, steals all her sisters' moods; wedded to the East wind she scoffs him, and lures the South and West by turns.[51]

Wright used personification to achieve in a more elaborate way what Thoreau did so simply more than a generation earlier: confer a distinctive character upon each season in a succinct manner. Thoreau put it this way in his journal for October 27, 1857: "Spring is brown; summer, green; autumn, yellow; winter, white; November, gray."[52]

When latter-day naturalists and writers with a seasonal bent take Thoreau as a benchmark, one wonders what they have read beyond *Walden*—is it *A Week* or the journals?—and just what they are recalling when they invoke him as *the* measure of excellence in American observational writing. Gladys Taber (figure 45), an extremely popular writer in the mid-twentieth century, organized several of her books on a seasonal basis. After reading *Days Without Time: Adventures of a Naturalist* by Edwin Way Teale (1948), Taber remarked: "What a treasure to have a new book by this modern Thoreau who not only writes so beautifully about nature but sparks it with humor. . . . This book enlarges one's horizon." What puts Taber's message in a direct line of descent from several of the late Victorians is her mood of nostalgia for life in a small, rural, tradition-oriented community that pays close attention to regular changes in the natural world.[53]

Seasonal information and inspiration can also be found in the gardening journals and magazines that began to proliferate at the turn of the century, as a few examples from an efflorescence that first emerged during the 1890s will illustrate. The appearance of roses in summer afforded one observer an opportunity to comment on the entire cycle of the seasons: "The annual birth of the Roses fills our hearts with joy and gladness. But a few days ago our garden

Roses were to all outward appearances as dead, now they are alive again. The falling of the autumn leaf was not a memorial but a prophesy, and the fulfillment is now clearly revealed to us. The winter's rest has been broken, and the new growth . . . is ten times more vigorous."[54]

Ten years later another writer made a case for the special efforts demanded by gardening in the off-season. "Every season has its peculiar charms," he wrote, "but dear old winter seems to require more attention to arrangement to bring out its beauties than do the others. . . . Its feeble sunshine must be conserved, the mellow autumn must be kept as long as possible and the returning spring must be encouraged to hasten its coming." A decade later, to add still a different touch, an author waxing ecstatic about the pussy willow suggested that if the plant could speak, it would surely say: "You love and admire me not for my intrinsic beauty, but for what I represent in the transition of the seasons," a reference to the plant's popularity as a herald of spring.[55]

Gardening magazines and journals, like many of the books published at the time, provided a venue for female voices. Back In 1850 the Ladies' Association for Mental and Other Improvements in Ludlow, Vermont, had put on a "Colloquy—The Seasons," written by Abby Maria Hemenway, who took the part of Summer. But at a time when so many vocational options were still closed to women, nature writing in general and garden-related journalism in particular offered a venue that many were glad to have and made the most of. Although their principal concerns were not always distinctively gendered, there was a pronounced stress upon the nurturing role of nature in seasonal development and change. What seems missing from almost all of this period's literature, however, is Thoreau's subtlety in making analogies between seasonal change and human development. Here, taken from Thoreau's journal for August 16, 1854, is a prime example of his distinctive use of metaphor and analogy that I find lacking in most of the late Victorians. "The season of flowers or of promise may be said to be over, and now is the season of fruits; but where is our fruit? The night of the year is approaching. What have we done with our talent? All nature prompts and reproves us. How early in the year it begins to be late!"[56]

Notwithstanding the parallels and convergences between writers and artists interested in the four seasons during the later nineteenth century, at least one

FIGURE 45
*Gladys Taber
(1899–1980).
From the
Gladys Taber
Collection in
the Special
Collections at
Boston
University.*

important contrast in their emphases must be noted. Whereas the landscapes and gardens depicted by painters are invariably controlled—not usually under cultivation, but always benign, serene, and marked by signs of mankind's mastery—many writers tended to call attention to "wildness" (a word that recurs frequently in American seasonal writing) and even to yearn for it. Sometimes it occurs in the process of describing great storms, a stock subject that we can trace back to the horrific blasts of summer and winter in Thomson's *Seasons* and even earlier. John Muir and Henry Beston are well known for their dramatic descriptions of intense storms, and Robert Frost's pulsing poem, "Once by the Pacific," evokes one as well.[57] But even more frequently cited, and with relish, is the great challenge provided to Americans by the sheer wildness of native landscapes under different seasonal conditions. Naturalists regarded it as a challenge to be cherished and perpetuated because it was spiritually beneficial to humankind. Hence we have Thoreau's yearning for "wildness, a nature which I cannot put my foot through" along with his well-known maxim that "in wildness is the preservation of the world," a perspective that Aldo Leopold would literally reiterate almost a century later. The familiar phrase "Forever Wild" appeared in the 1894 act passed by the New York State Legislature creating the Adirondack Preserve in order to achieve its forestry goals. And as Muir wrote from California to a friend in 1898: "Come here as soon as you can for this way lies wildness—the best on the Continent."[58]

Keeping the Adirondacks wild was important to conservationists and recreationists because logging companies had been extracting lumber resources there and elsewhere in the United States for almost a generation. That is noteworthy because the lumber business itself was seasonally problematic, especially between the 1850s and the 1880s. Those involved needed to invest money during the fall and winter when virtually no cash was coming in because ice prevented them from getting lumber to market. For Chicago and its hinterland in Wisconsin and Michigan, especially, seasonal variations in weather had serious consequences in terms of roads, travel, and transportation. Ice and storms closed off shipping on the Great Lakes for almost half the year, and then during the wet season roads turned into morasses and became impassable. As one visitor to Chicago put it at midcentury, "At all other seasons [than late spring to autumn] they were little less than quagmires." Consequently, trade and transportation waxed and waned with the seasons. People actually spoke of the "business season" and the "dull season." That would be especially true for the meatpacking industry. The development of significant railroad networks changed the way large numbers of people experienced the seasons at the close of the nineteenth century—the "flattening" phenomenon once again.[59]

Seed catalogues also provide a significant measure of seasonal needs, meanings, and commercial imperatives in American life. Although these engaging brochures and booklets began to appear early in the nineteenth century, their

most intense and voluminous "flowering" occurred between the mid-nineteenth and mid-twentieth centuries. There were two basic kinds of catalogues: those from seed companies concentrating upon vegetables and flowers and those from nursery companies emphasizing fruits and ornamentals. Seed companies customarily sent out an annual catalogue around the first of the year (usually January), but added smaller supplementary ones for summer plants (mailed early in spring) and for fall bulbs (sent at the start of August). The catalogues were actually named for the designated planting season—hence bulb catalogues were called "fall catalogues." Nursery companies tended to send out two sets: a larger "spring catalogue" mailed during the winter and a smaller "fall catalogue" made available during the summer.[60]

The earliest catalogues from the pre–Civil War era, when scientific agriculture was still very new, contained a fair amount of information that would later seem very basic and familiar, such as the optimal seasons for transplanting trees (early spring and late fall) or for shipping fruits. As late as 1853, moreover, the catalogues continued to convey a good deal of didactic writing, very much in the spirit of Hesiod, alerting an agricultural society to get ready for the "active season." Timeless homilies were included that might very well seem superfluous in retrospect. One from 1853, under the rubric, "TO BE REMEMBERED," admonished readers "to take time by the foretop in every thing which relates to gardening, and never omit what ought and can be done to-day, till tomorrow. . . . Never to work the ground when it is wet and heavy. It renders it compact and lumpy during the whole season," and so forth. This detailed "Descriptive Catalogue" also opened by explaining that "the names of the seasons are used instead of the months. By *Spring* is meant when *vegetation starts*, when buds begin to swell, and leaves to put forth." Taking nothing for granted and seeking to maximize its geographical appeal, the text then specified the variable times when spring usually began in venues ranging from lower New England to New Orleans and Mobile.[61]

By the later 1850s the vocabulary used in the seed and garden business borrowed heavily and metaphorically from the language of agricultural seasonality and crop production. In 1857 the catalogue of a Rochester nursery featured apple trees for summer, autumn, and winter. By the later 1870s and 1880s the catalogues place considerable emphasis upon new efforts to facilitate seasonal diversification and variability. In 1889 Johnson & Stokes of Philadelphia was promoting Christmas watermelons (with enthusiastic recent endorsements from "melon growers"). A year later the same company featured "All Year Round Louderback's Cabbage, Equally Good for Spring, Summer, Autumn, Winter." The text introducing an eye-catching image of three fat cabbages, assured potential customers, "We take great pains each season to inform ourselves fully as to the true character of everything offered as new or superior, either in this country or Europe."[62]

Major developments in color lithography during the 1880s made the seed catalogues ever more attractive visually, so that by the 1890s they were almost as eagerly awaited and examined by entire families as the well-known, consumer-stimulating Sears Roebuck catalogue. Seed catalogues had always been deemed "required seasonal reading" in a society primarily agricultural, and they were decorated and illustrated accordingly. During the 1870s and 1880s monthly issues of the *American Agriculturist* had four roundels at the corners of each black-and-white cover. They enclosed illustrations of animals and activities appropriate to the season rather than images of all four seasons simultaneously. By the turn of the century these publications literally became vernacular art objects as well, and their colorful descendants have remained so ever since.[63]

Catalogues for flower seeds began to proliferate with aggressive self-promotion starting in the 1890s and are notable because their visual imagery and verbiage became increasingly feminized (pretty young women depicted on the covers) owing to the presumed link between the loveliness of flowers and their growers. Such phrases as the "season of purchase" and "season of readership" also became increasingly common, calling attention to the relationship between the rhythm of the year and the required rhythm of attentiveness to planning for beautiful, varied, and novel flowers. In 1904, for example, Carrie H. Lippincott, a highly successful supplier in Minneapolis and Hudson, Wisconsin, called attention to flowers for "winter blooming" indoors. All of this indicates a rapidly growing orientation to the seasonal needs and desires of urban and suburban citizens.[64] Urbanization would also supply new opportunities for catalogue companies in the form of truck farming, victory gardens, and, subsequently, "prettiest yard contests."

As the twentieth century opened, however, there were few indications that seasonal change and perceptions of the seasons would break free from their traditional tropes. Nostalgia and nationalism remained the dominant sentiments. In Owen Wister's influential novel *The Virginian* (1902), progenitor and prototype of the popular genre of western fiction in twentieth-century America, references to the seasons remained entirely familiar. An eastern author used them to write about the natural setting of rugged western life in terms readily recognized all across the country.[65]

A few years later the widely popular *Scribner's Magazine* published a pictorial almanac and essay accompaniment that was so quaint it might just as well have appeared more than half a century earlier. Titled "The Farmer's Seasons: Four Pictures in Colors . . . with Apologies to the Old New England Almanacks," each section featured a full-page image of a wizened old farmer: using his pitchfork to turn the earth in spring, against a backdrop of flowering fruit trees; sipping for a brief rest while a heavily loaded hay wagon crosses his field in summer; gathering great pumpkins amid piled-up cornstalks in autumn; and trudging slowly up a snowy path while a few lads ice-skate on a dis-

tant pond in winter. In three of the four he has actually paused momentarily from the demands of the day. Each of these pictures was faced by a crowded page covered with a rustic poem, a list of holidays, weather predictions, and such, as well as a didactic column "Of Interest to Farmers" filled with moralistic advice that reads almost, but not quite, like a cross between Hesiod's *Works and Days* and *Poor Richard's Almanack*. For example: "We must have a plough in time for the spring ploughing; we must educate the children while they are still of school age; but we needn't build a new house, or a new barn or buy an automobile till we get ready."[66]

In 1914 Henry Chapman Mercer of Doylestown, Pennsylvania, antiquarian collector of every conceivable kind of Americana and founder of a unique museum of functional objects from yesteryear, designed a standardized four seasons fireplace that could be readily commissioned at his tileworks. Because his interest lay with seasonal labors, he linked the image on each seasonal tile with a traditional agricultural activity.[67] If, then, we judged only on the basis of these three early twentieth-century creations—Wister's *Virginian*, *Scribner's Magazine*, and Mercer's tileworks—we might be inclined to believe that Americans were reluctant to leave their rural past behind. They certainly sentimentalized it, and doing so in seasonal terms must have felt like an affirmation that they still lived in a Jeffersonian land of yeoman farmers (though seasonal cycles of rustic repetition may seem, from our perspective, like a curious way to cope with the astonishing realities of social change).

But 1914 also brought symptomatic signs, at least among the avant-garde with any affection for seasonal shifts, that the time had come for those engaged by modernism to look at the seasons in new ways that would be better suited to the nature of urbanized life. Early in 1914 the realist George Bellows painted *Love of Winter* (plate 24). In January, expressing the positive feelings about winter common among American artists, he had written to a friend that "there has been none of my favorite snow. I must always paint the snow at least once a year." When a major blizzard hit New York City on February 13, Bellows's opportunity arrived, and he seized it, making a lovely image that is, indeed, brightly descriptive rather than sentimental or nostalgic. Later that same year Man Ray, an American whose real name was Emmanuel Radnitzky (1890–1976), painted an enigmatic, modernist work in which a nude man and woman help a collapsing woman to leave some unspecified place. Its location does not matter. He titled the painting *Departure of Summer*.[68] (Man Ray would later become an expatriate, working primarily in France after 1921 as a leading Surrealist.) Sentimental Victorian presentations of seasonal life and experience were becoming passé. Creative responses to the four seasons would begin their accommodation to urban life and cultural change.

CHAPTeR 4

AMERICAN TRANSITIONS

THE SEASONAL SENSE OF PLACE,
TIME, AND IMAGERY

Seasonality as a cultural motif during the first half of the twentieth century did retain some notable signs of persistent continuity, especially in terms of nostalgia and the particularity of place. Nevertheless, new manifestations of creativity fostered elements of change as artistic and literary innovators engaged with the subject and as seasonal ruminations revealed fresh emphases upon color, light, sound, smell, and subjective concerns. Responses to the seasons became less romanticized during the twentieth century—not entirely, but significantly compared with responses in the nineteenth. All of these developments were symptomatic of a desire (even a need) to transcend the traditional iconography and literary imagery. By midcentury the four seasons were perceived less as a natural spectacle, perhaps, and more often as a metaphor for modern life—or else, increasingly as an allegorical antidote.

During the early decades of the new century, artists and writers intrigued by the seasons continued to display enthusiasm for particular settings and locations within a given region. Their admirers, however, called attention to the seasonal diversity of their own situations and home places, thereby indicating an expanding audience for creative work that provided insight into nature's variable beauty. Dialogues and conversations about seasonal change occurred. Certain prominent writers and artists "rediscovered" nature, both for themselves and especially in ways that would be meaningful for Americans who had lost touch with the natural world and needed to be reconnected by means of instructive books, essays, almanacs, paintings, and now photographs. In an era of accelerating social change, seasonal shifts still felt meaningful to writers and readers alike because transitions seemed increasingly germane to the circumstances of their own bustling lives and environments. By the 1950s an interesting divergence became apparent. Simultaneously, as modernism led poets and painters into more personal and allusive ways of describing (or employing) seasonal change for their own purposes, seasonality also expanded its visibility in

popular culture (as we shall see in chapter 6), ranging from fiction to children's art to the seasonal calendars produced by Norman Rockwell between 1948 and 1964.

Seeing Seasonal Sentiment and Diversity in America

In 1915, when the Panama-Pacific Exposition took place in San Francisco, architect Henry Bacon (best known for the Lincoln Memorial) designed a Court of the Four Seasons as a handsome variation on the seasonal theme in a venue, world's fairs, where it had not been much used previously. Interestingly, a description and rationale by a contemporary chronicler of the exposition does not even mention the presence of neoclassical statues symbolic of the seasons:

> As an Exposition feature, the Court of the Four Seasons is a decided innovation. At St. Louis, for instance, in 1904, everything seemed to have been done to excite, to overstimulate, to develop a craving for something new, to make one look for the next thing. Here, in the Court of the Four Seasons, one wants to stay. Most emphatically one wants to rest for a while and give one's self over entirely to that feeling of liberation that one experiences in a church, in the forest, or out on the ocean. I could stay in this court forever. To wander into this Court of the Four Seasons from any one of the many approaches is equally satisfactory.[1]

It would be premature, however, to suggest that at that moment the motif became comprehensively cohesive for the nation as a whole, because the realization of such a trend would require another half-century of literary projects and artistic creativity. Nevertheless, it is important to note the ways in which Americans were being made aware of seasonal diversity across a land so large and varied. In 1910 Clara Barrus published an article in the widely read *Century Magazine* based upon a camping trip that Burroughs and Muir (figure 4) had made together to the Grand Canyon. She titled it "With John O'Birds and John O'Mountains in the Southwest." The text made abundantly clear the differences in outlook between these two naturalists, one so closely associated with the Northeast and the other with the West but especially with Yosemite and the Sierra Mountains. Muir opened *My First Summer in the Sierra*, with these two sentences: "In the great Central Valley of California there are only two seasons—spring and summer. The spring begins with the first rainstorm, which usually falls in November."[2]

By the 1920s writer Bernard DeVoto would be praising the wondrous beauty of the four seasons in the mountain West. In 1935 Thomas Wolfe, the North Carolina novelist who had gone north to pursue his career, wrote passionately about the regional diversity of autumn in America.

Now October has come again which in our land is different from October in other lands. The ripe, the golden month has come again, and in Virginia the chinkapins are falling. Frost sharps the middle music of the seasons, and all things living on earth turn home again. The country is so big you cannot say the country has the same October. In Maine, the frost comes sharp and quick as driven nails, just for a week or so the woods, all the bright and bitter leaves, flare up: the maples turn a blazing bitter red, and other leaves turn yellow like a living light. . . . Meanwhile the Palisades are melting in massed molten colors, the season swings along the nation, and a little later in the South dense woodings on the hill begin to glow and soften, and when they smell the burning wood-smoke in Ohio children say: "I'll bet that there's a forest fire in Michigan." And the mountaineer goes hunting down in North Carolina. . . . October is the richest of the seasons.[3]

The seasonal sense of place during the early decades of the twentieth century still remained intensely regional, and the locus classicus continued to be New England. Wilson Flagg of Massachusetts had insisted until his death in 1884 that people who lived in warm, wet, and benign climates were denied the "poetical" opportunities that accompanied regions with significantly contrasting seasons, above all his own. As recently as the 1980s poet and essayist Maxine Kumin of Vermont would echo Flagg by declaring that "the impulse for poems is here for me, in the vivid turn of the seasons." She had in mind especially the long, harsh winters of northern New England.[4]

Artists John LaFarge, Childe Hassam, Frank Benson, and Willard Leroy Metcalf were New England contemporaries, all of them trained in Boston during the 1870s. Each one would paint the seasons, though in distinctive ways and locations, in the Northeast. Metcalf (1858–1925) is important in this context because, during the first quarter of the twentieth century, he managed to retain his New England identity yet achieved broad appeal to an expanding public wanting an American style devoid of European influences. As art historian Richard Boyle has put it: "The critics and the public found something very American about his landscapes. He was painting, celebrating even, a definite and specific American locale." Because Metcalf studied and worked in France and briefly in Algeria from 1883 until 1888, he greatly admired such European artists as Millet, Jules Bastien-LePage, and Monet. By the time of his death in 1925, however, his work was being widely praised for being so unlike Monet's! Royal Cortissoz, delivering the memorial address in Metcalf's honor, observed, "I return with a special appreciation to the Americanism of his art."[5]

Metcalf's primary focus was landscape painting in general and seasonal art in particular. Beginning around 1907 critics noticed his sensitivity to the distinctive attributes of each season and his concern for the qualities and effects of light, especially on foliage. He seems to have been equally interested in show-

ing the four seasons in transition and at their peaks, with perhaps a slight preference for the latter. Early in the century he produced such works as *Blossom Time* (1910, figure 46), *Midsummer Shadows* (1903–5), *October Morning* (1917), and *Winter's Festival* (1913). Charles Freer of Detroit purchased three of Metcalf's seasonal images that he viewed as a sequential triptych (*Blossom Time*, *The White Pasture*, and *October Morning—Deerfield, Massachusetts*), and they can now be seen at the Freer Gallery in Washington. In February 1923 Metcalf had a major exhibition of fifteen paintings, with a very strong and explicit seasonal emphasis, this time with greater stress upon seasonal transitions, exemplified by such works as *After the Frost*, *Indian Summer*, *Departing Autumn*, *The Last Snow*, and *March Thaw*. During the remaining two years of his life, Metcalf envisioned a suite of some twenty-five seasonal images, concentrating heavily upon New England's quadripartite scenery. The span of several decades that he spent seasonally with the artists' colonies in Old Lyme, Connecticut, and Cornish, New Hampshire, filled his mind with local images of southern and northern New England. He repeatedly returned to Cornish, where the snow season lasted longer, because of his growing interest in winter landscapes. Metcalf, whose parents lived in Maine, became known as "the poet laureate of the New England hills." In 1925 critic Catherine Beach Ely commented that "every picture of Metcalf's is a poignant portrait of a local American scene, so that a lover of New England landscape feels a grip at the heart in viewing a country church, an old homestead, a Spring, Autumn or Winter day of his."[6]

Marsden Hartley (1877–1943) also originated in Maine, but his relationship to seasonal landscape painting was, in a sense, exactly the opposite of Metcalf's: he was attracted to it quite early in his career and then turned away to various other motifs. Almost twenty years younger than the impressionist Metcalf, Hartley was influenced by the aesthetics of postimpressionism, especially its emotional intensity and vivid colors. Beginning in the autumn of 1908, Hartley painted an extensive series of views of the same mountains seen from North Lovell, Maine. These images rely upon color and atmosphere to highlight the seasons and what Hartley called "the God-spirit in the mountains." Prime examples in this series include *Carnival of Autumn* (plate 23), *The Blast of Winter*, *The Summer Camp*, *Silence of High Noon—Midsummer*, *Birch Grove: Autumn*, and *Winter Plumage—Blizzard*, all painted between 1908 and 1910. Hartley occasionally returned to seasonal landscapes in subsequent years, but he basically looked elsewhere for inspiration during his remaining decades. Robert Emmett Owen (1878–1957), another New Englander, painted countless landscapes of the seasons in his native region, mainly from the 1910s through the 1930s, but never an actual suite of the seasons in a given locale.[7]

Quite a few of these New Englanders seemed to feel that American regions with fewer seasons or less dramatic seasonal contrasts were in some sense inadequate, even inferior. Henry Beston, who produced two important seasonal

FIGURE 46
Willard Leroy Metcalf, Blossom Time *(1910), oil on canvas. Freer Gallery of Art, Smithsonian Institution, Washington, D.C. Gift of Charles Lang Freer, F1915.27.*

books and lived during his mature years on a farm in Nobleboro, Maine, read *A Northern Countryside* by Rosalind Richards in 1935. It gave him great pleasure, and he wrote to her that he felt "particularly moved with the description of the flowering time of trees, that floral season which so few really enjoy or heed. What a lovely time it is, and nowhere lovelier than in northern New England." Publishing a book that same year, Donald Culross Peattie (figure 47) claimed that Thoreau had "immortalized" spring in New England despite its being much less lovely than spring in the South. As late as 1955 Gladys Taber exclaimed that "every season has its own glory in New England [but] . . . October is the dramatic month."[8]

Henry Beston (1889–1968) was a young, unmarried Harvard graduate when, in 1926, he decided to spend several autumn weeks in a tiny, two-room, hand-

built house near Eastham on the east-
ern coast of Cape Cod. He found the
beauty of the site and his contemplative
life there so fulfilling that he decided to
stay for a cycle of the seasons and write
a book about it organized accordingly.
*The Outermost House: A Year of Life on
the Great Beach of Cape Cod*, published
in 1928, is so artfully composed and so
keenly observant that it swiftly came to
be regarded as a classic of modern na-
ture writing, even though its under-
lying sentiments were in many respects
deeply antimodern. Beston explained
his purpose at the beginning of his chap-
ter devoted to midwinter. Between the

FIGURE 47
*Donald
Culross
Peattie
(1898–1964) in
the late 1930s.
University
of California
at Santa
Barbara,
Special
Collections,
and courtesy
of Noel
Peattie.*

lines he quietly scorns those urban dwellers who are utterly out of touch with
the natural world: "A year indoors is a journey along a paper calendar; a year in
outer nature is the accomplishment of a tremendous ritual. To share in it, one
must have a knowledge of the pilgrimage of the sun." Much of the book's ap-
peal arose from the sense that Beston had combined close observation of na-
ture—from meteorology to marine birds—with a spiritual quest.[9]

The book received an exceedingly cordial welcome in major venues. Writing
for the *New York Times*, Brooks Atkinson called it "one of those priceless chron-
icles," and a reviewer for the *New York Herald Tribune* found it "written with
simplicity, sympathy, and beauty." Only Freda Kirchwey, editor of the *The Na-
tion*, wondered whether "nature lovers, or amateur naturalists, [must] always
turn mystic?" She objected to what she called Beston's "editorializing," mean-
ing that he commented on the possible implications of what he was experi-
encing, the very quality that has always made Thoreau's writing so cerebral yet
endearing.[10]

Twenty years later Beston gathered his monthly columns from *The Progres-
sive* into an engaging book that harkened back to his first, but from an interior
rather than a coastal perspective on seasonality.

> Country living is a pageant of Nature and the year; it can no more stay fixed
> than a movement in music, and as the seasons pass, they enrich life far more
> with little things than with great, with remembered moments rather than
> the slower hours. A gold and scarlet leaf floating solitary on the clear, black
> water of the morning rain barrel can catch the emotion of a whole season,
> and chimney smoke blowing across the winter moon can be a symbol of all
> that is mysterious in human life.

Still the "mystic," I suppose; but Beston must have felt gratified by a letter he received from Rachel Carson (figure 48) in 1954. After telling him how often she reread *The Outermost House*, she explained that while writing her own four seasons book, *Under the Sea-Wind*, in 1940–41, she spent part of a summer at Woods Hole on the Cape, "and one day drove to Eastham and walked down the beach to find the little house and the surroundings with which I felt so familiar through your pages." She then acknowledged that owing to the courtesy of a friend, she had only recently seen Beston's review of her uniquely oceanic seasonal cycle. "I found it the most beautiful, perceptive, and deeply satisfying one I had read, and because of my feeling about 'The Outermost House,' I was so grateful it was you who had written it."[11]

Even though readers all across the country could appreciate the appealing books and essays of these nature writers, it is clear from their correspondence that admiration did not diminish their sense of pride and fascination with seasonal change in areas well beyond the Northeast. The correspondence of John Burroughs provides an excellent measure of those sentiments because he received so much fan mail, and it has been carefully preserved. By the 1880s his essays actually began referring to letters and observations received from places ranging from the Deep South to the Great Plains. In 1884 a preacher's wife in Payson, Illinois, explained, "We think it very strange that you are not more interested in the west. There is nothing of interest here in winter or early spring. But if you would get here by the first of May & stay all Summer you would have some new pictures." In 1920 a correspondent in North Carolina indicated, "I am a little prejudiced in favor of my home country here in Asheville, even in this January season, perhaps; because the clouds over the great old Blue Ridge mountains, which fall back tier upon tier in the distance to the West from my windows, are ever changing visions of beauty. . . . Our occasional rough and cold day serves to make even more delightful our usual bright and lovely days, of the temperature of the Northern May."[12]

The erstwhile Confederacy had its own sentimental and proud reasons for engaging the four seasons motif. In 1912 the Confederate Memorial Association commissioned a French artist, Charles Hoffbauer (1875–1957), to paint four large murals on the walls of Battle Abbey's south gallery in what is now the Virginia Historical Society. Beginning the project in 1913, he was interrupted by service in the French army during the Great War but came back and completed the murals in 1920. When he returned to Richmond late in 1918, however, he wiped out much that he had done before the war, declaring that combat experience had given him a very different sense of the tribulations that southerners must have endured during the Civil War. *Spring* is devoted to early successes of the Confederacy in 1861–62 and shows Stonewall Jackson reviewing his troops in the Shenandoah Valley. *Summer* (figure 49), the dominant and most familiar of the four, shows Robert E. Lee astride Traveller with most of

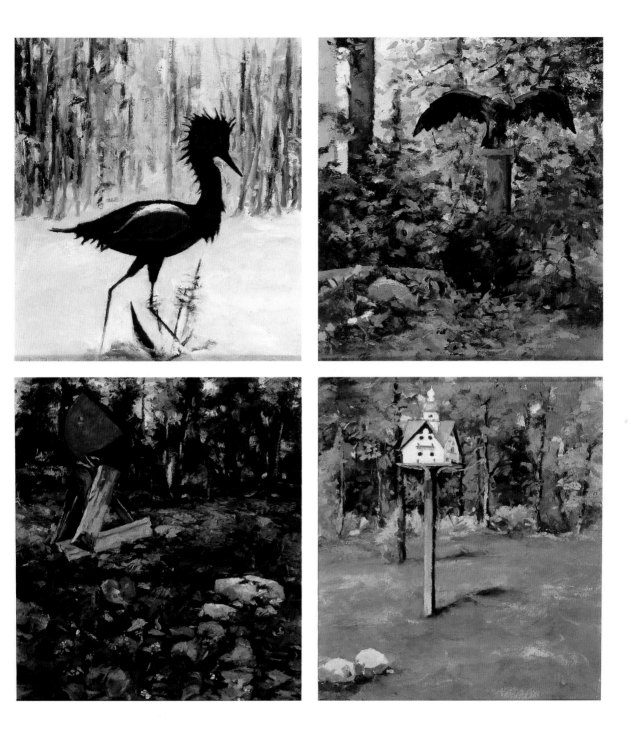

PLATE I. *Cuba Ray,* Four Seasons at "Il Nido" *(2000), oil on board. Collection of the author.*

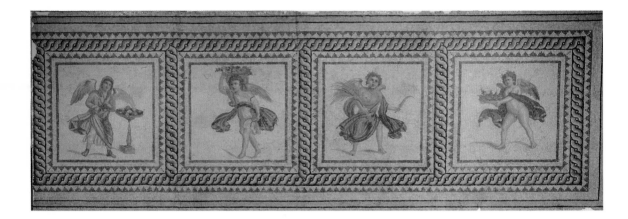

PLATE 2. *Section of a floor mosaic from Roman Antioch depicting the four seasons (late second to early third century A.D.), stone and glass. Virginia Museum of Fine Arts, Richmond. The Adolph D. and Wilkins C. Williams Fund. Photograph by Wen Hwa Ts'ao. © Virginia Museum of Fine Arts.*

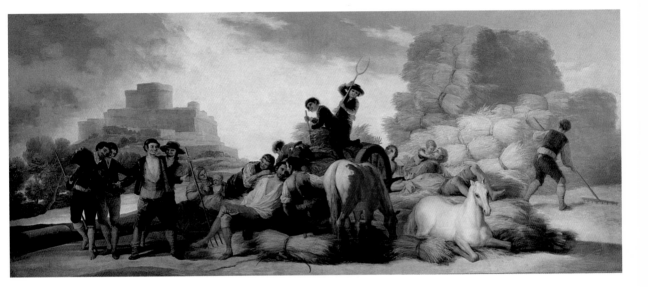

PLATE 7. *Francisco Goya*, La Era (The Threshing Floor) *(1786–87), oil on canvas. The Prado Museum, Madrid.*

PLATE 10. *George Harvey*, A Road Accident. A Glimpse Thro' an Opening of the Primitive Forest, Thornville, Ohio *[Summer]*, *engraved aquatint from George Harvey and William James Bennett*, Harvey's Scenes of the Primitive Forest of America *(1841)*. *Division of Prints and Photographs, Library of Congress.*

PLATE 11. *John F. Francis,* Winter *from* The Four Seasons *(1849), oil on canvas. Private collection.*

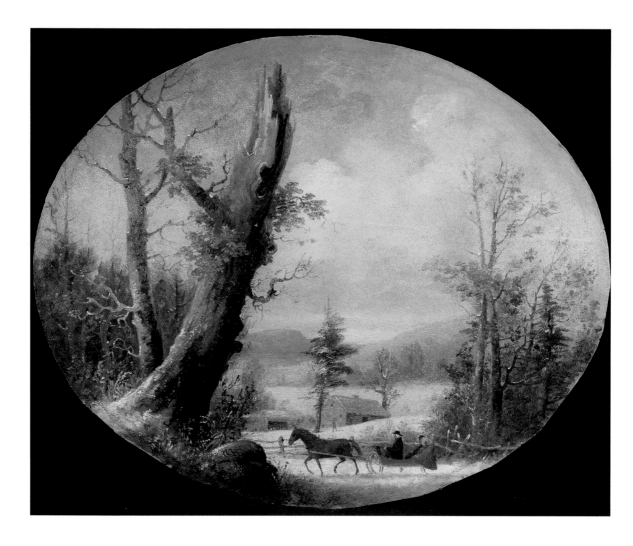

PLATE 12. *George Henry Durrie*, Winter *(1855), oil on board. Courtesy of the Richard York Gallery, New York.*

PLATE 13. *Rosewood table with four seasons caryatids (1860–62), the Morse-Libby House, Portland, Maine.*

PLATE 14. Spring.

PLATES 14–17. *Jasper Cropsey,* The Four Seasons *(1879), oil on canvas.*
Private collection, courtesy Spanierman Gallery, LLC, New York.

PLATE 15. Summer.

PLATE 16. Autumn.

PLATE 17. Winter.

PLATE 18. *Jasper Cropsey,* The Four Seasons *(1883), oil on canvas.*
The Newington-Cropsey Foundation, Hastings-on-Hudson, New York. Photograph by Jerry L. Thompson.

PLATE 19. *Dwight W. Tryon*, Springtime *(1892), oil on canvas.*
Freer Gallery of Art, Smithsonian Institution, Washington, D.C.: Gift of Charles Lang Freer, F1893.14.

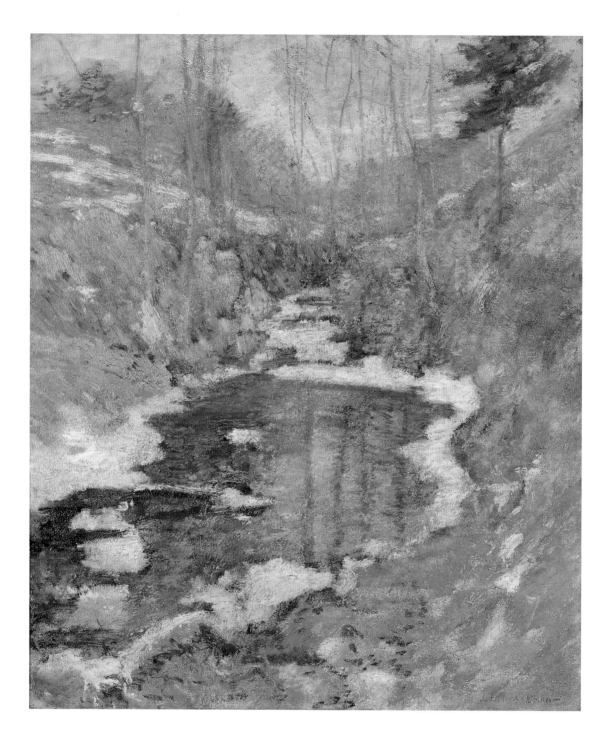

PLATE 20. *John Henry Twachtman,* Hemlock Pool *(ca. 1900), oil on canvas.* © *Addison Gallery of American Art, Phillips Academy, Andover, Massachusetts. Gift of anonymous donor, 1928.34. All rights reserved.*

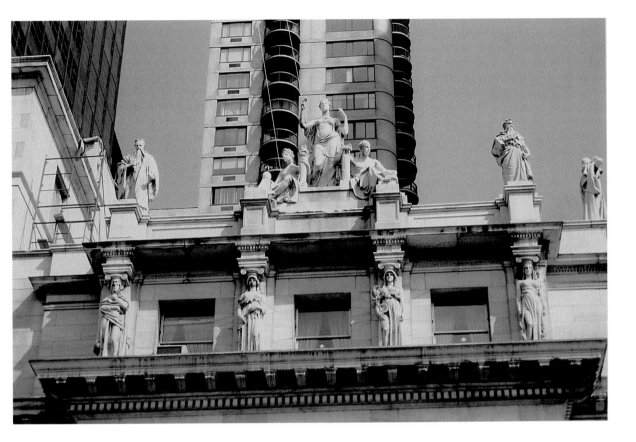

PLATE 21. *Thomas Shields Clarke, female statues of the four seasons (1897–1900),* marble.
New York Appellate Court House, Madison Avenue at 25th Street, Manhattan. Photograph by the author.

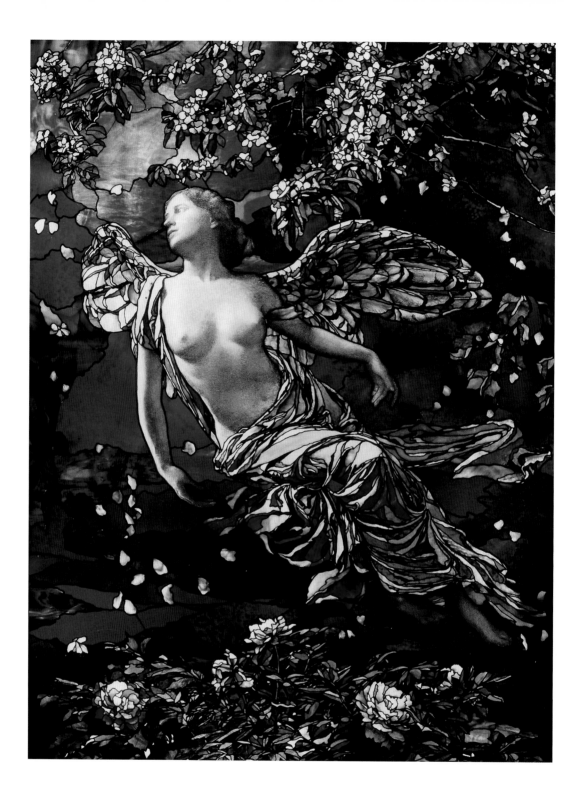

PLATE 22. *John LaFarge,* Spring *(1902), glass mural. Philadelphia Museum of Art: Gift of Charles S. Payson.*

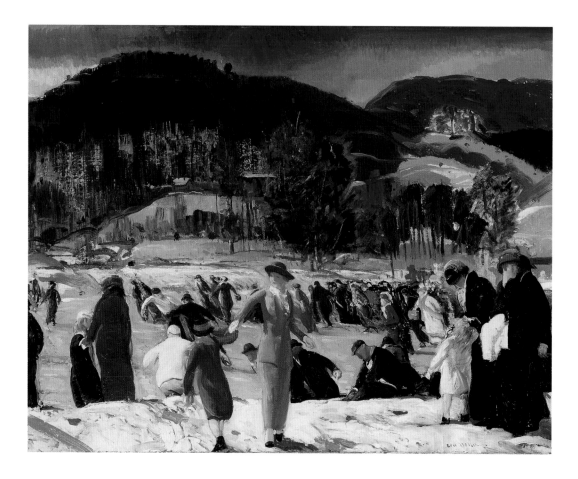

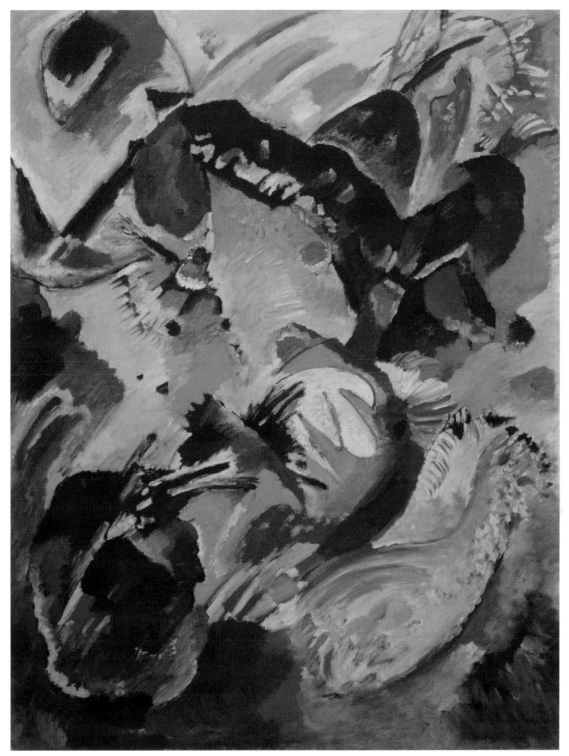

PLATE 25. *Wassily Kandinsky,* Panel for Edwin R. Campbell, No. 2 *("Autumn") (1914), oil on canvas. Museum of Modern Art, New York.* © *2004 Artists Rights Society (ARS), New York/ADAGP, Paris.*

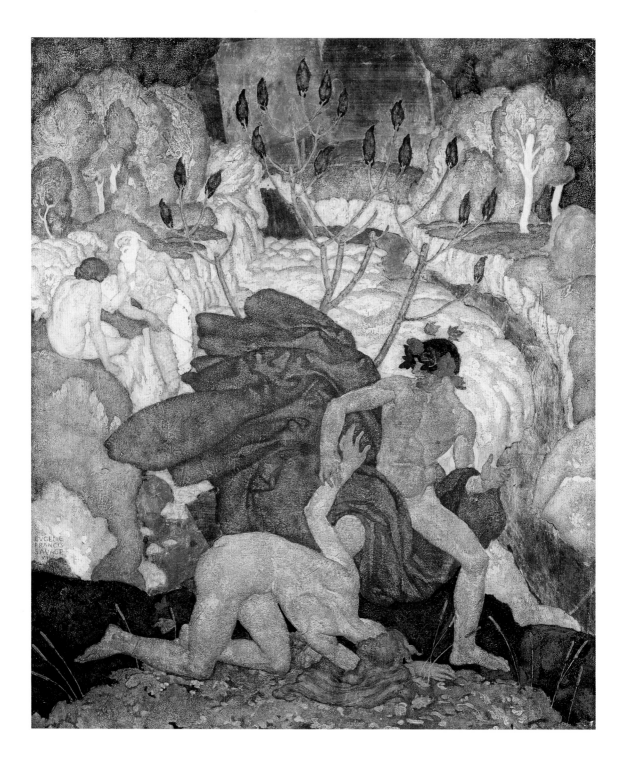

PLATE 26. *Eugene F. Savage,* Bacchanal (The Four Seasons), *(ca. 1920), oil on canvas.*
Indianapolis Museum of Art, Gift of the Friends of American Art.

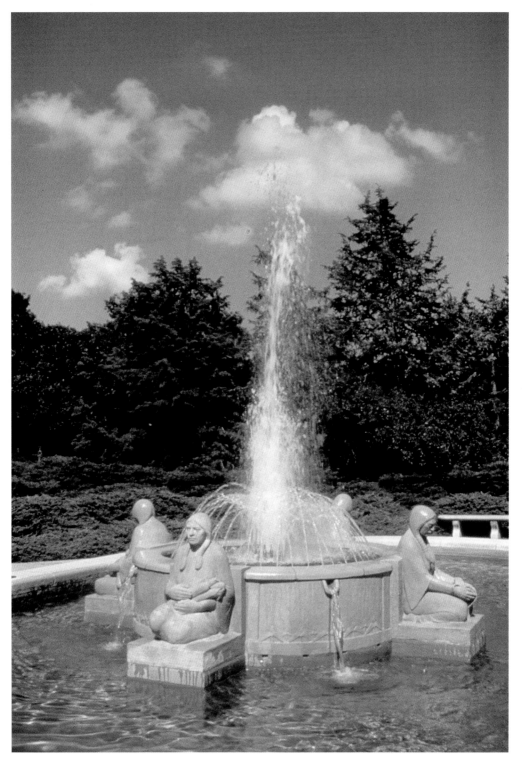

PLATE 27. *Christian Petersen,* Fountain of the Four Seasons *(1939–41), Bedford limestone.*
Iowa State University, Ames.

PLATE 28. *Charles Burchfield,* The Coming of Spring *(1917–43), watercolor on paper mounted to presswood. The Metropolitan Museum of Art, George A. Hearn Fund, 1943. (43.159.6) Photograph © 1986 The Metropolitan Museum of Art.*

PLATE 29. *Charles Burchfield*, The Four Seasons *(1949–60), watercolor. Krannert Art Museum and Kinkead Pavilion, University of Illinois, Urbana-Champaign. Festival of Arts Purchase Fund 1961-2-1.*

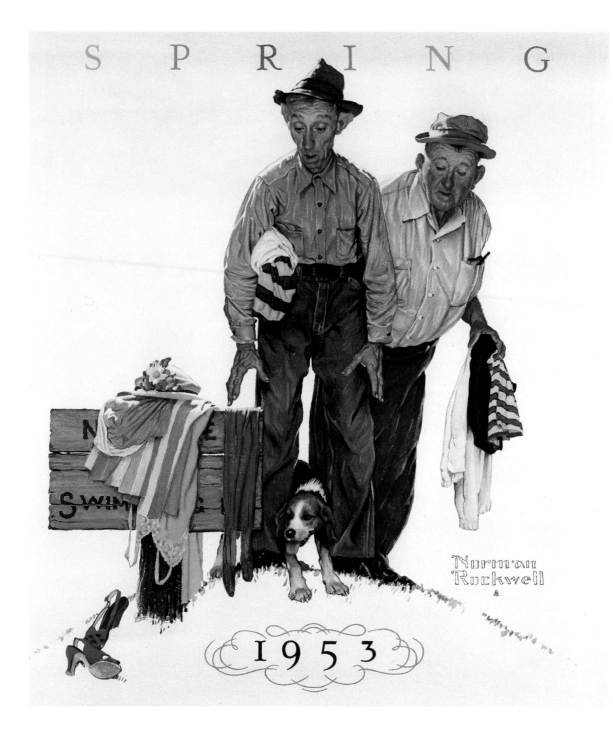

PLATE 30. *Norman Rockwell, "Spring" from* Old Men and Dog *calendar (1953). Collection of the author.*

PLATE 31. *Four seasons benches, Taos Plaza, New Mexico. Photograph by the author.*

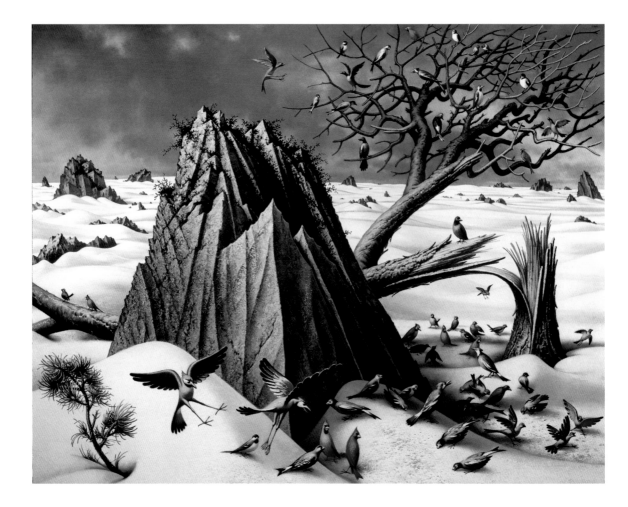

PLATE 32. *Peter Blume,* Winter *(1964), oil on canvas. Collection of Joann and David Honigman.*
Photograph courtesy of Hirschl & Adler Galleries, New York.

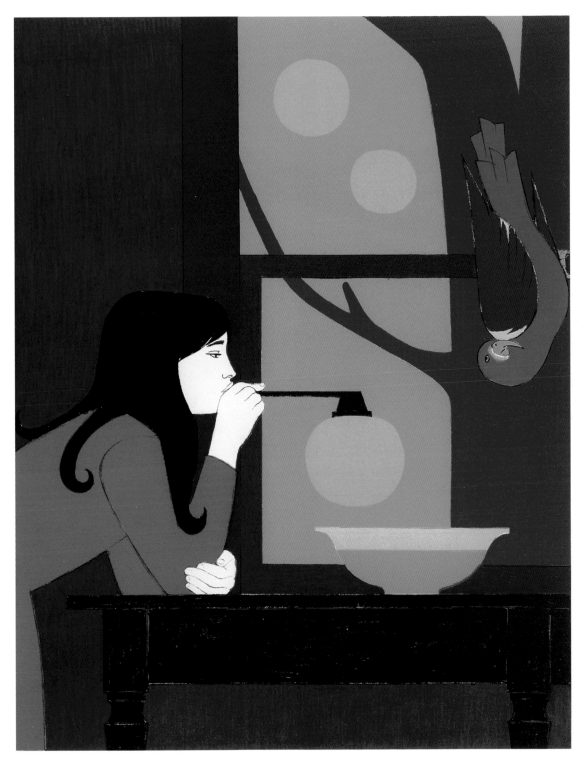

PLATE 33. *Will Barnet*, Silent Seasons—Summer *(1968), screen print.*
Collection of the author and courtesy of the Alexandre Gallery, New York.

PLATE 34. *Marc Chagall,* The Four Seasons *mosaic at the Bank One Plaza, Chicago (1972–74), glass, stones, and cement. Photograph courtesy of Elizabeth H. Francis.*

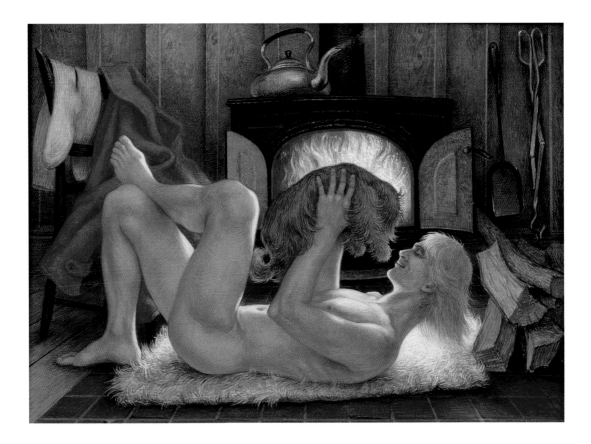

PLATE 35. *Paul Cadmus,* Winter *(Version #2) (1985), egg tempera on canvas panel.*
Private collection, photograph courtesy of the DC Moore Gallery, New York City.

PLATE 36. *Anne Abrons,* Four Seasons Allegory *(1982), oil on canvas. Collection of Richard A. Born, Chicago.*

PLATE 37. *William Harper,* Fall *from* Toasting Goblet for the Four Seasons *(ca. 1983), silver, gold, and cloisonné. Private collection, New York.*

PLATE 38. *Jasper Johns,* Summer *from* The Seasons *(1986–87), encaustic on canvas.*
© *Jasper Johns and ULAE/Licensed by VAGA, New York.*

PLATE 39. *Thomas Cornell*, Fall *from* The Four Seasons *(1986), oil on canvas. Portland Museum of Art, Maine. Gift of John Hancock Mutual Life Insurance Company, 1992.36. Photograph by Dennis Griggs.*

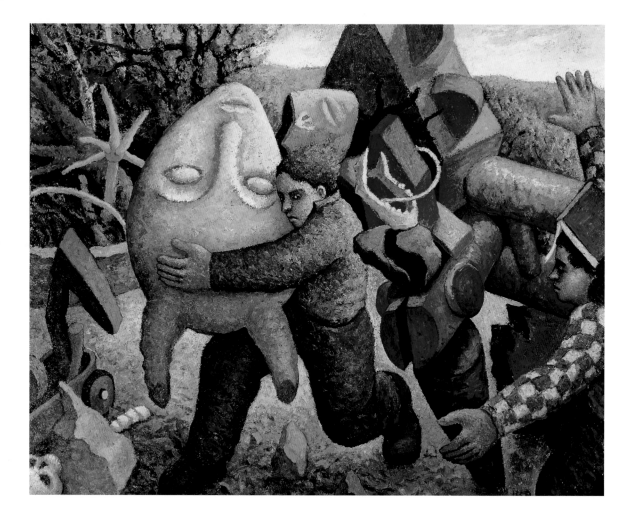

PLATE 40. *Robert Jessup,* Fall *from* The Four Seasons *(1986), oil on linen.*
Courtesy of the artist and The University of Virginia Art Museum.

PLATE 41. *David Campbell,* Summer *(1987), oil on canvas. Private collection and courtesy of the artist.*

PLATE 42. *David Sharpe,* The Gleaners *(1991), oil on canvas. Collection of the artist.*

PLATE 43. *Jennifer Bartlett,* Summer *(1993), from a set of four color silkscreens on Kurotani Hosho paper. Courtesy of the artist.*

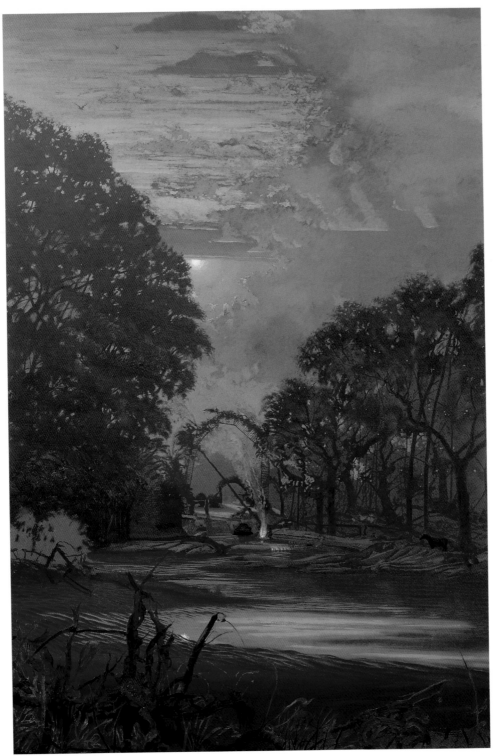

PLATE 44. *James McGarrell,* Fall *from* River Run *(1990), oil on canvas.*
Courtesy of the MCI Building, St. Louis. Photograph by Casey Rae of Red Elf, Inc.

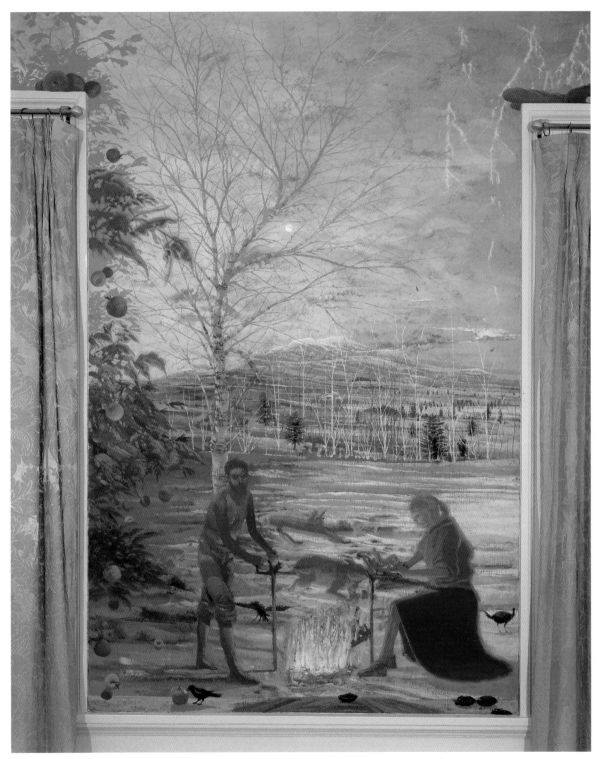

PLATE 45. *James McGarrell, "Fall into Winter" detail from* Redwing Stanza, a Painted Room *(1995),
oil on linen canvas on plaster. Courtesy of the artist, Newbury, Vermont.*

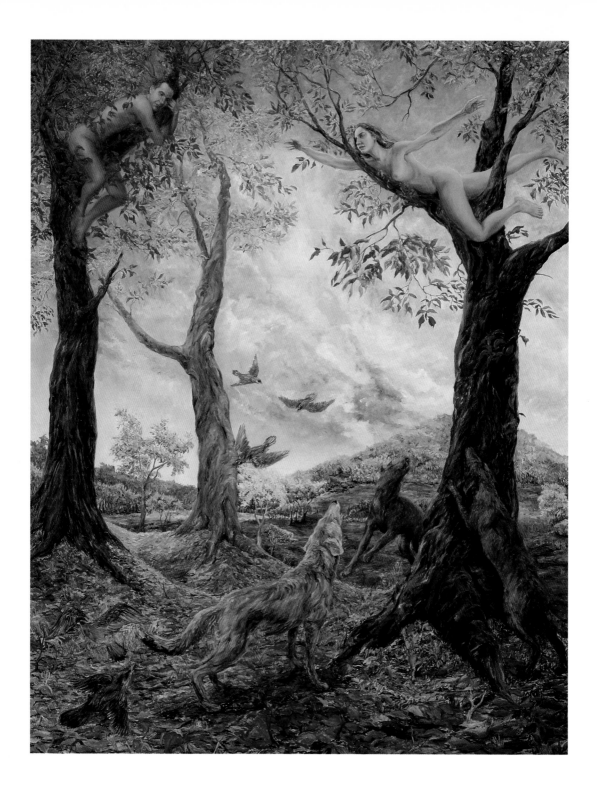

PLATE 46. *Lisa Zwerling,* Fall Flight *(1995), oil on canvas. Courtesy of the artist.*

PLATE 47. *Felix de la Concha*, One Season from Each Corner (West Second and Michigan Avenues) *(1995–96), oil on canvas mounted to wood. Columbus Museum of Art, Ohio. Museum purchase with funds donated by Louis W. Crane.* © *2002 Felix de la Concha / Artists Rights Society (ARS), New York.*

PLATE 48. *Thomas Buechner, four seasons perfume bottles (1999), hand-blown leaded glass. Collection of the author. Photograph by Robert Barker.*

his generals in 1862–63, when the Confederacy had achieved its greatest strength. *Fall* is linked to 1864, when major defeats had occurred but the valor of J. E. B. Stuart continued to be a source of pride: he leads his cavalrymen on a foray through the Virginia woods. *Winter* is the grimmest scene, relieved somewhat by the fact that the entrance to the gallery is in the wall on which it is painted and lessens the amount of space devoted to southern suffering amid snow and final defeat. Hoffbauer also decorated some walls of the State Capitol in Jefferson City, Missouri. He later worked for Disney Studios and was buried in Hollywood, California. His *Four Seasons of the Confederacy* remains a major showpiece for unreconstructed southerners and a curiosity, perhaps, to other visitors in the former capital of the Confederacy.[13]

FIGURE 49
*Charles
Hoffbauer,*
Summer
from The
Four Seasons
of the
Confederacy
*(1919–20),
mural.
Virginia
Historical
Society.*

Southerners certainly had no monopoly on nostalgia associated with seasonal memories and artistic endeavor. One of the strongest bonds between John Burroughs and Henry Ford involved their shared affection for memories of harvesting maple sugar in late winter, building stone walls in late spring after the planting had been done, and cutting hay in summertime. Well into the 1920s Ford indulged an annual summer ritual of gathering his relatives in the Detroit area to mow hay using only scythes. For Ralph Waldo Emerson, living in nature meant, above all, living in the present in order to "seize the day." But for many twentieth-century naturalists, and especially seasonal writers, there was a sense of "lost yesterdays," lamentation for a way of life long gone. Nostalgia persisted as one of the most enduring motifs in the entire body of American seasonal literature.[14]

The stimuli for so much sentimentalism came from numerous and varied sources, many of them actually quite welcome to the mainstream of American society. Rapid changes in technology and culture fostered the romanticization of seasonality as a quaint "relic" of yesteryear. The most basic features of the American diet, for example, had been fundamentally regulated by seasonal realities until the end of the nineteenth century. Suddenly, with the advent of refrigerated railroad cars and commercial canning, a great many foodstuffs became available on a year-round basis, even though they were not necessarily fresh. Seasonality became much less of a factor in American food consumption by the beginning of the twentieth century. Similarly, by the end of the nineteenth century the agrarian rhythms of traditional seasonal festivals had be-

come largely meaningless to city dwellers, or at best merely symbolic if noticed at all. Recalling his youth in the 1920s and 1930s, historian Henry F. May considered Valentine's Day, Easter, the Fourth of July, Halloween, and Thanksgiving to have been the significant lines of demarcation during the year, rather than plowing, haying, harvesting, and putting away adequate supplies of wood and meat, which had been the dominant concerns for centuries. Writing in the mid-1950s, C. Wright Mills observed that prosperity and growing ease of travel had radically altered the customary relationship between large numbers of Americans and the seasons. Many could afford to go and be where the seasons were most attractive and thereby escape the "bad" seasons.[15]

A different yet related reason for the surge of sentimentalism about nature and its cycles arose from the perceived increase in secularism at the close of the nineteenth century. As a broadly cultural and spiritual matter, this increase has been well documented by historians and others.[16] But we can follow its course with greater particularity by looking at the naturalists themselves. If we reach all the way back to Timothy Dwight's long pastoral poem, "Greenfield Hill" (1794), we find that he evoked the kingdom of God on earth in his distinctive vision of what villages and towns should look like in a sanctified America. Wilson Flagg concluded his last book, *A Year with the Birds* (1875), by praising the beauty of all the seasons and referring to God as "the Invisible Artist"—invisible but not yet disappearing. John Muir was a deeply religious man who identified God with nature in a manner not very different from James Thomson, a fellow Scot. But John Burroughs, who lived into the 1920s, was not religious, a fact that disconcerted many of his admirers. "I am sensitive to the physical sphere," he wrote to a friend, "I am wonderfully sensitive to people, to all places of nature, the weather, the seasons, the place, the household etc. Probably I am not nearly sensitive enough in the spiritual side." Very few of the twentieth-century naturalists interested in seasonality were believers in any vocal or traditional sense. It is apparent that many of their avid readers, like them, replaced orthodox religion with what Burroughs called "the Gospel of Nature."[17]

Before we leave Burroughs and Muir behind, it is instructive to compare the different ways in which they responded to fame early in the twentieth century when they became such iconic and idealized figures. Both men sat for countless portraits, busts, and posed photographs (figure 4). In 1902 Muir sent this passage to a confidant: "In many ways it is a weary burdensome thing to be known in books. Lately some friends worried me into helplessness & made me sit for a bust. . . . Setting here trying to write I often feel that I must escape to the wilderness once more." Compare that with Burroughs's sitting patiently for numerous portraits and with the kind of mash mail, such as the following, that he reveled in: "I congratulate you on all the mystic secrets you have been told, on all the Springs you have watched warm into Summers, on all the Summers you

have seen mellow into Autumn, on all the Autumns you have looked on as they fell asleep in Winter, & on all the winters you have known were through all their silence softly, slowly awakening again to Spring." Although written by a stranger, the letter was signed "Yours with love."[18]

Two other contemporaries, half a generation younger than the competitive Johns, provide a different kind of contrast in terms of the need for and the uses of seasonality. Samuel C. Schmucker (1860–1943), a prolific biologist with an extended career at a teachers' college in West Chester, Pennsylvania, was descended from a long line of Lutheran clergymen and wove their orthodox views into his widely read work, *Under the Open Sky: Being a Year with Nature* (1910). The book opens with these two sentences: "The nature lover's year begins in March. That is when God's year begins; and anyone who loves God's out-doors cannot but begin his year when it does." Nature and the seasons were entirely God's creation and gift to mankind.[19] Joseph Hergesheimer (1880–1954), a popular novelist, was born in Philadelphia, but by the time he achieved fame and fortune in the early 1920s, his secular passion had become the restoration of a handsome eighteenth-century home in exurban Pennsylvania, and the telling of an autobiographical narrative in which he blended the story of remaking the home to suit an aesthetic nostalgia with his feelings about writing and leisure at different seasons of the year. The book is formally structured according to the four seasons, starting with autumn. Overloaded with wistfully arch enthusiasms, it would have to be considered an acquired taste.[20]

For men like Hergesheimer and Ray Stannard Baker (1870–1946), best known as a muckraking journalist during the Progressive era and as a multi-volume biographer of Woodrow Wilson, the eighteenth-century notion of rural "retirement" was immensely appealing, and they established a pattern that Henry Beston, E. B. White, Hal Borland, Edwin Way Teale, and Archibald MacLeish would all pursue. As a young man Baker had devoured the books of Donald Grant Mitchell, especially his *Dream Life: A Fable of the Seasons*. Praising rusticity in words that could readily have been written by John Burroughs, Baker began writing the adventures of an "unlimited farmer" in 1906, and his *Adventures in Contentment* appeared the following year under the pseudonym David Grayson. Between 1907 and 1942 a total of nine volumes of these adventures appeared, with Grayson emerging as a kind of wandering farmer living somewhere in New England. Now forgotten, the books sold millions of copies in the United States and the British Commonwealth. They were also translated into several foreign languages. David Grayson Clubs sprang up spontaneously in different parts of the country. Noting his cultural similarities to Mitchell, in 1914 Vachel Lindsay referred to Baker as "Ik Marvel Afoot." While lauding rustic simplicity and the need to live close to nature, Grayson also looked to technology to help people lead the simple life more easily! His writing owed much to a long tradition of picaresque English heroes, and in several respects his out-

look is reminiscent of the ambivalent views about progress and "retirement" associated above all with James Thomson.[21]

Several of Baker's book titles, chosen in his guise as Grayson, are symptomatic. *Adventures in Solitude* appeared in 1931 and *The Countryman's Year* in 1936. The self-designation of "countryman" seems to have a very long provenance, by the way, dating back to sixteenth-century England, at least, where it was a synonym for "husbandman," a farmer who perhaps had sufficient help so that he did not need to perform *all* of the manual labor on his freehold. When Roger Sherman of Connecticut wrote tracts in favor of constitutional ratification in 1788, he used the pen name "A Countryman," which carried the dual inference of a rustic who also supports his country. Thoreau adopted "countryman" in reference to his predilection for rural living. So did John Burroughs. Much later Hal Borland would use the term constantly, virtually as a signature, and Gladys Taber, writing in rural Connecticut, referred to herself as a "countrywoman."[22]

Modes of Metaphor in Writing about the Seasons

American nature writers who called themselves countrymen wrote in a variety of styles, and could be fairly self-conscious about their craft. Burroughs repeatedly insisted that the literary naturalist observed and admired phenomena, whereas the "nature-fakir" personified and humanized such things inappropriately. The former kept human desires and emotions separate from the empirical rendering of nonhuman nature. The "nature-fakir" conflated and confused the two. In essays titled "Nature and the Poets" (1879) and "Real and Sham Natural History" (1903) Burroughs criticized writers like John Greenleaf Whittier for depicting nature inaccurately and Ernest Seton Thompson for giving animals personalities that were all too human.[23]

Many who wrote about the seasons were inclined to ascribe distinctive sounds to each one. Winter is often spoken of as the season of silence because there is not as much wildlife around, and snow muffles sound, yet there were frequent references to the groaning of trees or the creaking of limbs in rugged wind storms. Spring was invariably the season of spring peepers and bird songs, or as Wilson Flagg phrased it: "the music of the animated tenants of the streams, woods, and orchards." Summer has usually been associated with the burps of big frogs, but also the racket made by droning cicadas, locusts, and crickets. Autumn has most often been linked to the honking of geese hovering overhead, and the harsh cry of grackles gathering as huge flocks in September. Only the sound of owls at night persists from fall into winter.[24]

Ever since the Renaissance, at least, artists have associated certain colors with each season, and doing so carried over into the writings of naturalists, as we have seen already with Thoreau. The most traditional associations have been green with late spring and early summer; golden yellow with mid- and

late summer because of the wheat and corn harvest; reds, purples, and rust with autumn; white, blue, and icy silver with winter. Gladys Taber felt that a different color moon seemed most appropriate for each season: "A full pink moon— April's autograph in the sky—shines down over Stillmeadow. Remembering the white gold moon of January, the ball of pale copper at harvest time, June's daffodil eye of night, I ask myself: Who can say which is the most beautiful?" In 1974 the artist Brice Marden (b. 1938) decided to paint a quartet that he titled *Seasons—Small Version*. Using oil and wax on paper mounted on canvas, he simply painted four squares, each one a solid color. For spring he chose off-chartreuse (with a touch of mustard); for summer, green; for fall a bluish sea green; and for winter he used deep teal. Minimalism, to be sure, but there may well have been "method in his madness." Ever since antiquity the square has sometimes served as a symbol for nature in Western culture, and in East Asia the square has been used as a representation of the physical world.[25]

Smells also recur frequently in association with particular seasons. Burroughs recalled picking wild strawberries among "the fragrant memories of boyhood." Mabel Osgood Wright noted that "the autumn night has few voices and fewer perfumes. . . . The owl remains persistently and mingles his infrequent hooting with the cries of wild ducks and geese signalling the way to salt water; while the essence of decaying vegetation is the only perfume." Henry Beston extended this kind of imagery farther than most, but very gracefully.

> The seasons have their fragrance. In summer there is a smell of greenness, of heat, and grass and surface dust; in autumn the fragrance is one of cold dews and ripeness, of fallen leaves and the tang and ferment of leaves, of a world smouldering and withering away in the year's invisible fires. Sometimes the good hearty reek of some field crops is carried to the nose, and when an evening wind humid with a threat of rain blows through our kitchen windows a good, honest, country smell of cabbages. With winter will come a new earth and seasonal smell, fierce and keen and very real—the smell of snow. What a world of the nose the country can be from the cidery smell of apples rotting in the brown, frosty grass under a wild apple tree to the honorable aroma of freshly dug onions spread on sacking in the autumn sun.[26]

Edwin Way Teale would carry such sentiments forward into the following decades: "Each season fills the air along our path with its own particular scents. Midsummer brings the intensely sweet fragrance of the tiny white flowers of the bedstraw; autumn the rich perfume of the ripe fox grapes; winter the smell of snow in the air, of hickory smoke on the wind; spring the first faint scent of a distant skunk amid the melting snow, then the primeval odor of wet fresh-turned earth, then the perfume of the returning wildflowers."[27]

Clearly, seasonal evocations have long been commonplace, especially since the mid-nineteenth century, and not just among professional writers. During

the great California gold rush and subsequent mining booms in the West, the phrases "season of indulgence" and "season of regret" were commonly used by prospectors to describe the ongoing cycles of boom and bust. Psychological "seasons" as states of mind, being, and behavior have been with us for quite a while. At spas like Saratoga Springs and at Catskill resorts in New York, beginning in the late nineteenth century, references to "the season" were commonplace, resonant with meaning, and found their way into descriptive book titles. On a more sinister note, we know that episodes of lynching rose during the summer months when the hard work of planting was done and only the lucrative harvest remained. "Now is the season," explained an editor in Georgia, "when the tenant with the best crop gets run off the place."[28]

Among writers as well as artists, especially in the twentieth century, reference to the "progress of the seasons," an older usage, gradually gave way to the more metaphorical image of the seasons as a "procession." The nature-loving artist Charles Burchfield (1893–1967) used both. In 1916 he described in his journal one of his earliest objectives as a young man: "To design a plant which may suggest the progress of the seasons—Or a tree showing winter at the bottom, Spring in the lower branches, Summer in the upper with Autumn crowning the top with fruit." Seven years later, stuck at a job he disliked in Buffalo designing wallpaper and yearning for the emotional resonance of his early efforts at painting out of doors, he regretted that "that period, when the whole world, the procession of the seasons, is packed with wonder, must pass." We will return to Burchfield presently because that devoted reader of Thoreau was more deeply engaged by seasonal change and transitions than any other American artist.[29]

Laura Lee Davidson evoked the seasonal procession in her *Winter of Content* (1922), and Hal Borland (figure 11) used the image, in various forms and ways, more than anyone else. In a piece called "Autumn and the Color," he "thought of the harvest and the unaltered progression of the seasons." Five years later, in "October and a Song," he remarked that "the seasons come to fulfillment, not necessarily for the delight and satisfaction of man but in their own ineluctable procession."[30]

At least one other analogy has persisted in the United States for more than a century and a half: cyclical change as a tidal pattern of swelling and ebbing. We find it in Thoreau's journals from the outset and in John Burroughs's essay "Autumn Tides," which actually describes all of the seasons with an array of metaphors. In discussing the quality of sunlight in spring and fall, for example, Burroughs wrote that "one is the kindling fire; the other the subsiding flame." In her 1946 seasonal novel titled *The Bridge of Years*, May Sarton used the imagery of tides ebbing and flowing as a metaphor for the transition from spring to summer. In Rachel Carson's moving marine account of "the progress of the ocean's seasons—the old, unchanging cycle of the sea," such analogies abound,

as one might expect. And Edwin Way Teale used the analogy recurrently in his seasonal quartet. The seasons, he announced at the beginning of volume 1, "like greater tides, ebb and flow across the continents."[31]

A parallel pattern in the expository prose of these writers emphasizes what Wilson Flagg called "that constant play of light and shade" peculiar to each season, and especially the asymmetry between moments in time equidistant from the equinoxes and solstices. Mabel Osgood Wright made an astute contrast between moments in the spring and autumn when the length of days are comparable but the temperatures and shadows differ. In February 1946 Charles Burchfield made a similar reckoning in his journal:

> The other day, starting with Dec. 21, and working in opposite directions in time, I placed opposite each other the corresponding dates in their distance from the sun. Thus today is equivalent in the slant of the sun's rays to Nov. 2—And yet, what a different quality to the sunlight; now it is powerful, waxing and expanding, and in November, it is fading, and waning. It cannot be just a state of mind. I am sure that if after a period of oblivion, I should suddenly be set down on a sunny day in February (even if there were no snow) I would know what season it was.

Hal Borland remarked of the autumnal equinox that it was an occasion "when day and night are supposed to be equal, but aren't quite. When summer ends and autumn begins, which they don't quite, because you can't just turn the seasons off and on like a faucet or an electric light."[32]

As increasing numbers of Americans noticed both the flattening of the seasons and the arbitrary nature of the solstices and equinoxes (in terms of expecting instantaneous or dramatic shifts), they occasionally offered or turned to alternative solutions, most of them involving calendrical adjustments. In 1912 one reformer proposed dividing the calendar year into four equal seasons consisting of ninety-one days each. A more elaborate version of the same scheme received consideration in 1926 in order to achieve a "rational calendar" in which holidays like Easter would always occur on the same date and would lead off each new season. "Let us give to each season thirteen weeks—ninety-one days," ran the proposal. "This will make the four seasons nearly coincide with the natural divisions, each period of thirteen weeks beginning with the Sunday following the solstice or equinox. Easter, the first Sunday after the spring equinox, will fall always on what is now March 23 . . . and will be—the Church permitting, a fixed festival."[33] Needless to say, these proposals fell on deaf ears and came to naught. Yet almanacs retained a certain appeal, though more for their literary merits than as consensual solutions to how we should best regard the rhythm of the year. When Peattie published his *Almanac for Moderns* in 1935, his initial entry was for March 21, a popular, traditional, and widely accepted choice. When Hal Borland published his almanac called *Book of Days* in 1976,

however, he began with January 1, an equally popular and increasingly acceptable choice dating back to the adoption of the Julian calendar in 45 B.C. Neither naturalist felt any need to explain or justify his preference.

Nor were their choices indicative of any clear trend. Borland had begun three earlier books of the seasons with spring: *An American Year* (1946), *Sundial of the Seasons* (1964), and *Homeland: A Report from the Country* (1969), each one a collection of his columns and essays. Joseph Wood Krutch did the same in *The Twelve Seasons: A Perpetual Calendar for the Country* (1949). Edwin Way Teale had it both ways, beginning his prize-winning quartet (1951–65) with spring but *Circle of the Seasons* (1953) with January. Borland's *Twelve Moons of the Year*, gathered posthumously by his wife in 1979, also began with January. American nature writers continue to opt for both possibilities, and the public appears to have no clear preference.

Other American writers around midcentury with an interest in the seasons, though not launched upon book-length projects entirely devoted to seasonal change, simply went their merry ways and contemplated various objectives more fundamental to their projects. James Agee's *Let Us Now Praise Famous Men* (1941) makes the daily work routine evoke larger cycles of the seasons and years. In his poetry, most notably "Ann Garner," Agee had already used seasonal imagery to represent the desolation of winter. As one Agee scholar has put it: "Thus the lives of simple people are carried on from season to season and from generation to generation. . . . The humblest existence takes on cosmic dimensions; the structures of an individual life are repeated infinitely." During the 1940s and early 1950s, E. B. White wrote numerous short pieces with seasonal themes, sometimes an homage to Thoreau, sometimes a sarcastic swipe at what he called "the change-of-season editor of *Time*," and sometimes simply a delectable essay on "Summertime" or "Winter Back Yard." These required no expansive schema, only good sense and literary skill. When Grace Metalious wrote *Peyton Place*, her steamy best-seller, in 1954–55, she often started a paragraph by setting the "action" that followed in a particular month or season. The book begins: "Indian summer is like a woman. Ripe, hotly passionate, but fickle, she comes and goes as she pleases so that one is never sure whether she will come at all, nor for how long she will stay. In northern New England, Indian summer puts up a scarlet-tipped hand to hold winter back for a little while."[34]

Artistic Modernism and the Seasonal Motif, 1912–1961

James Agee may properly be regarded as a modernist, whereas White and Metalious may not. But modernism in relation to the four seasons emerged as early as 1912, when Helena Rubinstein commissioned the sculptor Elie Nadelman to create statues of the four seasons to enhance the décor of her Fifth Avenue beauty salon in Manhattan (figure 50). Made of terra-cotta and standing thirty

inches high, they utilize none of the traditional iconic symbols except for the amount of "drapery" appropriate to cover (or uncover) each woman according to the climate of her season. Their simplicity and graceful, flowing lines have marked them as a notable early achievement in the history of modern American sculpture.[35]

One year later, in 1913, Edwin R. Campbell commissioned Wassily Kandinsky, a Russian artist who had never been to the United States, to paint four panels for the entrance hall of his apartment on Park Avenue. Kandinsky actually created them at his atelier near Munich in 1914 and put them on exhibition in Berlin and Stockholm through 1916 before finally shipping them to New York, where they were installed in the fall of that year. Because the spaces in Campbell's foyer were not identical in size, two of the images are wider than the others. Clearly, they were meant to be an ensemble, but whether they were designed as a four seasons suite remains unclear, partly because they are so abstract that no familiar symbols of the seasons are present and partly because Kandinsky did not explicitly title them as a seasonal set. Each panel evokes a different mood, and based upon Kandinsky's selection of dominant colors for each, I believe they *were* intended to evoke the seasons. Just a few years earlier, between 1910 and 1912, Kandinsky had painted several works to which he did

give seasonal titles, among them *Fall* and *Winter*, and he very likely knew that for several decades the homes of affluent Americans had been decorated with four seasons sets. Kandinsky's "candidate" for spring has the most cheerful colors: carmine and yellow, vermilion and green; summer is suggested by rocks and trees—green, blue, and white predominate; the crucial colors indicative of fall are yellow, orange, ocher, brown red, brown black, and chilly blue (plate 25); the colors for the panel that remains as winter are blue tones, setting carmine against dull shades. At the top, rays emanate from a star. The evidence is not conclusive, but I am satisfied that Kandinsky had the four seasons in mind, even though he might have envisioned alternative possibilities as well.[36]

Other abstract or nonrepresentational modernists eventually painted works with seasonal titles, but there are no other sets as ambitious as Kandinsky's in terms of scale or startling innovation, so they remain a major landmark in several respects. Although Stuart Davis designed an array of autumn and summer landscapes between 1919 and 1940, the titles he gave them are allusive and perhaps deceptive because his primary interest was clearly in color and spatial configurations. Seasonal changes are barely hinted at through assorted combinations and juxtapositions of hues with different values and degrees of saturation. Arthur Dove's *Summer* (1935) also manifests an intense interest in forms and colors. In 1940 Hans Hoffmann painted *Spring*, probably the earliest avant-garde drip painting, and Jackson Pollock titled one of his best known works *Autumn Rhythm* (1950). Joseph Cornell's enigmatic *Theory of the Seasons* (1947–48) does not add much to our understanding of why the seasons occur or what their aesthetic meaning might be, even to the artist, though clearly he had seen color lithographs produced in London and Paris during the second half of the nineteenth century, usually titled "The Theory of the Seasons," that featured the earth's orbit, lunar phases, signs of the zodiac, and various astronomical symbols.[37]

There is a tendency to assume that Grant Wood must have cared a great deal about the seasons and American agriculture, and unquestionably he did; yet he never created a unified set of the cycle as a mature artist. (Quite early in his career, around 1922–23, Wood painted a very traditional quartet in the form of four large lunettes at a high school in Cedar Rapids. Each one consists of a single mythological or allegorical figure. They are barely recognizable stylistically as his work.) We can constitute a suite posthumously on his behalf, but it would have to consist primarily of lovely lithographs made between 1937 and 1941 for an enterprise called Associated American Artists. These were actually his very first attempt at making lithographs on stone, and they achieved immediate popularity. The editions of 250 impressions for each were quickly exhausted. The subjects are titled *January* (1937), *March* (1940), *Tree Planting* (1937), *July Fifteenth* (1938), *Fertility* (1939), *Seed Time and Harvest* (1937), and *December Afternoon* (1940). They pay homage to Midwestern fertility and self-

reliance, although the presence of farmers has to be largely inferred because they are mostly unseen.[38]

In 1935 Wood wrote an essay titled "Revolt Against the City" that indicates quite clearly his antiurban feelings. He may very well have envisioned a rural sequence covering all the months of the year, but it never neared completion. Such major (and quite wonderful) oil paintings as *Arbor Day* (1932) and *Spring in Town* (1941) remain singular works. In 1938–39 he conceived and completed one of his most whimsical projects: a series of four lithographs titled *Fruits*, *Vegetables*, *Tame Flowers*, and *Wild Flowers*, hand colored by his sister, Nan Wood Graham, in California. Once again, a charming suite that prompts thoughts of the seasons; but that is not exactly what it is. One could, I suppose, make a case that the tame flowers are being grown indoors during winter, that the wild flowers represent spring, the vegetables summer, and the fruits fall; but there is no firm evidence that Wood intended such a correlation. I suspect that he felt hesitant to come too close to what may very well have seemed a clichéd motif reminiscent of those jejune lunettes.[39]

Among the oil paintings of Thomas Hart Benton there are numerous works treating spring and autumn that he created between 1920 and 1963; but Benton's most concerted approach to seasonality occurred, like Wood's, in lithographs (in Benton's case, made entirely during 1939), also for the Associated American Artists project, which was intended to democratize art by making original works available for five dollars each. *Planting* he also called *Spring Plowing*. *Cradling Wheat* is a classic summer icon. And *The Woodpile*, which he also titled *Wood Cutter*, bears Benton's own inscription below one of the imprints: "Missouri farm set-up in the winter. Splitting wood for the kitchen stove." Alas, there is no vision of autumn to complete the suite, which is rather curious considering how often Benton painted autumn scenes in oil. Given some of the charges of social conservatism that have been leveled at Benton's outlook during the 1930s, it may be worth noting that the figures in *Spring Plowing* are clearly black, while those in the other two are white. There is no discernible difference in how they are depicted.[40]

Charles Burchfield (figure 51) was by far the most interesting and important figural painter from this generation with a deep and abiding love of natural phenomena in general and seasonal change in particular. From 1913 to 1922, his coming-of-age decade as an artist, until his death in 1967, his interest in the seasons never waned; and the sheer number of seasonal images that he produced is astonishing. In 1952 he confided a poignant lament in his journal:

> The great difficulty of my whole career as a painter, is that what I love most (i.e., weather, change of seasons) not only holds little of interest for most people, but in many of its phases, is downright disagreeable, and not even to be mentioned! I love the approach of winter, the retreat of winter, the

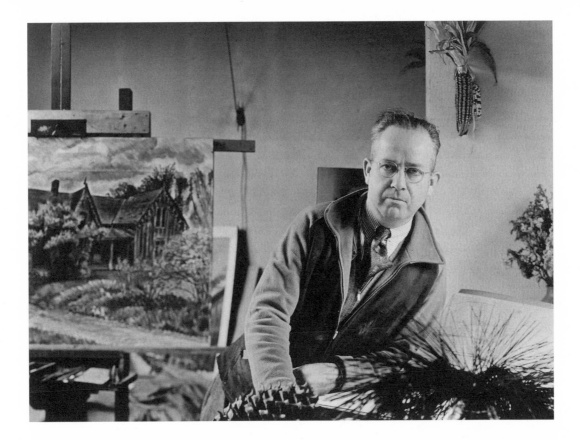

change from snow to rain & vice-versa; the decay of vegetation; and the resurgence of plant-life in the spring—These to me are exciting and beautiful, an endless panorama of beauty and drama.[41]

FIGURE 51
*Charles
Burchfield
in his studio
(1940s),
photographer
unknown.
Photograph
courtesy of
Kennedy
Galleries, Inc.,
New York.*

In 1945 Burchfield had written to friends in Cleveland that his *Autumnal Fantasy* was "one of a group of four pictures that I thought of as comprising a 'Symphony of Seasons'—I even fondly imagined them being sold as a group and staying that way." The quartet would have begun with *Cherry Blossom Snow*, followed by *Sphinx and the Milky Way*, then *Autumnal Fantasy*, and finally *The Blizzard*. Because *Sphinx* was unfinished in time for a scheduled exhibition, the group was shown with *August Twilight* and *Midsummer Caprice*. So it did become a seasonal suite, but not the "symphony" in four movements that had been envisioned. Seasonal transitions intrigued Burchfield above all other aspects of seasonality, as they did Thoreau, whose *Walden* and four seasonal journals (edited and published between 1881 and 1892) Burchfield read and reread. In 1917, for example, he began a watercolor of two ravines. As he explained to an interviewer in 1959: "One of them was to symbolize the coming of spring into the ravine, and the other ravine was to show that winter still held sway in that hollow. Spring was coming down one hollow and winter retreating up the

other." The concept was too complex for him to complete at the time, but he returned to it in the early 1930s and finally completed it in 1943, the year of his spiritual shift from pantheism to the Lutheran Church of his wife. The result is a great painting, *The Coming of Spring* (plate 28).[42]

In December 1964, nearing the end of his life, Burchfield once again contemplated a very grand suite of seasonal paintings. While he worked on *Autumn to Winter*, clearly meditating upon both the prospect of mortality and the improbability of immortality, he entered the following in his journal: "My mind is on fire now with the other three transitions—Winter-Spring, Spring to Summer and Summer to Autumn—A Note to Posterity—What I want is a circular museum, large enough to house these four season transitions and six month transitions. . . . The "Winter to Spring" transition now inflames my mind and ideas crowd tumultuously upon each other."[43] Burchfield did not live to complete these four large and ambitious works, nor was such a museum ever erected; but between 1949 and 1960 he did finish a remarkably innovative painting that he initially considered calling *Fantasy of the Seasons*, but eventually gave a more prosaic title, *The Four Seasons* (plate 29). In it the seasons steadily recede from the viewer's eye: winter and autumn are almost telescoped in the foreground, while beaming rays of sunshine warm the middle distance, and spring can be seen fading elusively into the background. The work almost seems to contemplate but then reject a notion that Burchfield confessed to his journal at a very early moment in his career, 1915. "I used to harbor the thought," he acknowledged, "that one year of Nature chronology would finish the job—would rob succeeding years of new chronologies."[44]

Burchfield's *Four Seasons* is one of the most creative attempts ever made by an American artist to capture the entire cycle in a particular painting. It is visually compelling and vividly conveys a sequential sense of an entire year in the serenity of a woodland scene such as we have all encountered at some time in our lives. Curiously, while Burchfield worked on that challenging image, two other American artists, both modernists, sought to suggest the very same concept on one canvas. Lee Krasner's abstract *Seasons* (1957) shows floating forms that might be leafy plants or, it has been suggested, anatomical parts of her late husband, Jackson Pollock, who had been killed in a car accident the year before. They are meant to allude to regeneration and the cycles of nature. Charmion von Wiegand (1899–1983), an American modernist deeply influenced by Mondrian, painted *The Wheel of the Seasons—Magic Square # 3* (figure 52) in 1957 also, and the work seems more successful than Krasner's because it is conceptually more innovative as nonrepresentational art and at least stimulates the viewer's seasonal imagination to think cyclically in a way that Krasner's more colorful but less creative work does not. In any case, it is notable that at least three major American artists had in view during the mid-1950s the same objective: suggesting the full seasonal sequence in a single picture.[45]

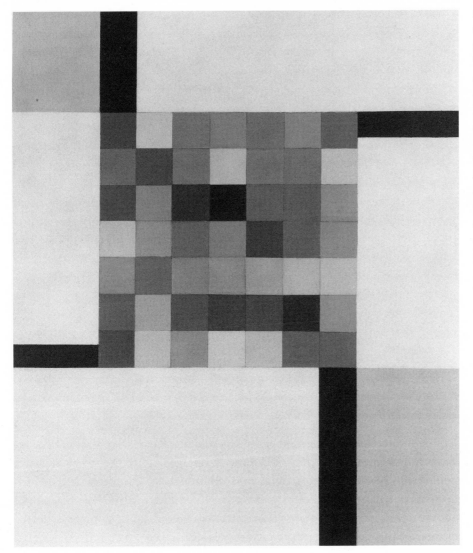

FIGURE 52
Charmion von Wiegand, The Wheel of the Seasons— Magic Square # 3 *(1957), oil on canvas. Albright-Knox Art Gallery, Buffalo, New York, Charles Clifton Fund, 1981.*

At the very same time a remarkable and unique project got underway that prompted children all across the United States to paint or draw images evocative of the seasons. The occasion was the second National Exhibition of American Child Art, held in June 1957 at the Galerie St. Etienne in New York City. The four seasons theme was selected in 1956 by the director of the division of art education at what then was called Illinois State Normal University, and the deadline for submissions was February 1, 1957. Within three weeks prior to that date, more than 16,000 pictures arrived from towns and cities in forty states, and paintings representing the seasons from twenty-four states were ultimately represented in the final selection of 100 images for the show. In choosing the motif, the organizers felt that it would "give children the greatest possible

range for expressing their observations of nature and daily life, their experience of various feasts and holidays, at the same time revealing the characteristics of the different regions of our country." Any child from kindergarten through the eighth grade from any public, private, or parochial school was eligible. The maximum size permitted was 18 by 24 inches.[46]

What did some of the successful entries depict? *Raking Leaves in the Fall* came from a six-year-old in Kansas City, Missouri, and *Cotton Harvest* from a twelve-year-old in Monroe, Louisiana. *Spring Baptism* was submitted by a twelve-year-old in Atlanta, Georgia; it shows three black men immersing a fourth in water while three women exult in the middle distance, arms upraised, clearly shouting with joy. *Easter Time* and *Thanksgiving Dinner* and *Chanukah* were especially popular themes along with Halloween and Christmas-related motifs. In many respects the entries indicated partiality for a festival-oriented manner of defining the cycle of the year rather than the more traditional labors of the seasons, though both kinds of events and activities are represented. A reviewer of the exhibition writing in *The Nation* on June 22, 1957, observed, verging perhaps on hyperbole, that "the pictures are of an extraordinary gaiety. The color is daring, vivid and harmonious. In the work of a grown-up artist, their easy freedom and vivacity would denote unheard of originality." After the show closed in New York, it traveled from August 1957 until April 1961 to sixteen locations from Florida to California, circulating under the auspices of the Smithsonian Traveling Exhibition Service.[47]

Although this entire event was unprecedented in participatory terms, it had interesting antecedents and anticipations. For more than twenty years prior to 1912, the nature essays written by John Burroughs had been repackaged by his publisher, Houghton Mifflin, into special editions as children's reading primers. By 1912 they were being used in almost every school district in the United States, which not only helped to make Burroughs's name a household word, but also expanded youngsters' understanding and vision of seasonal change and its significance. Moreover, naturalists writing for adults during the early twentieth century occasionally commented upon the seasonal enthusiasms of children. James Buckham, for example, writing in 1907 after observing his young son's response to a gray November day, remarked: "Why is it that almost all children seem to love and delight in the late fall and early winter? The season certainly has a peculiar charm for them. They are delighted when they see the dead leaves whirling in the wind and the first snow-flakes drifting down. The spell of that quiet joy of late autumn is upon their sensitive souls. They find no suggestion of melancholy in the mere soberness of nature's coloring."[48]

It has been widely observed that children's art grows from a mix of experience and perception. Although the images they create may seem "innocent," they are also authentic because they represent what youngsters know, not what they have been told.[49] What they read a few years afterward, in late adolescence,

could affect their sense of seasonality as well. The much-loved books written by Laura Ingalls Wilder, for example, invariably refer to the rhythms of the seasons, and in most of them seasonal hardships provide major challenges to be overcome. I have in mind *The Little House in the Big Woods* (1932, set in Wisconsin), *Little House on the Prairie* (1935, set in Kansas), *On the Banks of Plum Creek* (1937, set in Missouri), and *The Long Winter* (1940, set in the Dakota Territory).

Before leaving the subject of seasonal art during the first half of the twentieth century, we need to notice at least a sampling of efforts in the decorative arts. In 1925–26, before he entered Harvard College, young Lincoln Kirstein was apprenticed at the age of eighteen in the stained-glass studio of Charles Connick in Boston. While working there he made roundels with male and female figures (wearing sports clothes) representing the four seasons. They were later installed at his sister's farm in Ashfield, Massachusetts.[50] In 1941 a well-known teacher and pioneering artist in serigraphy, Harry Sternberg (1904–2001), created a four seasons suite in gala colors featuring idyllic settings for sports and romantic relationships. They are not memorable except for being, very likely, the first seasonal set to be made as colored screenprints, and therefore accessible to a much broader clientele than one-of-a-kind works in watercolor (like Burchfield's) or oil. On the cover of *The New Yorker* for January 4, 1941, the editors decided to use an attractive, brightly colored semimodern motif of the seasons designed by Ilonka Karasz. Although the four figures shown in her quadrant separation are not traditional in appearance, their symbolism is highly familiar. A lovely young woman holds spring flowers in both hands, a basket in one and a wreath in the other. The maiden in summer holds wheat sheaves and a sickle. The lad (or lassie?) in autumn holds grapes and a cup; and old man winter warms his hands over a blazing kettle while sitting on a log to keep him above the snow. The more things change . . .

At Iowa State University in Ames the Memorial Union fountain was, for a few years after its installation as a gift from alumni in 1936, a vertical water spout within a round reflecting pool. Every spring campus pranksters brought discarded toilets or toilet seats and perched them over the fountainhead during the middle of the night, causing consternation to university administrators. After numerous complaints, the president decided in 1939 to invite Christian Petersen, who taught at the college, to create sculptures that would dignify the fountain and thereby deter madcap students. Petersen welcomed the assignment because he loved making designs for fountains and he saw that the commission would enable him to take advantage of time he had spent with Native Americans early in the 1930s sketching tribal symbols. He designed sculptures of four Osage women to be situated on the outer edge of the fountain facing in four directions (plate 27). Each one represented a season, and more particularly the yearly cycle of corn. He drew upon four lines of an Osage chant:

Lo, I come to the tender planting [spring].
Lo, a tender shoot breaks forth [summer].
Lo, I collect the golden harvest [autumn].
Lo, there is joy in my house [winter].

By 1941 his plaster models had been carved in Bedford limestone, and the eloquent restraint of his *Fountain of the Four Seasons* was thereafter treated with great respect. It continues to grace the Memorial Union courtyard. Thus a non-Native sculptor used Native American imagery to signify nature's cycle and thereby dignify a site. Because of Petersen's ethnic background, a writer for an American Danish-language magazine wrote a story about the sculptor and the fountain as an "epic poem hewed in stone." The account concluded: "A quiet, complete life cycle—tenderness, Godliness, work, and reward is here."[51]

There has been a long history of four seasons fountains in Europe. One thinks immediately of the one at Versailles with designs by Charles Lebrun that are gilded and painted: Bacchus for autumn, Saturn for winter, Flora for spring, and Ceres for summer. Then there is the Dolphin Fountain on the Brühl Terrace in Dresden, Germany, with its elaborate four seasons sculpture group (*Vier Jahreszeiten*) designed by Johannes Schilling in 1868. The observation seems commonplace and obvious, but Petersen's fountain and similar ones in the United States have an endearing simplicity that appears so much closer, not merely to the American spirit, but to nature itself. Seasonal motifs in the built environment here glorify the natural world rather than man's elaborations upon it.

Eugenics: Seasons of Birth and Human Fertility

In 1938, the year before Petersen made the designs for his serenely solemn figures, a rather odd book appeared in the United States. Its now neglected author was in his own day a very distinguished scholar and polymath, widely recognized and honored in several disciplines and well known to the reading public. Ellsworth Huntington (1876–1947) was trained as a geographer and social psychologist. Like so many products of the late Victorian era, he wanted to understand and explain the reasons for human progress and its evolution through time. Hence he amassed great quantities of data in order to discern some sort of rhythm, pattern, or harmony in the narrative of human existence. The history and dynamics of climate in various locations became something of an obsession with him; but perhaps the key to comprehending his book, *Season of Birth: Its Relation to Human Abilities*, lies in his having been from 1934 until 1938 president of the American Eugenics Society. Knowing that he felt deeply committed to eugenics makes his book comprehensible, whether or not one is inclined to agree with it. His opening sentence also sends us a very clear signal that Huntington was, in a sense, a relic: one of the last "scientists" who funda-

mentally failed to recognize that seasonality had been "flattening" ever since the middle of the nineteenth century. He begins: "The season at which people are born has far greater importance than is generally supposed."[52]

Part of the problem with this book (which the publisher dissuaded him from titling "Season, Sex, and Genius") is that it blends a great many unexceptionable assertions with too many that seem absurd today. Sound enough are such observations as: "The demands of certain occupations upon people's energy may also play a part in causing the number of conceptions to vary from season to season. The greatest effect of all, so far as cultural factors are concerned, is produced by seasonal migrations, whereby the men tend to be away from home during part of the year." Or, equally reasonable: "Climatic advantages bring cultural advantages. Thus climate becomes by far the most important feature of man's natural environment. And the natural environment ranks with biological inheritance and cultural surroundings as one of the three all-inclusive factors which determine human behavior and make man what he is." So far, so good; and the book contains all manner of erudite citations and data compiled into impressive tables, graphs, and charts. It certainly looks and sounds scientifically informed and astute in the most positive sense of those words.[53]

The book contains much, however, to make modern readers incredulous.

- It is best that children should be born in the late winter or early spring. June has been rightly chosen as a favorite month for weddings. Nevertheless our mental activity is greatest in the spring and fall when the temperature averages about 47 degrees because that is the temperature at which it was best for our primitive ancestors to be born.
- The weather at or shortly before the time of conception exerts an important effect upon the embryo, and this effect continues throughout life.
- On an average the people born in February and March differ decidedly from those born in June and July. In the middle latitudes of the northern hemisphere . . . they tend to be more numerous, more evenly divided as to sex, and longer lived. By a curious quirk of fortune they also include a larger proportion not only of distinguished people, but also of unfortunates who become criminals or are afflicted with insanity or tuberculosis. Man is like the lower animals in having a definite seasonal rhythm of reproduction with a maximum of births in the late winter or spring.[54]

Could such a learned man, writing when he did, really be so out of touch with the notable and numerous changes that had occurred in medicine and the environment during the preceding century? The answer seems to be yes and no. As noted, at times he sounds quite sensible, or at least, mostly so.

If improvements in medicine, hygiene, diet, and sanitation change the seasonal incidence of disease and weakness, the seasonal distribution of births

changes also. If this brings births at a season unfavorable for the infants, the result is bad. In the case of the northern United States, however, this has not happened because with the change in the seasonal conditions of health among adults there has gone a still greater change in that of infants, so that summer is now highly favorable to them as well as to their parents.

But in his concluding chapter, "The Seasons and Human Progress," the ardent eugenicist emerges with such statements as these, which ought to suffice as evidence of the ways in which he was indeed out of touch.

- A change in the season of birth could easily be brought about within a few decades if society were convinced that it is worth while. It will probably begin among a small and highly enlightened group, and gradually spread downward.
- In view of the triumphs of modern medicine we may confidently expect that a realization of the importance of the seasons in relation to reproduction will stimulate research. Thus we shall discover why the children conceived at certain times have an advantage. That in turn will enable us to create the desired conditions at other seasons, or in greater measure at the chosen seasons.

It is tempting to be dismissive and say that by 1938 Huntington was hopelessly passé; but in key respects it is hard to imagine when his basic beliefs would have been altogether acceptable. (*Some* of his views concerning climate and fertility have actually been vindicated by studies conducted during the 1990s, as we shall see in chapter 8.) John Burroughs, for example, believed that April was the best month to be born in, but mainly for the romantic reason that that was when all of nature was new. Huntington's insistence that spring is so conducive to mental activity is contradicted by explicit statements to the contrary from Henry David Thoreau, Wilson Flagg, James Russell Lowell, and Burroughs. Flagg offered the representative view on this matter: "Spring, the true season of hopefulness and action, is unfavorable to thought. So many delightful objects are constantly inviting us to pleasure, that we are tempted to neglect our serious pursuits, and we feel too much exhilarated for confinement or study." He may or may not have been right, but that certainly was the dominant belief from the mid-nineteenth century onward. Ellsworth Huntington had little credibility to speak of with our seasonal writers and artists.[55]

Literary Modernism, Seasons of the Mind, and the Waning of Creativity

Nineteenth-century poets and poetic naturalists often identified different seasons with particular moods, capabilities, and desires. John Keats called autumn the "season of mists and mellow fruitfulness." Flagg designated spring as the

"season of anticipation" and summer as the "season of fruition."[56] Many American naturalists from Celia Thaxter (writing about the Isles of Shoals) in the 1870s to Joseph Wood Krutch in the 1950s had read Keats and liked to quote from seasonal invocations and allusions in his poems. His images and the uses that nature writers made of them were readily accessible and hence meaningful to ordinary readers who encountered them by way of the naturalists. During the 1930s and 1940s, however, several American poets with modernist impulses turned to seasonal motifs in a serious way that has been anything but accessible, sometimes even to literary scholars accustomed to close reading and critical analysis. Each of the pertinent poems is deeply subjective, as though the writer scarcely cared whether readers plumbed his meaning with discernment or not. Four poets seem especially apropos for seasonal consideration during those decades: T. S. Eliot, Allen Tate, Wallace Stevens, and William Carlos Williams.

The title of Eliot's "East Coker," written in the 1930s and gathered into his *Four Quartets* in 1943, refers to the English village that was the Eliot family's ancestral home. In the poem Eliot describes an open field at midnight in midsummer and evokes the timeless traditions that took place at that time of the year. There is music, people are dancing, and merriment prevails. "Keeping time," he writes,

Keeping the rhythm in their dancing
As in their living in the living seasons
The time of the seasons and the constellations
The time of milking and the time of harvest
The time of the coupling of man and woman
And that of beasts. Feet rising and falling.
Eating and drinking. Dung and death.

For Eliot, seasonal ruminations are wistful but realistic, tradition-oriented yet wanting to connect the "sacramental" past with the living present.[57]

During the second half of 1944 Allen Tate wrote "Seasons of the Soul," a poem dedicated to the memory of his friend, the Cape Cod writer John Peale Bishop, who died earlier that year. The poem is in four parts, starting with "Summer" and closing with "Spring." Although the poem is very much about death, it makes more explicit reference to men dying in battle in Europe than it does to Bishop, who did not serve in World War II. There are references to Normandy and brothers in arms, the loss of youth, and so forth. Numerous citations to the "mother of silences" would seem to be references to the stillness of lost lives, and given Tate's long-intended conversion to Catholicism, which was realized in 1950, it seems likely that the decision to end with spring, the season of renewal, meant an affirmation of hope. The "mother of silences" may even refer to hope for salvation through the Virgin Mary. The last canto beseeches the mother of silences,

Speak, that we may hear;
Listen, while we confess
That we conceal our fear.

The memory of Tate's friend is covered by the shroud of fearful deaths occurring far from home, and by then for several years.[58]

In much of Wallace Stevens's poetry there is a highly cerebral concern with the relationship between functions of the imagination and a greater natural order that includes not merely the seasons, but the physical topography of nature from the earth's surface to the starry skies above it. In one of his earliest poems, "The Snow Man" (1923), Stevens reminds readers that if they look with "a mind of winter" they will see not a void but a plenitude. The snowman is meant to be a real man observing nature stoically in winter; and in this poem, despite an element of nostalgia at the center, Stevens aspires to be a mind at one with nature rather than at odds with it.[59] Stevens's mature and capacious mind moved back and forth between self-reflexive meditation and cosmic thinking—the aspects known as well as those mysteriously unknown, understood as well as misunderstood. Two of his long, major poems, "Credences of Summer" (1947) and "Auroras of Autumn" (1948), are actually a pendant pair. Each one contains ten cantos. Writing both of them in later middle age, Stevens used imagery pertaining to those two seasons to ruminate on the exhaustion of fertility (i.e., creativity) as summer wanes, and then the need for acceptance rather than despair.

Employing "the mountain" as a dominant image in "Credences of Summer," he observes that it is

the final mountain. Here the sun
Sleepless, inhales his proper air, and rests.
This is the refuge that the end creates.

He moves back and forth between a description of how the physical world functions and what the human poet (or mind) must be resigned to. The second stanza of his first canto evokes this dialectic quite poignantly.

Now the mind lays by its trouble and considers.
The fidgets of remembrance come to this.
This is the last day of a certain year
Beyond which there is nothing left of time.
It comes to this and the imagination's life.

The poet/narrator stands upon a mountain to give witness to the apogee of the seasons and calls the fulfillment of summer "green's green apogee." Observation gives way to speculation when he raises the question on which the poem

pivots: "One day enriches a year . . . / Or do the other days enrich the one?" Stevens speculates about the passage of time and how we perceive its passage—but with uncertainty.[60]

The final cantos of "Credences of Summer" convey Stevens's realization that the metaphorical "rock" (or mountain) of summer must soon dissolve into an autumn that is nightlike, featuring the aurora borealis, which supplants the mountain as the dominant metaphor in "Auroras of Autumn" for facing the hard realities of middle age, a time when all moments of life are overcast with a mix of memory and anxiety. In an unconventional mode of skepticism Stevens observes, "A season changes color to no end, / Except the lavishing of itself in change." In fact the poem, luminous with references to bright colors, such as "blue-red sweeps," is all about the waning of creative and imaginative power. Reading about "an aging afternoon," "ice and fire and solitude," and "evening," we feel a palpable shift from warm to cold, and a chill gradually descends upon us as we progress through the ten cantos. Stevens brilliantly envisions "the velocities of change" in both a physical and a metaphysical sense. One passage, in particular, is so reminiscent of Thoreau, who constantly contemplated one season while his very being was in the midst of another. Thus Stevens begins canto 7:

Is there an imagination that sits enthroned
As grim as it is benevolent, the just
And the unjust, which in the midst of summer stops
To imagine winter? When the leaves are dead,
Does it take its place in the north and enfold itself,
Goat-leaper, crystalled and luminous, sitting
In highest night?[61]

Writing with considerable insight about these two difficult poems, Helen Vendler remarked that "whereas Summer represented repose, immobility, static piled haymows and monolithic mountains, Autumn is compounded of Stevens' most congenial subjects—flux, rapidity, flickerings, and winds." Literary critic David LaGuardia has examined both poems in the context of Stevens's work overall: "As each alteration of climate produces the characteristic changes that define spring, summer, autumn, and winter, so in the seasons of the mind, parallel to but separate from literal time, the world changes according to the imagination's perception of it within the 'floraisons of imagery.'" What differentiates the two poems from virtually all the rest of his longer ones is that they maintain an equilibrium between past and present. The authorial voice remembers, and what is recalled is very much a presence because it informs and shapes the writer's sensibilities and imaginative capacities even as they diminish—or face the fear of diminution. There is no other moment in all

of American poetry, so far as I know, when seasonality sustains such a complex interrogation of the psyche, the soul, and the writer's sense of what he has been and what he is likely to become. Where else has seasonal change been used with such intense and powerful effect?[62]

Although the seasons do not figure in the writing of William Carlos Williams in such a central and profound way, his provocative interest in them appears at the very beginning and once again near the end of his long career, fortuitously framing the chronological boundaries of this chapter. The closing paragraph of his "Kora in Hell: Improvisations" (1920), an experiment with expressionism in prose, is worthy of notice because it adapts the well-established fascination with parallels between the seasons and the human life cycle.

> Seeing the leaves dropping from the high and low branches the thought rises: this day of all others is the one chosen, all other days fall away from it on either side and only itself remains in perfect fullness. It is its own summer, of its leaves as they scrape on the smooth ground it must build its perfection. The gross summer of the year is only a halting counterpart of those fiery days of secret triumph which in reality themselves paint the year as if upon a parchment, giving each season a mockery of the warmth or frozenness which is within ourselves. The true season blossoms or wilts not in fixed order but so that many of them may pass in a few weeks or hours whereas sometimes a whole life passes and the season remains of a piece from one end to the other.

Williams would subsequently republish that work with poems titled "Spring and All," dedicated to his good friend, the Pennsylvania artist Charles Demuth.[63]

In 1962, at the age of seventy-nine, Williams wrote an extended poem, almost haikulike because of its tercets, which he titled "Pictures from Brueghel." Not all of the cantos touch base with the Flemish artist's five great oil paintings of the seasons. Some refer to his religious motifs that also were done during the 1560s. But three of the cantos cover "The Hunters in the Snow," "Haymaking" (plate 3) and "The Corn Harvest." The first and third of these are purely descriptive, as though Williams had looked at the images as plates in a volume on Bruegel and then simply editorialized the scenes spread before him. Only the second is intended to suggest some sort of commentary on the creative process, and even then it ultimately seems to conclude that the picture's larger meaning, if it was meant to have one at all, does not transcend what the viewer is permitted to see.

VI. HAYMAKING

The living quality of
the man's mind
stands out

and its covert assertions
for art, art, art!
painting

that the Renaissance
tried to absorb
But

it remained a wheat field
over which the
Wind played.

Although these are not Williams's most notable poems, they certainly are suggestive of the staying power and attraction of Bruegel's seasonal imagery, a matter to which we will return in chapter 7.[64]

"Demopiety"?: Dialogical Responses to Seasons in the City

A new syntax of seasonality had started to emerge as the cultural practices of modernism supplied glosses upon interior sensibilities, reflections upon earlier responses to natural cycles, and in certain cases feelings of anxiety about the aging process. Some observers and entrepreneurs, however, also began to discover and even celebrate the distinctive character of seasonal change in city life.

The appeal of the modern city in the minds of many had already created the sense of an attractive urban landscape as a monument to the new national prosperity. Consider the case of the St. Paul Winter Carnival, created in 1886 to attract tourists by making a virtue out of Minnesota's harsh winters. Its structural focus was an outdoor ice palace where a contest between the Fire King and the Ice King symbolized the national identity's having been shaped by extremes of climate, the cycle of the seasons, and creative tension between the frost belt and the sun belt. By 1916 the carnival had begun to be "deseasonalized" in response to visitors' desire for creature comforts. By 1982 most of the events were actually being held indoors and had little to do with winter per se. In 1984 the ice palace was entirely eliminated. Within a century the Winter Carnival had come around to minimizing winter![65]

During the latter half of the nineteenth century approximately 2,000 different lithographed urban views were published in the United States. By the beginning of the twentieth century the "City Beautiful" movement seemed to fulfill a mood that one historian has designated as "demopiety." At the turn of the century a great many people, such as Alfred Stieglitz, had become utterly fascinated by cityscapes undergoing change.[66] Happily, as exemplars of these developments, we have two useful texts published exactly half a century apart, in 1909 and 1959, that deal with the four seasons in New York City, along with

some seasonal images that are markedly urban and connect with those texts. In 1909 the writer and New York City resident John Van Dyke published *The New New York: A Commentary on the Place and the People*. Chapter 3, titled "Seasonal Impressions," is intensely boosterish and pays considerably more attention to buildings than to the realm that we regard as nature. Perhaps that is understandable at a time when tall buildings were beginning to transform the city's appearance in dramatic ways. Nonetheless, reading this chapter in the context of works that we have been considering thus far comes as a bit of a shock. Van Dyke is attentive to the changing quality of light, like Stieglitz, and to the variable colors of the city, but almost entirely in relation to the built environment.

> And how the color does crop out at every turn — is brought out perhaps with some extra sharpness because of the clear light! Everything shows color. And seldom do you find the same tone repeated. The buildings alongside of which run the elevated roads from the Battery to the Harlem River, are often alike in structure but seldom in hue. They differ each from the other by a tone or a shade. Stone, brick, cement, terra-cotta — no one could name or count the hundreds or even thousands of different tints or shades they show.[67]

Comparing the consequences of using coal and other pollutants in urban air, he insists that New York is a cleaner city than London or Paris. He acknowledges that snow makes a mess of mobility in the streets and tangles up the traffic; but "up in the Central Park and along Riverside Drive it looks very beautiful. The children, the skaters, and the coasters, with those who have horses and sleighs, enjoy it, and people who have offices up aloft in the skyscrapers and see it flying past the windows in great gusts and clouds are sometimes elated by it; but down in the street where it falls and lodges it is neither inspiring nor welcome." The aesthetic fascination that Stieglitz and Arthur D. Chapman found in early twentieth-century snowscapes on the streets of lower Manhattan had no counterpart in Van Dyke's urban realism. He boasted that spring came earlier to the city than to the country because the small parks, shut in by high buildings and therefore protected "in measure from the winds, respond quickly to the first warm sun." He acknowledged that New Yorkers did not much care for the heat of summer, however, but during the transition from spring to summer, at least, the flower shops along the avenues were "overflowing upon the sidewalks with bursting beauty." Ultimately, though, Van Dyke conceded that so many "hurrying" New Yorkers were too busy to pay adequate attention to the color changes brought by the cycle of the seasons. In his closing paragraph the author acknowledged that the "various conditions of humanity" in his city "manage to live through the seasons as they come and go."[68] Endurance seems to have prevailed over appreciation — all of which anticipates a very major issue that would become prominent during the third quarter of the century.

Almost a decade later, in February 1917, John Burroughs received a letter from an admirer and avid reader of his work who lived on Ninth Avenue in New York and whose father lived in Detroit. There had been a warmish spell, so the young man, having received a letter from his father and having been out of doors himself, sensed (or at least claimed) that "spring is being born." He began the final paragraph of this long letter, however, with the following, a highly representative sentiment among city dwellers at the time: "So, Mr. Burroughs, we in the city feel the change and how infinitely more wonderful it must be to you who can see the changes of the fields and the thousand signs that never come to cities. Surely it must be time to hunt up some forgotten swamp and in a spiritual pilgrimmage [*sic*] that renews one's soul discover the first skunk cabbage."[69] That sense of being disconnected from the complete manifestations and full glory of seasonal change would become a more prominent theme in American culture half a century later.

In 1959 John Kieran (1892–1981), a prominent sports columnist, radio personality, and naturalist with a special interest in ornithology, published an essay titled "The Four Seasons in the City." In 1956 he had actually retired from the vocational pursuits that paid his way and moved to quaintly maritime Rockport, Massachusetts. Shortly afterward he wrote that affectionate essay about the city where he had lived for so many decades. Unlike Van Dyke, he did not set out to show the shifting hues of buildings as the quality of light changed with the seasons and the weather. Instead, Kieran wanted to indicate that New York at midcentury had all sorts of wild birds and flowers if only people knew where to look for them and took the time to pause and appreciate them. "Whether in a crowded metropolis or a desolate wilderness," he believed, "nature's pace is always the same: slow, steady, relentless." His exposition was gentle and reassuring rather than chiding. He simply wanted to show that he had been a keenly peripatetic observer and that others could be also if they really wanted to achieve the delights of *rus in urb*, the country in the city. Less than a decade later, poet Marianne Moore agreed to write the introduction to a coffee-table book devoted to Central Park as precisely that: *rus in urb*. Her two-page piece is every bit as piquant as you might expect. Her closing paragraph is worthy of citation.

> Spring: masses of bloom, white and pink cherry blossoms on trees given us by Japan. Summer: fragrance of black locust and yellow-wood flowers. Autumn: a leaf rustles. Winter: one catches sight of a skater, arms folded, leaning to the wind—the very symbol of peaceful solitude, of unimpaired freedom. We talk of peace. This is it.[70]

Quite a few mid-twentieth-century writers, however, adopted a very different tone, and the complexities of their relationships with readers—sometimes poignant, sometimes complacent, more often dialogical or even antagonistic as

well as appreciative—will concern us next. Let's close with two anticipatory examples from seasonally oriented nature writers who really were nineteenth-century men in the mold of Donald Grant Mitchell because of their antiurbanism. The first observation comes from Henry Beston, writing a monthly essay for *The Progressive* in 1947: "It often strikes me that in our modern Babylons you never see anything begin. Everything comes to you, even thought, at a certain stage of its development, like an iceberg lettuce. . . . I begin to suspect that we should be more on our guard against Babylon when its urbanism has gone bloodless and sterile, and it insists on our taking its false maps of the human adventure."[71]

Because we know that Beston became something of a curmudgeon in his later years, and feistily antimodern, some may feel that his views are not altogether representative. So let's turn for our second illustration to Leonard Hall, a successful St. Louis businessman who abandoned that career after twenty years to farm, live close to nature, and write articles on the joys of rural life for popular magazines as well as a regular nature column for the *St. Louis Post-Dispatch*. As a youngster he had spent summers and many weekends on his grandfather's farm, so he knew what the work there entailed and that farming is a relentlessly tough taskmaster. After ten years of making a go of it on a small "city man's farm," Hall and his wife bought a larger, even more demanding one called Bellevue, some ninety miles southwest of St. Louis in the Ozark valley. His purpose in writing about seasonal change on his farm was not so much to reject city living as to bring the pleasures and rewards of rural life to the growing numbers of midwestern Americans who had lost touch with it. Above all, he remarked, while performing the requisite farm tasks, he and his wife "watch and appreciate . . . the swing of the seasons."[72]

So he reworked his essays into a book that followed the cycle of the seasons at Possum Trot Farm from March to the following February—from the start of spring to the close of winter. The book, along with one of Hal Borland's, was cordially reviewed in the *New York Times*, which noted that Hall was not a nature writer but a man deeply appreciative of the benefits derived from living close to the soil, and one desiring to repair "the damage which man has done to his earth in the course of a too-greedy gathering of its bounty." Calling him a "Thoreau of the Ozarks," the *Chicago Tribune* was less measured in its praise and advised its urban readership that the book would be a "tranquilizer for those hours when you are weary of people, noise, confusion and tensions." The *San Francisco Chronicle* called the book "unexcelled" in relating nature to farming activities and to the daily lives of rural people. Organized into twelve chapters in turn gathered into four seasonal sections, the book was highly representative of a genre that emerged with a burst at midcentury and then flourished for four decades.[73]

CHAPTeR 5

NATURE WRITERS, READER
RESPONSE, AND THE AMBIVALENCE
OF URBAN AMERICA

A Collegial Cohort of Seasonal Writers, 1941–1978

From the 1940s until the later 1970s a notable generation of nature writers produced an astonishing number and variety of four seasons books. Most of them reached a remarkably wide and enthusiastic readership. Fortunately, we can determine a great deal about the response to these books, not only because so many published reviews appeared, but also because several of the writers received so much appreciative mail that has survived in various repositories. Never before had there been a generational cohort quite so cohesive in their sense of collective self-awareness but also possessed of a belief that they were functioning within an "Anglo-American tradition" of nature writing, as one of them phrased it. Having called them a cohort, however, I hasten to point out that the participants in this "movement" can be viewed in two fairly separate categories. First, there were those I consider professionals: widely read men and women who wrote a great deal about nature in the United States and gained a considerable degree of prominence. They achieved national reputations as people who observed the natural world carefully and thoughtfully, over a span of decades, in order to enlighten Americans in various ways while earning a living by doing something that mattered a great deal to them.

The second group might be considered "amateurs" in the most traditional sense of that word: they loved what they did, but they wrote only one book or at most a few that tended to be more about "my life in nature," organized seasonally because that was the most attractive structure. They seemed to be saying: I have a personal story to tell, and I will try to make it interesting as well as instructional. More often than not their works were well received, but readers had little reason to expect that there would be a sequel. Both kinds of writers contributed in important ways to the distinctiveness of this generation in terms of seasonal writing; but the professionals dominated the scene and consequently will receive a disproportionate amount of attention here. Most of

the people I am referring to as amateurs did not communicate with and visit one another or gather in Concord on Thoreau's birthday as the professionals did. So theirs is the less important story in our scheme of things, though we will take them into account in the following chapter devoted to the seasons in American popular culture.

We have already encountered most of the "professionals" in one context or another; but it may be helpful here to identify the seven who are most central to the period now under consideration: Aldo Leopold (1886–1948), Joseph Wood Krutch (1893–1970), Donald Culross Peattie (1898–1964), Edwin Way Teale (1899–1980), Gladys Taber (1899–1980), Hal Borland (1900–1978), and Rachel Carson (1907–64). Although this group possessed many qualities and interests in common, their beginnings as nature writers varied in important ways. Leopold (figure 53) was a midwesterner who worked for the U.S. Forest Service (1909–27) before becoming a professor of wildlife management at the University of Wisconsin. Krutch (figure 54), born in Tennessee, served as drama critic for *The Nation* (1924–51) and as a professor of dramatic literature at Columbia University. After publishing his biography of Thoreau in 1948, he began devoting much more time to his avocation, natural history.[1]

Peattie (figure 47) came from a family of writers in Chicago and found his métier by combining a fascination with science and journalistic writing. Although his popular *Almanac for Moderns* (1935) emerged from his Illinois experience, he soon built a home in Santa Barbara, California, in order to live closer to western nature, a move that Krutch would replicate with a home in Tucson early in the 1950s. Teale (figure 55) was also a midwesterner, who grew up with great affection for the Indiana sand dunes. A self-proclaimed naturalist at the age of twelve, he was initially intrigued by insects and photography, both of which would figure prominently in his mature work. After thirteen years as a staff writer for *Popular Science Magazine*, he became a freelance author living in suburban Baldwin on Long Island. In 1959, following the publication of many successful books, he and his wife, Nellie, bought a farmhouse near the village of Hampton in north central Connecticut. With later contiguous purchases they eventually had 130 acres of woodland and open fields, two brooks, a waterfall, and a pond. Today the property belongs to the Connecticut Audubon Society. Teale is best remembered for his wonderfully readable four seasons quartet: *North with the Spring* (1951), *Autumn Across America* (1956), *Journey into Summer* (1960), and *Wandering Through Winter* (1965), for which he received the Pulitzer Prize in nonfiction. Teale and his wife traveled almost 80,000 miles in a car crammed with photographic equipment in order to research and write these best-selling books.[2]

Gladys Taber (figure 45), a New Englander, was educated at Wellesley. Beginning in 1932 she became a prolific writer for the *Ladies' Home Journal*, *Family Circle*, and other magazines, and the author of numerous books about

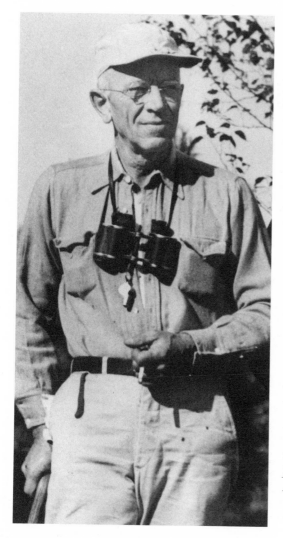

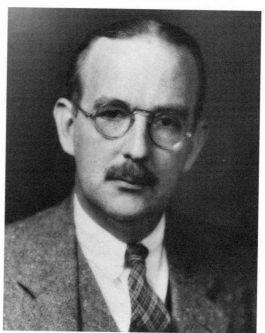

(left)

FIGURE 53

Aldo Leopold (1886–1948) about to embark on a bird-watching tour of his Wisconsin River farm. Wisconsin Historical Society.

(right)

FIGURE 54

Joseph Wood Krutch (1893–1970). Columbia University Archives—Columbiana Collection.

Stillmeadow, her rustic colonial home in Southbury, Connecticut. Her books are salted with recipes and loving accounts of her pets, family, and visitors, but also with observations about nature and the seasons. The least scientific of these seven writers, she was also the most sentimental and gender-oriented. She would not have protested the designation of "women's writer." Hal Borland (figure 11) grew up in Colorado, the son of a country editor, and turned naturally to journalism himself, writing especially about the West and then on all aspects of nature. He joined the *New York Times* Sunday Department in 1937. Four years later he submitted a short essay for the editorial page, and from then until he died, his unsigned pieces became a weekly and beloved feature of the paper. From 1957 through 1978 he also wrote four seasonal essays each year for *The Progressive*. His obituary in the *Times* fittingly designated him as "Chronicler of the Seasons."[3]

The Ambivalence of Urban America 177

FIGURE 55
*Edwin Way
Teale
(1898–1980)
in the woods.
University of
Connecticut
Archives
and Special
Collections.*

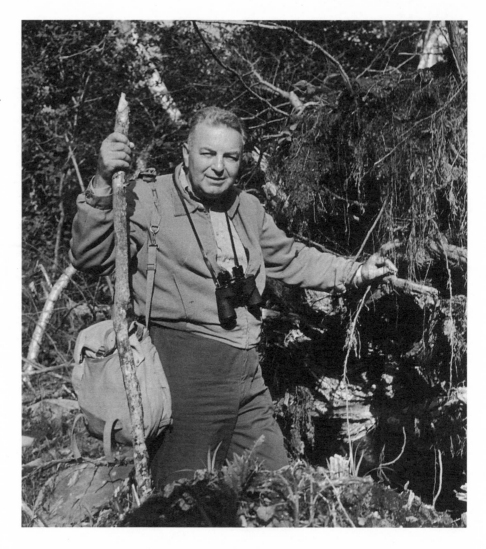

Rachel Carson (figure 48) was born in Springdale, Pennsylvania, received an M.S. in biology at Johns Hopkins, taught biology at the University of Maryland from 1931 to 1936, and spent summers at the Marine Laboratory at Woods Hole, Massachusetts. In 1936 she took a job in Washington with the Bureau of Fisheries, which became the U.S. Fish and Wildlife Service in 1940. Her first article on the sea appeared in 1937 in *Atlantic Monthly*, and she expanded that into *Under the Sea-Wind: A Naturalist's Picture of Ocean Life* (1941), a compelling account written in layman's language of the seasonal cycle of marine life in the Atlantic. Her next book, *The Sea Around Us* (1951), became a big best-seller and won the National Book Award for nonfiction. In 1952 she resigned her government job to devote full time to her writing. Following years of research, in 1962 she published *Silent Spring*, which attacked the indiscriminate use of poisonous chemicals to kill insects, thereby polluting the food chain for animals, birds,

and humans. The book sparked immense controversy, led to several major federal regulations concerning pesticide controls, and played a significant part in the genesis of environmental and ecological consciousness in the United States. As with Peattie and Borland, reviewers often referred to her as a poet.[4]

There were others, such as Paul Brooks, John Kieran, and Henry Beston, who interacted with this network of gifted writers. They referred to themselves as naturalists and frequently corresponded about two professional matters in particular: who should receive the annual John Burroughs Medal for meritorious writing in natural history and who would be attending the annual meeting of the Thoreau Society in Concord on July 12–13. An expansive letter that Teale wrote to Brooks in 1977, near the close of Teale's long and highly successful career, conveys some of the feeling this group shared that it belonged to a great tradition that seemed to be coming to an end.

The nature book or nature essay has flowered only among English speaking peoples. At least it has had its largest acceptance and greatest impact in England and the United States. . . . Sometime when I am in Concord, I hope we can sit down for an afternoon or an evening or while on a canoe trip and wander through the field of nature writing. . . . Indiana University Press sent me a copy of a life of William Beebe, by Robert Henry Welker. There is one section that may be of particular interest to you in connection with Rachel Carson. Considering all the new disciplines such as molecular biology and genetic coding, Welker ends up: "In other words it appears that the old disciplines are fast becoming obsolete, and their practitioners with them. Under the new dispensation, where is there a place for a botanist or an entomologist? What of the ornithologist. . . ? And of all such people, the naturalist surely is the oddest, a figure not merely old-fashioned but antique. A naturalist studies nothing less than the living world, perhaps out of love for it; and for such a man or woman, where is there a meaningful place? The word 'woman' suggests a wholly persuasive answer. In 1962, in the midst of the putative triumph of the new biology, Rachel Carson brought out *Silent Spring*. This book without question influenced thought and affected practice in a way analogous to important discoveries from the laboratory; and it was written by a naturalist, albeit one both famous and exceedingly learned."
. . . I have the impression that the literary naturalist of long and honorable tradition seems to be fading away. Nobody wants to work long enough to turn out a really good book, one of lasting merit, in other words, one that deserves the Burroughs Medal. Fast fact-books bring in more money. . . . The most influential book in the past quarter century in the field of nature has been Aldo Leopold's *Sand County Almanac*. It did not receive the medal. I was under the impression the medal could not be given posthumously. But when I looked up the rules I find that is not a proviso.[5]

Needless to say, Teale went on to propose that Leopold should receive the award in 1978, which he did; but that is not our primary concern here. If members of this group had such a strong sense of their vocational tradition, how did they define it and what comprised it? Who were their forebears and exemplars, especially in terms of explicating the seasons? That question is actually quite easy to answer because they have told us in a variety of very explicit ways. First, several of them devoted considerable effort to editing fat anthologies of selected works by outstanding nature writers. Examples include Krutch's *Great American Nature Writing* (1950), Teale's *Green Treasury: A Journey Through the World's Great Nature Writing* (1952), Borland's *Our Natural World: The Land and Wildlife of America as Seen and Described by Writers since the Country's Discovery* (1965), and a book by Brooks devoted to a biographical history of the tradition, *Speaking for Nature: How Literary Naturalists from Thoreau to Rachel Carson Have Shaped America* (1980). We also know because several of them wrote autobiographies that mention the naturalists they most admired.[6] Teale edited selections from the writings of Muir and Thoreau, each book structured differently: the first by sequential pieces and the second topically by using a great many brief extracts organized in a thematic fashion.[7]

Reviewers of these authors' own works commonly used words and phrases like "contemplative," "serene," "intimate," "introspective," "poetic," "gentle," "philosophical but not mystical," and above all "inspirational." The writers themselves unabashedly reviewed one another's books, with results invariably closer to backscratching than to backbiting. (They reserved the latter for occasional private letters.) Kieran and Krutch reviewed Teale's *Autumn Across America*, and Roger Tory Peterson assessed Teale's *Wandering Through Winter*, making an interesting distinction in the review between a naturalist (requiring curiosity with close observation) and naturist (meaning one who preaches appreciation). While Peterson regarded Burroughs as a naturist, Teale qualified as both! Teale reviewed *The Desert Year* by his friend Krutch, and the latter reviewed Leopold's *Sand County Almanac*. Early in 1953 the Teales visited with the Krutches in Tucson. Soon after Teale's review appeared, Krutch wrote to thank his friend and revealed that it "makes me feel that I am famous at last."[8] May Sarton, the author of a four seasons novel in 1946, reviewed Borland's *Report from the Country* in 1969, commenting that "he plays his subtle variations on the great seasonal themes. His genius is in making it all so fresh." When Borland reviewed Krutch's *Twelve Seasons: A Perpetual Calendar for the Country* in 1949, his response was unusual for this group in damning with faint praise. If Krutch is a gardener, he remarked, "there is little evidence of it. He even condones woodchucks. He lives with the country on an intellectual level." From Borland's perspective, Krutch observed and enjoyed without being a genuine participant.[9]

There were frequent occasions when awed remembrance of Thoreau's genius was accompanied by recognition of the need to build upon his legacy. When Peattie reviewed Teale's book *Autumn Across America* in 1956, he praised the modern writer for breaking with "the Thoreauvian tradition that a good naturalist must stick close to home, scorn all places but his own bailiwick." Late in 1967 when Borland accepted an invitation to address the Thoreau Society in Concord the following July, he felt grateful that the speaker customarily enjoyed what he called a "free hand[,] because there were some aspects of Henry that rub me the wrong way. That, of course, was characteristic of the man— there probably were few people of his day whom he didn't rub the wrong way at one time or another. But he was a landmark, and he endures, and I have the deepest respect for him." When Teale sent Borland a copy of his *Thoughts of Thoreau* the following April, Borland sent an appreciative but odd reply: "To tell the truth," he wrote, "I haven't read very widely in Thoreau, the Concord, the Maine Woods and Walden, and that's about it, plus a few of separate essays. So you provide a short cut to the pithy parts." Borland seems to have felt a bit sheepish that he had never done what so many of his cohort had: namely, read the journals from start to finish.[10]

Peattie's compliment to Teale is significant because it reveals that by the third quarter of the twentieth century the genre of seasonal nature writing had actually subdivided into two approaches: first, the older one of sticking very close to home that we associate with Thoreau, Susan Fenimore Cooper, and more recently an array of modern writers, including Beston and Borland; and second, the broader, transregional approach of people like Teale, Carson, and Krutch. When, in 1951, Charles Poore reviewed Krutch's *Desert Year*, a book about the cycle of the seasons in the Southwest, he made a droll but apt quip: "One thing that makes New York so crowded these days, I think, is that it is so full of Thoreaus, all writing eloquent books and pieces in praise of being somewhere else." A year later when Krutch contemplated compiling a volume of selections from Thoreau, he sought Teale's advice and offered this speculation on the prospects for such a project: "Thoreau is available in so many forms that I wonder how much demand there would be for another volume of selections. Probably it would have to sell on format and pictures." How prophetic. In 1975 the Sierra Club published a handsome volume titled *Thoreau Country* with selections from his works and enhanced photographs by Herbert W. Gleason (1855–1937), a professional whose career began at the turn of the century and who contributed the illustrations to *Through the Year with Thoreau* in 1917. The 1975 production is a most elegant and inspirational coffee-table item.[11]

Among English nature writers with particular enthusiasm for the seasons, two from the eighteenth century continued to be read, or certainly referred to by our cohort. Gilbert White of Selbourne actually remained the prototypical

writer of seasonal change in a microcosmic universe; and not only do references to James Thomson's poem recur in Teale's writing—he carried a pocket-size copy of Thomson on all of his seasonal trips across the country and called it the "classic of nature poetry"—his fan mail also indicates some of his readers' familiarity with and interest in Thomson. After Teale published *Journey into Summer* in 1960, one woman sent the following from Wilmington, Ohio: "It occurred to me before I knew you carried Thomson's *Seasons* that there might be a relationship between the poem and your series. Did your idea originate from the poem?" A man wrote from Chicago to express appreciation for Teale's books and remarked: "I suspect James Thomson is enjoying a special reward for his having inspired you to write them." Five years later, when *Wandering Through Winter* completed the quartet, a couple from Newcastle, Oklahoma, wrote to ask Teale where they could purchase a copy of Thomson.[12] Ironically, *The Seasons* remains out of print today, though many hundreds of used copies are available from dealers.

Even a casual perusal of the many books and essays concerning the seasons published during the third quarter of the twentieth century makes it plain that these writers possessed a strong sense of lineage. Reading their correspondence only confirms that perception. Hal Borland wrote to a friend in 1964 that "the really good nature writing began with the Bartrams and Wilson"; he went on to add Lewis and Clark, Bradford Torrey (who prepared Thoreau's journals for publication at the turn of the century), along with George Catlin and George Bird Grinnell. Little more than a decade later, when Borland was preparing his own *Book of Days*, he told his editor at Knopf how much he admired Peattie's *Almanac for Moderns* (1935), which served Borland as a kind of model. Writing in 1967, Gladys Taber told her readers that she had taken *Walden* down from her bookshelf once again and, with even more excitement, announced that Beston's *Outermost House* was newly available in a paperback edition that "everyone should have."[13]

These writers also displayed an intriguing desire to go where predecessors had gone and to do what they had done. In June of 1885 a party accompanied John Burroughs in climbing to the top of Slide Mountain, the highest in the Catskills. When Burroughs wrote about that adventure, he emphasized that at the top of the ascent they experienced a second spring, observing that every thousand feet of elevation made about ten days' difference in the vegetation. Consequently the seasons changed a month or so later at the peak than at the base. In 1949 Edwin and Nellie Teale, making the trip that resulted in *North with the Spring*, replicated that experience not once but twice, in the Blue Ridge Mountains of North Carolina and again, at the end of their journey in June, on the top of Mount Washington in New Hampshire. Yet Teale one-upped Burroughs by offering a more precise reckoning of the process and its implications. "Each hundred feet of elevation," he wrote, "theoretically represents one day's

advance of spring. In mountain country, however, the wheel of the seasons speeds up. Spring advances faster the higher it goes." So the latter-day naturalists did look to their forebears but did not hesitate to build upon their insights in an effort to improve them.[14]

Beyond such repetitions of experience, there are fascinating ways in which concepts, emphases, and language echo the writing of predecessors, in part, perhaps, because of shared enthusiasms and interests, but in part because of an appreciative awareness of the written tradition. In several different books Teale echoed Thoreau's passion for the wild. The Pine Barrens of New Jersey, he observed, "form a last stronghold of wildness in a long-settled region." Early in summer he experienced ecstasy in Vermont "wandering about the little glade, surrounded by the silence of that windless June day, breathing in the pure balsam-scented air of the mountaintop. I was on the edge of wildness and little things of interest were all around me." Moving through Kansas in August, west of Wichita, the Teales followed a sandy, dusty road "into wild country and into wild and memorable weather." The great appeal of moving to their rustic home in Connecticut called Trail Wood was that they "would be living on the edge of wildness."[15]

We get the same sense of déjà vu when Leonard Hall writes in *Country Year* about the benefits to farmers of an October "spell of Indian summer with mild nights and no killing frost, so that our fields will furnish a few more weeks of grazing for the cattle." Closing out his contemplation of autumn in New Hampshire, Donald Hall (unrelated to Leonard) lifts a chorus even more extravagantly than his predecessors:

> Late October or early November—after weeks of frost and the fields brown and the harvest long taken and the garden ripped up and dumped and the trees mostly bare and the house tucked up for Winter—comes the moment of miraculous restoration, Summer's curtain call or triumphal final tour: The wind relents, the sun rises, golden warmth rises from frozen acres, and Indian Summer visits like a millionaire; the expensive stranger walks over Kearsarge and Ragged and spends gold sunshine on the unreceptive fields.[16]

Leonard Hall's 1957 book touches base with Thoreau for an extended stretch when the author finds a bit of free time and envies his forebear: "The most important thing about *Walden* is that it is a leisurely book, written out of the fullness of days and nights of contemplation. There was time to think, time to vegetate, time to drain the full meaning from each observation of the small wild creatures of his woodland." Yet Hall also has immense admiration for and an easy familiarity with Aldo Leopold's *Sand County Almanac*, published less than a decade earlier than his own book, calling it "required reading for everyone with a serious interest in conservation." Because his farm chores were so demanding, "the steady rhythm of the farmer's year," Hall could not under-

take the reading and field studies that Thoreau and Leopold did, but at least he and his wife could closely watch and cherish what Hall called the "swing of the seasons."[17]

Cordial interchange was the norm among this enthusiastic cohort of writers. They were delighted when opportunities arose to visit one another. In 1951 Teale made a trip to Washington and stopped to see not only Rachel Carson but also Louis Halle, the author of a widely admired book titled *Spring in Washington* (1947). In the mid-1960s Gladys Taber informed her readers that when Hal and Barbara Borland come to visit, "we sit around and have wonderful conversations. . . . Hal's books on nature are among the best ever written. . . . I think *Sundial of the Seasons* [1964] should be on every bedside table." A few years earlier John Kieran wrote to Borland from Rockport in March that they expected a visit from the Teales quite soon: "They have a date with the Vernal Equinox in Maine and promised to stop by en passant. Hope we can have a day in the field together." (The Teales were doing fieldwork in order to complete *Wandering Through Winter*.) Two years later Kieran told Teale that the Borlands "descended on us unexpectedly . . . and it was a riot! She is a ball of fire . . . he's a quiet chap; very amiable." These were sociable people who loved good conversation about their shared interests and individual projects.[18]

Their mutuality extended to intellectual and moral support for each other's books. After Joseph Wood Krutch published his autobiography in 1962, he received the following in a letter from Teale, representative of the kinds of responses these writers customarily sent one another: "Years ago, Francis H. Allen said to me that he got the impression in reading most nature writers that they had never read anything at all. I still think . . . that it was a great day for American nature writing when someone with your breadth of reading and breadth of background came into the field. It has helped elevate it for all of us. And certainly natural history books have an audience and a standing they did not have when I first began a quarter of a century ago." A month later Krutch responded to the appearance of Teale's compilation of Thoreau's writings, *Thoughts of Thoreau*, with lavish praise. "I think you were quite right to keep the selections short," he wrote, "because, for one thing, that illustrates what a wonderful aphorist he was." A few years later when *Wandering Through Winter* appeared, Teale received a warm encomium from John Kieran, who called it "wonderful . . . you get better with that typewriter with each new book—if possible! I really think you spread yourself out more than you did when you first turned to general writing on Nature. If you feel the urge to go off on an interesting tangent or to come up with an apt quotation, you do it now where you might have repressed it in your younger days."[19] Kieran called attention to the quality that undoubtedly made Teale the most popular writer among this entire group—what made him the Norman Rockwell among modern naturalists: his

ability to inject human interest and personalize his books. More on his mass appeal in a moment.

We must first acknowledge the existence of at least one rivalry within the group, perhaps because the two figures involved, Teale and Borland, were temperamentally so different and wrote in distinct styles for audiences that certainly must have overlapped but were largely discrete. Very little correspondence passed between them, and the two residents of rural Connecticut did not actually meet, in fact, until 1968, when Borland received the Burroughs Medal in New York in April and then once again in Concord when Borland spoke on the occasion of Thoreau's birthday in July. Early communications through their shared vocational context seem polite but perfunctory and abrupt. In 1965, for example, Borland wrote: "I hear that your WINTER book is in the works, due out later this year. What next?" Because Teale was much more prolific than Borland, the latter may have felt that so much productivity must surely occur at some sacrifice in quality. What we learn from an interesting exchange between Borland and a friend late in his life, however, is that he basically felt Teale knew a lot but strung it out, repeated himself in various ways, and above all, lacked depth of feeling. He had no homely profundity about the spiritual *meaning* of seasonal change, which is what I believe Borland most prided himself on.[20]

In 1977, less than a year before he died, Borland received a letter from Joan Mills, a New England native, naturalist, and writer who had moved to San Diego because of her severe arthritis. She explained that she was writing because she had just read and loved Borland's *Book of Days*, but also because she needed advice on how to go about an "unusual assignment" that she had received from the *Reader's Digest*.

> In March, I am to leave here and go where spring is becoming manifest, wherever that may be; then follow it all around the country in broad northerly zigzags coast to coast, probably from the deep south westward, in and out of the west coast, up and down the heartland, and, finally arriving with full spring in New England. A book, or book-length feature. Anywhere I want to go, by whatever means. . . . A spring fantasy; an *experience*, not a travelogue, or even a naturalist's precise record of the literal greening of America. . . . So I was reading you, through the winter and into spring, feeling the pull of my own loved scenes and seasonal details. Much moved.

Borland's response is revealing. "Your Spring assignment for the Digest sounds wonderful. It should be, as you say, an experience, emotional as well as visual. Some time this winter, however, I suggest you take a look at Edwin Way Teale's 'North with Spring,' one of his four 'Seasons' books, for which he got a Pulitzer. A bit pedestrian, and somewhat botanical, but a book of which you should at least be aware before you start." (An essay that Borland included in

Homeland [1969] contains a swipe clearly aimed at Teale: "I came back down the mountainside [near his Salisbury farm] content to live with March and await April, content to be rooted here, *not walking north with spring*; to let spring come to me, as it always comes.") Mills thanked Borland for the suggestion and commented that she had read Teale's book but forgotten it. "As for the California seasons (or lack thereof)," she added, "only my arthritis *really* thrives on the sameness of blue and breezes. I miss that lovely week of greening toward the end of April most; and fall next; and the look of winter, but oh, not the cold!"[21]

In 1976 Borland and Teale both produced works that were widely reviewed together because both men were broadly admired authors and their subjects enjoyed considerable popular appeal. The books were Teale's *American Seasons*, a condensation of his prize-winning quartet, and Borland's *Book of Days*, his almanac designed to help the reader know what to look for on a seasonal basis. The comparisons that appeared in a double review must have pleased the aging Borland. The reviewer remarked that Teale's book "is genial and scenic, but not very deep. . . . The need to jam the field notes into the glove compartment and push on to the next natural wonder wars against tranquility. Observations are made, but reflection is scanted. One result is that after spending a chronicled year with the Teales, the reader knows nothing about them except that they are pleasant people." Borland, by contrast, came across as a "good teacher of observation, of useful inquisitiveness and of the stillness of mind that must come after the imponderable questions have been asked. Borland is elderly, and this stillness may be a knack he has had all his life. The likelihood is that it is an achievement, the result of a long lifetime of walking the meadows and woods near his house, of watching and thinking."[22]

Seasonal Receptions: How the Reviewers Responded

Published reviews of all these books were almost invariably positive, which helped to make a broad readership aware of the attention that this generation of writers showered on the seasonal wonders of North America and the need to preserve them for posterity. When *A Sand County Almanac* appeared in 1949, critics turned to flattering comparisons. One of them remarked that Leopold's ideas "were the man's life, and because of them we can place this book on the shelf that holds the writings of Thoreau and John Muir." Another wished that *he* had written the book and observed that only Krutch's *Twelve Seasons* "can equal it in contemporary nature writing." He concluded that it "contains a lifetime of powerful thinking on conservation. . . . In four lengthy essays, pungent, astringent, sometimes despairing and always profound, Mr. Leopold has poured out the essence of a fine mind." Writing in *The Nation*, Krutch himself proclaimed that Leopold was a nature writer "who has both an original sensi-

bility and a special, humorous awareness of the paradoxes of conservation."[23] Because he moved away from an instrumental or a religious emphasis to a holistic philosophy, many readers responded in especially empathetic ways to his contention that nature possesses significance independent of man's well-being. Everyone did not agree, but preservationists would increasingly emphasize the aesthetic and psychological values and uses of nature, usually without any appeal to a higher being.

When Krutch's *Twelve Seasons* appeared in 1949, he was already a well-established author and critic, so his first effort as a naturalist was more widely noticed than most such maiden efforts. It helped that it followed very close upon the heels of his biographical study of Thoreau (1948). Reviewers were especially likely to notice his enthusiasm for winter and the intensely cerebral qualities of the book. Krutch came across as more of an idea-hugger than a tree-hugger. As Lewis Gannett aptly summarized in the *New York Times*:

It is in winter that Mr. Krutch seems to feel his intensest emotions. One of his loveliest paragraphs—and there are many lovely paragraphs in this strange, lonely book—envies the man who never saw snow until he was old enough to sense the wonder of the microscopic detail of its crystals. . . . The only human beings who enter Mr. Krutch's thought-filled pages are his wife, an astronomer, and an anonymous friend from the city who hates the country—and some threescore writers of books. . . . This is a countryman who walks—or stands at his library window—alone, or sometimes accompanied by his cats.

Other reviewers were equally struck by Krutch's fascination with spring, noting that he chose to begin "the cycle, not with the opening of the calendar year, when, as he points out, 'nothing happens except to the calendar,' but with the rebirth in nature, which in his area takes place in April." Louis J. Halle, himself a seasonal author, caught the distinctive strengths of Krutch's book in an essay-review. By noting that he did not content himself with "describing what occurs in each act [season] as seen in his country home in Connecticut: snow, migration, autumn colors, and so forth. . . . The delight that the reader has in these pages is delight in watching the exercise of its freedom by a speculative mind to which education has given wings."[24]

When Krutch's fascination with the American Southwest led him to publish *The Desert Year* in 1951, he concentrated more directly on natural phenomena in the region near Tucson and less on learned assessments concerning them, which reviewers warmly praised. Because the area was relatively new to him, reviewers like Teale remarked that he transmitted "the excitement of an awakening understanding of the life of this enduring land." Another critic declared that "a better essay, impelled by a purple sunset, on the simple acceptance of natural phenomena versus their analysis by science as merely subjective impres-

sions would be hard to find." Paul Horgan, the nation's leading literary authority on the Southwest, decided that Thoreau was Krutch's "master [i.e., mentor], and in consequence, a physical fact of nature, intimately and devotedly seen, is to him interesting, not only for its own sake, but too for the lift it can give the mind into higher contexts of thought."[25] Because he felt smitten by this area, so different from New York City and suburban Connecticut, Krutch decided to relocate there permanently in 1952, right after *The Desert Year* appeared. His remaining years would be incredibly productive of nature books as well as social criticism. Like Henry Beston, he was antimodern and mistrustful of "progress." Krutch and Beston shared that penchant more strongly than any of the others in this cohort, though Hal Borland seems to have been very close behind.[26]

Borland's best medium was the nature essay, most notably seasonal in emphasis. His pieces, often referred to as "prose-poems," were gathered into bound format on a regular basis. The first one, *An American Year: Country Life and Landscapes Through the Seasons*, appeared in 1946 and received a very warm welcome. His "richly rewarding book," according to one prominent review, recreated the "changing patterns of a countryman's year, beginning at the vernal equinox, moving through reluctant spring to full-blown summer, from the dog-days to autumn fulfillment, from winter's peace to the awakening of yet another spring." A different admirer observed that Borland "is not over-sentimental about his country year. He is not an escapist. He simply feels that nothing can compare with the completeness of living that comes to one whose life has roots in the soil. He does a very good job of proving it."[27]

Next came *Sundial of the Seasons*, which gathered 365 "outdoor editorials" (Borland's preferred phrase) from the more than 1,200 he had written and arranged into a kind of latter-day almanac, the first of two for Borland. This volume, published in 1964, also received warm praise. A subsequent harvest of his writings appeared in *Homeland: A Report from the Country* (1969), which pulled together pieces from *The Progressive*. May Sarton reported that "the pleasure of reading about seasonal happenings has been extended once more in another fine book. . . . [It] takes us through the four Connecticut seasons of five years up on the Borland place in the Housatonic Valley [near Salisbury]." She then undertook a bold and intriguing line of inquiry.

It is tempting to compare writers concerned with nature and man's relation to it. There are never a great many in any literature. It is harder than it looks both to live and to make literature out of a life like Hal Borland's. Like Thoreau, he has had to create a style to express a personal vision of life, but there the resemblance ends. Thoreau was not really a countryman, perhaps. At least he was not interested in farming as a practical matter. Thoreau catches us up, sentence by sentence, with his stunning original images. The

Borland style has another virtue. We are not stopped on our way, but carried forward on a rhythm that deals with large wholes, not as much with minute particulars.[28]

"The mystery and power of this book," she concluded, "lie in the long rhythms it sustains, as long, as slow and inexorable as the tides of the ocean," a comment that echoes and harkens back to the raves received by Rachel Carson when *Under the Sea-Wind* was reissued in 1952 to capitalize on the success of her bestselling *The Sea Around Us* (1951).[29]

Between 1951 and 1978 Teale devoted himself to writing about the seasons more single-mindedly, and with greater popular success, than anyone else. The "experts" responded enthusiastically for the most part, though negative notes were sounded here and there when an apparent highbrow took issue with the author's effort to maximize his audience by injecting anecdotal human interest. *North with the Spring* was his first seasonal book, published in late fall of 1951, and the assessment in the *Christian Science Monitor* is fairly representative: "This book is a magical thing to have at hand as we approach the darkest and shortest days of the year." The book was the result of three carefully planned months that Teale and his wife spent in their Buick, following the season of renewal on a 17,000-mile jaunt from the tip of Florida to the summit of Mount Washington. Walter Harding, secretary of the Thoreau Society, loved it, and so did Robert Cushman Murphy, chairman of the department of birds at the American Museum of Natural History in New York. Donald Culross Peattie gave it a rave, calling it "beautifully written, and written out of a wide knowledge of nature, including insects, reptiles, batrachians, as well as the birds, flowers and trees in which everyone takes an interest." Carping comes at the very end of Peattie's review, where he notes that Teale "has passed up a great deal of the little-explored science of phenology—the relation between climate and periodic biologic manifestations—in favor of amusing details of motor-court sleeping and wayside eating, and scraps of chatter with strangers."[30]

When *Autumn Across America* appeared five years later, Peattie also reviewed the second installment and lavished compliments on Teale himself as well as his trek from Cape Cod through the northern tier of states all the way to Point Reyes on the coast of California. But then, once again, he provided what comes across as the most candidly balanced assessment: "Sometimes I missed autumn as I know it . . . North America has the most magnificent autumnal flora in the world . . . but our gentians, Joe-Pye-weed, and asters and our many colorful autumnal grasses receive scant mention. A large number of our big mammals mate in autumn, but Mr. Teale barely alludes to the fact. And where is the wistful autumnal song of the white-throated sparrow [a great favorite with virtually all of these naturalists]?" Otherwise he received wondrously favorable notices from his good friends John Kieran in the *New York Times Book Review* and

Joseph Wood Krutch in the *New York Herald Tribune Book Review*, the two places that mattered most in terms of bookstore orders and sales. What Krutch especially called attention to were the scope and variety in these travels: "autumn in the high country and autumn in the low—from sea level to the fourteen thousand foot peak of Mt. Rainier. It is also autumn in the dry as well as in the wet." Writing as the "Peripatetic Reviewer" for *The Atlantic*, Edward Weeks hit a note increasingly heard during the 1950s in response to all of these books: namely, that the country has a precious but perishable heritage—thereby adding an impassioned blend of patriotism to the emergence of a preservation crusade. He concluded that Teale "gets the best out of people as he does out of books; he is good for wild life and particularly good for Americans who should know more about America."[31]

Four years later *Journey into Summer* traced that season from Maine to Wyoming and Montana followed by a loop south through the Great Plains before climbing Pike's Peak in Colorado. Reviewers now began referring to Teale's volumes as "classics," and the poet who reviewed *Journey into Summer* for the *New York Times* declared that Teale "belongs in a class with John Bartram and John James Audubon and in a way is entitled to even more credit than those early travelers. They, after all, found it much easier to present their readers with things which had never been seen or imagined." One critic lamented that great American cities in the Midwest were scanted, and another found the mood of this volume "less active, quieter, and often nostalgic." Once again the observation was made that the book "gives us an America we realize we don't want to lose through ignorant or careless conservation practices."[32]

The planning for the fourth book touched off some troublesome tensions between Teale and his longtime publisher, Edward H. Dodd Jr., the president of Dodd, Mead & Company. "Tommy" Dodd wanted more human interest stories, less travel, and more of a "summing up, not just another journey." Fearing that the formula that worked so well for the first three might not hold the general reader's attention a fourth time, Dodd urged "a winter's survey of reflection." Teale would have none of that, and his ultimate response (and gritty determination) is worth noting.

> The way I have planned the winter book, it will tie all four of the seasonal volumes together, with threads of reference throughout. But I don't think we should abandon the original idea of having four books on the four seasons, each based on a long trip through a different part of the country. The final effect will be to cover the whole country with the trails of our trips and to show the different seasons as they occur under widely differing conditions. For example, winter in the desert and along the Gulf Coast is still winter although it is far different from winter in New England. Adding up all the winters will aid in giving a clearer picture of the season. We have traveled

about 35,000 miles through winter and have good material to draw on for the same trip-formula used in previous books.[33]

Dodd need not have worried. The brilliantly conceived final volume began south of San Diego, meandered up to Death Valley, looped through Arizona, and then gradually followed a zigzagging course diagonally to the Northeast, making it all the way to Caribou, Maine, before heading for home in Hampton, Connecticut, by way of the New England coast—a 20,000 mile trip in terms of the route actually followed rather than the researched byways that had to be omitted in the interest of balanced length. Reviewers loved it and, predictably, provided a reprise not only of the entire series, but of its place in the history of the whole genre. Roger Tory Peterson wrote a very long front-page assessment for the *New York Times Book Review*. Near the beginning he virtually canonized Teale in context.

> The decline of the old-fashioned naturalist was accompanied by a decline of good nature writing, which reached its nadir in the mid-thirties. Few of the new biologists seemed able to express themselves without resorting to the formal clichés of their specialty. Just when the slump leveled off and recovery began is disputed, but I believe it might be put at 1937 when Edwin Way Teale . . . published his first nature book, "Grassroots Jungles," heavily illustrated with his own photographs. In a review, John Kieran wrote, "I do not know which to admire more, his science or his art."

Peterson went on to say that Teale is interested in "everything that grows, walks, swims or flies and so skilled is he that we too are fascinated. . . . As one of his close friends commented: 'Memory seems to haunt Teale. The man is a squirrel who stores [information] for tomorrow.' But then, most of the best nature writing is nostalgic." Countless others joined the chorus of praise.[34]

From *Circle of the Seasons: The Journal of a Naturalist's Year* in 1953 until *A Walk Through the Year*, Teale's last book, in 1978, reviewers continued to laud his engaging prose, his fine photographs, the "fascinating and informative side paths" he took, and the coherence of his approach to nature. In reviewing *Circle of the Seasons*, Krutch assessed Teale's accomplishment in this way: "The two regions which good nature writers happen to describe are never as different as the describers are and the interpretation of Nature as opposed to fact finding about her is even more of an an art than it is a science. Mr. Teale is interested in both and he knows how to make the best of both."[35]

Seasonal Receptions: How the Readers Responded

Beyond the authorities' enthusiastic reception, how did members of the general public react to these works? As one woman began a very long (four single-

spaced pages) letter to Teale: "I wonder, sometimes, if you wonder about the people who read your books. Not the professional book reviewers, publishers, etc, but the ordinary grass-roots type people who buy and read them." Fortunately, a very considerable amount of unsolicited correspondence from average readers has survived, much of it fan mail sent to Borland and Teale. The latter's worshipful audience deluged him with letters, frequently explaining that they felt they really knew the Teales personally because the books seem so accessible and revealing about their aspirations, preferences, and feelings. The letters often began on a humble note, admitting that the writers know so much less about nature than the Teales, apologizing because they are so much less observant, and acknowledging that they have so much less time to travel in order to witness seasonal change all across the land.

It needs to be noted that Teale was hardly the first American to conceive of the idea of moving about the country in order to observe seasonal changes. John Muir had done so several times during the later 1890s and left vivid accounts of his travels in letters to close friends. Prior to the automobile and post–World War II road improvements, however, it simply was not possible for anyone to undertake the extended and exhaustive journeys made by the Teales. Muir and Burroughs talked about their travels in essays, however, and many of Teale's older readers were familiar with those essays and referred to them in letters to Edwin and Nellie.[36]

A typical letter might indicate that having read Teale, the respondent, being a nature lover, would like to do just what he had done though on a more modest scale. A woman wrote from Saginaw, Michigan, that she had "a yen to follow the *fall* from the north to the south. Right here now at my lonely cabin in the north central woods of Michigan I can detect the whisperings and smell of fall creeping in. I have my own 'Walden' and pond right by my doorstep, with all the other cottages across the lake. I only wish I had your eyes, and ears, and knowledge to appreciate it more." For vast numbers of people the Teales simply provided a delightful vicarious experience. After finishing *Wandering Through Winter* in 1966 a couple claimed: "Many times we have said, 'What fun it would be to follow the seasons around the country!' We did not get to so now I can take my travels through your knowing eyes." People who had made similar trips expressed their appreciation, too. A man wrote from Freedom, Maine: "This evening I finish the four seasons with you. It was a delightful journey. I was able to revisit with you many of the places I have seen from the saddle of my Indian motorcycle in all the seasons. The places my Indian didn't take me, your books have." Still others took Teale's books with them when they traveled, or they even tried to retrace at least part of his trek in a given season.[37]

People read the books in many different ways. Some read *Circle of the Seasons* straight through while others read one entry per day on the "designated" day:

"I want the surprise and pleasure of a fresh item each day," wrote a man from White Plains, New York. "It has paid off to restrain myself since so often what you write about has just happened here." Readers of volumes in the quartet revealed that they read slowly to make the pleasure last longer, and a great many declared that when they finished the set, they began it all over again. Some people preferred to read with the season while others chose to read against it: that is, they would read *Journey into Summer* during the winter when they were yearning for warmth or the gardening season. A Connecticut teacher wrote from Kenya that she had been given *Wandering Through Winter* just prior to leaving on a forty-one-day trip by cargo ship around the Cape of Good Hope. She declared that she sat on the deck in "sweltering heat" reading Teale's "wonderful tales of winter and longing for snow. I felt something of the same sadness you must have felt when you finished the quartet for I had no more books of the season to look forward to."[38]

Fans conveyed their appreciation by indicating that they read the books aloud, especially spouses taking turns in the evening or retired couples during the day. Some even reported that they read to one another "a little each night in bed." Grown children were grateful that reading Teale aloud to aging parents provided pleasure for both. Parents read the books out loud with their children; but as a woman in San Luis Obispo told Teale: "Perhaps 'together' isn't quite the right word, because we are reading it 'separately together'; none of us can wait for the other to reach the last page and pass it on, so we each have our book marks in it and whoever gets the book first reads it until he is called to some other duty, then the next one with a bit of free time picks it up. It is absolutely against the rules to remove the other fellow's book mark. However, at the table we discuss the parts we have all read." Another family, in Sidney, Ohio, had a more elaborate scheme. "We read the whole book aloud. The one who is being read to is not allowed to sit idly by, however. He must handle the maps, road maps, or more detailed ones as the story requires. Then we must refer to bird guides, flower guides, etc. It becomes quite a project."[39]

Most of Teale's readers, or at least the ones who chose to write to him, seem very much of the middle class, educated but not at an especially high level. Better-educated and more "sophisticated" people were more likely to be Borland fans, though certainly there was some overlap among their constituencies. An interesting glimpse of Teale's readers can be seen in extracts from a very long, carefully composed letter written in 1954 by a woman in New York City describing her family "dynamics" in response to the delight they derived from Teale's books.

The other evening my almost-twelve-year-old-daughter was sitting on the living room floor, at her father's feet, listening to him read aloud your Circle

of the Seasons. I, at the piano, was tremblingly executing a simple Bach pre-lude. Our several cups were indeed overflowing. [Dialogue between father and daughter about Teale's earthworms follows.]

Lise looked at me knowingly. Daddy always gets a certain look when he reads Teale, a wistful and/or envious look. She and I understand how it is with poor Daddy, for he is a clock-puncher; for his heart is yours and Thoreau's and Henry Beston's. . . . [Dialogue ensues between husband and wife about what kind of Teale trip they would take if they had a car.]

I didn't tell you the end of that scene by Daddy's chair. Daddy went on reading and presently I heard Elizabeth interrupt. "Daddy, tell me, surely you don't love Edwin Way Teale better than you do John Burroughs, do you . . ?" I had to run into the kitchen at that moment because the pressure cooker was tststsing, so I didn't hear Morey's reply. We'd be hard put to an-swer Lise's question, but what does it matter anyhow?[40]

Quite a few fans indicated both their admiration for the Teales' achievement and their familiarity with the entire lineage of American naturalists, from nineteenth-century figures like Alexander Wilson and Thoreau right through Beston, "David Grayson," Aldo Leopold, and many others from the first half of the twentieth.[41]

The reach of Teale's books and essays in popular publications like the *Reader's Digest* rippled out well beyond families and came to be used as a basis for discussion in all sorts of informal but well-organized social groups. Small town literary clubs thrived on his work, and he received letters from women who were preparing to "report" on the book or to read a chapter aloud to an elderly or blind friend. A woman in Rockport, Maine, indicated that Teale's book was being read and discussed "at our little bird club." Late in 1967 a woman living in the Great Plains was introduced to Teale's quartet by a friend from Oregon. "Now all four of your 'Seasons' are a part of our library and in each I have found more than a little delight." She and her husband were in-spired by their enthusiasm for the books to develop slide presentations, organ-ized seasonally, about beautiful or interesting places they had visited in the United States. According to her account, at least, these were very popular and had the added dividend of spreading the gospel far and wide that people really must "read Teale."[42]

The largest single category of respondents to Teale's books, however, was people who basically were "armchair travelers," people who, for various reasons such as age, infirmity, lack of funds, responsibility for aging parents, and so forth, simply could not travel but loved nature and the adventure of moving to dramatically different parts of the country to experience seasonal change in di-verse settings. As a man from Portland, Oregon, put it, he and his family always felt "that we were going on the journey with you." A woman from Atlanta re-

ceived *Wandering Through Winter* via her membership in the Christian Herald Book Club and planned all her subsequent reading in Teale so that she "could experience every single adventure along with you at the right time of the season," and do so with her family. Other people were obliged to read Teale "out of season" because their work left little time for reading during much of the year. Hence letters that said, "Summer just would not seem like summer any more unless I read some more of your books." And there were admirers who literally found comfort or solace in reading Teale. A self-styled spinster in Jamaica, New York, told Teale that she had read all four and was reading *Autumn Across America* for the third time: "These writings have interested me, inspired me, comforted me through several years of unhappiness, and filled me with awesome wonder. . . . I have even shed tears over some of the most beautiful passages!"[43]

Predictably, some people praised Teale and thanked him for "the beautiful word pictures you paint in these pages." One person wrote in 1954 that "after reading your article 'From Spring to Summer' in the April issue of Reader's Digest I instinctively hurried to the window to see the wonders of nature about which you write. Your descriptions of life outdoors bring to the reader's mind a picture as clear and distinguishable as if he were observing it personally." We know from unpublished autobiographical notes that Teale did admire the Barbizon school of nineteenth-century French painters, particularly Corot, Courbet, Rousseau, Millet, and Bastien-LePage "because they painted the landscape beauty and were close to nature." He claimed to have read everything that he could about them, along with reading Wordsworth and other English romantic poets who conveyed a deep appreciation for natural beauty. He must have been feeling expansive and artistic in the broadest sense when finishing up the fourth volume in 1964 because he referred to himself near the end as a "Plutarch of the seasons."[44]

It is clear from his correspondence that such a designation was accorded him by the American public as well. They had few complaints and only one regret. As a woman in Bradenton, Florida, put it: "What a pity there are not more seasons!" Another fan who wrote regularly after the appearance of each volume reiterated that sentiment in 1965 and added: "Your own similar regret, no matter how restrained, is frequently enough perceptible in a paragraph here or a paragraph there." He concluded with his "entirely unreasonable hope that, somehow, you will discover a FIFTH SEASON." Howard Swiggett, a widely read historical novelist and biographer, had written as early as 1956 after *Autumn Across America* appeared: "What a pity for the world there are only four seasons for you to see and write about."[45]

As it happens, there have been several writers who for diverse reasons refer in various ways to five seasons. Teale himself wrote that Colorado is a land of five summers and five life zones "where the season arrives and departs under

different conditions." A more recent naturalist, David Rains Wallace, wrote an essay called "The Fifth Season" when he moved back to the San Francisco Bay area after living for several years in Ohio. "The old complaint about California not having seasons is, of course, wrong," he remarked. "The dry season is California's winter, its plant dormancy period. For some reason, though, our culture doesn't really want to acknowledge the dry season. Millions of people swear by cold winters, and like nothing better than to put on down parkas and romp in the snow. Very few revel in cavorting through the chaparral and dry grass on a blazing California August day. The very idea seems perverse."[46]

Were there no serious complaints of any kind in this mass of adulatory correspondence? Yes, but the dissents invariably appeared following deeply appreciative remarks. The most common was conveyed by a Lutheran fundamentalist in Norfolk, Virginia, who loved Teale's books: "The one and most important sad fact tho'—I found in the early chapter on Michigan [in *Autumn Across America*] where you more or less expanded upon your belief in the theory of evolution. It was sad to me, because anyone with such a gift for showing the beauty of God-made nature to the ordinary person, ought also to have that "peace that passeth all understanding." We cannot have that whole peace without believing in God the Creator—the whole Book." Such sentiments were echoed in 1970 by a retired radio engineer in Franklin, Nebraska. "All through your fine narration you never mentioned one word nor did you hint or give credit to the great Creator of all the marvelous things on this earthly home for mankind. Would it not have been kind of you to have devoted at least one paragraph to honoring Jehovah God as the source of these works in the natural world?" Ironically, Teale had taught Sunday school during the 1930s, but he subsequently drifted away from organized religion. He seems to have felt that the world of nature provided him with much to worship and a "temple" in which to do so.[47]

The only other subject on which Teale's readers demurred was regionalism and pride of place, either because he had managed to miss their favorite spot in the entire country or else purely because of local pride. A physician in Oakland, California, who admired *Autumn Across America* wrote in the midst of spring and said: "This, I think, is one season of the year which offers many advantages [here] over the same season back East. Everything is green, bright, the flowers are out, and the birds are flying North." Californians also had continuous sunshine rather than all of that rain in the Northeast. A twelfth-grader who had just finished *Journey into Summer* wrote from Cleveland, Texas, that "spring comes early to Texas. . . . My enjoyment of spring has been greater than ever before. I now eagerly anticipate the coming of each new season, for I am now aware that each new season holds some unique discovery just for me."[48]

One clue to the socioeconomic composition of Teale's readership emerges from the many letters indicating that the books had been checked out of a pub-

lic library because, as the enthusiasts explicitly declared, "I can't afford to buy books," even though the seasonal quartet started out at $5.00 per copy in 1951 and reached only $6.50 by 1965 for volumes that averaged 360 pages of text and were abundantly illustrated with glossy photographs. Many of Teale's fans suggested to family and friends that what they most wanted for Christmas was a book written by their beloved naturalist.[49]

Borland's audience may have been a little more affluent and somewhat better educated, but they were no less worshipful. It took a while during the 1940s for people to learn that the unsigned "outdoor editorials" in the *Times* were Borland's, but as word got around, admiring letters began to flow in, often accompanied by laments like the following one from 1945: "Too many of us 'have been long in city pent,' and more of us 'having eyes see not,' and you open our eyes and our hearts, and 'what was a speck expands into a star, and we see the life of things'—like the flower in the crannied walk." By 1967, with two of his collected pieces from the *Times* available in book form, the "secret" was out, and letters reached him directly at his farm near Salisbury rather than being forwarded from the *Times* office building in Manhattan. In a typical letter a woman explained to Borland that "one of the nicest things you do is take time and thought, and provide space to comment editorially upon the flaming leaves of October, or the dragonfly days of midsummer or the majestic suit of the cardinal. These paragraphs always lift the spirit." In Borland's appreciative reply he came across as a philosopher of nature providing a core of spiritual content. The woman wrote once again to remark that "yesterday's piece on Midsummer stung my eyes with tears. I don't wholly know why—a startling echo of a time gone when I lived close to the earth and its turnings, I think. The sharp edge in it [his column] of awareness of rhythm, cycles, recurrences."[50]

Following Borland's death the *New York Times* received more than 800 letters mourning his loss, all of which were forwarded to his widow, Barbara. She kept a large selection, and they remain with his archived papers. Some of them revealed that the writers never knew until reading the obituary that Borland had been the author of the cherished commentaries, and virtually all expressed regret that those commentaries would come no more. "I no longer will be able to read those beautiful accounts of seasonal changes throughout the year," was a representative response. The more "poetic" letters looked back on Borland's work as a "world of the bursting bud, the opening blossom, the ripening fruit, the falling leaf and the transient snowflake. . . . He spoke to us of the great rhythms of the seasons, of wind and sea tides, of the great clock of the sky." Clearly, Borland's style was "infectious" in some sense. Many readers simply recalled wistfully that "he made me see and appreciate beauty in each seasonal change of the year—even what is happening when we are locked in a seemingly endless winter." One woman wrote that "for many years I have enjoyed his essays . . . painting in words his thoughts and impressions of the changing sea-

sons." Others had long responded with exactly the same sentiment.[51] Early in 1964 the ever popular Andrew Wyeth sent Borland (via editor John Oakes at the *Times*) a letter lauding his January 12 piece titled "The Unseen Tides." Borland wrote back to Wyeth at Chadd's Ford, Pennsylvania, that he had admired the painter's work for years: "You say things on canvas that I keep trying to say in words." Borland was flattered by the artist's attention and sent him a book.[52]

Wyeth actually began making watercolors and oils of individual seasons as early as his *Winter* in 1946 and as late as *Spring* in 1978 and *Autumn* in 1982. In 1956 he made two charming drawings of a hearse: one on wheels for use during normal weather and the second one on sleigh runners for use in serious snow. In 1963–64 he assembled a boxed portfolio consisting of twelve prints titled *The Four Seasons* with an accompanying text by Lloyd Goodrich, director of the Whitney Museum of American Art. The prints reproduced dry-brush drawings Wyeth had made between 1941 and 1961 that had not been previously exhibited. The subjects ranged from *Spring Sun* (1958) and *The Berry Picker* (1961) to the golden light of *Early October* (1961) and the white hush of snow on *Brinton's Mill* (1958). According to Goodrich, Wyeth and his wife selected the motif because of the essential role the cycle of the seasons played in his painting. Which naturalist was Wyeth's favorite is not at all clear, however. We know that Teale's *Wandering Through Winter* once rested on his bedside table for a while, and that he asked his wife, Betsy, to read to him from both writers while he painted.[53]

As these authors became rich with years and honors, they surely must have felt a certain sense of satisfaction knowing how widely and warmly their work was read and cherished. When Samuel H. Gottscho, a gifted photographer who completed a beautiful four seasons portfolio in 1965, finished reading *Wandering Through Winter*, he told Teale that he had been doubtful "whether anyone with the theme of Winter could do 347 pages against the background of that most austere season [as Tommy Dodd had also feared a few years earlier] and hold the reader's interest to the end, but you have accomplished that!" Like so many others, Gottscho deeply regretted that the series was now complete. He declared that he would start all over again with *North with the Spring* just as soon as he finished Walter Harding's newly published, big biography, *The Days of Henry Thoreau*.[54]

In March of 1964 Ruth Hard Bonner of Brattleboro, Vermont, explained to Borland that she had been reading a brand new book by Robert Murphy called *Diplomat Among Warriors* "when my passion to be outside digging and planting became almost ungovernable." As an anodyne for her impulses she picked up Borland's *Sundial of the Seasons* "intending just to read the March entries. I delighted in the vital willows, the song of the brook, the daylight stretch, the dawn of a late March day. And then it came to me that this was one way I could hurry the season, and so I read on into April, and through April

into May." In a review of the book that happened to appear one day earlier, however, the author indicated that "the proper way to read *Sundial of the Seasons*, I suspect, is one day's entry at a time. I can't think of a more pleasing beginning for each day of the year." Perhaps Borland should have the last word on these alternative ways of keeping pace with or moving ahead of the seasons. In one of his essays he made a remark that recurs throughout his work: "here it is summer again, and despite all the uproar by human beings the season follows its own pattern. We are trying to keep up with it, but not to outrace it or in any way supervise it."[55]

City Readers and Country Writers: Connecting the Distance

The nineteenth-century nature writers, with certain exceptions, mostly seem descriptive rather than moralistic. Although Thoreau certainly provided messages concerning the desirability of simplicity, economy, and self-reliance, at the time he came across in his books as more of an antimodern eccentric, and perhaps a bit of a misanthrope, rather than as a scold. Not many of his successors in the century after *Walden*'s appearance in 1854 sounded moralistic, at least not in a way that was aimed at altering human behavior or beliefs. In a book titled *Winter Sunshine* (1875), John Burroughs might make this sort of assertion: "The simplicity of winter has a deep moral. The return of Nature, after such a career of splendour and prodigality, to habits so simple and austere, is not lost either upon the head or the heart."[56] As late as 1953 a review in *The New Yorker* could praise Teale's *Circle of the Seasons* for not trying "to pry sermons from fungi and finches." A response to his *Wandering Through Winter* that appeared in *America*, a Jesuit journal, however, declared that "there was a time when a nature book had to have a moral. The improvident grasshopper. The industrious ant." For Teale, the reviewer indicated, it seemed sufficient to get out the message that nature existed for people to enjoy. He appeared to abjure any interest in traditional moralizing. Yet that had already begun to change in several different ways.[57]

The shift shows up in a surface manner when we note the nostalgic antimodernism that emerged as a motif among both the writers and their readers. We find Gladys Taber commenting that "nowadays turkey is so available it is no longer a seasonal treat. At times I am sorry it is so common, for that first thrill of seeing it on Thanksgiving morning is gone." A young couple in southern California three years out of college in 1967 wrote to Teale (they had read each of his books twice) lamenting "that madly rushing world of work and keeping house. . . . Seems like something is lost when a person grows up—perhaps it's *time*— time to sit and *see* things in the outside world. Seems as if we are so busy."[58]

The altered mood certainly appears in Borland's essays during his last fifteen years or so. He ended a January 1969 piece in *The Progressive* in a hortatory

manner: "Knowing, as well as we know right from wrong or day from night, that you can't waste a season. Not even winter." That sounds like a maxim right out of *Poor Richard's Almanack* back in the mid-eighteenth century. Less than a year later Borland wondered "how much of the uncertainty and apprehension of today comes from rootlessness." In May 1971 he urged readers to "get back to the land and learn patience." Late in 1973 he devoted a seasonal essay to "The Work Ethic." An increase in moralistic fervor shows up much more explicitly with the growth of the conservation movement. Leopold and Carson were obviously pioneers in that effort beginning exactly at midcentury, but gradually Krutch, Borland, and even Teale would become increasingly vocal about the need to care more seriously for the quality of our natural environment. By the time Earth Day began to be observed in 1970, few American writers with anything to say about the seasons could resist the inclination to include some sort of homily. The only variation occurred in the level of stridency.[59]

All of which is reasonably familiar by now. What has not been much noticed, however, emerges very loud and clear in the actual "dialogues," if I may call them that, between our nature writers and their readers during this period. I have in mind the sense of loss and dismay that both groups shared about the dramatic growth of the urban population and its own distancing from and lack of familiarity with the natural world. The phrases "alienated from themselves" and "alienated from nature" became a kind of mantra beginning in the 1950s.

Four examples, two from writers and two from readers, serve to document this type of shared conversation. First, in 1947 Henry Beston wrote the following to Teale, and if Beston said it once, he would say it several dozen times in public as well as in private correspondence: "The essential characteristic of our age is an alienation from Nature unexampled in human history; a characteristic which is the fons et origo of the fooleries and violence which have overtaken us."[60] Next, a 1957 letter to Teale from a man who had just finished reading *Autumn Across America*: "Once I lived in the country. I still live in the same house, but suburbia has spread all around me and, like the other suburbanites, I find it easier to contact nature in books rather than in the reality." And another from Daly City, California, south of San Francisco, written two years later. After the chatty woman thanked Teale for his three major books of the decade, she confided the following: "The only complaint I have about any of the books is that they fill me with a longing for the outdoors which is pretty hard to cope with when the opportunities are so limited for getting away from the city." Then take note of an extract from a Borland essay in 1967: "I wonder what we have gained and what we have lost as we, a nation, have become so largely an urban people, not only living apart from the land but alien to it. . . . Lacking the continuity of the seasons and the certainty of the great rhythms inescapable on the land, [the American] has achieved a strange arrogance that mistakes data for knowledge and makes gods of his machines."[61]

What is novel about these observations is not so much their substance but their greatly increased frequency and intensity during the third quarter of the twentieth century. Four seasons prints made by Currier and Ives had delighted city dwellers nostalgic for remembered rural pasts. When Henry Duncan published his American edition of *Sacred Philosophy of the Seasons*, the fourth volume evoked images of spectators coming out from the dirty cities to breathe "health and refreshment." He actually contrasted the corrupt city with the wonderful countryside in a simplistic manner that was typical of the time, echoed by Harry Penciller in 1855. Two years later, as noted in chapter 3, "The Four Seasons" essay in *Putnam's Monthly Magazine* claimed that urban dwellers were disconnected from nature. Writing his seasonal book in 1907, James Buckham compared urban turf unfavorably with the rural landscape: "How Mr. City-man would pride himself on a house-lawn as ripe with age, as velvety and rich, as that produced by his cows in their domain between barnyard and pasture." During the last decades of his life John Burroughs's fan mail was filled with messages like the following: "It is this love of country life with its peace and beauty that enables me to live the strenuous months in the city [Cleveland]"; and from someone appreciating a reading of his essay "Leaf and Tendril," "It will make me feel as if I were back in the blessed country instead of in this baking town [Washington, D.C.]."[62]

For more than a decade beginning in 1949, a sequence of assertions by broadly acclaimed writers who happened to be antimodern nature lovers precipitated a cascade of comments about the precarious relationship between the conditions of urban life and the detachment of Americans from their environmental heritage. A bold declaration in Krutch's *Twelve Seasons* (1949) is a good place to begin: "Even we complicated creatures who have attempted in so many and such ingenious ways to declare our independence of the seasons, and even of nature as a whole, respond more fundamentally than we know to her rhythms." Then Gladys Taber chimed in with similar sentiments in not one but three books of her widely read *Stillmeadow* series: "I believe this return to the country in our time is based on a primary need: to get back to something stable, secure; in short, something to hold on to. . . . There is no feeling comparable to a return from time spent in the city."[63]

Curiously, although the Teales had chosen in 1959 to relocate from suburbia on Long Island to a rustic spot in north central Connecticut, they did not wax nostalgic nor did they want to make people feel guilty or inadequate for living in settled areas without easy access to nature. But many readers felt that way nonetheless. The Teales' fan mail is filled with letters from people who are either defensive or, more often, simply filled with regret: a man from the Bronx felt that "I've missed much of your experiences, being just a city boy and unaccustomed to seeing the beauties of nature"; and a woman from Philadelphia, after being "enchanted" by *Autumn Across America*, wrote to Teale about his ac-

count of Minnesota that it "prompts a few recollections of what that state was like 45 years ago. Before highways. Before tourists. Before the machine age changed the face of the earth."[64]

Hal Borland would cap it all off, in a way: first by focusing an essay in 1966 upon a New York City couple who had bought a vacation home near him but soon decided to relocate there permanently, and second by writing a potent piece in 1975 that acknowledged the impossibility of returning to Jeffersonian times yet continued by asserting, "But we obviously can go back to the land when the cities become unbearable. And those who go back to the land are discovering autumn and winter again. Many of them, as vacationers, knew spring or summer in the open. But not Thanksgiving and Christmas. Or the winter solstice, which is the milepost of the year."[65]

Near the end of his life Borland became engaged in two fascinating dialogues, quite different from one another in some ways but both very revealing about the man, the times, and the cultural tensions surrounding the issue of city dwellers' alienation from nature. The first one is worth examining at length because it epitomizes the entire issue. Janet Kroll, a highly intelligent and articulate woman who lived in Manhattan, sent a two-page, single-spaced letter to John Oakes, an editor at the *New York Times*. In it she explained that she was vexed by faithfully reading Borland's "outdoor editorials."

> Do you have any idea of the frustration and resentments these rustic ruminations inspire in carless people who have no access to nature except on two-week vacations? Probably not. . . . This is really just a long-winded way of asking that you sometimes acknowledge that many of us can't experience the rural delights that Borland describes, and that you record some of the few modest moments of beauty that can occur even in our grimy city. Our children are so hungry for beauty. . . . Maybe Mr. Borland could pry himself from his bosky dell in Connecticut and take a train to New York one day (driving would be a cop-out; make him take the train). His observant eyes surely could find a scrap of city beauty to extol, something I could read to the children without hearing the cry, "Mommy, why don't we live in the country?" . . . Survival in New York isn't easy when stew meat is $1.49 a pound and there are no school crossing guards on Amsterdam deathway, and Hal Borland's outpourings don't make it any easier to keep cheerful.

Oakes forwarded the letter to Borland, who called it "splendid" and replied within a week of receiving it.

> When I first saw New York City, in the 1920s, it was from the Palisades. . . . What I saw was a magic city, a dream city, the Mecca of course for one who would be a writer. In the next couple of years I explored most of its sights

and odd corners, from far shores of Staten Island to Queens and the Bronx, and I wrote reams about it. . . . Some of it sold. I left and was gone almost 15 years, and when I came back the magic was rather tarnished, the city rather grimy. . . . Then, with a family, I moved to the suburbs, commuted, "for the sake of the kids." But by the mid 1940s I had cut loose from the job, was risking everything, so we cut loose from suburbia (Stamford area) and came up here. It was a gamble, a big risk. But we are still here. . . . Now, why can't or won't I write pretty pieces about the city? Because after the first two sentences they would turn ironic. If I wrote about beauties there it would be about beauties I knew long, long ago. Now when we go down there . . . we are warned not to go afoot to this area, not to walk alone on this street, be wary if we dare the subway, never leave a door unlocked. . . . Stay out of Central Park unless you have a cop for escort. . . . As for why The Times keeps on using my Nature Edits as we call them, that's for someone else to say. Maybe just to keep the franchise, to remind a few people that the country still is out here—after all, the whole urban spread in the United States occupies less than 5% of the total area. Ninety percent of the people, more or less, on five percent of the area. Did you know that? Our major problem is to keep them from paving it all. I didn't mean to write a screed. . . . But that's more or less what is back of those pieces, at this end, anyway. . . . And thank you for reading my books.[66]

That was Borland "unbuttoned," and that's the way he explained his vocation and feelings in private correspondence when asked about them by a lively, self-described "Quaker lady" he clearly found engaging. He provided a public version of his answer to her query with a crisp statement of his priorities and commitments in a 1967 essay.

I read the other day that some architect, obviously not one of those who build towering, windowless boxes, had said that man, even in an urbanized environment, needs "the vital stimulus of shifting light, passing time, and the changing of the seasons." Maybe that is why we countrymen insist on living where we do. Not for the fishing or the partridges we sometimes hunt, but for that vital stimulus. Maybe that is why we don't look on winter as such a dour, forbidding season. We see the light shift, are constantly aware of passing time, and are a living part of the changing seasons. We don't have to look at the calendar or the almanac to know what time it is.[67]

That final point was an important one that Borland and most members of his cohort reiterated often. Only Gladys Taber would say things like, "We always look ahead in the Farmer's Almanac to be sure of the weather." Far more representative was Borland's oft-repeated assertion that "you do such chores at the behest of the weather, not of the calendar or the clock." As he wrote in 1966:

"Spring doesn't even abide by our mathematically meticulous almanacs. Neither do any of the other seasons, for that matter."[68]

The second important dialogue in which Borland engaged near the end of his life is also connected to Janet Kroll's citified sense of grievance, but it did not involve another reader such as Kroll. Early in 1977 Max Frankel replaced John Oakes in charge of the editorial page of the *New York Times*. He sent Borland, perhaps the most permanent fixture among all *Times* writers at that point, a rather peremptory message, asking him to continue but to "complement the essays with comment of a similar quality about the urban scene, about family life, about internal sensations." At the age of seventy-six Borland was not about to abandon his métier, so he sent a polite but firm reply.

> What I have tried to do . . . is show that some of the beauties and satisfactions of a simpler life persists out here in the country. Some of the uglies too, of course. But they don't seem to dominate out here as they do, for instance, in certain sections of New York. Quite a few readers obviously think of this as nostalgia, but it actually reflects life up here today. . . . This has been home and "the source" for twenty-five years. It is a kind of nature reservation. . . . I have been to New York only once in the past five years. Editors come up here to discuss books and articles. We would welcome you when and if you can get away.[69]

Borland died thirteen months later. He did "his own thing," seasonally speaking, until the very end.

Changing Attitudes and Continuities: The Flux of Stable Cycles

We noted earlier that most American writers during the later nineteenth century, unlike their European counterparts, had fairly positive things to say about winter. Wilson Flagg would write repeatedly about "the charm of a winter's walk," and Thoreau made winter at Walden sound enchanting even though he often yearned for spring. One admirer told Burroughs that "from my reading of 'Winter Sunshine' dated all sorts of new insights and responses." A year later, in 1908, Burroughs asked a friend from Oneonta, New York, who was living in New York City: "Do you long for the pure bracing winter upon the hills? A fine bracing winter so far here [at Riverby on the Hudson] most of the time. I take long walks away off through the woods and back by Slabsides [his cottage for isolation and writing] pretty often."[70]

Virtually all of the twentieth-century successors we have been considering also conveyed those upbeat sentiments. Joseph Wood Krutch commented that "to be part of summer one must feel a part of life, but to be part of winter one must feel a part of something older than life itself. Here is beauty which is more literally . . . its own excuse for being than is even the beauty of a flower. . . .

Nothing else in nature demonstrates more abundantly her profusion, the end-less extravagance of her inexhaustible ability to create the beautiful." Edwin Way Teale appreciated winter for its diversity. "There are seasons within seasons," he wrote in 1965. "Winter is a hundred seasons in one. . . . In its own way, winter is a time of superlative life. Frosty air sets our blood to racing. The nip of the wind quickens our step." He saw still other benefits beyond the sheen of a newly fallen blanket of snow. Writing about his time spent in the southwestern desert, he declared: "I was seeing its sky in winter, in the season of stars. To most people, the winter constellations are the most familiar." Hal Borland loved winter not only for its beauty but also as a time of relative rest. And when he experienced what he called "Squaw Winter," meaning not as much snow as usual, that was fine too.[71]

Some readers resonated with the naturalists' enthusiasm, but no more than a minority. A man writing to Teale from California would acknowledge only that winter is "certainly the most dramatic of the seasons." Another Teale fan who lived in Maine eagerly awaited his winter volume because "that season is our specialty." An English woman who had lived in Ontario for twenty years following World War II told Teale that she "found the winters hard to bear," but after reading his *Wandering Through Winter* she could "now find more beauty around me, & am more content."[72] A considerable majority of their readers wanted the naturalists to know that they simply did not share the enthusiasm for cold and bleak weather. A couple from Iowa told Teale how much his books helped them "to endure many a *winter* day in *town* which is neither my favorite season nor place to live." A Rhode Island woman explained that "each winter I die a little" and continued: "As a New Englander born and bred some three hundred years, it seems strange to some and somewhat to myself that I should have such an ingrained hatred of cold and snow. Be [that] as it may, having grudgingly acknowledged the beauty of the first snow fall I go into a sort of spiritual hibernation until the first coppery thrust of skunk cabbage pokes through the ground."[73]

The New Englander's closing remark brings to mind several enduring sentiments about spring that seem to be especially prominent in the literature and correspondence from this period. Of course feelings about spring are unique in this respect: it is the most anxiously anticipated season—actually being referred to as "the season of anticipation"—and the only one about which people eagerly ask when it will begin and speculate on what its first harbingers are. Spring simply flows imperceptibly into summer, summer into autumn, and fall into winter. But virtually everyone wonders when spring will arrive; and even when they know better, they are likely to locate its advent at a particular moment in time, depending upon where they live. In 1968 Krutch devoted an essay in a popular magazine to explaining "How Spring Comes to America." In 1957 Leonard Hall began his chapter on "April" by asking the question that so

many others do, mentally and in print: "When is the beginning of this magic season we call spring?" For some, as just noted, the answer is when skunk cabbage appears in marshy places. For a great many others it is associated with the immense racket made by the mating calls of tiny male frogs called spring peepers. Still others connect it with the arrival of robins, while for Edwin Way Teale the most meaningful sign was the arrival of the blue butterfly. Hall correctly observed of spring that "part of its wayward charm lies in the very unpredictability of this coy maiden among the seasons." Less than a year later Hal Borland wrote that "I happen to think of spring as a beginning, because my human mind and habit tend to work that way." But then he quickly acknowledged that doing so was a very arbitrary way of reckoning. He concluded that *any time* can actually become a beginning.[74]

Readers felt no need to sound so judicious. Quite a few of Teale's correspondents revealed to him that they liked to read (and reread) *North with the Spring* in February when "feeling a bit of winter gloom." As a woman in Iowa confessed, "On a cold wintry day in February when it seems as though spring is so far away, I get out *North with the Spring*, and it really lifts my spirits." One fan from Appleton, Wisconsin, who listened to *North with the Spring* on Talking Books records from his local library, responded to Teale's rhetorical question to his readers: "In the book you ask many natives from Florida to Maine what first made them aware of the approaching spring. For my wife and me, the first harbinger of spring appears on wings and the crow makes the air raucous with his cawing."[75]

It may or may not be meaningful that much as our writers liked to find pithy ways of characterizing each season, and did so often, if they omitted any season from the litany, it was winter. I think they sensed that for many readers, the less said about winter, the better. Hence Hal Borland in 1964: "Spring is all eagerness. Summer is hot laziness or sweaty haste; but autumn is achievement and a measure of contentment." Two years later, almost by instinct, he reiterated the rhetorical ritual with slightly different attributes. "On the land you live by the seasons," he wrote, "and it is good to have them clearly defined, not by the calendar but by the weather. . . . Spring is sprouting, summer is growth, and autumn is ripeness and completion."[76]

Suppose we ask, by way of conclusion, what these naturalists liked best about their chosen subject, and what pleased their audiences most. In response to the latter question we have already seen, in numerous ways, the pleasures that an increasingly urban society derived from at least a vicarious experience of the natural world. I must add to that something that we have barely mentioned, though the "expert" reviewers most certainly did. As one of them said when writing about *Wandering Through Winter* (and, by implication, germane to Teale's entire project): "Many an American should find here a new dimension of patriotism." Very rarely did the naturalists come across as ardent flag-

wavers, never mind as cold warriors. Nevertheless, patriotic passages pop up from time to time and must have felt very welcome to native readers. Teale, for example, in *North with the Spring*, writes: "Our long trip . . . continually underscored the prodigal variety of American nature. Where else in the world does nature offer such striking contrasts in the spring?" Reaching Pike's Peak at the end of *Journey into Summer*, he boasts: "Other nations have glorious mountains, breath-taking views. But none can approach the incomparable variety of wild beauty that is the heritage of this land." And at the very beginning of *Autumn Across America* he reiterated what writers had been saying for well over a century: "Nowhere in the world is autumn more beautiful than in America."[77]

As for what the naturalists themselves liked best, one of the least prominent put it very well for all of them in 1971: actually experiencing the process of *transition*. Charles Seib, a Thoreauvian newspaperman who built a cabin in the woods of northern Virginia as a place of refuge from the intensity of Washington, wrote: "I like the turn of the seasons—any seasons: fall into winter, winter into spring, spring into summer, and, as now, summer into fall. The immutable progression conveys a feeling of purpose, of order in a disordered world."[78]

By the later twentieth century the language of seasonal cycles and circles had largely given way to prevalent notions of procession and progression. Even among naturalists, a linear mode of conceptualization seemed more apt for a society moving ever more swiftly through time and space via satellites, superhighways, and the demanding schedules of urban survival. Under the circumstances, it seemed almost appropriate to hasten the pace of nature by "rushing" the seasons.

CHAPTER 6

THE FOUR SEASONS AND
AMERICAN POPULAR CULTURE
CALENDARS AND CONSUMERISM

Seasonal Cycles and Singular Lives in a Society Still Diverse

Devoting a separate chapter to the four seasons in popular culture means introducing a somewhat arbitrary category. After all, writers like Carson, Taber, Kieran, and especially Teale and Borland reached a very wide audience. Their essays appeared in venues like the *Readers's Digest*, *Family Circle*, and other mass-circulation magazines. Early in 1954, not long after initial publication of *Circle of the Seasons*, Teale told Carson that his book was going into its fourth printing. Late in 1960, when his *Journey into Summer* received a swift third printing, he explained to Carson that three book clubs had adopted it as a selection for the coming year and taken 100,000 copies. In addition to the better-known book distribution enterprises, the Outdoor Life Book Club, the Christian Herald's Family, and the Bookshelf Club all promoted his work. After the posthumous publication in 1979 of Hal Borland's *Twelve Moons of the Year*, that book appeared in condensed segments in the *Reader's Digest*, and excerpts also ran in *Science Digest*.[1]

So by any reckoning the four seasons motif has already been seen to have permeated popular culture. And even before Teale, Borland, and company, that could arguably have been the case, of course, when lengthy extracts from James Thomson's poem, *The Seasons*, appeared in *Poor Richard's Almanack* during the middle of the eighteenth century; or when a New York City publishing house in 1846 brought out sheet music bearing the title, *The Seasons. A Farmer's Song Arranged as a Quartet as Performed by the Hutchinson Family*, selling for 25 cents a copy (figure 56); and especially when four seasons prints by Currier and Ives were all the rage from the mid-1850s until the 1880s and beyond. In fact, if the motif did not enjoy popular appeal, it certainly would not have endured with such sustained vigor from antiquity through the twentieth century—especially not over the past 150 years or so, as the actual cycle of nature has become less meaningful to a society growing ever more urbanized. As Ron Powers has writ-

ten of a small community like Hannibal, Missouri, where seasonality had long mattered so much, by the 1950s the people living there were no longer "children of the seasons" because of technological change. And as Mary Taylor Simeti observed in a fascinating four seasons book in 1986, "A calendar based on the seasons, on sowing and harvesting, on death and rebirth, is irrelevant to us now, its recurrent cycle out of step with the linear conception of time and progress that urges us forward."[2]

Nevertheless, during the decades following World War II and then acceler-

ating from the 1960s until the present, the motif became more rather than less visible at all levels of American culture. That was due, in part, to an increase or intensification of phenomena already noted, such as nature books and poems whose intellectual content was "diluted" in order to engage a much broader audience. It was also due to new developments in communication technologies, such as film, television, and now the Internet. (Type in "four seasons" as a subject entry on the eBay web site and you will find a listing in excess of 400 items on any given day. The consistency and diversity of the "inventory" are astonishing.) But above all, the four seasons motif emerged with greatly enhanced visibility because it was perceived by all sorts of entrepreneurs as an appealing way to sell and promote things—all manner of them, ranging from household objects to tourism and the hospitality industry. In 1982, when Stephen King had completed four novellas in order to "blow off" steam after finishing a series of very long books, his publisher agreed to bring the stories out together in one fat volume. King reports that he told his editor: "We'll call the book something like *Different Seasons*, just so people will get the idea that it's not about vampires or haunted hotels or anything like that." It was a clever packaging device, and the volume has remained one of King's most popular. Using the four seasons as a label has provided new ways to market products of every imaginable variety, from colorful women's cardigans to muffin pans. In the process, of course, a venerable theme became a veritable cliché.[3]

From a more "political" perspective, of course, it can also be argued that the seasonal motif became democratized. For thousands of years following Hesiod and Virgil, the cycle of the seasons for most of humankind meant toil for the sake of survival. The pleasure derived from books of hours, from decorative art in castles and fine homes, from elegantly conceived landscape vistas and leisurely seasonal vacations all supplied satisfaction to elites and affluent people, but not very much to the working classes, even though some of the finest craftsmanship in producing four seasons objects resulted from the skilled hands of artisans who took great pride in their work. It should also be kept in mind that as late as the Renaissance, painters who provided beautiful murals and frescoes of the four seasons were simply regarded as "laborers," and were paid accordingly. Although many of them died in absolute poverty, even as late as the close of the seventeenth century, their endeavors meant that the "people's hands" played a critical role in perpetuating seasonal motifs and traditions.[4]

What complicates matters in the half-century following World War II, however, is that creative work by artists and writers could often achieve a very large audience and broad popular success. Sometimes, in the case of a beloved author like Wendell Berry, the reason is because his work is so accessible, and news of its appeal spreads by word of mouth. His four line poem, "Fall," is a fine example.

The wild cherries ripen, black and fat,
Paradisal fruits that taste of no man's sweat.
Reach up, pull down the laden branch, and eat;
When you have learned their bitterness, they taste sweet.[5]

And sometimes an aspiring writer comes along with a quite serious histori-cal novel that happens to take the country by storm, just as Charles Frazier did with his 1997 story of the Civil War odyssey of a disillusioned Confederate vet-eran. The homeward-bound soldier named Inman carries with him a copy of William Bartram's *Travels*, and having him read while at his rest provides Fra-zier with a perfect opportunity to alert the reader to the fact that seasonal knowledge is gained from close observation and familiarity, all the while being influenced by book-learning. Here is one example:

> A picture of the land Bartram detailed leapt dimensional into Inman's mind. Mountains and valleys on and on forever. A gnarled and taliped and snaggy landscape where man might be seen as an afterthought. Inman had many times looked across the view Bartram described. It was the border country stretching endlessly north and west from the slope of Cold Mountain. Inman knew it well. He had walked its contours in detail, had felt all its sea-sons and registered its colors and smelled its smells. Bartram was only a trav-eler and knew but the one season of his visit and the weather that happened to fall in a matter of days. But to Inman's mind the land stood not as he'd seen it and known it for all his life, but as Bartram had summed it up.[6]

When *Cold Mountain* topped the best-seller list for months and months on end, selling millions of copies, it too transcended categories of cultural strati-fication and became a player in American popular culture. So we are obliged to concede at the outset that this is a very protean category.

In 1973 Hannah Tillich published a deeply personal memoir containing bit-tersweet revelations about the endless philandering of her late husband, Paul, the most eminent theologian in the United States. In a chapter titled "East Hampton," she opened with a moving account of seasonal change on eastern Long Island: "East Hampton was the seasons, the scanty prespring with the ocean droning, the overwhelmingly sweet young summer, the hot humid Au-gust, the quick and cool September. It was Indian summer with red gleaming woods. I drove through copper and wine-red leaves to the blue bay. I drove to Montauk, the road lined with autumn-colored bushes and berries, men and women picking beach plums for their jellies." Lyrical passages like that helped to counterbalance the many embarrassing and unattractive details about the lifestyle of her famous husband. Shocked readers took note of her sensitivity to the natural world.[7]

Arguably, the most notably successful seasonal writing in the United States

in the half-century following World War II either occurred in works totally devoted to that subject, like Teale's and Borland's, or else incidentally in books like Frazier's that made other objectives primary but lit up the landscape for color or contextual purposes. Nevertheless, consider "lesser" works that did not necessarily sell millions of copies but acquired devoted followers: either because of some special regional interest, or because of publication in newspapers, or because of the author's ability to intertwine an engaging human interest story with the cycle of the seasons, or, finally, because the expository prose simply glows and thereby illuminates a natural world the reader would not otherwise have noticed.[8]

Books with local or regional appeal created the smallest splash, ordinarily, and seem to be least well remembered. But a few are worth noting (in chronological order, because I believe that they get better as they progress toward the present). Fredric Klees was born in Reading, Pennsylvania, and grew up in Philadelphia. He began teaching literature at Swarthmore College late in the 1920s but summered in the hills of Berks County close to his family origins. Written as a journal beginning with spring, his *Round of the Year: An Almanac* (1963) is more autobiographical and nostalgic than most examples of this genre. Klees comes across as a fastidious bachelor and aesthete who prizes beauty over utility. He would very much like to see flowers in bloom every day of the year, and wishes that nurserymen would educate their customers to plant trees so that the color contrasts would be maximized in the fall. The book is chock full of curious digressions and an enthusiasm for the culinary delights of the Pennsylvania Dutch country. It is a pleasant book, but its primary appeal would have been to those living in the "neighborhood," or else to those who once had lived there and wished for a remembrance of things past.[9]

Hazel Heckman arrived in the Pacific Northwest in 1946. Her book *Island Year* (1972) describes the plants, animals, birds, and sea creatures that she observed on and near Anderson Island in Puget Sound during 1969. She is an impressive naturalist but actually says less than many of her contemporaries about seasonal change, perhaps because it is much less dramatic in the Puget Sound area than in other parts of the country. Winters, for example, are exceptionally benign, and spring actually shows its face in January. Like most writers of her generation she does not do what virtually all of their nineteenth-century forebears had done: namely, identify every species by its Latin name, a practice that became routine for more than half a century after Susan Fenimore Cooper did it in *Rural Hours* (1850), which also began in spring. Although Heckman is an engaged environmentalist, her book is lacking in human interest because she tells us much less about herself and her community than others in this group do. She did receive fan mail, however, and she mentions the letters and warm response to her previous book, *Island in the Sound* (1967).

Focusing on the middle of the country, naturalist John Janovy surpasses

Klees and Heckman in his *Keith County Journal* (1978) because he strikes a very judicious balance between describing his life as an avid conservationist based at the University of Nebraska and keenly observing the natural world around him during each phase of the year. "Standing in the South Platte [River] beneath the I-80 exit bridge at Ogallala in late October," he writes, "one can still gaze up at the cliff swallow nests. Scrambling down the sand bank with seines and buckets brings a flurry of activity from the colony." A different passage almost takes us back to Hesiod and Virgil in terms of the necessary labors required by seasonal change. "There is work to be done in this country, before winter. The car must be equipped, the martin house cleaned out and stored, the firewood ordered, the snow tires bought." Not exactly tasks known to Hesiod, but the very same sense of urgency is present and makes this a compelling testimony to local seasonality.[10]

Whereas winter was the least notable of Heckman's seasons in Puget Sound, Donald Hall, a distinguished poet, tells us in *Seasons at Eagle Pond* (1987) that spring is the least important of his seasons when in New Hampshire, which specializes in winter. Here we have a prose work by a man who is not a naturalist and consequently is more interested in people and the distinctive weather conditions of northern New England than in the flora and fauna, though he is not oblivious to the latter. He conveys a very strong sense of the flattened seasons without even trying, because he so emphasizes the farming chores that once were routine in his grandfather's day but have now largely disappeared. Hence his designation of fall as a "lazy season," which most people living on the land throughout history would be astounded to hear. His stress upon festivals rather than natural signs of seasonal change mark Hall as a modern man, yet he is a traditionalist, nonetheless. He tells us that Labor Day is important to the natives because it marks the departure of the summer residents, a moment that he refers to rather gleefully as "exodus and restoration." But then he notices yet another indication of "deseasonalization": "With the growth of retirement condominium barn-palaces, we begin to witness in New Hampshire the newest phenomenon: year round Summer people." Like the natives, he doesn't like it, even though his real home is in New Haven, Connecticut. He has Hampshire roots, but he's actually been away for years and has returned on a nostalgia trip as a sometime summer visitor himself.[11]

Finally, *Of Time and an Island* by John Keats (1987) tells a compelling story, starting with winter, in which a distinguished journalist and biographer from Washington, D.C., and his family fall in love with a small island in the Thousand Islands region of the St. Lawrence River, buy it, and learn to cope with the capricious weather and (once again) summer visitors. Somehow years pass within this framework of a single year's natural rotation. The result is that seasonal changes become a metaphor for the life cycle of an entire family through a generation as the children grow up and become adults, and eventually the

time comes for them to leave the island after many personal and social changes. They must get on with their education and new beginnings. In the lovely envoi that follows "Fall" and ends the book, Keats contends, despite all, "that nothing has changed in this always new and infinitely old center of our lives. We never feel homeless in winter because we know where we live. We live in a house on a stone in the middle of a river in the center of the world at the very heart of time."[12]

In the second category, where semiautobiographical stories told in seasonal terms beguile the reader because of unusual human interest, two prime, but very different, examples appeared in the same year, 1986. *A Country Year: Living the Questions*, is a graceful account by Sue Hubbell, a middle-aged woman who moved from the life of a librarian at Brown University to that of a commercial beekeeper in the Ozark Mountains in southern Missouri. Although her new vocation gives her much satisfaction, and she lives close to nature's changing rhythms (she's the daughter of a botanist and granddaughter of a beekeeper), there are many wistful moments when she looks back poignantly on her divorce after decades of marriage and the changes that have occurred in her own life cycle. She describes naïve folks who try life in the Ozarks without sufficient skills or temperament in much the same way that Hall referred to "Summer people": "What they have not yet discovered is that a life is as simple or as complicated as the person living it, and that people who have found life in the city overwhelming will find it even more so here." An enthusiastic reviewer for the *New York Times Book Review* felt that Hubbell wrote "appreciatively, non-evangelistically, of life in her chosen slow track, 'where we older women fit into the social scheme of things once nest building has lost its charm.'"[13]

Mary Taylor Simeti, the author of *Persephone's Island*, studied history as a Harvard undergraduate and then went bravely off to rural Sicily early in the 1960s to "find herself," as the saying goes, and also to make some sort of contribution to a society frozen in time. She married a Sicilian academic (in agronomy) and lived a seasonally divided life between Palermo, where he taught, and his family farm, Bosco, which she grew to love as a retreat where seasonal change could be closely observed. Even in the city, however, her keen eye took note of our enduring motif. "From the Via Venezia," she wrote, "we turn on to the Via Maqueda and pass the Quattro Canti di Città, the four corners of the city, each corner decorated with a fountain in which a pagan lady representing one of the four seasons is chaperoned by one of the four virgin saints who are the patronesses of the four *mandamenti* of old Palermo." Unlike Hubbell, who began her narrative with spring, Simeti starts with Sicilian winter, which is not much of a season by American standards (unless you live in the area of Puget Sound, perhaps). Reviewers enjoyed the book immensely because the author weaves in stories of Mafia misdeeds, travel to ancient sites throughout Sicily, and the delights of traditional food specialties unknown outside the island. As

one reviewer remarked, Simeti also found "her alter ego, Persephone, Demeter's beautiful daughter, who was kidnapped and carried off by Hades to the underworld where, because she ate the seeds of a pomegranate . . . and so was his wife, she must remain for four months of every year. The darkest months. On her release to the upper world, nature celebrates. There is sun again. Fruit trees burst into bloom. Frail translucent shoots of grain ripple in the fields and vines put out their first feathery leaves. They promise a harvest, life itself."[14] The seasonal pattern of Simeti's own life begins to intrigue her more and more with the passage of time, and in the course of her narrative this expatriate draws the reader into her adopted world, where the seasons most certainly matter but are accompanied by very different expectations and markers than would have been the case if Simeti had remained in the States.

Our third category brings us to the two most gifted seasonal writers belonging to the generation that followed the midcentury cohort. Ann Zwinger, who lives in Colorado Springs, with a hideaway high up in the Rockies at 8,000 feet near Woodland Park, was in fact a protégé and friend of Edwin Way Teale. He admired her passion for ecology, which began when her family purchased land in the mountains in 1963. Although Zwinger has never written a book that is seasonally structured, her sensitivity to the beauty of seasonal change is manifest throughout her many books, which are exceedingly well done and beloved by loyal followers. Here is an exemplary passage from *Beyond the Aspen Grove* (1970), an early book: "This land is a place of all seasons, for even in winter there is the promise of spring, and in spring, the foretaste of summer. The white of snow becomes the white of summer clouds; the resonant green of spruce becomes the green head of drake mallard; the gray of rock and lichen endures in the gray of lowering winter skies; the same orange-red of Indian paintbrush bars the blackbird's wing and stains the western tanager's head. Here part of each season is contained in every other."[15]

That last sentence seems to have become a kind of chorus for the modern naturalists, though it also appeared recurrently in Thoreau's journals. In *Pilgrim at Tinker Creek* (1974), Annie Dillard (figure 57) informs the reader near the outset that she proposes to keep what Thoreau called "a meteorological journal of the mind," telling some tales and describing some of the natural phenomena and curiosities of her valley in southern Virginia. Later in this Pulitzer Prize–winning work, written at the age of twenty-eight, Dillard has much to say about our societal sense of the seasons, culminating in an echo of Zwinger.

> I wonder how long it would take you to notice the regular recurrence of the seasons if you were the first man on earth. What would it be like to live in open-ended time broken only by days and nights? . . . It must have been fantastically important, at the real beginnings of human culture, to conserve and relay this vital seasonal information, so that the people could anticipate

dry or cold seasons, and not huddle on some November rock hoping pathetically that spring was just around the corner. We still very much stress the simple fact of four seasons to schoolchildren. . . . But there's always unseasonable weather. What we think of as the weather and behavior of life on the planet at any given season is really all a matter of statistical probabilities; at any given point, anything might happen. There is a bit of every season in each season.[16]

Although Dillard has clearly learned a great deal about insects from reading Teale, and cites him frequently, she is also critical of him for what she perceives to be his "curious" blandness because he is content to describe the oddities of nature in great detail without observing any larger pattern or significance for humans. The great strength and special appeal of her book is that she interweaves philosophical and religious ruminations with her close observation of the natural world—a major reason why the book has enjoyed such a strong "shelf-life" and has come to be regarded as a modern classic.[17] Flowing in tasteful fashion from winter to fall, *Tinker Creek* gives each season a distinctive character with which Dillard associates particular activities, albeit ones much different from those covered by Virgil's *Georgics*. "In summer," she writes, "I stalk," meaning she is then able to observe natural life most closely, almost microscopically.[18]

There is an extremely important feature that has contributed a great deal to the popularity of nature books intended for a general readership: attractive line drawings and woodcut illustrations, usually profuse in number, and most frequently featuring wildlife. The books by Zwinger and Dillard are interesting exceptions, perhaps because their publishers did not anticipate such a broad readership, or possibly because their authors wished to avoid the "cuteness" that can be conveyed by some illustrations and might suggest that the book is not altogether a serious one. In the volumes by Leopold, both Leonard and Donald Hall, Borland, Heckman, and Hubbell there are charming line drawings or woodcuts, as there are in some works that we have not discussed, such as Allan W. Eckert's *Wild Season* (1967), Edward Abbey's *Desert Solitaire: A Season in the Wilderness* (1968), Verlyn Klinkenborg's *Rural Life* (2003), and in the nature books of Joseph Wood Krutch.

FIGURE 57
*Annie
Dillard
(b. 1945).
Photograph
by Rollie
McKenna.
Courtesy
of Annie
Dillard and
Timothy
Seldes.*

Fredric Klees and Bernd Heinrich created their own illustrations. Although the artists are invariably identified on the title page, with a very few exceptions— such as the well known Lynd Ward (1905–85), who made the drawings for books by Donald Culross Peattie—almost all of these artists labored in obscurity. Their contribution to the popular success of these literary projects was not trivial, however, and warm appreciation of their work was frequently acknowledged in reviews. The illustrations make the books far more appealing than did the rather dim and poorly reproduced photographs that accompanied most of the nature books that appeared between the 1890s and the 1920s.

Two other kinds of seasonal books need to be mentioned, and for one of them the illustrations are not only essential, but at least as important as the text: namely, such children's books as *Four Seasons of Flower Fairies* by Cicely Mary Barker (1985) and *Park Beat: Rhymin' Thro' the Seasons* by Jonathan London (2001). The second type of book, though seasonal themes are not common within the genre as a whole, is science fiction. Brian Aldiss, for example, has written a seasonal sequence about creatures called Helliconians who must accommodate to the cycle of the seasons that defines their world (just as humans must on earth), an accommodation that in the final volume, *Helliconia Winter* (1985), results not in pessimism but in an empathic connection among themselves and with sentient beings elsewhere in the universe. In *Helliconia Summer* (1983), Aldiss delineates a society reminiscent of Renaissance Europe. Helliconia faces the cyclical threat of fire in summer and ice in winter. Only in spring and fall is their planet truly habitable. Aldiss even titled a collection of his stories, published in 1984, *Seasons in Flight*; he has created imagined creatures going where no man had yet dared to go, only to encounter seasons well known to earthlings but even more challenging in terms of survival. Might Hesiod have imagined such scenarios almost three millennia ago? Perhaps, but it's not likely that he could have envisioned the "flattening" of the seasons that has occurred during the past century, never mind some extraterrestrial world that exists in the fantasy universe of Brian Aldiss.[19]

Norman Rockwell: Marking Seasonal Time with Youngsters and Codgers

In addition to seasonal children's books' being a long-standing staple, and the children's four seasons art contest in 1956–57 discussed in chapter 4, seasonality figures in the lives of children in still other ways that profoundly affect the sense that adults now have of the cycle of a given year. Surely the school year, beginning in most places directly after Labor Day, ending in mid-June, and punctuated by certain familiar holiday breaks, is the rhythm so many Americans now resonate to, as do the travel industry and others as well. Tracy Kidder provided an especially clear sense of that consequential rhythm for teachers as well as children in his 1989 bestseller, *Among Schoolchildren*. As he remarked at one

point about a teacher named Chris, she "half believed in the power of the moon. She strongly believed in the power of the season now upon them [spring]—Little League baseball and the warm, long evenings of daylight savings—to bring on academic decline. She fumed at the class a few times during May, and one day when almost no one had done the homework, she went to the Teachers' Room and declared, 'I hate them right now. I'm going to the Golden Lemon and start drinking *now*." In a memoir about the social centrality of schoolboy football competition, another writer commented about a father whose son had carried the ball but seemed hesitant about crossing the goal line "as if he was scared of getting hit. In the world of a small Texas town, where the four seasons of the year were football, basketball, track, and baseball, there was no greater condemnation."[20] A prime example of the seasons becoming denaturalized in modern times.

During the 1930s and 1940s, when Norman Rockwell became the nation's best-known and unquestionably its best-loved illustrator because of his regular covers for the *Saturday Evening Post*, he also achieved wide acclaim on account of his annual calendar designs for the Boy Scouts of America. In April 1947 *Coronet* magazine ran a feature story alerting readers that Rockwell had agreed with the same company that produced the Boy Scout calendars, Brown & Bigelow in St. Paul, Minnesota, to create four seasons calendars that would be mass distributed to any commercial firms, such as insurance companies and car dealerships, that wished to purchase them for use in their offices and for distribution to their customers. Another feature story about Rockwell's creation of these calendars appeared in December 1947 in *This Week* magazine, which arrived as an insert in many syndicated newspapers. As a result Rockwell was deluged with letters from admirers suggesting subjects for his seasonal calendars. Some not only specified themes, but included little sketches indicating the most appropriate colors for each season! My favorite suggestion came from a woman in Jamestown, New York: "At a summer resort, a young lady was wheeling an elderly man in a wheel chair. They had stopped to chat with a young mother pushing her young child in a stroller. There were the two, one at the end of life, the other at the beginning."[21]

That, of course, brings immediately to mind the most famous (now cherished by collectors) four seasons calendar that Norman Rockwell ever made: the one for 1951 called *Four Sporting Boys* (figure 58), with gangly adolescents preparing for baseball in spring, golf in summer, football in the fall, and basketball in winter. The kids are humorous caricatures, of course, and many who had seen pictures of the readily recognized Rockwell as an adult simply assumed that he must have been so athletically inept himself when beginning his own teen years. Long after 1951, Rockwell's fan mail would include queries from people wanting to know where they could obtain copies suitable for framing. As a woman wrote from Kalamazoo, Michigan, in 1964, "They seem

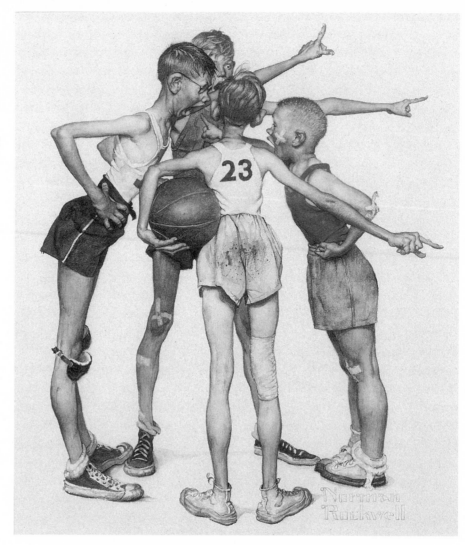

to capture our boys' childhood better than our colored home movies, with all due respect to my husband and his camera." A woman in Louisiana explained to Rockwell in 1965 that these pictures had been framed and were still hanging in her husband's office. A man in Valparaiso, Indiana, had a set and wrote to request a complete checklist of all the calendar designs that Rockwell had made: "sources of purchase and price list," as though Rockwell had mass-produced them and maintained a complete inventory of reproductions at his studio in Stockbridge, Massachusetts.[22]

In the December 31, 1950, issue of the mass-circulation *Parade Magazine*, there was yet another widely noticed story (titled "Four Kids Help Make a 1951 Calendar") about the newly issued *Four Sporting Boys* calendar that created a stir. Rockwell then received numerous requests from people who assumed that

he had a personal stockpile. A man in Ephrata, Pennsylvania, sent Rockwell his copy of the calendar "in hopes that you will autograph each page to me real warm and friendly, with just a line or two and your esteemed personal compliments finally making my long time wish to you come true at last. If you should have some old original[s] around now that you could send at this time please do so, but by all means autograph the Calendar and return it." In 1960 a group of people contacted Brown & Bigelow with an offer to purchase the original paintings for the famous 1951 calendar. Rockwell had long since given the oils to the alumni association of the local Williams High School, where the models had been students. (Technically that organization still owns them although they are held by the Rockwell Museum.)[23]

So what motifs did Rockwell himself select for the first seven calendars? Starting with 1948: *Grandpa and Me: Ice Skating, Fishing, Picking Daisies, and Raking Leaves.* He always began with winter. Then came *Young Love* for 1949; *Two Old Men and Dog* for 1950; then the *Four Sporting Boys* that so caught the nation's fancy; *Old Man and Boy* for 1952, which brought affectionate fan mail for spring, *Flying the Kite*; the whimsical *Two Old Men and Dog* again for 1953 (plate 30); and *Me and My Pal* for 1954. The pal, of course, is a boy's beloved pup. (On one occasion when Rockwell wanted to try a "modern" approach for a *Saturday Evening Post* cover, he sent a painting of old man Winter being driven out by a young girl Spring. When the conservative editor of the *Post* rejected it, Rockwell sold the painting to the *Elks* magazine.)[24]

In October 1954 Rockwell explained his thoughts in designing what would become his second most popular set: *Four Ages of Love.* He called spring *Flute Serenade*, and it showed the puppy love of early teenagers, perhaps thirteen or fourteen years old. Summer he titled *Courting Couple*, in which an attentive suitor brings a basket of flowers to his would-be bride. Autumn is sedately designated *Tea Time*, and of it Rockwell wrote for *American Weekly*, in a piece that was seemingly autobiographical: "Autumn depicts the era into which I am entering. Here is the time of love when she can sit with her hair in curlers and he wear his bedroom slippers, when they can understand the silences, when they don't have to talk. This is the love of adults who know each other well; idealism and youthful passion have been replaced by gentle memory and understanding. It is what I call comfortable love." His explanation for winter, titled *Tender Memories* (figure 59) and showing a plump and elderly couple seated snugly together on a wicker love seat, is droll in its calculated ambiguity: "The gentleman has been courting the lady for years, but due to finances or, perhaps, lack of courage, they have been unable to marry. Of course, he might be a distant relative or a recent widower. Whatever the relationship, they now find themselves in the growing warmth of platonic friendship."[25]

Brown & Bigelow's in-house magazine for the sales staff anticipated the success of this set with relish: "This year the four seasons are not seasons of the

BROWN & BIGELOW

motivational communications

year but rather the four seasons of our lives . . . childhood, youth, middle age and old age. It's a real heart tugger with a chuckle in each and every picture." After seven years Rockwell's calendars proved so successful that they became available in two sizes: a large and long version for hanging on the wall of a commercial establishment ("executive") and also a smaller one for "home coverage." Predictably, *Four Ages of Love* proved so popular that people not only

saved and framed sheets from the calendar, they even did the same with the illustrations that had appeared in *American Weekly*. For years to come people who had missed or misplaced the images wrote to Rockwell in search of fresh copies. Once again, correlating the four seasons with the human life cycle proved to have remarkable staying power. It had become a cliché centuries earlier, but continued to appeal in what by this time had transcended popular culture: the reach of these calendars into the tens of millions qualifies as mass culture.[26]

The subjects and themes for Rockwell's remaining seasonal calendars between 1956 and 1964 shifted back and forth between old men and young boys (usually with frisky dogs), but eventually came to father and son doing seasonal things together in 1962 (skiing, going to church, fishing, and hunting), and ended in 1964 with something new, *Salesman*: with a refrigerator and an eskimo for winter, a milkmaid for spring, a country peddler for summer, and a horse trader for autumn. The problem was not that Rockwell was running out of ideas, but that he had so many other lucrative commissions that he was delayed in delivering the paintings to Brown & Bigelow, who in turn had difficulty getting the calendars ready on time and gently chided Rockwell about his tardiness.[27]

B&B had always retained the right to approve Rockwell's choice of subject for the calendars, and by 1962 the company's art director and his colleagues seemed to be exerting more authority over, rather than giving greater leeway to, America's best-known artist. Following the publication in 1960 of his autobiography, *My Adventures as an Illustrator*, in which Rockwell acknowledged that he enjoyed receiving fan mail, he became deluged with it. Yet by 1962 he was not only being prodded because of his delinquency in delivering; he was receiving letters from the secretary to the art director informing him that although "the committee liked the four-seasons idea very much [for a calendar that would be called *Young Boy*,] they would like you to change that subject to some idea having to do with the young heir apparent that is always such a subject of kidding." Being famous, wealthy, and recently married to his perky and companionable third wife, a retired teacher, Rockwell had grown weary of this commitment (it had been *his* idea in 1947) and did only one more calendar set, for 1964. Meanwhile, admiring letters praising the calendars and asking where copies could be found continued to flow in to Stockbridge. Moreover, dealers and clients were constantly hoping to purchase the original oil paintings, which B&B always returned to Rockwell, but which he in turn often gave away![28]

The idea of making annual nature calendars available commercially was actually not new in 1947. Early in the century an enterprising printing company in New York City had printed a John Burroughs Nature Calendar, designed for wall hanging, with each page devoted to one week and containing an epigram extracted from Burroughs's writings. These were attractive and qualify as pop-

(opposite)
FIGURE 59
Norman Rockwell, Tender Memories *from* The Four Ages of Love *(1954), oil on canvas seasonal calendar. Art from the Archives of Brown & Bigelow, Inc.*

ular culture because an enterprise of that sort certainly was not intended solely for some cultural elite. But the success and reach of Rockwell's calendars is virtually incalculable. Not only did they enjoy a mass audience between 1948 and 1964, they have been adapted and reprinted in various formats ever since. Moreover, the motifs of youngsters and codgers continue to be available and popular on ceramic and porcelain plates.[29] Advertisements for them still appear on a regular basis in the weekend inserts of syndicated newspapers, and at any given time vendors are offering many versions of Rockwell's four seasons characters on all sorts of household objects. One might conclude, I suppose, that by the 1960s and 1970s the motif had become so hackneyed in commercial culture that no self-respecting artist could possibly contemplate painting a four seasons suite. Yet the final quarter of the twentieth century turned out to be an astonishingly fecund time for American art of the four seasons.

Before we depart from the realm of children in seasonal art along with art for folks who are young at heart, it needs to be noted that seasonality has appeared in television programs aimed at children, and in various other ways. Just when Rockwell's calendars enjoyed their greatest popularity during the 1950s and 1960s, for example, the *Howdy Doody* program featured a character called Princess Summerfall Winterspring, played by an actress named Judy Tyler who later performed opposite Elvis Presley in the movie "Jailhouse Rock" (1957).

In literacy classes for young adults, when students have made good progress and are encouraged to try their hand at writing poems, one of the most popular subjects chosen is some variation on the seasonal motif, such as "Seasons in the Country."[30]

Using the Seasons to Sell Things

For much more than a generation now it has occurred to entrepreneurial types, individuals as well as organizations, that the four seasons motif is an attractive rubric or designation for selling things—all sorts of things—to consumers situated at every taste level, along with many whose eclectic preferences transcend the customary categories of cultural stratification. In 1925 the Illinois Central Railroad sought to promote wider use of its South Shore Line by seasonally displaying large, brightly colored posters advertising "Winter Sports in the Dunes," a pretty girl wearing a bathing suit on "Dune Beaches" for summer, and "Autumn in the Dunes" with brilliantly red trees providing shade for a harvest wagon. Coca-Cola has been advertised on the full surface of metal serving trays with a four seasons design since at least 1922 and as recently as 1981. In 1999 a china manufacturer produced oversized cups featuring brightly colored four seasons motifs around the sides, a Coke bottle boldly upright within each seasonal quadrant.

Upscale catalogues offer items like the Japanese Ajiro Four Season vase avail-

able for $160. The weekend insert in Gannett newspapers and others advertises a quartet of seasonal murals painted annually by the "renowned Master of Americana," Charles Wysocki, reproduced and framed in wood for only $39.95. In Calistoga, California, located at the north end of the Napa Valley, the All Seasons Café and Wine Shop serves a delicious lunch for a reasonable price and sells seasonal art by local painters at affordable rates. Even more low-key, one can purchase Four Seasons Ice Cream in Greene, New York, or visit the Four Seasons Snack Shop for fast food in Yellowstone National Park. Four Seasons Sporting Goods in Oxford, Iowa, has been in continual operation since 1868. The 4-Seasons Sporting Goods shop in Rising Sun, Indiana, along the Ohio River, is more of a consignment and trading shop for that small, working-class town. Gardens and "outdoor rooms" (commonly referred to as four seasons rooms) can be decorated with four seasons garden plaques, handcrafted in unglazed terra-cotta with a curious mix of neoclassical and contemporary figures for the reliefs ($95).

The perception that one particular appeal of four seasons consumerism was customarily gendered is at least partially valid. Four seasons cookbooks abound, such as Martha Holmes's *Four Seasons Recipes Cook Book* or Charlotte Adams's *Four Seasons Cook Book* or *Seasons of Central Pennsylvania: A Cookbook* by Anne Quinn Corr. There is also an abundance of seasonal books aimed at people who knit, embroider, and work with textiles, such as *The Season Sewn: A Year in Patchwork* by Ann Whitford Paul (1996). And there are sprightly seasonal cardigan sweaters for women along with other kinds of outerwear. From the 1950s through the 1980s a California dress designer and night club singer named Suzanne Caygill concocted an elaborate theory of the appropriate colors in cosmetics and clothing best suited to women with a certain coloration (hair, eyes, complexion) that connected their identity to a particular season. Caygill's book, *Color: The Essence of You* (1980), was expensive and clearly intended for affluent clients; but because the notion of connecting a woman's seasonal identity with her presentation of self caught on, much less expensive and multiracial variants of the book appeared at affordable prices, among them Carole Jackson's *Color Me Beautiful*, distributed by Ballantine, a mass-market paperback publisher.[31]

Even a poet like Maxine Kumin, who handles all sorts of rugged farm chores at her place in Vermont, writes about kitchen motifs in a manner that is primarily directed at women and, I think it is fair to say, that reflects the feminine sensibility of a woman of her generation. One chapter of her prose work *In Deep: Country Essays* closes with these reflections:

Early in summer, color the country kitchen scarlet, a ripeness streaked with sunlight shading into purple. Rhubarb, the first lifeblood of the season, is ready in early June. . . . In full summer, color the kitchen green, streaked

with yellow. Erect as milkweed, asparagus pops above ground, thickens, and yields to the gatherer's knife. . . . Color the kitchen buttery yellow once the corn comes in. . . . On hottest nights, color the kitchen crepuscular, only one light glowing, all harvest activities suspended. . . . All too soon the first frost threatens. Gardens grow ghostly under their sheets and old drop cloths. . . . Nothing fancy takes place here. Merely the steady rhythm of the life of the farm and the people who live here. Making all seasons better.[32]

Although I do not believe that women are more interested in the seasons than men, there appear to be certain situations when seasonality seems more apropos in defining or describing a woman's life than that of a man. Here, for example, is an excerpt from a recent obituary of a woman who died at the age of ninety-seven. I have never seen anything comparable in a man's death notice: "Edith especially enjoyed the spring wildflowers, and the soughing of the wind through the needles of the Ponderosa pines. Ripening of the gooseberries and the rhubarb always meant that fresh pie was soon to follow. Later the winter squash would meet the same fate, producing a pumpkin pie second to none."[33]

Our principal concern here is with merchandising, however, and the four seasons is obviously a natural name for gardening businesses and plant nurseries. Countless examples could be cited. A characteristic one appeared in an advertisement in the Yellow Pages for the San Gabriel Nursery & Florist, near Los Angeles, in which bold Chinese characters for spring, summer, fall, and winter are aligned vertically on the left-hand side of the boxed ad. As if to reinforce the logic of such enterprises, newspaper columns written for gardeners are likely to emphasize the importance of thinking about the proper season for planting and the best way to maximize an attractive display of plants throughout the year.[34] The Missouri Botanical Garden in St. Louis—along with other public gardens—likes to call itself "A Garden for All Seasons" in its promotional brochure, and the comparable brochure for Dumbarton Oaks Gardens in the Georgetown section of Washington, D.C., explains that "plants were chosen for beauty and interest in winter as well as during the spring and autumn." The Fort Worth Botanic Garden in Texas makes the same declaration. The motif is evidently a public garden perennial.

As for selling destinations in the hospitality industry, the four seasons have become virtually trivialized, and not merely because hotels, restaurants, and resorts with that name are ubiquitous attractions for the wealthy. During the 1980s an upscale and highly successful Manhattan restaurant named Arcadia had all of its walls covered in lush murals depicting the four seasons in bucolic splendor. Yet the Four Seasons Country Inn in Branchport, New York, on Keuka Lake is a pleasant but modest bed and breakfast; and the Four Seasons Motor Inn and Restaurant located on Main Street in Kalispell, Montana, is a perfectly acceptable but unexceptional motel accommodating mortals with or-

dinary budgets. The Four Seasons Health Care Center in Columbus, Indiana, is a handsome but unpretentious place. The historic Printing Office in Nauvoo, Illinois, features one bold line below its name on the sign above the mid-nineteenth-century entrance: "Times & Seasons" with a space followed by "Nauvoo Neighbor." It too seems to be welcoming, and the Mormons have managed an excellent job of historic preservation at the primary site of their community before it moved west to the Great Salt Lake late in the 1840s.

Places to Go, Things to See, and Vicarious Seasonal Travel

Beginning in the 1950s, with the proliferation of paid vacations for large numbers of Americans and a marked increase in tourism throughout the United States, the seasonal motif acquired an additional dimension. Books about the cycle of the seasons began explicitly to address what it meant to live in, or visit, a place where people came seasonally, to ski, or swim, or see the fall foliage at its most spectacular. *Nature's Year: The Seasons of Cape Cod* by John Hay (1961) provides a representative early example. The author initially went to the Cape from New Hampshire as a tourist; he fell in love with the location and bought land in West Brewster during the 1950s. He deliberately began the book with summer because that is the Cape's most distinctive season, and the one most widely known. As Hay indicated at the outset, the resident population of the Cape is "some 80,000, and in July the number increases to an estimated 250,000 or more, a kind of barometric rise that is equivalent to what is happening to the earth at large. After Labor Day, when the summer tribe has gone back to the cities, relief comes. You can cross the road in comparative safety."[35]

For many states and communities, seasonality became a matter of pride and perhaps a magnet for tourists and possible permanent residents. There are signs along the road as one enters an Ohio town: "Welcome to Mansfield. A Reason for All Seasons." On the other hand, in 1949 when Minnesota celebrated its centennial as a state, a big contest was held seeking a better slogan than "The Gopher State" or "The North Star State." When the winning entry turned out to be "Minnesota—Theater of Seasons," residents became upset and no change was made. In the autumn of 2001 New York State's Department of Economic Development began placing full-page, handsome color ads urging people to "Discover New York." In the lower right-hand corner the ad features a square divided into quadrants with tulips for spring, a boy about to swim for summer, brilliant red apples for fall, and a man skiing for winter. As far back as 1965, however, *Look* magazine published a fairly lavish spread using twenty-five images to illustrate an essay about the four seasons on Long Island. They included, for example, a farmer plowing his field in Suffolk County for spring.[36]

People able to move about the country are increasingly likely to encounter man-made reminders of the seasonal cycle in public places: monuments, me-

morials, and decorative "touches" intended to make civic space more attractive. As an example of the latter, consider the colorful four seasons cast iron benches that provide places to rest not only in the main plaza of Taos, New Mexico (plate 31), but also at the venerable St. Francis Church just south of town in Rancho de Taos that has been rendered visibly memorable in paint by Georgia O'Keeffe. (An identical bench but entirely black, without the four ovals being brightly painted, sits in front of an elegant restaurant on Fifty-sixth Street in Manhattan.) Visitors to the Westhampton Memorial Park in Richmond, Virginia, established in 1954, will find in a section called "The Garden of the Four Seasons," added in 1978, four sets of sprightly putti characterizing the seasons in a slightly whimsical manner that is nonetheless redolent of neoclassical influence. The youngsters hold flowers, sheaves of wheat, and grapes, and warm their fingers over an imagined fire to evoke winter.

Representative of public sculpture is a four seasons monument carved in limestone that originated at an Italian villa along the Brenta Canal between Padua and Venice but migrated in 1923 to Wilmington, Delaware, where it enhances the Bald Cypress Allée. There are four female figures, each one standing on top of a three-part pedestal also made of limestone. Winter cups in her hands a container with a burning flame. Spring holds a basket of flowers in her right hand and carries a bouquet of flowers in the crook of her left arm. Autumn clasps her drapery with her lowered right hand and holds a bunch of grapes in her left. An organization known as Preservation Delaware received the Save-Outdoor-Sculpture Conservation Treatment Award in 1999 for restoring this attractive piece of transatlantic public art.[37]

Because travel is not an option for everyone, coffee-table books in brilliant color devoted to the seasons began to appear in 1962 when the Sierra Club published a stunning volume titled *In Wildness Is the Preservation of the World*. It contained seventy-two color photographs by Eliot Porter on right-hand pages facing texts drawn from writings by Thoreau. The book, with an introduction by Joseph Wood Krutch, was organized according to the seasons (from early spring to winter), reviewed widely and with raves, and appeared in an accessible paperback edition as early as 1967. The project marked a major departure for the Sierra Club because its previous emphasis in publications and activities had concentrated on the West, especially the Sierra Nevada. This volume traced the seasons and the passage of time pictorially in the Northeast, mainly to further the agenda of the club on behalf of wilderness protection beyond the West. Perhaps its availability and enthusiastic reception brought the spirits of John O'Mountains and John O'Birds a bit closer together![38]

Similar volumes soon followed early in the 1970s. Needless to say, affluent and mobile people perused them, often as souvenirs of places they had visited, or, more often, as emblems of local or regional pride. These handsomely illustrated picture books with their brief but well-written texts also served as a

mode of armchair, or vicarious, travel. Whatever the experience may have been for those who enjoyed them, the books most certainly called attention not merely to seasonal cycles but to their variability and distinctive qualities in different parts of the country. One simply titled *Seasons* (1973) has an eloquent text written by Hal Borland and sixty-four glowing pictures taken by Les Line, the editor of *Audubon Magazine*. It received praise as a "spectacular" work and figures in popular culture because it was intended to be not only a gift book, but one that could be widely used as well in secondary school classrooms for nature study. The text had substantive content. An admirer wrote to Borland that "it is a book to relish slowly. And it's nice to have the winter pictures to look at in this weather. But it is, to state a truism, a book for all seasons."[39]

By the end of the 1970s it must have been clear that a significant market for such books existed. In 1979 a company called the Four Seasons Book Publishers brought out *The Four Seasons of Chester County* (Pennsylvania). The following year witnessed two of the most impressive and interesting examples of this genre. Arthur Griffin and Houghton Mifflin published *New England: The Four Seasons, with Original Essays by 51 Famous Authors*, including Maxine Kumin and Tim O'Brien writing about spring, Henry Cabot Lodge and Arthur Schlesinger Jr. for summer, Richard Wilbur and Archibald MacLeish for fall, and John Updike and Justin Kaplan for winter. Truly an all-star cast. Griffin himself took all of the color photographs. That same year Oxmoor House in Birmingham brought out *The American South: Four Seasons of the Land*, with photographs by William A. Bake, a talented editor/photographer with the National Park Service, and the text written by James J. Kilpatrick, a political journalist who at the time had the most widely syndicated column in the United States. Like Griffin's book, it begins with spring, but instead of finishing with a fairly predictable scene of a church in a country town under snow at Christmas time, *American South* ends with a "reprise": glorious photos of Harpers Ferry, West Virginia, at the peak of each season. The images in this work are about as good as they get.

A very distinctive volume resulted from an unusual collaboration during the mid-1990s. *A Covenant of Seasons* consists of lovely monotype scenes prepared by Joellyn Duesberry, seasonal poems by Pattiann Rogers, and a concluding essay on the seasons in art by historian of art and museum curator David Park Curry. Their teamwork resulted in a project with the appearance of a coffee-table book, but one that requires more serious contemplation. It is an evocative effort in every sense.[40] Some other examples from recent years include Evelyn Lauder, *The Seasons Observed* (1994); Todd Caudle, *Colorado Seasons* (1994); Sy Montgomery, *Seasons of the Wild* (1995); Keith Bowen, *Among the Amish* (1996), with seasonal drawings as well as text by Bowen; Terrell S. Lester, *Maine: The Seasons* (2001), with essays by Ann Beattie and others; and finally R. H. Macdonald, *Four Seasons West: A Photographic Odyssey of the Three Prairie*

Provinces (1975), prepared by a "prairie journalist" intimately familiar with Alberta, Saskatchewan, and Manitoba.

After a while, someone in England must have noticed that these coffee-table books did well and rewarded the capital investment. In 1993 Pavilion Books in London produced one of the most striking examples, *England: The Four Seasons*, with an excellent text by Ronald Blythe and photographs by Michael Busselle. An extract from Blythe's introduction suggests the book's charm overall.

> England itself has come to expect a little less winter than Scotland, not as much rain as Wales and Ireland, but its seasonal changes are as influential as ever they were. They have helped to make us what we are. With their four defined bouts of weather and degrees of light, they provide a near obsessional interest and fascination, as well as the most legitimate subject for our small talk. The spring continues to be less enchanting than we remembered, the summer goes on being glorious by fits and starts, the autumn pursues winter, catching up with its bitterness at last, and the winter is usually blamed for not being wintry enough. And so the English year goes round, dragging ourselves as well as the rest of nature with it, marking our lives and doing far more than politics to shape our national characteristics, did we but know it.[41]

What differentiates this book a bit from its American counterparts is that Blythe's text is somewhat more historical and contains considerably more literary allusions. Writers like Geoffrey Chaucer, James Thomson, John Clare, John Keats, and many others are quoted.

One of the most notable and singular works of this kind is *Monet's Garden: Through the Seasons at Giverny* by Vivian Russell, first published in London by Frances Lincoln in 1995, but available in venues throughout the English-speaking world, and especially popular in the United States. The text, which is superb and more substantive than what we ordinarily associate with coffee-table books, begins with an essay on Monet as a poet of nature and then proceeds through the seasons starting with winter, "As If In Mourning," followed by "Spring Lights Up the Garden," "Summer Splendour," and "Autumnal Glory." It's an incomparable production, cherished by everyone who has seen it.

Seasonal Films and Music

It was perhaps predictable that Walt Disney would work the seasons into his animated films, and, in fact, he did so at the very beginning of his career in 1929–30 by using seasonality in some of his Silly Symphonies. He returned to seasonal allusions in 1940 with *Fantasia*, which is now regarded as a classic but was not commercially successful when it was released because the public was eager for more feature-length films along the lines of *Snow White and the Seven Dwarfs* (1937) and *Pinocchio* (1939). *Fantasia* is noteworthy in our context, how-

ever, because Disney teamed up with conductor Leopold Stokowski in using Bach's *Toccata and Fugue in D Minor*, Beethoven's *Pastoral Symphony*, Moussorgsky's *Night on Bald Mountain*, and Stravinsky's *Rite of Spring*, along with other selections, to highlight the movie's major theme of cycles in the natural order: rebirth, growth, development, and ultimate harmony. The ongoing visual emphasis upon water, along with clouds, falling leaves, twirling snowflakes, and billowing milkweed seeds, served as heightened reminders of seasonal change. Disney even used "The Dance of the Hours" from the ballet in Ponchielli's opera *La Gioconda* (1876) for melodies to evoke times of the day: morning, a sunny afternoon, evening, and night. Despite the evocative music and nonfigural narrative, *Fantasia* was clearly ahead of its time, and without a compelling story line it lacked appeal for children and for many adults as well. *Bambi*, on the other hand, a huge hit in 1942, enhanced its gripping saga by highlighting the glory of nature as seen through the course of the year with special stress upon emerging seasons.[42]

When Disney moved more intensively into the making of "pure" nature films during the later 1940s and the 1950s, the studio invariably suffused nature with morality and revealed the hand of God throughout all creation. Always astute about marketing and the rapid growth of new constituencies, Disney recognized a yearning in the swiftly sprawling suburbs for contact with the environment. In the documentary *Nature's Half-Acre* (1951), for example, which won an Academy Award and other major accolades, the wildlife featured is a familiar reminder of spring and summer to people viewing nature through sliding-glass doors of ranch-style homes. As Gregg Mitman has observed: "Within the themes of seasonal change and the balance of nature lie the moral lessons of family life that accompany the symphony of spring. Nest-building constitutes the real work of the season, and we are witness to the varieties of materials and shapes of nests built by the inhabitants." Above all, these Disney films bolstered religious values by adhering to natural theological explanations of the balance of nature. No mention of evolution ever occurs, and the films lend tacit support to a theory of divine creation.[43]

Although a great many American films have seasonal highlights for cinematic beauty as well as metaphorical purposes, the earliest film for a mass audience explicitly utilizing the cyclical theme, albeit loosely, was Alan Alda's comedy *The Four Seasons* (1980), the first feature for which he was the writer and director as well as appearing on screen. It concerns the friendships and tensions of three middle-aged couples who spend four vacations together during the course of a year while most of them are having some sort of difficulty negotiating a harmonious passage through the storms of midlife. There are predictable seasonal shots in appropriate venues, but as Alda's wife has explained, because the movie was filmed in just nine weeks (the producers lacking the patience of those eighteenth-century Dutch artists who waited an entire year to complete

their floral still lifes), there were inevitable problems of a logistical nature. The movie was scheduled for shooting in New York, Vermont, Virginia, Georgia, and the Virgin Islands. As Arlene Alda remarks: "Beautiful places. Not only did the locations have to look different, but between March and May we needed to get snow for winter, autumn leaves for fall, flowers for spring, and boats and sun for summer." The movie turned out to be a hit, and that encouraged Alda to create a television series titled *The Four Seasons* early in 1984. Spiked with music from Vivaldi's 1726 concerti of the same name, the series also took as its theme the trials and tribulations of friendship. It opened to warm praise from such serious TV critics as John O'Connor, but the cloying motif soon wore thin and the series did not endure.[44]

The most ambitious and philosophically suggestive cinematic treatment of this motif comes from the venerable French director, Eric Rohmer, who began his *Tales of the Four Seasons* at the age of seventy-one in 1991 with *A Tale of Springtime*. All of the films have been released in the United States with English subtitles but played to audiences of modest size because their philosophical content is often so allusive, and such comedy as there is may be too subtle and situational rather than broad, as in Alda's film. Only the fourth and final installment, *Autumn's Tale* (1999), achieved acclaim in the United States, an Oscar for best foreign film at the 2000 award ceremony, because the movie's motif is the most accessible: namely, that it is difficult to find love in the autumn of one's life, especially when well-intentioned friends manage to mess things up. Perhaps this final film also enjoyed success in America because it has an upbeat ending after so many trials, tribulations, and doubts about whether the autumnal couple could actually overcome unfortunate misunderstandings and come together as a happy match.[45]

Although Rohmer insists in the numerous interviews he has given that in writing the scripts for the series he never envisioned any unifying theme or grand design, connections and parallels among the films are readily apparent. At the very least, Rohmer must have considered potential relationships within the quartet as they emerged. David Heineman has provided the clearest understanding of how Rohmer's *Tales* cohere.

> Viewed as a unit, the four films stand like the four cardinal points of a globe, each related to the others in opposition and similarity, contrasting with each other yet embodying common themes. *A Summer's Tale* [1996] and *A Winter's Tale* [1994] both feature protagonists who, in their search for love, demonstrate the necessity of faith. *A Tale of Springtime* [1991] and *Autumn's Tale* have at their hearts matchmakers who try to pair off friends, with schemes ranging from pragmatic to fanciful. In all four films characters dream of an ideal love, which, like the grail of Arthurian legend, they know exists, even if they haven't yet found it.

In *A Summer's Tale*, for example, Gaspard, a young math student on vacation at a seaside town in Brittany, is pursued by three women and attracted to them all; but, unable to make a commitment to any one of them, he eventually loses all three. His final lament, "It's my destiny," resonates with the sense of loss that most of us feel when summer wanes and proves ephemeral. It is a commonplace observation among students of Rohmer's work that "luck comes to those who believe in it." Perhaps; but David Denby has put it very well by observing that Rohmer's films manage to combine endlessly intellectual dialogues with elements of erotic farce.[46]

Most American audiences find the first three of these films somewhat enigmatic. The one thing that they can grasp for sure involves the settings and cinematography. In *Springtime* there are frequent images of flowers, and cherry trees are in bloom at the father's country home. All of the colors, indoors and out, tend to be soft pastels. Natasha, the temperamental heroine, is about nineteen, and blossoming herself. In *Winter*, set in Nevers on the Loire River, snow falls on Christmas Day, and there are deliberate echoes of *The Winter's Tale* by Shakespeare. In *Summer* there are many beach scenes with the characters in swimsuits that display their attractive bodies. And in *Autumn* it is not so much the foliage as the need to harvest grapes (the heroine, North African–born Megali, owns a vineyard), the color of clothing, and the festive band playing for a wedding at the close that create a symbolic ambience.[47]

By the end of the 1990s seasonality began to figure prominently in films made by Asian directors. Perhaps the most noteworthy is Tony Bui's *Three Seasons* (1999). It won several awards at the annual Sundance Film Festival and enjoyed fairly broad distribution in the United States, in part, I suspect, because one prominent character is an aging American marine who is seeking his daughter in Ho Chi Minh City. The film, which skillfully interweaves four separate plot lines (or personal dramas), begins in the dry season with the characters complaining frequently about the overpowering heat, even at night. A rainy season follows, characterized by endless downpours in which both children and adults wear cheap plastic pullovers for protection. Finally, and rather briefly, when the romantic couple is united (and presumably lives happily ever after), there is a spectacular autumnal scene with trees fully crowned by brilliant orange and rust-colored leaves. This season is brief, but obviously it is the most pleasant of the year. Autumn also seems to serve as a metaphor for maturity, as, in this case, the ripening and realization of true and enduring love overcomes misunderstanding.

Turning to popular music, I will pass over the many songs that refer to one or more of the seasons but not all four, such as "All the Things You Are" by Oscar Hammerstein II: "You are the promised kiss of springtime / That makes the lonely winter seem long." A better place to begin is with the seminal folksinger Woody Guthrie, who in his autobiography, *Bound for Glory* (1943),

evoked memories of his childhood in Okemah, Oklahoma: "Peace, pretty weather. Spring turning things green. Summer staining it all brown. Fall made everything redder, browner, and brittler. And winter was white and gray and the color of bare trees." Those seasonal memories would inflect many of his early folksongs, and he eventually wrote more than 3,000.[48] His comrade and disciple, Pete Seeger, took the familiar passage from *Ecclesiastes* (chapter 3), "To every thing there is a season, and a time to every purpose under heaven," and made it a signature song that generations of fans instantly recognize from the initial chords as "Turn, turn, turn, to everything there is a season," which Seeger sings joyously, even triumphantly, as though perseverance and justice will surely win out in the long run.

During the 1960s and 1970s that song was "covered" by the Byrds, the Association, and many other performers, thereby reaching a mass audience numbering in the tens of millions. Seasonality and nostalgia figured prominently in folk music popular during this period. Joni Mitchell's 1970 album, *Ladies of the Canyon*, for example, featured songs like "Woodstock" (with its "back to the garden" refrain) and "The Circle Game," whose memorable chorus became standard fare for camp songs right through the 1980s:

And the seasons, they go round and round,
and the painted ponies go up and down.
We're captive on a carousel of time.

Mark O'Connor grew up in Seattle exposed to his mother's extensive collection of jazz, folk, and classical long-playing records. Music became his passion, and at the age of seventeen he won the country's most prestigious fiddling contest, held in Weiser, Idaho. He moved to Nashville in 1985 at the age of twenty-three, and before turning thirty he had become the most celebrated musician in the city. From 1990 through 1995 he was voted the Country Music Association's Musician of the Year. He then began exploring classical composition, and by the year 2000, having collaborated with cellist Yo-Yo Ma on Appalachian folk music played in a semiclassical style, he composed a work titled "American Seasons," a four-movement reflection on the stages of life. As one enthusiastic reviewer observed, it is "bracingly dissonant. Angular and bristling, it scuttles along, off center. Yet for all its dissonance and density (at one point in the final movement, violins, violas, cellos and Mr. O'Connor [on fiddle] each play an entirely different theme—a very heady stew), 'Seasons' is wholly listenable, buoyed by its jazzy rhythms and by Mr. O'Connor's unstoppable melodic gift." The life cycle in this composition transcends the traditional quadripartite equation with the seasons. Instead it goes from infancy and adolescence into coming-of-age, maturity, old age, and death. He uses the blues, for example, to convey adolescence. For the final season of winter he returns to some of the musical motifs he used with infancy in order to suggest ties to children of children and there-

fore continuity into the future. It is a lengthy and impressive piece of contemporary music, and by incorporating folk, jigs, and Copland-like passages along with the blues, it could hardly be more American.[49]

When Christopher Wheeldon became principal guest choreographer for the Boston Ballet in 1999, he very much wanted to devise a dance suite to be accompanied by Antonio Vivaldi's *Four Seasons*. Baffled at first by the challenge of providing so many steps for so much lively music, he felt intrigued when he read Vivaldi's own words, which have survived along with the scores of the concerti. "In the winter," Vivaldi wrote, "our feet chatter with cold. We shiver in the snow." That was all the inspiration that Wheeldon needed, and his imagination took it from there. His forty-eight-minute ballet had its premiere on September 28, 2000, at the Wang Theater in Boston. In a very real sense, Wheeldon was following in the footsteps of Jerome Robbins, who in the 1970s choreographed a ballet to music that Giuseppe Verdi had composed for an 1851 divertissement called "Les Quatre Saisons."[50]

Composer Michael Torke, like Mark O'Connor, blurs the boundaries between classical and popular music. Trained at Yale, he is considered an exponent of the postminimalist musical idiom. Late in the 1990s the Walt Disney Company commissioned Torke to create one of two "Disney Millennium Symphonies," and he chose to write a composition that he titled *Four Seasons*, with a libretto by Phillip Little. Primarily concerned with the cyclical passage of time, the work proceeds through a calendar of the seasons, somewhat in the manner of a book of days. It received its premiere on October 8, 1999, by the New York Philharmonic, with music director Kurt Masur conducting at Avery Fisher Hall. Its second performance took place at the Epcot Center in Orlando on New Year's Eve at the close of 1999.

Contemporary American composers are not alone in being attracted to the seasonal motif and to blending musical genres once assumed to be in quite separate categories. Lawrence Ashmore, who is British, has also composed a work titled "Four Seasons" based upon English folk song settings and featuring a clarinet and string orchestra. On February 7, 2001, the Camerata Australia performed in Cambridge, Massachusetts, the premiere of a new work simply titled *Seasons* by Barry Conyngham, who served in 2000–2001 as Harvard's visiting professor of Australian Studies.[51]

Seasonal Journalism and Cartoons

Essays and editorials commenting upon the seasons, most notably seasonal change, have long been familiar in newspapers and mass-circulation magazines. But there seems to have been an intensification of this pattern during the final quarter of the twentieth century, perhaps because so many Americans who have led only urban lives feel so disconnected from the natural world. During the

1970s, for example, Gene Hill, a regular columnist for *Field and Stream* maga-zine, wrote pieces with titles like "Changes," a fairly poetic listing of signs that mark the passing of all four seasons. John Ed Pearce, another journalist with a regular newspaper column, frequently devoted it in semihumorous fashion to such topics as "Sounds and Smells of Summer," "What Have I Done with My Summers?" and "Why Foul Up Fall?" Here is how he began a piece titled "Ten-nis, no one?": "Life has a way of labeling things. Especially seasons. You can't have just the Winter of 1977. It's got to be the year the river froze over. The win-ter we went to Florida and you got that awful sunburn. The summer Paul got drunk going through Georgia and married that check-out girl—what was her name? This past season, I suppose, must go down as The Summer They Found Out [that I really can't play tennis]." And in "A Little Fall Must Reign" he makes fun of the obligatory newspaper essay on the wonders of fall foliage: "The lot of the magazine writer, like that of the policeman, is not always an easy one. For every rose there is a thorn, a cloud for every silver lining. And for every writer there is an editor who, soon or late, appears in the writer's doorway with a smile through which sadism flickers like summer lightning, and demands an article on the glories of autumn."[52]

Some of the late Mike Royko's syndicated columns coming out of Chicago concerned what he once called "the blessings of our four seasons," meaning the capricious unpredictability of weather in the Windy City area. One installment begins this way:

> While giving a friend a recent lift to the airport, I pointed out the fall colors and asked if he had ever thought about how fortunate we are to live in a cli-mate where we have four distinct seasons.
>
> "Ah, yes," he said. "I was thinking about that just the other day while play-ing golf. The foliage on the first hole was spectacular."
>
> Did you play well?
>
> "I played the first hole OK. But a heavy cold rain suddenly blew in and I was soaked to the skin before I could wade through the puddles back to the clubhouse. Thought I'd catch pneumonia for sure."
>
> And I'll bet the first thing you did was order a heavy drink to ward off the chill.
>
> "Exactly. A warm rum toddy."
>
> That's what I mean about the four seasons. A golfer in Southern Califor-nia or Arizona or the other monotonously warm, sunny climes is deprived of that invigorating sort of experience.[53]

The reader can well imagine how the piece continued. Columns of a similar character abound in local papers, usually written by writers not quite so droll or sardonic, but in one way or another attempting to come to terms with me-teorological conditions associated with seasonal change that are less than opti-

mal. As one Ithaca, New York, newspaper writer concluded her essay on early autumn rains: "As that dreary rainy day settled into a dark rainy night and I listened to the sounds of the traffic splashing through the water on Main Street and I thought about the roof springing leaks and the basement getting flooded, I also realized that—like it or not—I should probably take my cue from nature and accept that change is inevitable."[54] Seasonality doth make homely philosophers of us all!

Casual essays about the seasons for mass circulation date back more than a generation, at least. Joseph Wood Krutch wrote a representative one for *Family Weekly* in 1968 that is fairly conventional in enumerating things to look for as harbingers of spring: robins, ruby-throated hummingbirds, spring peepers—the usual fare somewhat simplified for a readership even broader than Teale's or Borland's. *Family Weekly* reached tens of millions rather than tens of thousands. Almost at the outset Krutch made an assertion that is intriguing because it has recently been contradicted by a "scientific survey." Well, sort of. Krutch declared: "One thing is certain, [spring] is everyone's favorite season. Until about 200 years ago, Spring even was the beginning of the year on calendars, which made March 1 New Year's Day."[55]

Early in the 1990s two Russians who had emigrated to the United States did a considerable amount of polling in various countries to learn people's preferences regarding many aspects of art. It's an amusing survey, and it is based on a large number of respondents. Whether or not it can qualify as "scientific" is beside the point; it was an engaging exercise in the sociology of art, and of art in relation to nature, which is what matters here. When asked flat out, "What is your favorite season?" the respondents from eight nations deviated from Krutch's norm by indicating these preferences:

Winter	15 percent
Spring	26 percent
Summer	16 percent
Fall	33 percent
All Equal/Depends	9 percent
Not Sure	1 percent

But when asked which season they would most like to see represented in a painting, respondents seemed to validate Krutch. Their preferences were:

Winter	10 percent
Spring	35 percent
Summer	13 percent
Fall	22 percent
All Equal/Depends	17 percent
Not Sure	3 percent

The survey included people from China, Finland, France, Iceland, Russia, Turkey, Ukraine, and the United States. Did the pollsters disaggregate the data so that we could learn the percentages for the United States alone? No. So here we have an international survey, and we can take it or leave it.[56]

What about syndicated cartoons? In 2001 an installment of the *Wizard of Id* cartoon strip had just two panels. In the first one the wizard is shown asking an undertaker at Sickle's Funeral Parlor, "What's Your Favorite Season?" In the second panel the solemn undertaker replies, standing next to an expensive coffin: "Flu." Once again, the commercialization of seasonal entrepreneurship! Seasonal motifs and themes actually appear frequently in cartoons, but in diverse ways. When Jules Feiffer began drawing his strip for the *Village Voice* in 1956–57, he introduced a dancer with a "dance to spring." He then had her do interpretive pieces for the other seasons. According to one authority, "in spring her dance was stretchy, hopeful and giddy. In summer it was 'lazy, so lazy' and ultimately wilted in the heat. In the autumn she danced wistfully to the leaves falling." She and the strip were syndicated in 1959. In a *New Yorker* drawing a fashionably dressed woman is conversing with a Buddhist monk at some sort of cocktail party. (She holds a wine glass, but he does not.) Her capacity to make conversation seems to race ahead of common sense, or else her specialty is cheerful non sequiturs. She asks the placid monk rhetorically: "I imagine serenity's pretty much the same, one season to the next?"[57]

Although Hal Borland died in 1978, seasonal editorials continue to appear on an occasional basis at the bottom of the editorial page of the *New York Times*. What's new is not that some are unsigned, as Borland's were, while others carry a byline—that of Verlyn Klinkenborg. What's new is that roughly half the time they are about what is happening in the natural world, like the arrival of the equinox, while the rest are actually devoted to aspects of popular culture during the season under consideration. One titled "The Blockbuster Culture of Summer" opens with reflections on the waning of that season:

> Summer dwindles, even as high August comes. The roar of summer culture has reached its climax, and the county fairs are beginning to kick in. They are the grace notes that really signal the beginning of this season's coda. Since June, every arena, every theater, every amphitheater and grassy bowl in the country has sponsored a festival, a jamboree or a concert series of some sort. Rock-and-roll retirees are giving it one more go wherever they can, and so are the senior citizens of hip-hop. . . . In most cases, the special intimacy of the summer season of dance, bluegrass, jazz and classical music is dwarfed by that other summer season of mass-produced artifacts for a mass audience [meaning blockbuster movies].[58]

Popular and mass culture have seized upon (and for many people even shape) a sense of seasonality. That has carried the flattening process, first discerned in

the later nineteenth century, a giant step farther than the naturalists of yester-year could possibly have imagined. Is this a bad thing? The answer depends upon the behaviors preferred by different sorts of people with varied enthusi-asms. In terms of following the seasons in the media, however, I suppose that we've usually done better than a headline that appeared when the Cold War was at its peak: "Autumn Held Likeliest Season for Launching an A-Attack." Why autumn? Because that is when such an attack could ruin the largest amount of unharvested food, and because someone had noted that the weather in that sea-son was most conducive to spreading nuclear radiation.[59]

CHAPTeR 7

THE FOUR SEASONS IN CONTEMPORARY AMERICAN ART AND POETRY

Despite all the reasons why the seasonal cycle in nature might logically become less meaningful to an urbanized and self-absorbed society, an astonishing burst of interest in the four seasons motif emerged from the studios of American artists during the final third of the twentieth century. A similar burst occurred in the realm of poetry, though to a lesser degree and without the same intensity or accessibility. The most striking aspect of all this productive activity in the arts— we have work by well over twenty painters and several poets to consider—is its diversity. No single stimulus or style dominates or explains what lay behind the surge of creativity. For purposes of convenience, I will explore work by the artists in four categories: landscape responses, life cycle responses, the aesthetic appeal of representational and symbolic serialism, and urban responses.

I must also concede that there are several sources of stimulation that cut across my four categories: responses to what might best be referred to as "memory and desire" (Eliot's oft-quoted phrase at the opening of *The Waste Land*) or, more explicitly, an interest in the very tradition of this genre itself (e.g., Marc Chagall, James McGarrell, Anne Abrons, and Cy Twombly) and an engagement with sexuality delineated in seasonal terms (exemplified by Paul Cadmus and Lisa Zwerling). The connection between seasonality and subjectivity turns out to be less troublesome than I had expected during the span of about fifteen years when I collected images of the artists' work. Because most of them wrote some sort of text to accompany exhibitions of their art, or else consented to be interviewed or correspond with me, very few of these four seasons suites can be considered difficult to comprehend. The only serious candidate in that respect is Cy Twombly's set. In contemporary confessional poetry, however, obscurity is more problematic. The art and the artists, more often than not, speak for themselves despite the fact that some of them (like Jasper Johns) seem unwilling to "tell all." That's all right. A little enigma now and then enhances enchantment and provides viewers with food for thought.

Somewhat surprisingly, contemporary American artists interested in the

four seasons are largely unaware of one another's work. They constitute a "cohort" only in the eye of the beholder, unlike the naturalists considered in chapter 5, who literally formed a network and perceived themselves as a group. When asked about their sense of seasonality in art, contemporary painters are far more likely to refer to works by Renaissance masters, Bruegel especially, whose work they have seen in European museums or in art books. Moreover, they rarely refer to American predecessors for whom painting the seasons was a dominant concern—artists like Jasper Cropsey, John Twachtman, Willard Leroy Metcalf, or Charles Burchfield. To the extent that there exists a sense of tradition concerning the genre among American moderns, it is discontinuous and eclectic. That is one reason why I find symbolic serialism to be a viable category. Several of the artists, such as Jennifer Bartlett, explicitly allude to the appeal that serialism has for them as a mode of expression, and the appeal is loosely rooted in a sense of heritage, of older works seen somewhere, sometime. Perhaps the variability and degree of innovation found among contemporary artists owes something to the fact that they are aware of a tradition, but just barely, with the consequence that their works are anything but derivative. In many respects their efforts are fresher and contain more surprises than the work of American artists who depicted the seasons between the 1850s and the 1950s. What the moderns clearly do know, perhaps intuitively, is that the four seasons motif lends itself marvelously to making metaphorical or allegorical statements: about time, atmosphere, the intensity and rhythms of urban life, and sometimes even about nature itself.

Landscape Responses, ca. 1964–1999

Let's begin with the only modern instance of four seasons art that I have seen involving collaboration between a visual artist and a writer (outside of children's books). In 1965 the Pennsylvania State University Press published (in a large portfolio format) four seasons etchings by Harold Altman (1924–2003) with an introductory essay by the novelist William Styron. The writer no longer remembers how the collaboration came about except that a mutual friend arranged a brief meeting, and Styron decided that he liked Altman's work. (They are exact contemporaries.) The etchings themselves are perhaps less impressive, especially for our purposes, than what Styron had to say about them, because his comments provide a perfect introduction to where we have now arrived in space, time, and temperament. In the crucial passage from his essay, Styron observed:

> Obviously possessing a sensibility that is undeflected by fashion, Altman is an artist bold enough to seize upon that most conventional of poetic themes—the rhythm of the seasons—and to employ nature as a mirror in

which to reflect inner states of mind. At first glance, the prevailing mood in the four scenes is of nostalgia, of fleeting time, of the fragmentary interlude tenderly yet dimly evoked, as in a dream; indeed, there is an intensity of yearning for the past moment similar to that borderline region of desire and memory which comes to us often at the brink of sleep, when for the briefest space of time some unrecapturable scene is in truth recaptured, and an autumnal day or a summer evening many years ago is reborn with a flashing immediacy that stops the heart.

A few more sentences can adequately convey the essence of this eloquent pairing. Styron felt persuaded that in Altman's etchings "nature has evoked a response which, though peculiarly modern in its tone of pessimism, is still rich and alive." He concluded his piece by observing that "from such a vision, foreshadowed in these modest but lovely etchings, there may yet be restored to art a sense of the sweetness and the touching brevity and the glory of life."[1]

Peter Blume (1906–92), a Russian-born artist who came to the United States with his family at the age of five, has been described as a magic realist. In 1963 he began work on *Winter* (plate 32), which he completed the following year and which became the first in a seasonal suite that he did not complete, with *Spring*, until 1989. He never seems to have doubted that he would live long enough to do so. His explanation of the stimulus for *Winter* is intriguing. Blume and his wife lived in rustic Sherman, Connecticut. "During winter up here," he noted, "we feed birds. And we have vast collections of them. One night I heard a terrific crack and I went out the next day, and I saw a tree that had snapped near the base. And that impressed me. It became part of the picture, with the birds playing in the branches and eating down below, as did the conflicts between the various birds. . . . When you watch birds for any length of time fighting for survival there is always a conflict among them."[2] The inspiration for *Summer* (1966) arose from a trip to the Netherlands, where Blume was dazzled by the colors of the tulip fields, "that interweaving of color going off, and the sense of distance and perspective." When he resumed work on this project two decades later, he once again envisioned an unprecedented image, an indoor-outdoor scene with a still life of dried gourds resting on a tabletop and above them, seen through a window, a couple outside raking leaves. The latter view is fairly conventional, but as Blume's biographer has observed, "the gourds are not only appropriate to the season, they are possessed of an uncanny electric energy of their own: they appear almost to be in motion, like Mexican jumping beans." Blume finished *Spring* two years later, though it is the least imaginative of the quartet: a couple planting flowers. But at the age of eighty-three, he had completed a strikingly cohesive seasonal suite begun more than a quarter of a century earlier.[3]

Marc Chagall was even older, eighty-five, when in 1972 he began work on his

massive mosaic block, *The Four Seasons* (plate 34), using countless thousands of small pieces of glass, marble, and granite to create scenes alive with people, animals, fish, and birds under blazing suns, stormy skies, and an array of intermediate meteorological conditions. This unique work of public sculpture, which "resides" at Bank One Plaza in downtown Chicago, is 14 feet high, 70 feet long, and 10 feet wide. From one perspective it harkens back to those wonderful Roman mosaic floors made between the third and sixth centuries. Yet its modernity, to which light is so vitally important, recalls Monet's extensive series of *Wheatstacks* paintings done in 1890–91 to demonstrate atmospheric effects at all seasons of the year and times of the day, and under varied conditions of rain, snow, and light. The connection is especially appropriate because Mrs. Potter Palmer of Chicago bought so many pictures from the *Wheatstacks* series, and consequently, quite a few now belong to the Art Institute of Chicago.[4]

How did Chagall's remarkable undertaking come about? When he left Europe for the United States during World War II, he received a warm welcome in the Windy City and made enduring friendships there. He returned in 1958 to visit the University of Chicago, refreshed the old friendships, and made new ones. An encounter in Washington, D.C., in 1971 with some of those friends led one of them to propose some sort of major project, telling Chagall and his wife: "Chicago is so fond of you. Wouldn't it be nice if people could think . . . Chicago . . . Chagall." Both Chagalls were intrigued, agreed to "think about it," and then decided to accept the invitation, with the cost being underwritten by Mr. and Mrs. William Wood Prince in memory of Mr. Prince's father, a turn-of-the-century railroad financier. The bank at First National Plaza was delighted to provide a site. Chagall chose the theme of the four seasons, saying: "There will be many people going through this Plaza in the heart of the city of Chicago. In my mind, the four seasons represent human life, both physical and spiritual, at its different stages." The work, which was dedicated on September 27, 1974, suffered damage during the subsequent two decades because it had no protective cover from the blistering heat, sleet, and cold of Lake Michigan's weather. It was restored and rededicated in September 1996, this time with an appropriate but unobtrusive "roof." Its brilliant surfaces gleam in the sun and glow at night because of well-angled spotlights. It is one of the great treasures of seasonal art.[5]

Within a decade several American artists had begun to explore seasonal landscapes, but using diverse conceptual underpinnings. James McGarrell (b. 1930) has had an ongoing fascination with the four seasons motif as a means of describing the passage of time and our perceptions of it. First came a series titled *Tendril Nights* (1983) and then a predella that he called *Spots, Near Distance* (1984–85) with seven panels that followed a sequence from winter to two phases of spring, an expansive summer in the center, two phases of fall, and then winter again. It comes closer to capturing the meteorological realities of

the seasons, especially spring and fall, than the work of any other artist except Charles Burchfield. McGarrell's object, of course, was to create an ongoing cycle rather than a simple sequence with no sense of continuity and renewal. Answering a question about his artistic interest in time, he said:

> The near impossibility of depicting Time within a painting makes it an interesting problem. . . . Beyond that, however, there is the passage of depicted time—travel through a night, as in my painting *Nightlife and Northlight* or the passage of the annual cycle of the seasons, as in *Spots, Near Distance* or *Alba*. My recent use of extreme horizontal formats and polyptichs with predella panels is partially for the control they might give me in dealing with both of these conceptions of depicting the passage of time within the fixed confines of painting.[6]

In 1990 McGarrell received a commission from MCI to paint a major seasonal suite for the lobby of their building in downtown St. Louis. He calls these panels with their intense colors—particularly the crackling thunderstorm of summer, the blazing reds of fall (plate 44), and the brilliant blues of winter— *River Run*, and for a brochure that appeared when the suite was dedicated in November 1990 he wrote: "The words to my music speak of the river—the White, the Wabash [McGarrell grew up in Indiana], the Ohio, the Mississippi—moving through the annual cycle of seasons. Or does the year drift downstream along the river bank? In any case it's all in the ride." After McGarrell retired from teaching at Washington University in St. Louis in 1994, he moved to a farmhouse in Newbury, Vermont, where he covered the four walls of his spacious dining room with delightful murals collectively titled *Redwing Stanza*, displaying all the seasons once again but in a fresh manner filled with people interacting in the foreground (plate 45).[7]

A *Four Seasons* series (1987–90) by David Campbell (b. 1936) is fascinating because his stimuli are so different from the others we have now noticed. Campbell's concerns are scientific, cerebral, and spiritual. His seasonal images show the very same field in suburban Massachusetts at four times of the year (*Summer*, plate 41). The paintings become all the more compelling when one reads his views about what he was trying to achieve.

> Because I see nature as the basis of life, it is sacred to me. Nowhere have I felt its sacredness more strongly than in the field where I painted these pictures. . . . The fact that I live in a city makes me feel especially exhilarated when I visit this field. The look of things is so thoroughly different through the seasons that my industrial home neighborhood is changeless by comparison. Important cycles other than the cycle of the seasons are recorded in the series.
>
> I long ago observed that summer cumulus clouds have the same form as

the heads of broadleaved trees. In recent years I learned that foliating trees pass into the air an enormous amount of water, which rises on heat and when meeting air that is cool enough, reconstitutes as water: clouds. The clouds resemble the trees, then, because they are made by the trees. . . .

I make discoveries in the course of painting. In the winter version it took me a while to register how the oblique light entering the woods on the right was stopped trunk by trunk and replaced by darkness as it moved to the left edge.[8]

Still other contemporary artists are attracted by landscape art as a means of envisioning seasonality. Neil Welliver has repeatedly shown the same marsh in Maine at many times of the year. During the mid-1980s a fine Canadian artist, Glenn Priestley, painted a seasonal suite from a hilltop park in his Toronto suburb, a different point of the quadrant for each season of the year. *Spring* (1984) faces east; *Winter* (1985) to the west; *Summer* (1987) to the south; and *Fall* (1988) faces north, making a 360-degree panorama. In 1990 a younger painter living in Richmond, on the James River, David Freed, designed a printed intaglio and relief (30 by 60 inches) titled *The River—One Year*. He studied the same landscape in rain and in sunlight, under clouds and in all seasons in an effort to understand its many moods. Ultimately, he was intrigued by the way that a watery landscape changed yet remained the same. During the 1990s a Massachusetts artist, Stephen Haley, created a seasonal series showing cornfields at various times of the year. And in 1999 the Museum of Fine Arts in Boston exhibited *Seasons* by Michael Masur: four semiabstract landscapes observed from his homes in Cambridge and Provincetown, Massachusetts. His work reminds one very much of Kandinsky's 1914 suite, though it is even easier to make out that he begins with the lush greens of summer and concludes with transitional tones of spring. His primary concern is with the changing atmospheric effects revealed in the landscape at seasonal intervals.[9]

We observe, then, how many different approaches have recently been employed to explore ways of representing the changing seasons at diverse American locales. The artists have intimate personal relationships with all of these locales but quite varied purposes in undertaking the projects depicting them. There will be elements of landscape in some works among the next group to be considered—life cycle responses—just as Altman and Chagall, while creating landscapes, were certainly not oblivious to parallels between seasonal change and the human life cycle.

Life Cycle Responses, ca. 1977–1996

The appeal of connecting the seasonal sequence with the human life cycle has been evident for centuries; and given the personal subjectivity so characteristic

of modernism, it is not surprising that links between the two persist into our own time. We will consider five cases, four of them quite important—major works. The first, the least familiar, was most likely meant by a well-known artist as a kind of jeu d'esprit, an intimate work to record for himself and a few friends the great love of his later years. Paul Cadmus (1904–99), a superb draftsman whose social iconoclasm has been apparent in his art ever since the early 1930s, never made a secret of his homosexuality, but neither did he flaunt it. In 1964 he met a singer and actor named Jon Anderson and was smitten by his blonde good looks and remarkable physique. They became lovers, and Anderson would be the inspiration for numerous paintings and drawings by Cadmus. Between 1977 and 1985 Anderson served as the model for a seasonal suite of paintings. In winter Anderson is warming himself in front of a blazing fire, wearing only socks. For autumn he wears jeans and reclines on his back during a break from harvesting work. For summer Anderson is shown emerging from a dip in a stream, displaying his lithe body with full frontal nudity. And for *Spring: Cleaning* he is on his hands and knees using a vacuum cleaner whose very long hose serves to call our attention to Anderson's penis, which we must imagine because we cannot quite see it. In a second version of winter the model lies on his back on a sheepskin rug before an open, warm woodstove, fondling a furry kitten (plate 35). Because the model's age does not change, the cycle is really one of labor and leisure during the course of a year.[10]

Jasper Johns (b. 1930) painted the best-known set of the seasons created by any contemporary artist, and the one most clearly tied to the painter's own life cycle. After completing his *Seasons* quartet of large works done with encaustic on canvas in 1986–87, Johns subsequently made limited edition prints of them in 1988–89 and in 1990 took elements from all four in order to create a cruciform version of the seasons (etching and aquatint in a limited edition of fifty) that is more suggestive of their cyclical nature, eliminating any beginning or ending (figure 2). It is noteworthy that Johns did not set out to create a four seasons suite. In 1985 the Arion Press invited him to illustrate a special edition of Wallace Stevens's poems. Having just completed a painting that he called *Summer*, he decided to make an etching based upon it for the frontispiece of the book. In rereading Stevens's poetry Johns was especially intrigued by "The Snow Man," and only then conceived the idea of making a complete seasonal sequence. The *Winter* panel includes an image of a snowman that explicitly evokes Stevens's poem. His *Summer* had actually been inspired by a Picasso painting, *Minotaur Moving His House* (1936), which became meaningful to Johns because in 1985 he was in the process of moving his studio from Stony Point, New York, to a townhouse in midtown Manhattan.[11]

The series is subtly autobiographical, and Johns devised a clever surrogate for something like a self-portrait. He had a friend trace his own full-length shadow, and that cut-out gray outline of a man dominates all four pictures.

Hence the delicious irony that Johns's self-portrait was "painted" for his *Seasons* by someone else! As critic Barbara Rose has put it, the shadow is a "featureless spirit, ethereal and evanescent in comparison with Picasso's lusty minotaur so that Johns's quasi-transparent shadow is a poignant self-portrait of the artist who cannot be distinguished from his art, whose figure literally merges with his works." The shadow appears whole in all but *Autumn*, where it is divided vertically, with roughly half on either side of the panel: a divided self. This is the only one of the quartet that Johns has kept for his personal collection because he was in the autumn of his life when he created them. *Autumn* also has in the very center a partially obscured skull and crossbones, above which are the words "chute de glace," the phrase one encounters in the Alps to warn skiers of dangerous slippery spots or possible avalanches. Midlife can be a treacherous time. All four images contain a ladder, yet another emblem borrowed from Picasso's painting, but in *Autumn* the ladder is most prominently broken in half. Whether the ladder represents an admonition about ambition or simply the trickiness of making a successful transition, its symbolism is striking.[12]

In *Spring* a silhouette of a boy appears beneath the shadow, along with an array of emblems that initiate a reprise of Johns's artistic career: a favorite vase that is also an optical illusion for two royal faces in profile; cross-hatching that characterized a major phase of Johns's career after he had exhausted American flags and maps of the United States; a circle with an arm and hand that shifts to a different position on an imagined clock face with each season (the passage of time); and considerable rain in diagonals across the picture as an explicit invocation of spring. The arm (with a hole through the hand, like stigmata) reaching for help also invokes the memory of Hart Crane, a troubled poet (much admired by Johns) who committed suicide by drowning in 1932. Some six years before his death Crane wrote as the fourth and closing stanza in a poem titled "At Melville's Tomb":

> Compass, quadrant and sextant contrive
> No farther tides . . . High in the azure steeps
> Monody shall not wake the mariner.
> This fabulous shadow only the sea keeps.[13]

We should also note, perhaps, that the hand is a left hand, an unclean hand, the hand that one never extends in many parts of the world because it is the hand traditionally used for dealing with waste.

In *Summer* (plate 38) the shadow is more complete than in the other three paintings and has a certain solidity that is lacking in them. It is less ethereal here, a genuine summertime shadow. In addition to the cross-hatching, extended arm, and unbroken ladder, there are even more emblems of artistic retrospection: two American flags, an image of the Mona Lisa by Leonardo, and, prominent in the center, a sea horse, a species in which the male carries the

newborn offspring in a pouch, perhaps a symbol in some sense for an unusual reversal of sex roles. In all four seasons the shadow has a twig at the level of its head. In *Spring* the twig has buds, in *Summer* there are new green leaves, in *Fall* it is leafless and broken, and in *Winter* it is covered with snow. In all of the images the various works of art that are incorporated are suggestively tied to the ladder (necessary both for moving one's studio and for climbing to success), but the rope that secures objects to the ladder is taut in every panel except *Fall*, in which it is slack, perhaps indicating that the art itself is insecurely situated. The paradox, of course, is that by this stage in Johns's meteoric career, his art was anything but insecure. The media doted on him with a burst of laudatory essays in 1987–88, and when *Winter* was sold at auction by Sotheby's in 1995, it commanded a price of $3,082,500.[14]

Given all of the analytical attention that Johns's *Seasons* have received, there is rich irony as well as indirection in an interview recorded by art historian Paul Taylor. Their interchange indicates not only the vagaries that can underlie the production of important art, but also the inclination of *some* major artists to be laconic—almost vexingly enigmatic—about their work. The qualities that Taylor ascribes to the series are very widely accepted as valid, almost self-evident; but in the interview Johns keeps his own counsel, and his cards quite close to his chest.

PT: In these works you embarked on a narrative series for the first time. Up to that point your work seems distinctly antinarrative.

JJ: There had to be four things that were related.

PT: But this was a sequence, a temporal sequence, such as you find in narrative art, in fiction, and so forth. That's a change for you, because your earlier images were so emblematic.

JJ: Well it's just the convention of that subject, isn't it? It's the seasons.

PT: Why did you introduce autobiography into your paintings?

JJ: They're not particularly autobiographical. Where is the autobiography?

PT: The different paintings pertain to particular stages of your life and artistic career.

JJ: That's just a kind of cliché tradition representing the seasons, isn't it? What would you do?

PT: The incorporation of flags, *Mona Lisa*, cross-hatching, and other motifs from your earlier work all suggest that you're narrating a form of autobiography. I wonder if you're telling the story of your own development by incorporating these elements into your work.

JJ: But I don't see that it tells of any development. That's the point that I'm makng. I don't really see that it's a narrative, in that I don't see what it narrates—unless you think that the representation of the seasons is in itself a narrative. I don't see it that way. In a sense none

of it represents me. And, in a sense, all of it represents me. It's like any other painting in that respect. You can say it does, or you can say it doesn't.[15]

An astute French critic, writing in response to the display of Johns's *Seasons* at the 1988 Venice Biennale, may pertinently have the last word here. "Johns in his turn," wrote Georges Boudaille, "practises these veiled allusions to masterpieces from the past, but so secretly that his viewer has to question them. Is he playing some kind of game in which the viewer has to guess where these mysterious signs come from? Does he prefer to hide them in order to better excite the art lover's curiosity?"[16]

In 1985 Thomas Cornell (b. 1937) received a commission from the John Hancock Mutual Life Insurance Company to create a four seasons suite to hang in their corporate headquarters building in Boston. In that phase of his career as an artist, Cornell had adopted a pastoral style that highlighted lyrical celebrations of life and nature. He sought to create images of people so beautiful that they would inspire viewers actually to change their lives. Appreciation of his *Four Seasons* (1986) is fairly uncomplicated when compared with the necessity of getting around Johns's exasperating reticence, and yet Cornell manages to combine tradition with innovation in terms of the long history of this genre. He has small children playing in springtime and families enjoying leisure in summer, both visions unsurprising and unexceptional. But for *Fall* (plate 39) he breaks with tradition through a graceful scene of courtship and young love, a motif normally reserved for spring or summer at the latest. And he saves for *Winter* (figure 60) an image that seems in keeping with his sponsor's business: an elderly couple look back and survey their past in a landscape of the life cycle in the mind's eye. It seems to ask, "Did we plan and prepare adequately for our golden years?"[17]

Instructive here are extracts from what Cornell has said about his own work and what an appreciative observer has written. First Cornell: "Fundamental to all my work is the concrete measurement of Nature—my experience and memory of its material form and its morphology. When I am moved to open my eyes to see through faulty conceptions to a new vision my work is inventive, and the viewer can take pleasure in recapitulating and evaluating the quality and process of pictorial thinking—careful composition of the perception of Nature." Next the observer, Martica Sawin: Cornell's *Four Seasons* "breaks a number of unspoken present-day taboos. The shock is not in the juxtaposition of the naked and the clothed that disturbed Manet's public, rather it is in the seriousness with which a harmony of human relationships is portrayed, the high-key color that radiates optimism and well-being, and most of all, a genuine humanism that harks back to the Renaissance."[18]

Exactly when Cornell and Johns were working on their seasonal suites, Rob-

ert Jessup (b. 1952) was also creating one, quite unaware of what his contemporaries were up to and influenced, if at all, by his knowledge of work done in this genre during the Renaissance. He brings far more fantasy and sheer inventiveness to his colorful and vigorously dimensional work. He regards painting as performance—"a nostalgic clinging to selfhood," as he puts it—and he favors the use of iconoclastic children (literally destructive) or else young-at-heart adults for his *Four Seasons*. Despite the influence of early modern Old Masters in his art, he breaks with tradition by beginning his series with *Fall* (plate 40), and his own explanation for this choice is intriguing.

> Normally, when the seasons are used as an allegory of the stages of life, the first season is spring and the last is winter. However, in my earliest thoughts about these paintings, I knew I didn't want my series to end in the image of winter and that spring would be more about procreation than birth. No, it

was in the fall that I first put sizing and paint to one of the big canvases and it would be *Fall*, with its associated reflections and forebodings about the passage of time and life, that would be the first image of the four. (Nor is this so unusual for, after all, our academic and cultural calendars also begin with fall.) I then saw that *Winter* would be an image of harshness and battle while *Spring* must be a scherzo both sensual and foolish.

When Jessup had a major exhibition at Richmond and Charlottesville in 1989, one curator declared that "in *The Four Seasons* he based the spatial recession on Renaissance painting, to create a stage big enough for his world dramas. In doing so, however, he felt that he had sacrificed lateral space and thereby diffused the compositional tension."[19]

We have one more modern artist to consider in the life-cycle category, and once again the first response that comes to mind is diversity. Not only is Lisa Zwerling's work radically different from that of other four seasons artists, past as well as present—she concentrates her *Four Seasons* suite entirely upon one of the conventional stages, courtship—but she makes it so in two unconventional ways: by highlighting her fascination with the bodies of wild animals in juxtaposition to the human form, and by placing the consummation of courtship in a season that no other artist has, to the best of my knowledge—outside in winter, coupling bare naked in the snow! So her theme is not merely courtship, but its own phased rhythms: longing and risk-taking in springtime, separation and frustration in summer, an apparent impasse in autumn (plate 46), and finally fulfillment in winter. These very large paintings (seven and a half feet high by six feet wide) are titled *Spring Comet* (1994), *Summer Sentinel* (1994), *Fall Flight* (1995), and *Winter Passion* (1996). Among the several critics who have written about this series, I find the comments of Donald Kuspit most provocative, even while acknowledging that the images lend themselves to multiple meanings, which I regard as essential to a truly stimulating artist.

> I think Zwerling's *The Four Seasons* are feminist in import. They are a critique of the myth of ideal love between man and woman. She sets them in an ideal landscape, a kind of garden of paradise—every season has its own beauty for her—and shows that, under even the most perfect of conditions, their relationship doesn't work, except transiently, on the most physical level. Indeed, the seasons convey transience as well as inevitability: Zwerling is telling us that love is inevitably transient. Even when man and woman are in a state of nature—naked, and thus unimpeded by society—they cannot really get together. Romance is not what it seems: there is always an element of violence in it—undermining it from within.[20]

When the Frye Art Museum in Seattle provided this suite with a superbly dramatic setting in 2000, Zwerling addressed a gathering there, and it seems

(opposite)
FIGURE 60
Thomas Cornell, Winter *from* The Four Seasons *(1986), oil on canvas. Portland Museum of Art, Maine. Gift of John Hancock Mutual Life Insurance Company, 1992.36. Photograph by Dennis Griggs.*

appropriate to let her elaborate on a project that she had envisioned for twenty years.

> The project waited in my brain until I realized my growing dreams of making landscapes speak as potently about the human condition as any figure or face. I have always maintained that my pictures are not narratives—rather something seems to be happening, but you don't have to figure out what: they are meant to evoke a feeling, not a story. . . . [the first two compositions were suggested by the dreams of friends]. In *Fall Flight* the couple is thrust into the trees—a compositional challenge since in the two previous seasons the people are at the bottom of the canvas. While he clings to the tree, she dares to attempt flight. Being a woman painter, the hero of my work is always a heroine. The title *Fall Flight* combines the idea that fall is autumn, but also, a fall is what might happen if you attempt to fly. In *Winter Passion* the couple finally gets together and heats up. But relationships are still a duality of fire and ice, intimacy and a withdrawal from intimacy.[21]

Symbolic Serialism as a Structured Response to a Disorderly World

Representational and symbolic serialism lies behind the work of several contemporary painters who have turned to the four seasons motif. For a number of creative individuals, making serial art and decorative objects satisfies some imperative not clearly connected with landscape, or the human life cycle, or the urban realities that will be the focus of the following section.

In 1967, for example, Will Barnet (b. 1911) painted a quartet in oil that he called *Silent Seasons*. He clearly found his creation pleasing because he promptly made a screen-print version in an edition of 100 copies. His subject was deceptively simple. Using his teenage daughter as a model, he pictured her in contemplative poses, with books and an apple for autumn (figure 61); knitting needles, thread, and wool for winter; and listening to a record and sniffing a fresh flower for spring—all in soft, quiet colors, and always with the family's pet parrot close at hand but in different positions and changing attitudes. *Summer* (plate 33), where the girl blithely blows bubbles, stands out because in the screen-print series it is a riot of colorful greens, reds, and yellows. Its very intensity makes the other three seem all the more meditative, cool, and calm. The other images comprise a fairly subdued trio of seasons with the suggestion, perhaps, that the intense heat from a fourth season is almost too potent to overcome inertia. As an artist of many moods, and one who experimented with varied modes of painting, Barnet has presented what critic Robert Doty describes as an "unchanging structure . . . the architectural form of a window and a table. The window is a source of light from the world beyond, indicated by a tree glimpsed through the window. . . . The variations in activity, objects, and

FIGURE 61
Will Barnet, Silent Seasons—Fall *(1967), oil on canvas.*
Whitney Museum of American Art, New York.
Purchase, with funds from Mr. and Mrs. Daniel H. Silberberg.
Photograph by Geoffrey Clements.

color within each of the four pictures in the series denotes the passage of time and the emotional impact of the seasonal shifts in light and atmosphere throughout the cycle of a year." Let's call this representational serialism with a deliberate seasonal digression.[22]

Distinctive and stunning contemporary examples of serial seasonalism can also be found in the decorative arts. In the early 1980s, for example, William Harper, a highly skilled enamelist and jewel craftsman, created a toasting goblet made of silver, gold, and cloisonné enamel with four interchangeable enamel trivets representing the four seasons (plate 37). An imaginative viewer may find Harper's self-portrait within several of the beads that decorate the bowl of the goblet. He seemed to be rejecting the notion that one "seasonal size" fits all, and proposing instead that, if you could afford such an object, you should make your toasts with a seasonally appropriate symbol and signifier at hand.[23] One would like to have something worthy of such a toast in each season of the year!

In 1999 Thomas Buechner, a skilled glassblower raised and trained in the Steuben glass tradition at Corning, New York, fashioned a set of four elegant, leaded-glass perfume bottles, with an appropriately seasonal color and motif marking each one (plate 48): newly minted green leaves on a tender tree for spring, cattails on a blue pond under a brilliant sunset for summer, colorfully variegated autumn leaves beneath wind-whipped wispy clouds, and finally a snow-covered tree for winter. These lovely objects do not qualify as practical or particularly useful. Their raison d'être is sheer beauty with a touch of whimsy, and their inspiration is quite simply the serial nature of seasonal change.

The words "serialism" and "seriality" often arise in discussions concerning the art of a creative painter and printmaker from California, Jennifer Bartlett (b. 1941). In 1990 the Seibu Department Store in Tokyo commissioned her to paint a suite of four seasons in oil. She promptly did so in a big way—each one is six feet square—after which she made yet another set, quite similar, in four-foot squares. She then proceeded in a more leisurely (in fact, literally seasonal) fashion to make silkscreen prints closely based upon the oils: *Autumn* in the fall of 1990, *Winter* early the next year, *Spring* in the spring of 1992, and *Summer* (plate 43) during the summer of 1993. Because they are closely based upon the originals, the screen prints are heavily layered and impastoed, so that they have the look and feel of paint. From Bartlett's perspective, however, they are completely new fabrications, built up with layer upon layer of pigments using a technique quite different from that employed in the paintings.[24]

We know that Bartlett was moved by the seasonal poems of Wallace Stevens as well as by Jasper Johns's *Seasons* of 1986–87, and that she is engaged by the social desire for order (hence her patterned serialism) despite the perceived inevitability of disorder in the world, often bordering on chaos. She finds chaos theory in the realm of physics fully logical and would push its larger implica-

tions beyond the realm of natural science. She observed in an interview just when she was making her *Four Seasons*, "I'm always interested in the concept of order and disorder. Perfect order always seems to be a momentary thing which you can only get in a flash." Hence the deliberate, carefully planned disorder in her seasonal squares. As one critic has commented: "The most striking feature of the entire project is the puzzling and disjunctive variety of objects that populate—often awkwardly—the settings. Some of these motifs are constant and appear in almost every frame: a female skeleton, a mysterious red box, four plaids, four pots or bowls, playing cards and or dominoes, and ceramic tiles. Others are variable entities: climatic conditions, an abundance of flora and fauna, child-like squiggles, an emblem for the points of the compass . . . and handprints."[25] Because the pieces in Bartlett's *Four Seasons* are filled with such an eclectic array of objects as repetitive motifs, devising and releasing some sense of order seems to be the primary challenge offered to the viewer. Life and the seasons are both complex, and consequently so is Bartlett's vision of their embodiment in art. The contrast with the serenity and simplicity of Will Barnet's *Silent Seasons* could not be more striking, reaffirming that diversity is the most notable quality of contemporary art devoted to the seasons.

Having acknowledged the presence of numerous objects and elements in Bartlett's *Four Seasons*, amounting to what even her admirers call "clutter," I must add that I find the works extremely attractive and appealing. The colors are vivid and lively. The objects have not been randomly placed, and the intentional echoes of other artists working in this genre are fun to find: a hand that appears recurrently is a direct reminder of the Hart Crane hand from Jasper Johns's work, except that it is always a right hand rather than a left. The mysterious red box (sort of a small chest, actually) changes its hue with each season. The flowers present in *Spring* through *Autumn* are perfectly complemented by flowerlike snowflakes in *Winter*. And the atmospheric conditions are not subtly suggested the way they are in Monet's *Wheatstacks*; they are virtually self-evident: rain is making the flowers grow joyously in *Spring*; puffy clouds and a trio of aces suggest that *Summer* holds a very strong hand (the physical hand is blue), though three cards lying face down add an element of mystery about what lurks beneath summer's apparent strength; the skeleton, which is shadowy in spring and lying in repose during summer, becomes upright and ominous in autumn; and the dominoes that first appear in autumn, configured end to end like a question mark, drop to the bottom in winter, partially obscured by three very large white flowers growing on vigorous stems in defiance of the season supposedly inhospitable to flowers. Indeed, they seem to be flourishing, which is exactly the impression that one takes away from the suite as a whole. Bartlett's seasonal set is playfully subtle, but hardly incomprehensible.

Anne Abrons (b. 1950), who lives and works in lower Manhattan, first painted a four seasons quartet in 1982–83 in an unusual horizontal format of 20 by 60 inches. The paintings were experimental but initiated an engagement with the motif that Abrons has developed in different ways for two decades now. She also combined four seasons in a single allegorical painting by creating a full-length nude self-portrait (plate 36). Her retrospective reflections (presented in her distinctive style of exposition) explain her outlook memorably:

> in a way painting the seasons is a form of self portrait—and i've done a lot of those too. . . . there is also definitely an urban connection. living in the city makes me feel an urgency about connecting to nature. as does the general climate of disconnection we live in. . . .
>
> in october of 81 (amy [her daughter] was born in april 81) i did a still life—an allegory of persephone. 6 months later in june 82 came the self portrait allegory of the 4 seasons. and by early september 82 i was doing the still life, summer, the first in a series consciously titled 4 seasons. although I've only done 4 sets titled the seasons, much of my work reflects the seasons either because of still life subject matter choice or because i prefer to work from natural light. . . .
>
> a woman's body is like the seasons. there is a growing time which includes a blooming period. then comes a producing time which can or cannot be fruitful depending on choice and circumstances, followed by the inevitable withering period and then death.
>
> When i painted allegory [plate 36] I was in my producing season—i'm standing in the studio naked, my toe nails painted red. my spring was over—there are petals fallen on the floor from the bouquet i'm holding, and i know that fall is coming from the wreath of dried leaves and vines that encircle my head. death, as ever, guides me. it is almost like my unconscious—the thoughts of my deathbed do haunt me—will i have regrets, feel that i worked enough, made enough progress contributed enough loved enough. . . .[26]

Early in 1990 the Michael Walls Gallery in Greenwich Village, knowing of Abrons's fascination with the seasonal motif, invited her and her artist husband, David Sharpe (b. 1947), each to paint a set of the seasons, which they proceeded to do in the apartment and studio that they share at the south end of Chelsea. The eight panels, roughly 48 by 60 inches for her and 50 by 70 for him, were exhibited together by Walls in March 1992. They were cleverly hung with the two winter scenes side by side because a sliver of Sharpe's *Winter* could be seen in Abrons's. Their styles are very different and therefore engagingly complementary to each other: Abrons's being more formal or figurally traditional, with carefully selected objects, Sharpe's being deliberately casual,

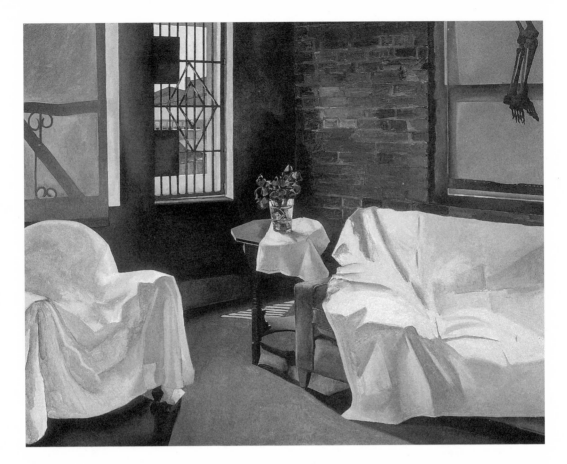

almost childlike and intensely colorful. Her *Spring* features flowers and vegetables on a table, while *Summer* (figure 62) shows the living room chairs all covered, because the couple usually went away to escape the city heat. Her "pet" skeleton hangs from the ceiling. *Autumn* displays fruits and vegetables of the season.[27]

FIGURE 62
Anne Abrons,
Summer
(1991),
oil on canvas.
Collection of
the artist.

Whereas all of the images in Abrons's suite are interior scenes, all of Sharpe's show outdoor locations somewhere in the neighborhood of their studio. *Autumn* is a brightly colored vision of Washington Square Park; *Winter* shows their young daughters trudging home from school on a rather snowy Eleventh Street, passing the site of the old Sephardic Jewish graveyard. *Spring* presents a cheerful Korean fruit and vegetable stand on Sixth Avenue with many wares well displayed. *Summer* is most emblematic of genre innovation, titled *The Gleaners* (plate 42) and showing trash being collected and loaded onto a big truck in the middle of Fifteenth Street—making for a kind of droll update of Pieter Bruegel's *The Wheat Harvest (The Harvesters)* from 1565 (plate 3). Although their actual subject matter, urban exteriors and interiors, indicates a very marked departure from traditional (as well as other recent) ways of presenting the four seasons, Abrons and Sharpe scrupulously did what many art-

Contemporary American Art and Poetry 257

ists had been doing for centuries, dating back to those floral still life paintings by Dutch masters in which each flower is painted when fresh in its own season, the sign of natural authenticity. Abrons and Sharpe painted their suites over a calendar year, between November 1990 and August 1991.[28]

Nor did they abandon the motif even then, although various other projects intervened for each of them. In the winter of 1996–97 they received a commission to paint several four seasons suites on eight doors in a duplex apartment on the South Side of Chicago. Their distinctive styles are immediately recognizable. Some of the door panels are whimsical; others are more meditative. Abrons's continue to be interiors and Sharpe's exteriors. Some panels are divided into quadrants, while narrow doors simply have one season high and the other placed low. Sometimes they collaborated on a given door, each one contributing a panel, while at other times they had their own respective doors on which to work. Nudes, skulls, summer games, and lovely still lifes proliferate on the insides as well as the outsides of the various doors. This clearly became an intensely engaging as well as amusing collaboration—receiving free rein to literally fill a household frequently peopled with guests with their signature styles and favorite motifs. The project required nine months because once again each painting was done in its own season. Near the end of the 1990s, Abrons found yet another way to fulfill her quest for a seasonal aesthetic: by means of full-body portraiture. A male model posed for her, wearing only khakis for fall, complete cold weather regalia for winter (with four of David's paintings on the studio wall as background), a colorful shirt and shorts for spring, and nothing at all (seated on top of a ladder) for summer. The suite is simply titled *Model in the Studio* (1997–98).[29]

The Four Seasons by Rome-based Cy Twombly (b. 1928) could not be more different in style, tone, and texture. Painted in 1993–94 and given to the Museum of Modern Art by Twombly, they are undoubtedly the most enigmatic of all the series we have been considering. I have placed them in the "urban" category because Twombly has lived in Rome since the later 1950s, and there seem to be numerous allusions in these paintings to the ancient as well as the modern city. They could certainly qualify just as easily under the rubric of symbolic serialism. In any case, the critics have differed in their assessments. Kirk Varnedoe is clearly the most appreciative, and his descriptive observations convey a clear sense of what the suite is like.

> [Twombly] thinks of the series as beginning not with the fresh promises of April, but with the richer mellowness of October; the deep reds and purples of the *Autumn* canvas, and its outpouring of energy, resonate with the intoxication of the yearly wine festivals at Bassano [Italy], where the series was initiated. The panels *Winter* and *Spring* both continue the motif of the "ship" from previous Gaeta canvases, but each in a sharply separate spirit:

somber, in the deep black, chilly white washes and stately, tough rhythms of the former, densely layered with lines of poetry from Seferis; more soaring and open, with brighter space and warmer hue, in the latter. Flowers and sun-warmed lyricism naturally attend *Spring*, but Twombly has also been reflecting on Stravinsky's *Rite of Spring*, and its reflections of more rasping sharpness, in his choice of color combinations. *Summer* is the most purely abstract and most liquid of these tall . . . canvases. An image of engulfing heat, it sets notes of fiery red within a field of humid, dripping yellows and whites—evoking, by a Turner-like density of water-laden atmosphere, the lassitude of torrid days beside a sun-dazzled sea. The subject of the seasons' cycle is, of course, traditionally associated with quiescent or even melancholic retrospect; but the grand scale and ambition of these canvases speak more forcefully of new confidence and freedom—savoring the pleasures and mournfulness of each part of the turning year, but drawing special energy of renewal from the season of Silenus, heady with autumn's deepened wine and the sustenance of the harvest already gathered.[30]

The reaction of critic Jed Perl, which is closer to my own, was less enthusiastic. He found the series lyrical yet deeply ironic about its own lyricism. The large expanses of empty white canvas, he commented, offered the feeling of being grounded in the white marble landscape of classical legend (a standard trope for Twombly). Perl concluded that "the work doesn't take off," that Twombly attempted color combinations "that are really beyond him," that he scribbled too many words in a handwriting almost impossible to read, creating the feeling of incomprehensible Delphic pronouncements. Ultimately, perhaps, Twombly seemed to be "a Dadaist in Classicist's clothing."[31]

Finally, an urban response to seasonal change appears in the work of a Spanish artist named Felix de la Concha (b. 1962) who moved to Columbus, Ohio, in the fall of 1995. He promptly planted his easel out of doors in his own Harrison West neighborhood at the corner of Michigan and West Second Avenue to begin a work, *One Season from Each Corner* (plate 47), like no other in the entire four seasons genre. What he did was to systematically survey the scene from all four corners during every season in eight contiguous views, making for a total of thirty-two canvases in all. When the series was installed and opened for exhibition at the Columbus Museum of Art in May 1998, de la Concha ended his introductory essay to the brochure for that extended project and another work (*Gates of Darkness As Mirrors of Light*) by saying: "For some cultures the natural year begins in spring, when nature awakens. I painted the series at a frenetic pace, at this intersection of seasons when the vegetation announces its desire to revive again. And the changing light made me move from one manhole to another as if I were a piece on a giant checkerboard. Connecting dot to dot, I discovered a new design." Perhaps we might add that he captured the chang-

ing design made by seasonal light patterns on an ordinary urban neighborhood in middle America.[32]

Although the panels initially have the appearance of stark realism, when we notice that people are entirely absent and that vehicles of any kind barely appear, we begin, as the curator of twentieth-century art at the Columbus Museum observed in a press release at the time of the installation, to appreciate the conceptual virtuosity of the series and its overall rhythmic quality. Houses, hydrants, and brick streets dominate in waves of repetition with constant variations in the play of color and light. In an interview at the time of installation, de la Concha explained to a reporter that he "decided to paint on only cloudy days, so that was practically every day. I had discovered that cloudy days give you more variation in tone. It's more delicate." When it rained, he simply worked beneath an umbrella. In snow and freezing temperatures he wore a ski mask and bulky gloves. The seasons, truly plein air, in a city. Seen in its intriguing entirety, the project is highly unusual and expands our tradition in distinctive ways.[33]

Versed in the Seasons: Confessional Moods and Contemporary Poetry

Although the seasonal art of Jasper Johns and Paul Cadmus cannot be called "confessional," their four seasons suites certainly incorporated very personal aspects and allusions, as do many of the others discussed above. Some of those allusions or references we understand, while others go unnoticed or undetected. Almost from the outset of American literary culture there have been subjective connections made with the seasons. Some are actually autobiographical, while others refer to personal aspects of experience in a more generalized way. As Thoreau wrote in his journal: "Some men think that they are not well in spring, or summer, or autumn, or winter; it is only because they are not *well in* them." A generation later John Burroughs would remark that "man can have but one interest in nature, namely, to see himself reflected or interpreted there."[34]

By the 1950s and 1960s, however, a number of very notable American poets began to mine their own lives and psyches as the basis for their art, or clearly to mobilize material for that art. Poets like Robert Lowell, Anne Sexton, John Berryman, and Sylvia Plath come promptly to mind. The term "confessional" has commonly been used in discussing their work. Its application can be somewhat vague at times, but useful nonetheless.[35] Among such poets William D. Snodgrass (b. 1926) is most pertinent to our story because he made confessional poetry impressively acceptable if not exactly fashionable by the 1960s, and he did so with frequent reference to the four seasons. A highly skilled observer and reader of nature, Snodgrass (figure 63) often used the seasons to parallel the many ups and downs in his personal relationships. Not merely content

to invoke the seasons in order to create a mood, he specifically sought to come to terms with his daughter and their complex relationship through seasonal imagery—in lines like the following:

> Though trees turn bare and girls turn wives,
> We shall afford our costly seasons;
> There is a gentleness survives
> That will outspeak and has its reasons.[36]

In "Heart's Needle," the title poem of a volume for which he received the National Book Award in 1959, Snodgrass alludes to the seasons in multiple ways and for various purposes: to make different moods and emotions more vivid by giving them a degree of meteorological weight, color, or tone, and to convey ambiguity or guilt. The seasons recur in this long poem in a cyclical manner. Since he had recently remarried and had a child, his bond to a daughter by his first marriage grew tenuous because a new human cycle of relationships had begun. At issue is where that leaves the previous cycle. The first three stanzas of canto 4 illustrate the point as well as any.

> No one can tell you why
> the season will not wait;
> the night I told you I
> must leave, you wept a fearful rate
> to stay up late.
>
> Now that it's turning Fall
> we go to take our walk
> among the municipal
> flowers, to steal one off its stalk.
> to try and talk.
>
> We huff like windy giants
> scattering with our breath
> gray-headed dandelions;
> Spring is the cold wind's aftermath.
> The poet saith.[37]

Canto 5 begins with this stanza:

> Winter again and it is snowing;
> Although you are still three,
> You are already growing
> Strange to me.

A final example toward the close of canto 9:

The window's turning white.
The world moves like a diseased heart
 packed with ice and snow.
Three months now we have been apart
less than a mile. I cannot fight
 or let you go.[38]

Snodgrass's eighth volume of poetry, *Each in His Season*, received its title from its most important composition, the twenty-two-page lead poem. The pieces comprising the volume were mainly written during the 1980s and took Snodgrass into realms well beyond the confessional. Parts of "Each in His Season" first began to appear in 1990, and the complex work was published in its entirety in 1993. Vivaldi's *Four Seasons* (1726) provided Snodgrass with inspiration and the impulse to write an extended poem with musical organization and a comparable structure. Snodgrass happens to be an accomplished musician and an amateur musicologist who has often taken music as the subject matter for his poetry. In 1984 he actually made a translation of the sonnets that Vivaldi wrote to accompany his concerti, and the volume was published in an elegant edition with the Italian original and Snodgrass's English version on facing pages. There is even a brief foreword by Snodgrass explaining why he undertook the project and what he sees as its significance.[39] Here is the essence of his meticulous approach and concern: "In translating these sonnets I have tried not only to approximate the original metre and rhyme scheme but, far more important, its exact order of phrasing. Thus my lines, like their Italian counterparts, may be extracted and set at the proper places in the score. They might also be read as a part of the performance; I believe they should be."[40]

Critic and poet Fred Chappell has argued persuasively that a similar agenda underlies "Each in His Season." The major difference, Chappell notes, is the inevitable one: "The poet cannot sound instrumental music from the pages of his volume and so must supply a comparable verbal music. His ambition to write an evocative verbal music was in fact the motive that inspired the sequence."[41] The structure of the poem follows an orderly yet flexible pattern. There are four sections. "Spring Suite"

has nine cantos, "Summer Sequence" has ten, "Autumn Variations" has eight, and so does "Snow Songs."[42]

Snodgrass is clearly familiar with James Thomson's seminal work, *The Seasons*. He could hardly have missed it. Although he differs from Thomson in terms of meteorological particulars, such as the latter's sanguine vision of winter giving way graciously to spring, the two poets are consistent in one important respect: both incorporate social and moral commentary alongside their observations of nature's behavior and consequences. Winter snow, which pervades all eight sections of Part 4, becomes a trope for the loss over time of historical truth and memory. In "Spring Suite" we are told that "history sucks," and "Summer Sequence" makes reference to "the dry bones of its past," each of which foretells the persistent stress of "Snow Songs." Canto 2, for example, compares the falling brown leaves giving way to snow with the confetti of a ticker-tape parade honoring a hero who has performed some historic deed:

> Now, into a near-zero
> Visibility
> Where nothing can be
> Known sure of events,
> What with the pervasive, dense
> Smother of shredded documents.[43]

Clearly, it is not simply winter that obliterates social memory; it is the ongoing cycle of nature, the unrelenting passage of time. And in a dramatic departure from "Heart's Needle" and the confessional mode of his earlier years, "Each in His Season" becomes self-referential only in the final canto of the poem, where Snodgrass echoes the *Vanitas* motif of seventeenth-century Dutch art by conceding that even his poem will soon become "history" and therefore fall into oblivion. These are the beginning and closing lines of the poem's finale:

> Leaving the snow
> bank, your boot leaves
> a fossil print—an
> emptiness remains. Just so
> across the field you've made
> a trail of vacancies.
>
> while they last,
> these chicken scratchings hold
> the voice unspoken on
> the finished page as under
> plaster hardening,
> a fading face.[44]

Chappell demonstrates persuasively that the principal characteristics of "Each in His Season" comprise an impressive array of qualities not commonly found in a single poem: "formal virtuosity and experimentation in the pursuit of musical qualities, description of natural process and landscape, *paysage moralisé* [the countryside moralized], elegiac lament, and social satire."[45]

Admirable as the eloquence and erudition of "Each in His Season" may be, the poem's intense social criticism and concluding pessimism about what we may (or may not) hope to leave behind as our own cultural traces are not representative among recent American voices that speak of winter. Here are two others by way of conclusion. First the opening lines of a poem titled "Winter Trees" by Mary Oliver.

> First it was only the winter trees—
> their boughs eloquent at midnight
>
> with small but mortal explosions, and always a humming
> under the lashings of storm.
>
> Nights I sat at the kitchen door
> listening out into the darkness
>
> until finally spring came, and everything
> transcended. As one by one
>
> the ponds opened, took the white ice
> painfully into their dark bellies.

And then a positive prose passage from one of the best American naturalists of our time, John Janovy Jr. His vision is from the South Platte River at Ogallala: "It is the middle of the Nebraska winter as I write this, and the middle of the Nebraska winter is a time to reflect on the past and future, a time to put into a framework the events of a life, so that when the spring thaw arrives one is ready and equipped for new lessons from nature."[46]

CONCLUSION

SCIENCE AND THE SEASONS, RETROSPECTION, AND REPRISE

We have had occasion to notice now and again, particularly in chapters 4 and 5, the ambivalent responses of many naturalists to "progress." First observed as central in James Thomson's *Seasons*, that ambivalence turned to overt antimodernism in the work of writers and painters like Thoreau, Donald Grant Mitchell, Henry Beston, and Charles Burchfield. During the second quarter of the twentieth century a significant manifestation of that sentiment took the form of skepticism about excessive faith in the marvels of science and technology. Such a Pollyannaish belief increasingly seemed to divert attention from the compelling wonders of the natural world. Joseph Wood Krutch first achieved fame in 1929 when he published *The Modern Temper*, a disillusioned indictment of modern science for destroying his faith in a beneficent universe and of psychology for diminishing his belief in the nobility of mankind. Aldo Leopold's cynical reference twenty years later to "mechanized man" also speaks volumes.

Most American naturalists, however, have not been overtly hostile to the lessons that science and new ways of thinking about the seasons can impart, so we must turn our attention, if only briefly, to the role of seasonality in certain aspects of recent scientific research, and human biology in particular. Some naturalists during the past century have pleaded that seasonal observation and inquiry be made more systematic, sustained, and comprehensively informed. For them, calling attention to the "procession of the seasons" purely for aesthetic reasons and to enhance our sense of wonder was not enough. Mary Rogers Miller, for example, writing a century ago, observed that writers invariably remarked upon the waning of bird song as spring gives way to summer and beyond. Increasing silence had long been noted as a distinct marker of seasonal change. Once territories have been established and mates chosen, the great chorus grows quiet. Why, Miller wondered, didn't botanical writers who are so enthusiastic about spring flowers actually follow their life course through to late summer when they bear their "fruit"? "Their fruits are every bit as varied and often more showy than their flowers. Their ruddy or russet colors give character and spirit to the woods of early autumn, just as their delicate blos-

soms are the charm of May." More than a generation later, Edwin Way Teale would read rather widely in the biological sciences. Consequently he could inform readers about seasonal changes in the body iodine content of blood (greater in summer than in winter). I am not at all sure that such tidbits ranked very high on the list of things that readers were eager to learn, but they did inform his work every so often.[1]

Contemporary Science, Seasonality, and Human Cycles

Beginning very gradually in the 1970s, books about seasonality and biology (animal as well as human) began to appear. Well-informed and substantive in content, they aimed to provide the general reader with a clearer understanding of climate variations around the world and their consequences, seasonal rhythms within and beyond the temperate zone, patterns of migration and hibernation, and discussions of "life without seasons" as well as "the sexual seasons." By 1980 books of this sort were readily available for school use in Britain and the United States. Overall, however, they offered considerably more information about the seasonal habits of animals, fish, and birds than they did about humankind.[2] In the meanwhile, however, cutting-edge research that would significantly alter our knowledge and understanding of seasonality and its influence upon human abilities and behavior was taking place in the biological sciences. The new information began reaching the public's attention around 1990. Four examples should suffice to suggest that we are in the process of entering a new era in our thinking about seasonality and the human life cycle, with the difference that now the connection is literal rather than metaphorical. Naturalists are just beginning to take these breakthrough studies into account.

In 1990 a comprehensive report that appeared in the *Journal of Reproductive Rhythms* offered a large amount of empirical evidence showing that human fertility rates are influenced by the seasons. This in-depth, worldwide study asserted that the two most important factors affecting reproduction rates are the amount of sunlight and the temperature. Scientists responsible for the work explained that although human reproduction is far less seasonally determined than that of other creatures, it nonetheless rises and falls in distinct patterns throughout the year. The researchers acknowledged that peak fertility times vary from one latitude and climate to another and explained that discrepancies within a given geographical area can occur when people in those places are exposed to differing mixes of daylight and temperature approximating ideal conditions for human conception. Scientists who were not participants in the project generally found it persuasive. As one of them put it when interviewed, "Many studies have shown that there is an annual periodicity in reproduction among animals. What hasn't been clearly shown is that a similar phenomenon occurs in humans."[3]

The investigating team actually looked at tens of millions of birth records for 166 countries. Their data for the United States, Europe, and other nations of the temperate zone in the northern hemisphere found that there are two annual conception peaks, which remain true up to the present but were far more pronounced prior to extensive industrialization and urbanization. One spike occurs around the time of the spring equinox in March, resulting in a higher birthrate late in December and early in January. The second peak arrives in autumn, during October and November, leading to a notable increase in babies born in midsummer. The principal author of the report characterized the ideal time for conception in terms readily accessible to nonscientists: "the sort of day in spring or autumn when you have nice nights and days that are agreeable and warm."[4]

A little more than a year later, in 1991, a somewhat more surprising study was announced at a meeting of the Society for Neuroscience, building upon earlier investigations that showed male testosterone levels to be lower in the spring than in the fall. The new inquiry revealed that men seem to have better spatial perception when tested in spring and that variations in perception were linked to seasonal fluctuations in male hormones. One result showed that after puberty boys were likely to score as much as fifty points higher on math tests in spring than in fall. A follow-up profile, after many previous studies, involved seventy males and sixty-eight females, using blood and urine samples in coordination with tests of spatial and verbal skills. The women showed some seasonal variation, but the differences turned out not to be statistically significant. The leader of the research group speculated whether the fluctuation in seasonal testosterone levels might also affect other forms of behavior, such as crime and risk-taking.[5]

In 1995 a team at the clinical psychology branch of the National Institutes of Mental Health in Washington found that circadian rhythms in women, based upon the brain's production of melatonin, differed significantly from those in men. The researchers discovered that when the sun rises later and sets earlier, the amount of melatonin secreted at night increases, and in summer the production drops off—for women but not for men. As the media coverage put it, "Women were found to respond to the song of seasons but men were tone deaf." The exact consequences of that differential remain unclear, but it may very well explain why women suffer disproportionately from seasonal affective disorder, or SAD, a type of depression that strikes most often in winter. What this research group is attempting to do in the relatively fresh field of photoperiodicity in humans is ascertain the impact of day length on hormonal fluxes, sleep patterns, and behavior. They hope to measure key indices of seasonal rhythms in humans and learn when and how those measurements might change during the course of the year. What they know with assurance thus far is that women's internal clocks—the part of the brain that responds to light

and dark—keep track of the seasons and adjust melatonin output accordingly. Women receive reduced melatonin when they are less inclined to sleep anyway because the days are longer. Researchers also know that the modern schedule of work and play, with less time available for sleep for both sexes, means less production of the hormone prolactin, which is responsible for long and peaceful stretches of sleep. Thus yet another example of the very real, physiological differences between the biology of humankind before and after the onset of industrialization and urbanization.[6]

Because of a closely related study, scholars now believe that the poet Emily Dickinson very likely suffered from a mild form of manic depression (or bipolar disorder), resulting in high periods of poetic creativity coinciding with exuberant phases that bordered on mania. This report adds credibility to earlier suggestions by numerous Dickinson scholars that her mood swings fluctuated with the seasons. The more than 1,800 poems that she wrote contain many references to winter despondency and periods of heady summer enthusiasm and literary excitement. The latest, most exhaustive study of her poetry in terms of seasonal highs and lows has been made by John F. McDermott, professor of psychiatry emeritus at the University of Hawaii School of Medicine in Honolulu. What's new here is not the inference about Dickinson's temperament but the qualitative depth of the data and analysis devoted to understanding it.[7]

Continuities and Change: The More Things Change . . .

Given the importance of sun to our circadian rhythms, and more generally to the sequencing of seasonal change, the sun seems a logical place to begin our reprise of continuities and changes in human appreciation of the stimuli for seasonal realities that we live with. Although many more particulars about the physiological effects of sunlight and air temperature have been discovered in recent years, humankind has always understood that a causal relationship exists between the position of the sun and seasonal qualities. That linkage appears initially in ancient art and writing and is featured in Poussin's famous painting *A Dance to the Music of Time* (figure 15), in which Phoebus Apollo rides high in the sky in his chariot while the four seasons exult in an exuberant dance directly beneath him on earth. Virtually all American naturalists have customarily commented on the crucial role played by the sun—albeit in various ways in order to illustrate different points—ranging from Thoreau through Burroughs to Samuel Schmucker and Edwin Way Teale.[8] Hence the wonderful watercolor and gouache image by American artist Richard Pousette-Dart that he titled *Seasons of Light* (1942–43), and the centrality of sunlight in seasonal art by painters as different as Charles Burchfield and Cy Twombly.[9]

Closely related issues involve two connected questions: should literary and

artistic accounts of the seasonal year begin with winter (and more specifically January for almanac purposes) or with spring? and, then, when does spring really begin? There has been no consensus concerning the first, and responses hinge upon practical as well as aesthetic preferences. In general, I believe, there has been a shift, though not an absolute one by any means, from a European penchant for starting with winter to an American predilection, more often than not, for beginning with spring. Almost all American naturalists have been quick to acknowledge that spring arrives ever so gradually, taking one step backward for every two steps forward. That has never stopped them, of course, from overtly asking, as Thoreau did in 1853, "What is the earliest sign of spring?" On numerous occasions he noted in his journals that we simply cannot be sufficiently observant to actually capture the very moment. "No mortal is alert enough to be present at the first dawn of spring, but he will presently discover some evidence that vegetation had awaked at least some days before." John Burroughs and many others have highlighted the appearance of hepatica, spring peepers, and the hammering of woodpeckers as essential indicators. Donald Culross Peattie, committed to realism, wrote unsentimentally that the advent of spring was really not "nice." "It transpires in nakedness and candor, under high empty skies. Almost all the first buds to break their bonds send forth not leaves but frank catkins, or in the maple sheer pistil and stamen, devoid of the frilled trimmings of petals." Teale called the violet the emblem of North American spring, but like many others, he also acknowledged that the emergence of skunk cabbage was a standard indicator in woodland areas. Bernd Heinrich, writing most recently, has called attention to the changing colors of distant hills as different trees gradually unfurl buds that are shifting from brown to shades of green, russet, and deep purple. All of these are valid signals, of course, and all of the authors concede the capricious variability of spring's debut.[10]

A constant refrain throughout generations of nature writing calls attention to the migration of birds as a seasonal marker. The most common references, of course, reflect upon the return of birds early in spring, repeatedly mentioning the males' arriving ahead of the females. The more interesting discussions of bird migration mention two obviously related phenomena. The first is that when birds migrate from the south, others that have wintered in the northeast, for example, head farther north for their summer breeding places. Hence what Burroughs called "The Spring Bird Procession" in an essay actually describing "dual lane" traffic. And, second, the most thoughtful writers also make reference to the fact that migration occurs not once but twice each year, even though most people seem a little less likely to notice it in the fall, except for those who live in more rural areas and cannot miss hearing the honking of geese in ceaseless communication as their asymmetrical vees make purposeful

paths through the sky. Peattie had particularly thoughtful comments on the differences between migration at the two seasonal points of transition and our relative awareness of them.

> Dear to the wistful human heart is the return of the birds, that is like a renewal of our hopes. It is not nearly so prolonged, so sweeping as the autumnal flight, nor does it involve nearly the same numbers, since in autumn all the newborn are on the wing, while in spring many may never come back or they are seeking fresh homes. But the autumn migration is more difficult for the amateur to observe; it lacks the music and the plumage with which the army of the birds swings onto the stage in spring.

Because of the breadth of Teale's interests, we are indebted to him for going beyond the usual litany of bird migrations to mention the spectacular diversity of species that migrate in the fall, including box-elder bugs, tiger salamanders, and monarch butterflies. Moreover, Teale, Henry Beston, and above all Rachel Carson genuinely enlightened nature lovers everywhere by carefully describing the autumnal migration of eels (in Beston's case, sand eels).[11]

Thoreau's journals contain numerous references to bird migrations, as we would expect, but only Thoreau (figure 64), owing to his awareness of historical change and man's encroachment upon the natural world, provided an insight, from 1856, such as, "Many of those animal migrations . . . by which the Indians marked the season are no longer to be observed."[12]

Perhaps because summer begins and ends less dramatically than any other season—its transitions seemingly seamless—only Thoreau had the acuity to mark and describe it in truly memorable ways. His journal invariably placed the start of summer several weeks before the solstice, usually at the beginning of June when certain flowers, like the wild pink and lady's slipper, appeared in sunny places on the hillsides. His ear was just as keen as his eye for subtle changes that separated the seasons. As he observed on June 4, 1857: "One thing that chiefly distinguishes this season from three weeks ago is that fine serene undertone or earth-song, as we go by sunny brooks and hillsides, the creak of crickets, which affects our thoughts so favorably, imparting its own serenity." Two days later, however, Thoreau outdid himself with an extraordinary journal entry that bears reading and rereading.

> This is June, the month of grass and leaves. Already the aspens are trembling again, and a new summer is offered me. I feel a little fluttered in my thoughts, as if I might be too late. Each season is but an infinitesimal point. It no sooner comes than it is gone. It has no duration. It simply gives a tone and hue to my thought. Each annual phenomenon is a reminiscence and prompting. Our thoughts and sentiments answer to the revolutions of the seasons as two cog-wheels fit into each other. We are conversant with only

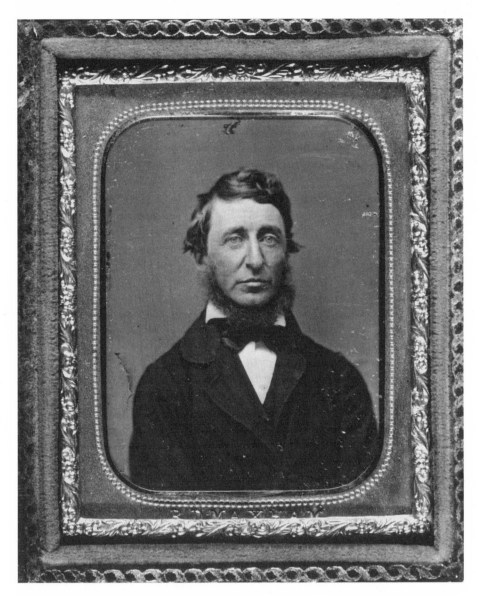

FIGURE 64
*Benjamin D.
Maxham,*
Henry David
Thoreau
*(1856),
daguerreotype.
National
Portrait
Gallery,
Smithsonian
Institution.*

one point of contact at a time, from which we receive a prompting and impulse, and instantly pass to a new season or point of contact.[13]

Thoreau noted more frequently than any other naturalist that the seasons were literally and figuratively intermingled in so many ways, especially in terms of how we think about seasons other than the one we are actually in. Here are two brief examples from his journals, both made in November. In 1850: "There seems to be in the fall a sort of attempt at spring, a rejuvenescence, as if the winter were not expected by a part of nature." And later, in 1857: "I, too, have my spring thoughts even in November." The seasons, being inherently inconsis-

tent, were not the sole and rigid determinants of his outlook. Wilson Flagg blended perception with reality in this sentence written less than two decades later: "From the beginning to the end of the month the landscape suffers a complete metamorphosis; and October may be said to represent in the successive changes of its aspect all the floral beauty of spring and summer."[14]

But in this regard Thoreau and Flagg certainly were not singular. Burroughs observed, for example, "Nature looks ahead and makes ready for the new season in the midst of the old." Teale offered comparable comments in all of his books, regardless of whether he was searching for spring in Florida or northern Vermont, autumn in Ohio, or winter in Texas. The curiosities of subseasons occurring *within* seasons never ceased to intrigue Hal Borland, and the tradition of calling that oddity to the attention of readers has persisted in *New York Times* nature editorials written by Verlyn Klinkenborg. Most recently Diane Ackerman has remarked that "the ragged interface of fall and winter (roughly overlapping November) is an entire season in itself."[15]

The seasons intermingle in two quite different ways in autumn: in physical perceptions and emotions. As for the first, Thoreau and many successors have long been fond of noting about witch-hazel that "while its leaves fall, its blossoms spring. The autumn, then, is indeed a spring. All the year is a spring."[16] For numerous writers, autumn has meant the promise of ultimate renewal and actual preparation for it. For others, however, despite their awareness that spring will eventually come, their inclination has been to speak of "autumnal desolation" and to associate the season with "melancholy," a sentiment that dates back at least to Posidinus in the fourth century. Wilson Flagg made that linkage repeatedly. In April 1902 Burroughs published a poem in *Harper's* magazine in which he emphasized at the end "autumn's frown." Edith Wharton's novel *Summer* (1917) describes a romance that covertly and charmingly blossoms in summer; but when high winds strip the trees of their leaves, the "midsummer radiance" of love is dissipated in the "dark autumn twilight." Finally, when Teale wrote *Autumn Across America* (1956), he chose to include a quotation from Thomas Hardy's seasonal novel, *Under the Greenwood Tree* (1872): "Give me the roughest of spring days rather than the loveliest of autumn days for there is death in the air."[17]

Noticing the Nuances of Seasonal Variability

These ambivalent responses to autumn (and to winter, as well) are significant because they suggest that "moderns" (for our purposes, people living since the later eighteenth century) are more inclined to acknowledge seasonal unpredictability than were the "ancients" before them. Literary historian Lawrence Buell has asserted that Thoreau was the first Anglo-American writer to rigorously question seasonal categorization. Others have also correctly suggested

that Thoreau challenged the traditional notion of the seasons as a symmetrical and predictable "grid" without abandoning the idea of seasonality itself, which always remained immensely important to him. Whatever his successors in the American line that we have been tracing may have felt about other aspects of Thoreau's thinking as a nature writer, they routinely agreed with him in this regard. Noting that severe and mild winters had alternated in 1873 and 1874, John Burroughs developed the point at length in an essay titled "Spring Relish," observing that "all signs and phases of life in the early season are very capricious, and are earlier or later, just as some local or exceptional circumstance favors or hinders." Later he asked more broadly and bluntly, "Who shall say when one season ends and another begins?" Frances Parsons flatly declared in 1894 that "our seasons vary from year to year."[18]

With the remarkable cohort of nature writers active from the 1940s through the 1970s, this insistence upon unpredictability becomes more than a mantra. It had evolved into a positive source of pleasure because the anticipation that arises from not knowing quite what to expect, or when, makes nature at once more mysterious and more interesting. As Aldo Leopold remarked, in autumn "the robin is silent, and it is quite unpredictable whether the covey chorus will occur at all. The disappointment I feel on these mornings of silence perhaps shows that things hoped for have a higher value than things assured." Hal Borland felt so strongly about the foolishness of relying upon a seasonal "grid" that he wrote a lengthy essay on the subject in 1963 and reprinted it six years later. "The seasons as we have charted them," he insisted, "are close to ultimate error and actually violate the solstices and equinoxes more often than they abide by them; but we know that winter doesn't wait on the winter solstice, and that the spring equinox isn't going to open apple blossoms the next day."[19]

Precisely because American nature writers believed that the seasons, the weather, and everything they determined were so variable, they constantly reiterated that behavioral repetition was essential to sound observation and understanding. Burroughs put it this way: "The walk to take today is the walk you took yesterday. You will not find just the same things: both the observed and the observer have changed." Three quarters of a century later, all that had altered was the mode of travel: "Not that we mind particularly taking the same drive twice," remarked Fredric Klees, "for a change in weather or in the season makes the road seem almost new."[20]

There is highly suggestive evidence, however, that when Americans who have taken seasonality for granted find themselves in unfamiliar (and especially what they regard as exotic) places, they become inclined to "chart" the seasons and their "deviations" in the new environment in ways that would never have occurred to them "at home." That happened when the Reverend William E. Griffis went to Japan as a missionary during the 1870s, but also when Americans were sent to Vietnam a century later. In Tim O'Brien's prize-winning

novel, *Going After Cacciato* (1977), one of his characters contrasts the alien absence of autumn in that faraway place with all the changing aspects of the seasons that he recalls along the Des Moines River from when he made camping trips with his father, lamenting that there is "no lingering foliage. No sense of change or transition. Here there was no autumn. No leaves to turn with the turning of seasons, no seasons, no crispness in the air, no Thanksgiving and no football, nothing to gauge passage by."[21]

Beginning with Thoreau, yet again, keen observers of nature became increasingly intrigued by transitions rather than seasons at their peak, and in that respect perhaps they differed somewhat from the lay population. In his writing and tireless revising of *Walden*, Thoreau's fascination with the transition from winter to spring intensified. And during the remaining years of his life after the book appeared, Thoreau's journals reveal his steadily growing attentiveness to transitions between all of the seasons. In 1861 the artist Benjamin Champney painted a symptomatic landscape that he titled *Winter Lingering in the Lap of Spring* (figure 65), and that transitional fascination, as noted in chapter 4, was one of the great obsessions in the art of Charles Burchfield. Mabel Osgood Wright phrased it most emphatically in 1894: "Nature knows but two changes, putting forth and withdrawing, and between these there is a constant transition."[22]

Although our nature writers lacked the scientific diagnoses and designations for seasonally related illnesses, such as SAD, they have always remarked upon the relationship between seasonality, human moods, and psychological states. More specifically, they often associate certain seasons with particular abilities or strengths in terms of human performance. Wilson Flagg did so throughout his long career. He believed that spring is "the inspiring season of enterprise, rather than of poetry, as instead of telling of joys that are past [nostalgia], it unfolds the promise of future happiness. It is not the season of thought, inasmuch as it is not the occasion of melancholy and retrospection." Later, in 1875, he declared in *A Year with the Birds* that "summer is surely the season of epicurism," and in the same book, his last, he ruminated about winter, when there is no wonderful scenery to distract a person. Therefore "the mind is affected with nobler thoughts; it is less bewildered by a multitude of fascinating objects, and is more free to indulge itself in a serious train of meditation."[23]

Hal Borland perpetuated, as well as anyone among modern observers, that Thoreauvian sort of linkage between season and mood. "Periodically we have to endure the autumn and winter of the emotions, littered with disillusionment and alienation," he wrote in 1967, when American feelings were running very high because of Vietnam, civil rights, and the war on poverty, "but eventually that litter becomes the rootbed for another spring, in ourselves, and the maturity of another summer." Less than a year later, when attitudes had become especially intense because of American involvement in Southeast Asia, Borland once again invoked nature's impact without making any explicit reference to in-

ternational affairs or domestic politics. "Winter is an introspective time at best," he mused, "a season in which the ordinary follies of mankind become a burden on the conscience." What we have here, of course, from Thoreau through Flagg to Borland, is the Swedenborgian doctrine of "correspondence," originally received and promulgated by way of Emerson. Thoreau repeatedly reiterated Emerson's "Nature" in his observations concerning correspondences between seasons and the mind.[24]

Seasonal Creativity and Spheres of Civil Life

The timing of Borland's season-based observations, coming when the United States was so bitterly divided over engagement in a war halfway around the world, prompts some speculation about the frequency with which seasonal writing seems to be especially heightened during periods of political and military conflict. Virgil wrote his *Georgics* amid the chaos of civil war after the Roman Republic had collapsed, and he explicitly refers to the dark time he was living through. As one leading Virgil scholar has noted, "There was clearly need for an end to civil war if the countryside, neglected where not actually devas-

tated, was ever to recover." Bruegel painted his great seasonal suite in 1565, when the Spanish Inquisition was causing terrible strife and loss of life in the Low Countries. The proliferation of Dutch painting and engraving expressive of the four seasons flourished throughout the Thirty Years' War that ravaged Europe between 1618 and 1648.[25]

We observed in chapter 2 that four seasons art and writing became particularly prolific and intense in the United States during the years 1849–51, a period of heated sectional disputes in the wake of the Wilmot Proviso, the Compromise of 1850, and the nationwide storm that arose over litigation caused by the fugitive slave cases that led to blacks' being seized by federal marshals for return to their masters. It was a time of combative political and social animosities. We have also observed in chapter 3 the remarkable burst of seasonal writing and painting that occurred in the aftermath of the American Civil War. And there may well have been a similar impact because of World War II. That is when Aldo Leopold was writing the essays that came together in *A Sand County Almanac*. We encounter such imagery as: "Bur oaks were the shock troops sent by the invading forest to storm the prairie; fire is what they had to fight." Leopold's pines, standing "rank upon rank" like American soldiers, gave him "a curious transfusion of courage," and their vigorous growth just when the United States went to war is not incidental as a subtext for Leopold: they "made a special effort to show the world that pines still know where they are going, even though men do not." Despite the immense appeal of this book to conservationists and nature lovers, it is not generally noticed that Leopold imbued nature and the seasons with a subtle message for both nationalism and international peace. See, for instance, his reference to the "international commerce of geese" that "honked unity" for Leopold.[26]

Most of our nature writers, most of the time, have actually *not* come across to their readers as people on political or ideological missions. They are either subtly metaphorical about it, as Leopold could be, or else overtly indifferent to reform agendas, with the obvious exception of dedicated conservationists like Leopold and Carson. At the end of his famous chapter called "Economy" in *Walden*, Thoreau closed his critique of institutionalized reform by displacing it with an image of individual freedom being achieved within nature. Early in the twentieth century, when John Muir and others were engaged in a losing battle to preserve the Hetch Hetchy Valley inside Yosemite National Park from being flooded to create a reservoir that would supply San Francisco, John Burroughs wrote the following to Robert Underwood Johnson, an impassioned nature lover: "I must tell you that I can't get up any enthusiasm over Hetch Hetchy. . . . I think a lake there would be an added beauty. If the women and children of San Francisco need that water let them have it. One Yosemite is enough for all the world. Who goes to H. H. but an adventurous tourist now & then. . . . Grand scenery is going to waste in the Sierras—let's utilize some of it." Rather

shocking stuff coming from the best-known naturalist in the United States at the time.[27]

Quite a few of these writers, as we have seen, had genuine reservations about developments of all sorts that most members of society regarded as "Progress." The majority, however, liked to think of themselves as apolitical or else kept their views carefully to themselves. When Hal Borland prepared the foreword to *Homeland*, his collected seasonal essays from *The Progressive*, he explained to readers that he began writing the essays in the first place because the editor of that journal "suggested some years ago that my country-based, non-political viewpoint might be an offbeat addition to his magazine, which is primarily political and societal in its approach." To the extent that Borland considered himself a "radical," he used the word in a very different way than most Americans did during the later 1960s. "I am a man well along in his middle years," he remarked, "who, simply by living on the land and apart from the crowds, has become one of a dissenting minority. It is a rather strange feeling to be a radical, at least in the root sense, by holding to fundamentals. I feel engaged with fundamental matters, not alienated." Borland may have been a self-styled "countryman," but he was no hippie. "We are performing a rite," he concluded, "for we are participating in something far greater than ourselves. We are a part of the season, a part of time itself."[28]

Although Edwin Way Teale occasionally mentioned the importance of conservation in his seasonal books, even as early as 1953, more than one reviewer complained that Teale's work seemed to be oblivious to the politically explicit need for a wildlife preservation ethic. Annie Dillard's *Pilgrim at Tinker Creek* reads like the journal of a misanthropic biological voyeur. Not only is the book without people, it is utterly devoid of so much as a hint of any conservationist agenda. Amid all the praise that was lavished on her book, she did receive ongoing criticism for abdicating any sort of advocacy role. Her revealing self-defense appeared in a 1978 interview: "The kind of art I write is shockingly uncommitted—appallingly isolated from political, social, and economic affairs. There are lots of us here. Everybody is writing about political and social concerns. I don't. I'm not doing any harm."[29]

These widely esteemed nature writers received criticism on one other count, from a highly vocal though small minority of their readers: they were faulted for the absence of any indication of religiosity. Nature seemed to be their god, or perhaps more precisely, they seemed to practice their religion by closely observing (sometimes almost worshiping) nature, no more and no less. Even in the so-called Age of Enlightenment, James Thomson had suffused sufficient praise for God to satisfy readers that his great poem was truly a theodicy. Teale, as we have noted, received among his fan mail letters from people who enjoyed his books but complained that the Creator never received credit for the wonders that Teale enthused about. After Joseph Wood Krutch had seen the re-

views of his book *The Twelve Seasons*, he told Teale that he felt surprised that he had not received "more Catholic protest. . . . *America* [a Jesuit journal] reviewed briefly the 'Seasons' saying that though I talked a good deal about 'contemplation' I obviously knew nothing concerning true contemplation and that though I seemed to have some reverence for God's works I had none whatever for God himself." In 1967 Hal Borland received a letter from an admiring reader in Tucson who knew Krutch in his capacity as a member of the board of the Sonora Desert Museum. "I probably shouldn't say this," he wrote, "but I shall: I like your writings far better than his. He lacks all trace of spirituality or deep feeling."[30]

Almost without fail, even going back to progenitors of the genre, American nature writers have been exceedingly cautious about acknowledging a favorite season. They liked to insist, as Thoreau and Flagg did repeatedly, that nature has "nearly equalized the enjoyments of every season." Flagg asserted that trees should be closely observed during all seasons of the year, and not just for a few weeks in October. Thoreau commented in his journal for December 1856, "I love to have each thing in its season only, and enjoy doing without it at all other times." More recently, as Bernd Heinrich declared about his life in rural Maine: "Here, my favorite season is always the one I'm in." Close to the end of *Wandering Through Winter*, Teale cited the seventeenth-century English poet William Browne: "There is no season such delight can bring as summer, autumn, winter, and the spring."[31] They didn't play favorites; or if they did, perhaps most of them felt that they couldn't afford to confess it, unlike so many of the seasonal artists, who did so readily.

Only the highly urbanized American might have a different answer, and that goes to the very heart of the alienation from nature about which so many of the naturalists have expressed concern. Early in the 1970s, Duke Ellington was asked: "Do you have a favorite season of the year and, if so, what do you specially like about it?" He replied without hesitating: "Being a chronic indoorsman, it's unimaginable that I should be any sort of authority on this."[32]

Although Thoreau's *Walden* and Leopold's *Sand County Almanac* are both organized seasonally, each one contains moral messages that mattered greatly to the authors, however much both men were genuinely intrigued by seasonal change. That melding of ethical and environmental issues with an accessibly meaningful structure has been essential to the most creative and important cultural appropriations of the four seasons motif. It might be apt, therefore, to close with the most prominent link between these two great American naturalists: their shift away from a theological or an instrumental approach to the belief that nature possesses value independent of humankind's well-being. Their respective predecessors had invariably touted the aesthetic, psychological, and

spiritual significance of nature. Because nonhuman nature had intrinsic value for Thoreau and Leopold, improvements in man's ecological behavior were imperative. For that reason, in a very real sense each man looked to the past in order to contemplate the future, and each one expressed with considerable passion his concern about the need for a new land ethic. In Thoreau's case, he asserted in *Walden* that "ancient poetry and mythology suggest, at least, that husbandry was once a sacred art [he clearly had Virgil's *Georgics* in mind]; but it is pursued with irreverent haste and heedlessness by us, our object being to have large farms and large crops merely."[33]

In the autumn of 1999 the fiftieth anniversary of *A Sand County Almanac*'s publication was celebrated with rich praise, far more than it received in 1949. By the end of the century, the conservation movement had certainly come of age, and that slender book's time had most surely arrived because it had done so much to lead the way. A Klinkenborg editorial in the *New York Times* that evokes memories of Hal Borland appraised Leopold's importance in this way:

> Leopold's principal and extraordinary contribution to our world was to articulate the idea of a land ethic. The human relation to land, he wrote, "is still strictly economic, entailing privileges but not obligations." Leopold believed that the basis of successful conservation was to extend to nature the ethical sense of responsibility that humans extend to each other. This idea has acquired tremendous force since *A Sand County Almanac* first appeared. The fact that the idea now seems unexceptionable is a measure of its widespread influence.[34]

The four seasons motif, then, has been more than just a portmanteau means to achieve and disseminate certain aesthetic ends. Its appeal to many of our most engaged naturalists, painters, poets, landscape architects, and essayists has done much to enhance our sensitivity to the environment's vulnerability as well as our appreciation of how nature functions—and hence our sense of obligation that quite properly should be responsive to both. Ultimately, however, a persistent fascination with parallels between the natural world and human life cycles reveals the varied ways we have pictured and considered our very being in relation to seasonal change. The latter has not merely conditioned our material lives, but increasingly provided a metaphor through which we come to terms with our spiritual and corporeal existence.

ACKNOWLEDGMENTS

Locating and gathering the necessary materials for this project required more than the usual amount of guidance and assistance from thoughtful archivists, curators, colleagues, students, and friends. Because the book has been in gestation for many years, I know that I cannot remember everyone who has helped, but I will do my best to thank those who have played an indispensable role in making the work as inclusive in scope as it is.

Georgia B. Barnhill, the Mellon Curator of Graphic Arts at the American Antiquarian Society, sent me copies of all sorts of prints as well as leads to related visual materials that I would never have otherwise known about. Graham Hood, formerly vice-president for collections at Colonial Williamsburg, made a wonderful array of Anglo-American objects available to me from the extraordinary holdings there. Herbert I. Lazerow, inveterate French flâneur, called to my attention quite a few seasonal objects of art and architecture spotted on his strolls through Paris and its museums.

Among archivists and curators of special collections, I owe a great debt to Rutherford W. Witthus of the Thomas J. Dodd Research Center at the University of Connecticut for help in the Teale Papers; to Stephen C. Jones of the Beinecke Library at Yale for assistance with the not-yet-organized papers of Hal Borland as well as the wonderfully catalogued papers of Rachel Carson; to Linda Pero at the Rockwell Archives in the Norman Rockwell Museum, Stockbridge, Massachusetts; to Kathleen Kienholz at the American Academy of Arts and Letters; to Kenneth Maddox, historian at the Newington-Cropsey Foundation in Hastings-on-Hudson, New York; to Maja Keech, reference specialist in the Prints and Photographs Division of the Library of Congress; to Ellen Endslow at the Chester County Historical Society in Pennsylvania; and to Margaret Glover and Sharon Frost in the Division of Art, Prints and Photographs at the New York Public Library in New York City.

Richard Dressner, associate director of George Washington's Mount Vernon, made available unpublished materials concerning slaves and seasonal labor at Mount Vernon. Martha Fleischman, president of the Kennedy Galleries in New York City, led me to four seasons art that I would not have known about and most graciously made visual materials available to me. Robert V. Wells of Union College answered questions about demographics and the seasonality of marriage and births in early modern times. Michele Bogart, Anne Abrons, and David Sharpe provided insights concerning seasonal art from different perspectives, and Martin Bruegel supplied invaluable information about "deseasonalization."

At Cornell University I was fortunate to hold a fellowship at the Society for the

Humanities in the fall term of 2001 that enabled me to make considerable progress on this project and provided critical feedback from a thoughtful, lively, and diverse group of fellows. I have also received patient assistance from two considerate curators at Cornell's Herbert F. Johnson Museum of Art: Nancy Green, curator of prints and drawings, and Ellen B. Avril, curator of Asian art. Robert Dirig, assistant curator at Cornell's Bailey Hortorium, and Sherry Vance, curator of the catalogues, very kindly made the hortorium's marvelous seed catalogue collection accessible. Margaret N. Webster, director of Cornell's Visual Research Facility, was invaluable in providing me with 35mm slides. And six undergraduates who served sequentially as research aides—Alicia K. Anderson, Virginia E. Fritchey, Sara Jean Giguere, Edmee Hernandez, Ian D. McCauley, and Romy Silver—contributed substantially and tirelessly. Katie S. Kristof and Shelly Marino helped me through assorted computer crises and facilitated essential technological "assignments" with patience and good cheer. Kathryn Torgeson prepared the index with great care.

In the years 2000, 2001, and 2002, three very fine and diverse groups of Cornell undergraduates took my seminar concerning the four seasons motif and delighted me with their careful and astute readings of the materials we examined, visual as well as literary. Erica K. Anderson deserves special thanks for her meticulous work on the four seasons as a thematic trope in film, Alicia K. Anderson for her inspired investigation of seed catalogues at the Cornell Hortorium, and John T. Fitzpatrick for a remarkable comparative study of garden journals published in England and America at the turn of the century. Among my Cornell colleagues I owe a special debt to Sherman Cochran, Walter LaFeber, and Joel Porte for careful listening over the years, thoughtful responses, and passing along pertinent clippings. James Webster, of the Department of Music, kindly shared with me a harvest of his own original material concerning Haydn's great oratorio, *The Seasons*.

James A. Hijiya, Carol Kammen, Joy S. Kasson, and Alicia Anderson read the entire manuscript with meticulous and critical care; Finis Dunaway and Mary Norman Woods read extensive segments with equal care; and they all provided candid, constructive feedback, for which I am deeply grateful. At the University of North Carolina Press I have been the beneficiary of superb editorial skills, guidance, and friendship on the part of Sian Hunter and Ron Maner, along with a wonderfully supportive "team" that includes Director Kate Torrey, David Perry, and Kathy Ketterman.

Carol Kammen has lived with this project for almost as long as I have, and along the way supplied abundant leads, sage advice, constructive criticism, and general concern about my own well-being as well as the book's. I could not have brought it to completion without her.

Above Cayuga's Waters
Michael Kammen

NOTES

Abbreviations

ALUVA Alderman Library, University of Virginia, Charlottesville

BLYU Beinecke Library, Yale University, New Haven, Conn.

CW Colonial Williamsburg, Inc., Williamsburg, Va.

DLUC Dodd Library, University of Connecticut, Storrs

ex. cat. exhibition catalogue

NYT *New York Times*

NYTBR *New York Times Book Review*

Prologue

1. John Keats, *Complete Poems*, ed. Jack Stillinger (Cambridge, Mass., 1982), 176–77. See also "To Autumn," ibid., 360–61.

2. The "topicality" phrase is from Lawrence Buell, *The Environmental Imagination: Thoreau, Nature Writing, and the Formation of American Culture* (Cambridge, Mass., 1995), 243; Annie Dillard, *Pilgrim at Tinker Creek* (1974; New York, 1999), 76.

3. John Burroughs, *Signs and Seasons* (Boston, 1914), 202–3. For a fine example of seeing one season amid another, see "Immortal Autumn" in Archibald MacLeish, *New and Collected Poems, 1917–1976* (Boston, 1976), 153.

4. Starting with *Spring*, the paintings are now located in the Louvre, Paris; the Museum of Fine Arts, Boston; the Metropolitan Museum of Art, New York City; and the National Museum of Wales, Cardiff. See André Fermigier, *Millet* (Geneva, 1991), 122–25.

5. Martin Bruegel, "How the French Learned to Eat Canned Food, 1809–1930s," in *Food Nations: Selling Taste in Consumer Societies*, ed. Warren Belasco and Philip Scranton (New York, 2002), 114; Sarah F. McMahon, "'All Things in Their Proper Season': Seasonal Rhythms of Diet in Rural New England, 1620–1840," *Agricultural History* 63 (Spring 1989): 130–51.

6. Joseph Wood Krutch, *More Lives Than One* (New York, 1962), 294–95, 331–32, and 355–57, as well as 363–64 for the growing mood of alienation; Diane Ackerman, *Cultivating Delight: A Natural History of My Garden* (New York, 2001), 7.

7. Bradford Torrey, ed., *The Writings of Henry David Thoreau: Journal* (Boston, 1906), 10:127.

Introduction

1. Joel Porte, ed., *Ralph Waldo Emerson: Essays and Lectures* (New York, 1983), 1317.

2. H. G. O. Blake, ed., *Winter: From the Journal of Henry David Thoreau* (Boston, 1887), 123, 399–400; Sharon Cameron, *Writing Nature: Henry Thoreau's Journal*

(New York, 1985), 56; Robert Sattelmeyer, "The Remaking of Walden," in *Writing the American Classics*, ed. James Barbour and Tom Quirk (Chapel Hill, 1990), 63.

3. Lawrence Buell, *The Environmental Imagination: Thoreau, Nature Writing, and the Formation of American Culture* (Cambridge, Mass., 1995), 250; Richard Lebeaux, *Thoreau's Seasons* (Amherst, Mass., 1984), 221.

4. James Thomson, *The Seasons*, ed. James Sambrook (Oxford, 1981), lines 432–68; Lebeaux, *Thoreau's Seasons*, 221; Burroughs, "Autumn—Nature's Invitation to Rest," in *John Burroughs' America: Selections from the Writings of the Naturalist*, ed. Farida A. Wiley (1951; Mineola, N.Y., 1997), 110; Aldo Leopold, *A Sand County Almanac* (New York, 1949), 4; Fredric Klees, *The Round of the Year: An Almanac* (New York, 1963), 199, 214, 264; Edwin Way Teale, *North with the Spring* (New York, 1951), 11–13.

5. For an unusual exception, casually referring to Ceres, Pomona, and Bacchus, see Harry Penciller [pseud. for Henry Carmer Wetmore], *Rural Life in America; or, Summer and Winter in the Country*, 2nd ed. (New York, 1856), 122. Among the hundreds of images of Vertumnus and Pomona, perhaps the most beautiful was painted by Francesco Melzi, a student of Leonardo da Vinci, ca. 1518–22, when Leonardo was at the court of François I but suffering from gout. The painting is located in the Gemäldegalerie in Berlin.

6. *A Picture of the Seasons: with anecdotes and remarks on every month in the year* (Dublin: William Folds, 1818), 5; Henry Duncan, *Sacred Philosophy of the Seasons . . .* (Boston, 1839), 1:x, 4:11.

7. Robert Jessup, *The Four Seasons and Drawings in Anticipation of Spring* (New York: Ruth Siegel Ltd., 1987, ex. cat.), 1–2.

8. See Hal Borland, *An American Year: Country Life and Landscapes Through the Seasons* (New York, 1946); Borland, *Sundial of the Seasons* (Philadelphia, 1964); Borland, *Homeland: A Report from the Country* (Philadelphia, 1969). Teale produced a one-volume abridgment of his quartet called *The American Seasons* (New York, 1976).

9. For less familiar anticipations and variations of this schema, see Frances Theodora Parsons, *According to Season: Talks about the Flowers in the Order of Their Appearance in the Woods and Fields* (1894; New York, 1902); Hazel Heckman, *Island Year* (Seattle, 1972); John Keats, *Of Time and an Island* (Syracuse, 1987); Donald Hall, *Seasons at Eagle Pond* (Boston, 1987); and Rick Marsi, *Wheel of Seasons* (Binghamton, N.Y., 1988).

10. See Robert Thomas, "Farmer's Calendar," in *Farmer's Almanac* (Boston, 1817); Rev. John Pike, "Observable Seasons," New Hampshire Historical Society, *Collections* 3 (1832): 62–67. From 1682 to 1709, Pike kept track of major snowfalls, heavy rains, unusually high tides, and notably stormy weather.

11. James Buckham, *Afield with the Seasons* (New York, 1907), 29–30. See also Cameron Shelley, "The Influence of Folk Meteorology in the Anaximander Fragment," *Journal of the History of Ideas* 61 (Jan. 2000): 7–8.

12. Wiley, ed., *Burroughs' America*, 112; Mary Hunter Austin, *The Land of Little Rain* (Garden City, N.Y., 1903), 5; Edwin Way Teale, *Circle of the Seasons* (New York, 1953), 95. Robert Wilson Lynd (1879–1949), the Belfast-born journalist and poet, wrote the following in 1925: "If the four seasons had not been invented long before England was discovered by civilized man, I doubt if they would have been given

their present order. The Four Seasons, however, were invented by southern races who lived in countries in which it was actually possible to count on the summers being hotter than the winter. When the Romans conquered the world, they took this purely local theory of the Four Seasons wherever they went, and it still remains with us like the Roman roads and the foundations of the Roman villas. Had the Romans never got so far as this, there is no reason to doubt that an insular world of men of science would have divided the year quite differently. . . . I myself lean to the opinion that there are 365 seasons, and 366 in Leap Year. And one never knows which season it is till one has got out of bed and looked out of the window." *Daily News* (London), Oct. 21, 1925, 6.

13. Lebeaux, *Thoreau's Seasons*, 113, 138, 327. Annie Dillard cites Thoreau's memorable phrase and says that she hopes to achieve the same goal in *Pilgrim at Tinker Creek* (1974; New York, 1999), 13. See also Scott Slovic, *Seeking Awareness in American Nature Writing* (Salt Lake City, 1992), chaps. 2, 3, and 5.

14. Leopold to Hans Hochbaum, Nov. 20, 1944, in *Companion to A Sand County Almanac: Interpretive and Critical Essays*, ed. J. Baird Callicott (Madison, 1987), 100–101; and see Cameron, *Writing Nature*.

15. Teale, *Circle of the Seasons*; *Hal Borland's Book of Days* (New York, 1976); Donald Culross Peattie, *An Almanac for Moderns* (New York, 1935), 21.

16. Stevens to Barbara Church, July 25, 1951, *Letters of Wallace Stevens*, ed. Holly Stevens (New York, 1966), 721. Burchfield's painting *Autumn to Winter* (1966) belongs to the Terra Museum in Chicago; Bishop's sculpture is in the Pennsylvania Academy of the Fine Arts, Philadelphia.

17. Beadford Torrey, ed., *The Writings of Henry David Thoreau: Journal* (Boston, 1906), 5:477.

18. See George M. A. Hanfmann, *The Season Sarcophagus in Dumbarton Oaks* (Cambridge, Mass., 1951), 1:89, 124–25, 188; Ovid, *The Metamorphoses*, trans. A. E. Watts (Berkeley, 1954).

19. Lebeaux, *Thoreau's Seasons*, 195–97; H. G. O. Blake, ed., *Autumn: From the Journal of Henry David Thoreau* (Boston, 1892), 109–10. See also Penciller, *Rural Life in America*, 203, 204, 213–14.

20. Hal Borland, "Winter: The Visions and the Dreams," *The Progressive* 33 (Jan. 1969): 25. See Daniel Levinson's obituary, *NYT*, Apr. 14, 1994, C19.

21. Manuscript diary of Adaline C. Hosmer, Mecklenburg, N.Y., Jan. 16, 1862, Special Collections, Cornell University Library, Ithaca, N.Y. Cole's painting is in the Albany Institute of History and Art.

22. *James McGarrell: Recent Paintings* (New York: Frumkin/Adams Gallery, 1991, ex. cat.), 4–5; McGarrell to the author, Aug. 21, 2000; David Sharpe to the author, June 11, 2002.

23. John R. Stilgoe, *Borderland: Origins of the American Suburb, 1820–1939* (New Haven, 1988), 11, 13, 31; Edward J. Renehan Jr., *John Burroughs: An American Naturalist* (Post Mills, Vt., 1992), 104; John Burroughs, *Signs and Seasons* (Boston, 1914), 239, 241, 246–47.

24. Parsons, *According to Season*, 3, 31, 37, 125; Samuel C. Schmucker, *Under the Open Sky* (Philadelphia, 1910), 7, 24, 52, 168. For purposes of comparison, see André

Guillerme, "La Disparition des Saisons dans la Ville, les Années 1830–1860," in *Les Annales de la Recherche Urbain* 61 (1994): 8–14.

25. Henry Beston, *Northern Farm: A Chronicle of Maine* (Camden, Me., 1948), 245; Krutch review in the *Omaha World Herald*, Apr. 24, 1949.

26. Hal Borland, "January: Winter and the Totals," *The Progressive* 31 (Jan. 1967): 16; Charles B. Seib, *The Woods: One Man's Escape to Nature* (Garden City, N.Y., 1971), 84; Marsi, *Wheel of Seasons*, 135.

27. George W. Pierson, *The Moving American* (New York, 1973), 147. See also Verlyn Klinkenborg, *The Rural Life* (Boston, 2003), 139–40; Susan Orlean, *Saturday Night* (New York, 1990), xviii.

28. Bernard Mergen, *Snow in America* (Washington, D.C., 1997), 61, 93; Borland, *Homeland*, 140.

29. Hal Borland, "Spring: A Reiteration," *The Progressive* 36 (Apr. 1972): 22; Torrey, ed., *Writings of Thoreau: Journal*, 12:400.

30. Thoreau, "Autumnal Tints," in Torrey, ed., *Writings of Thoreau*, 5:276. For a modern photographic "reprise" of Thoreau's sentiment, taken at Harpers Ferry, W. Va., see William A. Bake and James J. Kilpatrick, *The American South: Four Seasons of the Land* (Birmingham: Oxmoor House, 1980), 187.

31. These works were exhibited at the National Museum of African Art in Washington, D.C., in 1997–98. See Simon Ottenberg, *New Traditions from Nigeria: Seven Artists of the Nsukka Group* (Washington, D.C., 1997).

32. Marguerite Hurrey Wolf, *Seasoned in Vermont* (Shelburne, Vt.: The New England Press, 1982), 37–39; Noel Perrin, *Third Person Rural: Further Essays of a Sometime Farmer* (Boston, 1983), 11; David Rains Wallace, "The Fifth Season," in Wallace, *Idle Weeds: The Untamed Garden and Other Personal Essays* (Columbus, Ohio, 1986), 27–31; Edwin Way Teale, *Autumn Across America* (New York, 1956), 308; Austin, *Land of Little Rain*, 5. The paintings by Peter Hurd (1940 and 1947) are located in the Brooklyn Museum and the Roswell Museum and Art Center, Roswell, N.M.

33. Richard Dunn, *Sugar and Slaves: The Rise of the Planter Class in the English West Indies, 1624–1713* (Chapel Hill, 1972); Hippocrates quoted in David M. Potter, *People of Plenty: Economic Abundance and the American Character* (Chicago, 1954), 3.

34. Huai-Nan Tzu is quoted in *Bartlett's Familiar Quotations*, 15th ed. (Boston, 1980), 97; John C. H. Wu, *Four Seasons of T'ang Poetry* (Rutland, Vt., 1972).

35. Outstanding examples of all these objects will be found at the Metropolitan Museum of Art, New York City; but the most extraordinary collection belongs to the National Palace Museum in Taipei, Taiwan. Kangxi period armoires can be found at the Guimet Museum in Paris.

36. Hal Borland, "Autumn: A Time for Summary," *The Progressive* 26 (Nov. 1962): 25; Michael Kammen, "Charles Burchfield and the Procession of the Seasons," in *The Paintings of Charles Burchfield: North by Midwest*, ed. Nannette V. Maciejunes and Michael D. Hall (New York, 1997), 38–49; Laura Lee Davidson, *A Winter of Content* (New York, 1922), 9–10.

37. Quoted in Peter Bermingham, *Jasper F. Cropsey: A Retrospective View of America's Painter of Autumn* (College Park, Md., 1968, ex. cat.), 9–10.

38. H. G. O. Blake, ed., *Summer: From the Journal of Henry David Thoreau* (Bos-

ton, 1888), 12; Blake, ed., *Autumn: From the Journal of Thoreau*, 76–77 (Oct. 6, 1857). See Elizabeth Helsinger, "Turner and the Representation of England," in *Landscape and Power*, ed. W. J. T. Mitchell (Chicago, 1994), 103–25.

39. See Jeffrey B. Spencer, *Heroic Nature: Ideal Landscapes in English Poetry from Marvell to Thomson* (Evanston, 1973), 275; Alan D. McKillop, *The Background of Thomson's Seasons* (Minneapolis, 1942), 6. For the influence of statuary on Thomson's seasonal imagination, see Thomson, *The Seasons*, xxix.

40. George Gissing, *The Private Papers of Henry Ryecroft* (1903; New York, 1987), 57.

41. Peattie, *Almanac for Moderns*, 394, 396.

42. See Helen Vendler, *On Extended Wings: Wallace Stevens' Longer Poems* (Cambridge, Mass., 1969), 254, 263–64.

43. Bernd Heinrich, *A Year in the Maine Woods* (Reading, Mass., 1994), 69.

44. Thoreau, Jan. 23, 1858, in Torrey, ed., *Writings of Thoreau: Journal*, 10:253; *The Poetical Works of Edmund Spenser* (New York, 1882), 517–65. For the ongoing influence of both Spenser and Thomson, see John Clare, *The Shepherd's Calendar* ([1827], Oxford: Woodstock Books, 1991).

Chapter One

1. The J. Paul Getty Museum in Malibu, Calif., has a well-preserved mosaic floor, also from the third century A.D., showing Orpheus and the four seasons. It was found at Saint-Colombe in southern France.

2. Carnegie Museum of Art, Pittsburgh. A similar painting by a follower of Tintoretto is located at the National Gallery of Scotland, Edinburgh.

3. Eric Cochrane, *Florence in the Forgotten Centuries, 1527–1800: A History of Florence and the Florentines in the Age of the Grand Dukes* (Chicago, 1973), 109.

4. George M. A. Hanfmann, *The Season Sarcophagus in Dumbarton Oaks* (Cambridge, Mass., 1951), 1:78, 88, 102, 110–11, 113, 118. (All references are to vol. 1 unless otherwise indicated; vol. 2 has notes and plates.)

5. Ibid., 78–84, 87.

6. Ibid., 124, 231, 249.

7. Ibid., 22, 62, 64, 72, 230; Erwin R. Goodenough, *Jewish Symbols in the Greco-Roman Period* (New York, 1953–68), 8:172.

8. Hanfmann, *The Season Sarcophagus*, 6, 17, 20–21, 24, 62; Camille S. Jungman, "A 'Seasons' Sarcophagus in the Elvehjem Center, Madison, Wisconsin," *The Classical Journal* 76 (Oct. 1980): 21–33; Christine Alexander, "Unpublished Fragments of Roman Sarcophagi in the Metropolitan Museum of Art," *Metropolitan Museum Studies* 3 (1931): 38–47.

9. Hanfmann, *The Season Sarcophagus*, 72, 203, 208, 245.

10. David G. Roskies, *Against the Apocalypse: Responses to Catastrophe in Modern Jewish Culture* (Cambridge, Mass., 1984), 27, 32; Goodenough, *Jewish Symbols*, 4:61, 218.

11. Goodenough, *Jewish Symbols*, 1:241, 2:26–27, 5:11–12, 76, 79; the quotation at 8:201. Reproductions of decorations from the two synagogues can be seen at the Jewish Museum in New York City. And see Steven Fine, ed., *Sacred Realm: The Emergence of the Synagogue in the Ancient World* (New York, 1996), no. 60.

12. Hanfmann, *The Season Sarcophagus*, 156; Susan Raven, *Rome in Africa*, 3rd ed. (New York, 1993), 86; Helen C. Evans, "The Arts of Byzantium," *Metropolitan Museum of Art Bulletin* 58 (Spring 2001): 5, 25.

13. Cole is quoted in Angela Miller, *Empire of the Eye: Landscape Representation and American Cultural Politics, 1825–1875* (Ithaca, 1993), 52 n.

14. Robert L. Dorman, *A Word for Nature: Four Pioneering Environmental Advocates, 1845–1913* (Chapel Hill, 1998), 67–68; H. G. O. Blake, ed., *Early Spring in Massachusetts: From the Journal of Henry David Thoreau* (Boston, 1893), 36; Blake, ed., *Winter: From the Journal of Henry David Thoreau* (Boston, 1887), 61–62, 370; John Burroughs, *Signs and Seasons* (Boston, 1914), 9–10, 22, the quotation at 32.

15. Hesiod, *The Works and Days; Theogony; The Shield of Herakles*, trans. Richmond Lattimore (Ann Arbor, 1959), 18–117. The Greek word "kairos" meant seasonal time as distinct from mere chronicity.

16. Virgil, *The Georgics*, ed. and trans. L. P. Wilkinson (London, 1982).

17. James Thomson, *The Seasons*, ed. James Sambrook (Oxford, 1981), xxiv; L. P. Wilkinson, *The Georgics of Virgil: A Critical Survey* (Cambridge, 1969), esp. pts. 4, 6, and 9.

18. Wilkinson, *The Georgics of Virgil*, 270–313; Wilkinson, ed., *The Georgics*, 46–47. For an excellent brief summary of *The Georgics'* influence upon medieval literature, see Nils Erik Enkvist, *The Seasons of the Year: Chapters on a Motif from Beowulf to the Shepherd's Calendar* (Copenhagen, 1957), 30–32, 38.

19. Ovid, *The Metamorphoses*, trans. A. E. Watts (Berkeley, 1954), 24–25.

20. Hanfmann, *The Season Sarcophagus*, 1:117, 2:62 n. 90.

21. Enkvist, *Seasons of the Year*, 24, 32; Rosemond Tuve, *Seasons and Months: Studies in a Tradition of Middle English Poetry* (Paris, 1933), 129, 134, 136, 153. For an explanation of the rationale for only two seasons early on, see François Zonabend, *The Enduring Memory: Time and History in a French Village* (Manchester, U.K., 1984), 198–99.

22. Tuve, *Seasons and Months*, 38, 54, 147; Enkvist, *Seasons of the Year*, 55, 63, 73. See also James Fowler, "On Medieval Representations of the Months and Seasons," *Archaeologia* 44 (1873): 137–224, esp. 178, 180–82, 188.

23. Enkvist, *Seasons of the Year*, 97; Chaucer, *The Canterbury Tales*, ed. David Wright (New York, 1985), 375–76; Chaucer, *Troilus and Criseyde*, ed. Margaret Stanley-Wrench (London, 1965).

24. Tuve, *Seasons and Months*, 46, 187; Enkvist, *Seasons of the Year*, 74–76, 90, 157.

25. Tuve, *Seasons and Months*, 71.

26. Ann Kussmaul, "Time and Space, Hoofs and Grain: The Seasonality of Marriage in England," *Journal of Interdisciplinary History* 15 (Spring 1985): 755–79; Robert Darnton, *The Great Cat Massacre and Other Episodes in French Cultural History* (New York, 1984), 83; Jon Butler, *Awash in a Sea of Faith: Christianizing the American People* (Cambridge, Mass., 1990), 17.

27. Derek Pearsall and Elizabeth Salter, *Landscapes and Seasons of the Medieval World* (Toronto, 1973), 145–46; James Carson Webster, *The Labors of the Months in Antique and Mediaeval Art to the End of the Twelfth Century* (Evanston, 1938).

28. Roger S. Wieck, *Painted Prayers: The Book of Hours in Medieval and Renaissance*

Art (New York, 1997), 26–38; Marie Collins and Virginia Davis, *A Medieval Book of Seasons* (New York, 1992). For the cultural nature and role of work, see Jacques Le Goff, *Time, Work and Culture in the Middle Ages* (Chicago, 1980).

29. Della Robbia's Labors of the Months are now located in the Victoria and Albert Museum, London (nos. 7632–1861 to 7643–1861). For a discussion of the relation between calendrical rites and the four seasons, see Edward G. Muir, *Civic Ritual in Venice* (Princeton, 1981), 75–76.

30. Pearsall and Salter, *Landscapes and Seasons of the Medieval World*, 155–56.

31. Ibid., 153; Wieck, *Painted Prayers*, 31–33; Bridget Ann Henisch, *The Medieval Calendar Year* (University Park, Pa., 1999).

32. Hanfmann, *The Season Sarcophagus*, 121, 157–58, 222.

33. *The Poetical Works of Edmund Spenser* (New York, 1882), 517–65, but esp. 520–21, "The General Argument of the Whole Book," and 524, 528, 562; Isabel G. MacCaffrey, "Allegory and Pastoral in the *Shepheardes Calender*," *English Literary History* 36 (1969): 88–109; A. C. Hamilton, *The Structure of Allegory in the Faerie Queen* (Oxford, 1961), 44–50.

34. Enkvist, *Seasons of the Year*, 178; Alexander Pope, "A Discourse on Pastoral Poetry," in *The Prose Works of Alexander Pope*, ed. Norman Ault (Oxford, 1936), 1:297–302, the quote at 302. For an excellent historical account of the late medieval shepherd's life, including seasonal migrations with the flocks, see Emmanuel Le Roy Ladurie, *Montaillou: The Promised Land of Error* (New York, 1979), 5, 75, 92, 110, 107, 115, 278–79.

35. These works inspired by Aratus's poem were exhibited at the Pierpont Morgan Library, New York City, in the winter and spring of 1988. A facsimile edition of Aratea was published that year by Verlag Luzern in Switzerland. For Aratus, see Hanfmann, *The Season Sarcophagus*, 107–8. Medieval tradition is responsible for the tenacious survival of an old or older man wearing a heavy coat warming himself as a standard symbol of winter. See ibid., 2:123.

36. *Summer* is in the National Gallery, London; and *Deerhunting* is in Bologna. Most of the rest are located at the Germanisches National Museum in Nuremberg.

37. All three of these paintings are located in the Prague Castle Gallery, Czech Republic. There is a four seasons set by Alessandro Bassano in the Hermitage Museum, St. Petersburg, Russia.

38. Edith Templeton, *The Surprise of Cremona* (New York, 1957), 54; Tuve, *Seasons and Months*, 146; John Shearman, *Raphael's Cartoons in the Collection of Her Majesty the Queen and the Tapestries for the Sistine Chapel* (London, 1972), 43–44, and pl. 6, fig. 14.

39. Iain Buchanan, "The Collection of Nicolaes Jongelinck, II: The 'Months' by Pieter Bruegel the Elder," *The Burlington Magazine* 132 (Aug. 1990): 541–50; Fritz Grossmann, *Bruegel: The Paintings* (London, 1955), pls. 79–109. The mystery of the missing Bruegel painting inspired Michael Frayn's entertaining novel, *Headlong* (New York, 1999).

40. The van der Heyden engravings are at the Metropolitan Museum of Art, New York City. Bruegel the Younger's *Spring* is at the Vassar College Art Museum, Poughkeepsie, N.Y. See also Alan Riding, "Pieter Bruegel and Sons, Painters," *NYT*, Mar. 31, 1998, E3.

41. The works by Grimmer and van Goyen are located in the Dayton Art Institute and the Rijksmuseum, Amsterdam, respectively.

42. Saenredam's works are reproduced in K. G. Boon, ed., *Hollstein's Dutch and Flemish Etchings, Engravings and Woodcuts, ca. 1450–1700*, vol. 23 (Amsterdam, 1980), 66–77; van Schoel's works can be seen in ibid., vol. 26 (Amsterdam, 1982), 16–17. Grimmer's work is located in the Royal Museum of Fine Arts in Brussels. See also Ilja M. Veldman, "Seasons, Planets and Temperaments in the Work of Maarten van Heemskerck: Cosmo-astrological Allegory in Sixteenth-Century Netherlandish Prints," *Simiolus* 11, no. 3/4 (1980): 149–76.

43. Van de Venne's paintings are in the Rijksmuseum, Amsterdam. See also William W. Robinson, ed., *Seventeenth-Century Dutch Drawings: A Selection from the Maida and George Abrams Collection* (New York, 1991), 52 (no. 17).

44. There is a modern edition of *Hortus Floridus* edited by Eleanour Sinclair Rohde (London: Minerva Press, 1974).

45. Still lifes by Bosschaert and van der Ast are located in the Walters Art Gallery, Baltimore, and in the Indianapolis Museum of Art. Examples of van Huysum's year-long still lifes are located at the Getty Museum in Malibu, Calif., the Los Angeles County Museum of Art, the Museum of Fine Arts in Boston, and the Hermitage Museum in St. Petersburg, Russia.

46. Van Blarenberghe's *Four Seasons* are framed together at the Rijksmuseum, Amsterdam.

47. Griffier's set is in the Galleria Sabanda of the Musei Aperti in Turin, Italy. Almeloven works can be seen in Boon, ed., *Hollstein's Dutch and Flemish Etchings, Engravings and Woodcuts*, vol. 1 (Amsterdam, 1949), 28. See also Kahren Jones Hellerstedt, *Gardens of Earthly Delight: Sixteenth- and Seventeenth-Century Netherlandish Gardens* (Pittsburgh: Frick Art Museum, 1986, ex. cat.).

48. Richard T. Godfrey, *Wenceslaus Hollar: A Bohemian Artist in England* (New Haven, 1994), 14; J. L. Nevinson, *Wenceslas Hollar, The Four Seasons* (King's Lynn, U.K.: The Costume Society, 1979), 5–6.

49. Nevinson, *Wenceslas Hollar, The Four Seasons*, 6–12; Godfrey, *Wenceslaus Hollar*, 40, 78–81.

50. Elizabeth Cropper, *Pietro Testa, 1612–1650: Prints and Drawings* (Philadelphia, 1988), 155–77, but esp. 155–56; Cropper, "Virtue's Wintry Reward: Pietro Testa's Etchings of the Seasons," *Journal of the Warburg and Courtauld Institutes* 37 (1974): 249–79.

51. Manfredi's painting is in the Dayton Art Institute. Van Veen's can be seen in John Rupert Martin, *Baroque* (New York, 1977), 220. For larger-than-life sculptures by a contemporary of Manfredi, see Angelo Marinali (1654–1702), *Four Seasons*, carved from Istrian limestone, in the Museum of Fine Arts, Springfield, Mass.

52. One of Arcimboldo's sets is located in the Kunsthistorisches Museum in Vienna, and another set in the Louvre. A version of *Summer* is in the Denver Art Museum. There are several other variants. See Simonetta Rasponi and Carla Tanzi, eds., *The Arcimboldo Effect: Transformations of the Face from the Sixteenth to the Twentieth Century* (New York, 1987), 74–78, 101–9.

53. See Arnold Van Gennep, *Manuel de folklore français contemporain* (Paris, 1947–

58), vol. 1, pt. 4, "Les Cérémonies Périodiques, Cycliques et Saisonnières"; pt. 5, "Les Cérémonies Agricoles et Pastorales de L'été"; and pt. 6, "Les Cérémonies Agricoles et Pastorales de l'Automne."

54. Nicole Villa, *Le XVIIe Siècle vu par Abraham Bosse, Graveur du Roy* (Paris, 1967), nos. 57, 78, and 79. I am indebted to Professor Herbert I. Lazerow for his eagle eye as a Paris flâneur.

55. *Autumn* is located in the Carnegie Museum of Art in Pittsburgh. *Spring* from this set was destroyed by fire in France in 1848. At the Musée Jacquemart-André in Paris there is a tapestry from Beauvais entitled "Le Repas après la Chasse, ou l'Automne," made after a cartoon by Boucher. The existence of three others making a set is unknown.

56. Works by Jean Poyet exhibited at the Pierpont Morgan Library in New York City in March 2001. The roundels are in the Victoria and Albert Museum, London.

57. The Swiss plates were exhibited in Prague in 1988. See *Švýcarské umělecké řemeslo*, 17. Století (Prague, n.d.). The vase is in the museum for artistic handicrafts in Frankfurt. An elegant but less elaborate nautilus goblet was made in Dresden, ca. 1620. See the Pierpont Morgan Library newsletter, Spring/Summer 1987, 1.

58. Dining room visited and photographed by the author in May 1999.

59. English roundels in the Victoria and Albert Museum, London; tapestry shown at an exhibition, "The Treasure Houses of Britain," at the National Gallery of Art, Washington, D.C., 1985–86; Donne quoted in *Bartlett's Familiar Quotations*, 15th ed. (Boston, 1980), 255; Paul Fussell, *The Great War and Modern Memory* (New York, 1975), 159.

60. Wilkinson, *The Georgics of Virgil*, 297; Raymond Williams, *The Country and the City* (New York, 1973).

61. Burial structure visited by the author, July 14, 1987.

62. Northrop Frye, *Anatomy of Criticism: Four Essays* (Princeton, 1957), 160–61.

63. Ibid., 162–63, 186–87, 206–7, 223–24.

64. Patel painted his series in 1699 for the Jesuits' Convent of the Maison Professe in Paris. Although the pictures were confiscated during the French Revolution, they were relocated afterward.

65. CW owns several sets of the London engravings, and the Museum of Early Southern Decorative Arts in Winston-Salem, N.C., owns a set published in London by John Fairburn in 1796. The Library Company of Philadelphia owns a very comprehensive collection of American editions of Thomson's poem.

66. See Alan D. McKillop, *The Background of Thomson's Seasons* (Minneapolis, 1942), 89; Williams, *The Country and the City*, 142–43.

67. McKillop, *The Background of Thomson's Seasons*, 11; Keith Hutchison, "Reformation Politics and the New Philosophy," *Metascience* 1/2 (1984): 10.

68. See Gabriel Mourey, *Gainsborough* (Paris, n.d.). Earlier versions of Musidora by American artists Mather Brown (1761–1831) and Ezra Ames (1768–1836) have not been located for many years. Sully's painting is at the Metropolitan Museum of Art, New York City, and he did a second version in 1863–64, *Lady Preparing to Bathe (Musidora)*.

69. Porcelain figurines of this sort are located at the High Museum of Art, Atlanta,

and at the Wallace Gallery of CW. The Victoria and Albert Museum, London, has sets symbolizing the four seasons that were made in Ludwigsburg around 1760 as well as a set from Meissen (ca. 1755–65) in which winter's symbol is a hot pot, summer's is wheat and a sickle, autumn's is grapes and wine, and spring's is children.

70. Marquis de Saint-Lambert, *Les Saisons: Poème*, 4th ed. (Amsterdam, 1771), esp. "Discours Préliminaire," xv–xvi, xxxi–xxxiv. See also François Joachim de Pierre de Bernis, *Les quatre saisons: ou Les géorgiques françoises. Poëme* (Paris, 1764).

71. The 1745 sets are located in the Wallace Collection, London; the 1755 set is in the Frick Museum, New York City. Boucher did several versions of *Vertumnus and Pomona*. One from 1749 is located at the Columbus Museum of Art, Columbus, Ohio, and another (more elaborate) from 1763 is in the Louvre.

72. Janis A. Tomlinson, *Francisco Goya: The Tapestry Cartoons and Early Career at the Court of Madrid* (Cambridge, 1989), 158–68; Juliet Wilson-Bareau, ed., *Goya, Truth and Fantasy: The Small Paintings* (New Haven, 1994), 184, 190.

73. In 1804 a young poet wrote a poem praising the innovation and accomplishment of Goya's winter scene from 1786–87. See Nigel Glendinning, *Goya and His Critics* (New Haven, 1977), 50. The Clark Art Institute in Williamstown, Mass., has a small work by Goya titled *Autumn* in which a woman walks with a basket of grapes on her head. Goya's suite may also have influenced the *Cuatro Estaciones* painted by Mariano Salvador Maella in 1795 for the royal palace in Madrid, now also located in the Prado.

74. David Cressy, "The Seasonality of Marriage in Old and New England," *Journal of Interdisciplinary History* 16 (Summer 1985): 1–21. For meticulous contextual detail, see Ronald Hutton, *The Stations of the Sun: A History of the Ritual Year in Britain* (Oxford, 1996).

75. Peter A. Gunn, "Productive Cycles and the Season of Marriage: A Critical Test," *Journal of Interdisciplinary History* 21 (Autumn 1990): 217–43.

76. Ibid., 240–44.

Chapter Two

1. See David Hackett Fischer, *Albion's Seed: Four British Folkways in America* (New York, 1989), 164, 743–47; Paul S. Boyer and Stephen Nissenbaum, *Salem Possessed: The Social Origins of Witchcraft* (Cambridge, Mass., 1974), 106. See also Lyon Gardiner Tyler, ed., *Narratives of Early Virginia, 1606–1625* (New York, 1907), 80–81.

2. Martin Bruegel, *Farm, Shop, Landing: The Rise of a Market Society in the Hudson Valley, 1780–1860* (Durham, N.C., 2002), 43–46; Bruegel, "Men, Women and Work in an Agricultural Community: Austerlitz, N.Y. in the Early Republic," unpublished paper presented to the Society for the History of the Early American Republic (July 1992), 6; James Stuart, *Three Years in North America* (Edinburgh, 1833), 1:261–62, 280.

3. Harriet Martineau, *Retrospect of Western Travel* (London, 1838), 3:166–96; Julian P. Boyd, ed., *The Papers of Thomas Jefferson* (Princeton, 1954), 9:369; Elaine F. Crane, ed., *The Diary of Elizabeth Drinker* (Boston, 1991), 1:760 (Dec. 13, 1795).

4. Jack N. Rakove, *Original Meanings: Politics and Ideas in the Making of the Constitution* (New York, 1996), 329–30; Roy F. Nichols, *A Historian's Progress* (New York, 1968), 153.

5. David D. Hall, *Worlds of Wonder, Days of Judgment: Popular Religious Belief in Early New England* (New York, 1989), 171; Fischer, *Albion's Seed*, 743–45; and for comparisons with French Canada, see Robert V. Wells, "Marriage Seasonals in Early America: Comparisons and Comments," *Journal of Interdisciplinary History* 18 (Autumn 1967), 299–307.

6. Robert V. Wells, *Revolutions in Americans' Lives: A Demographic Perspective on the History of Americans, Their Families, and Their Society* (Westport, Conn., 1982), chaps. 3–4; Jacques Henripin, *La Population Canadienne au début du XVIIIe siècle: nuptialité, fécondité, mortalité infantile* (Paris, 1954), 122.

7. David W. Blight, ed., *Narrative of the Life of Frederick Douglass, an American Slave, Written by Himself* (1845; Boston, 1993), 39. See also Joel Williamson, *Rage for Order: Black/White Relations in the American South Since Emancipation* (New York, 1986), 29.

8. This paragraph and the next rely upon weekly reports kept in 1785–86 and summarized by Mary V. Thomson, a research specialist at Mount Vernon, in "They Work Only From Sun to Sun: Labor and Rebellion among the Mount Vernon Slaves" (unpublished typescript, Mar. 7, 1997), 6, 22–24, 26–28.

9. Mechal Sobel, *The World They Made Together: Black and White Values in Eighteenth-Century Virginia* (Princeton, 1987), stresses the seasonal nature of work more generally.

10. Solomon Northup, *Twelve Years a Slave*, ed. Sue Eakin and Joseph Logsdon (Baton Rouge, 1968), 7–9, 123–24, 130–31, 133, 159–61.

11. [Charles Ball], *Fifty Years in Chains; or, The Life of an American Slave* (New York: H. Dayton, 1858), 204–6, 213–14, 220, 240.

12. Ibid., 280, 360, 363, 372.

13. F. N. Boney, ed., *Slave Life in Georgia: A Narrative of the Life, Sufferings, and Escape of John Brown, a Fugitive Slave* (1855; Savannah, 1972), 10, 23. For Brown's seasonal description of cotton, tobacco, and rice cultivation, see chap. 18.

14. William H. Wiggins, *O Freedom!: Afro-American Emancipation Celebrations* (Knoxville, 1987), 25–26; [Ball], *Fifty Years in Chains*, 146.

15. Photograph published in Lincoln Kirstein, ed., *The Hampton Album: 44 Photographs from an Album of the Hampton Institute* (New York, 1966), 24.

16. The best collection of these "rewards of merit" is at the American Antiquarian Society, Worcester, Mass. Examples date from the 1820s. The Pennsylvania Dutch also used rewards of merit, but those collected at the Philadelphia Museum of Art do not have representations of the seasons. They date from 1815–40.

17. Franklin to William Strahan, Feb. 12, 1744/45, in *The Papers of Benjamin Franklin*, ed. Leonard W. Labaree (New Haven, 1961), 3:13–14. For *Poor Richard's Almanack*, see ibid., 260–61, 348–49, 400–401. Gilbert Chinard, ed., *The Literary Bible of Thomas Jefferson: His Commonplace Book of Philosophers and Poets* (Baltimore, 1928), 174.

18. Jennings's allegory of freedom is in the Library Company of Philadelphia, with another version located at the Winterthur Museum in Delaware.

19. All these editions of Thomson are located at the Library Company of Philadelphia.

20. These American editions are located at the Library Company of Philadelphia. For the characteristic English motifs, see J. William Middendorf II, ed., *American Printmaking: The First 150 Years* (Washington, D.C., n.d.), 52, and figs. 102–5.

21. The Philadelphia editions can be found at the Library Company of Philadelphia. Raeburn's painting is located in the National Gallery of Scotland, Edinburgh.

22. Both editions at the Library Company of Philadelphia; the 1828 edition also in the author's collection.

23. Countless examples of porcelain figurines will be found in the Abby Aldrich Rockefeller Folk Art Collection, CW.

24. Numerous examples of engravings at CW. An early set (ca. 1740s) has traditionally hung in the dining room of the Brush-Everard House at CW, and a somewhat later set in the dining room of the General Salem Towne House at Old Sturbridge Village in Massachusetts.

25. See Joan D. Dolmetsch, ed., *Eighteenth-Century Prints in Colonial America* (Charlottesville, 1979). Fine examples of the textiles will be found at CW and at the Winterthur Museum in Delaware.

26. All examples from the Abby Aldrich Rockefeller Folk Art Collection at CW.

27. Ibid.

28. The Brunton registers are located at the American Antiquarian Society, Worcester, Mass., and the Connecticut Historical Society, Hartford; one clock, seven feet tall, was owned by Brimfield Antiques in Fiskdale, Mass.; and the kerchiefs belong to the Chester County Historical Society and a private collector.

29. The schrank belongs to Professor and Mrs. George Kimball Plochmann of Carbondale, Ill. It has been in Professor Plochmann's family continuously for several centuries.

30. See Ralph Cohen, *The Unfolding of the Seasons* (Baltimore, 1970), 36–37; Frank H. Goodyear Jr., ed., *Thomas Doughty, 1793–1856: An American Pioneer in Landscape Painting* (Philadelphia: Pennsylvania Academy of the Fine Arts, 1973, ex. cat.), 30–31.

31. James Fenimore Cooper, *The Pioneers* (1823; New York, 1959), 1, 302; and see Alan Taylor, *William Cooper's Town: Power and Persuasion on the Frontier of the Early American Republic* (New York, 1995), 288–91, 313–16, 412–24.

32. Angela Miller, *The Empire of the Eye: Landscape Representation and American Cultural Politics, 1825–1875* (Ithaca, 1993), 95; *The Crayon*, Jan. 3, 1855, 4; ibid., Nov. 14, 1855, 303.

33. Jeanine Hensley, ed., *The Works of Anne Bradstreet* (Cambridge, Mass., 1967), 65–72, the extracted verse at 70.

34. Fred Lewis Pattee, ed., *The Poems of Philip Freneau: Poet of the American Revolution* (Princeton, 1902–7), 2:282.

35. Nathaniel S. Prime, *A History of Long Island, from Its First Settlement by Europeans, to the Year 1845. . . .* (New York, 1845), 205; Joan Hedrick, *Harriet Beecher Stowe: A Life* (New York, 1994), 193; Jacob Abbott, *Rollo's Museum* (New York, 1855), is discussed and quoted in Shirley Teresa Wajda, "'And a Little Child Shall Lead Them': Children's Cabinets of Curiosities, 1790–1860," in *Acts of Possession: Essays on Collecting in America*, ed. Leah Dilworth (New Brunswick, N.J., 2003).

36. A copy printed in Brimfield, Mass., was given to Mrs. Anne B. Cabell by her

husband (ALUVA, Special Collections). For Thoreau's review of Howitt's book, see Henry David Thoreau, *Early Essays and Miscellanies*, ed. Joseph J. Moldenhauer et al. (Princeton, 1975), 26–36.

37. See Henry Duncan in the *Dictionary of National Biography* (London, 1885–1901); [Ithaca] *Volunteer*, June 28, 1842.

38. Henry Duncan, *Sacred Philosophy of the Seasons; Illustrating the Perfections of God in the Phenomena of the Year* (Boston, 1839), 1:1, 3; 3:11, 14; 4:6.

39. Ibid., 1:x; 2: 13n; 3:11.

40. Edward Hitchcock, *Religious Lectures on Peculiar Phenomena in the Four Seasons* (Amherst, 1850), 2, 79.

41. Ibid., 85, 87, 90, 95, 113–14, 117, 120, 122. For Cole's *Voyage of Life*, see Michael Kammen, *Selvages and Biases: The Fabric of History in American Culture* (Ithaca, 1987), 189–94.

42. The privately owned set of Francis's still lifes was exhibited and researched by Berry-Hill Galleries in New York City in 1990. See Frederick Baekeland, *Roads Less Traveled: American Paintings, 1833–1935* (Ithaca, 1998), 122–23.

43. See Perry Miller, "Nature and the National Ego," in Miller, *Errand into the Wilderness* (Cambridge, Mass., 1956), 204–16; Merritt Roe Smith, *Harpers Ferry Armory and the New Technology: The Challenge of Change* (Ithaca, 1980), 22–24; Sarah F. McMahon, "'All Things in Their Proper Season': Seasonal Rhythms of Diet in Rural New England, 1620–1840," *Agricultural History* 63 (Spring 1989): 145, 151.

44. Alice Ford, *Edward Hicks: His Life and Art* (New York, 1985), 77, 80, 81, 84, 97, 99, 101, 109, 110, 127; E. McSherry Fowble, *Two Centuries of Prints in America 1680–1880* (Charlottesville, 1987), 350–52; Hermann Warner Williams, *Mirror to the American Past: A Survey of American Genre Painting, 1750–1900* (Greenwich, Conn., 1973), 120, for Thomas Birch's *Winter* (1838); the bust of *Winter* is in the Fine Arts Museums of San Francisco; Gloria Gilda Deak, *William James Bennett: Master of the Aquatint View* (New York, 1988), 49–51; Donald A. Shelley, "George Harvey and His Atmospheric Landscapes," *New-York Historical Society Quarterly* 32 (Apr. 1948): 104–13.

45. James Collins Moore, "The Storm and the Harvest: The Image of Nature in Mid-Nineteenth-Century American Landscape Painting" (Ph.D. diss., Indiana University, 1974), esp. 234, 243–44.

46. For Durrie, see Sotheby's sale catalogue #6854 (May 22, 1996). The Miller watercolors were located at the Kennedy Galleries in New York in 1990; they have been resold several times since then.

47. Flasks in the Henry Ford Museum, Dearborn, Mich.

48. Timothy Dwight, *Travels in New England and New York*, ed. Barbara Miller Solomon (Cambridge, Mass., 1969), 2:100–101.

49. Timothy Dwight, "Greenfield Hill: A Poem in Seven Parts" (1794), in *The Major Poems of Timothy Dwight . . .* , ed. William J. McTaggart and William K. Bottorff (Gainesville, Fla., 1969), 376–96, 510; Henry David Thoreau, "A Winter Walk," in Thoreau, *Excursions* (Boston, 1893), 222.

50. Clericus, "Reflections on the Change of Seasons," *Ithaca Herald*, Nov. 30, 1836; Henry David Thoreau, *Journal*, ed. Leonard N. Neufeldt and Nancy Craig Sim-

mons (Princeton, 1992), 4:144; James Russell Lowell, "A Good Word for Winter," in *The Complete Works of James Russell Lowell: Literary Essays* (Boston, 1890), 3:255–90. See also Tim Armstrong, "'A Good Word for Winter': The Poetics of a Season," *New England Quarterly* 60 (Dec. 1987): 568–83. For the view that spring is not so conducive to clear thinking as autumn and especially as winter, see Wilson Flagg, *Studies in the Field and Forest* (Boston, 1857), 86–87.

51. Lowell, "A Good Word for Winter," 262; H. G. O. Blake, ed., *Winter: From the Journal of Henry David Thoreau* (Boston 1887), 259; Thoreau, "Autumnal Tints," in Bradford Torrey, ed., *The Writings of Henry David Thoreau* (Boston, 1906), 5:249.

52. H. G. O. Blake, ed., *Summer: From the Journal of Henry David Thoreau* (Boston, 1888), 137; Blake, ed., *Early Spring in Massachusetts: From the Journal of Henry David Thoreau* (Boston, 1893), 172.

53. Blake, ed., *Winter: From the Journal of Thoreau*, 256; Richard Lebeaux, *Thoreau's Seasons* (Amherst, 1984), 327–28; Moore, "The Storm and the Harvest," 172–73; "Sketchings," *The Crayon* 7, part 5 (May 1860): 142.

54. John Dixon Hunt, *The Figure in the Landscape: Poetry, Painting, and Gardening during the Eighteenth Century* (Baltimore, 1976), 115, 117.

55. Ibid., 121, 123, 129, 142. See John R. Knott, *Imagining Wild America* (Ann Arbor, 2002), and W. J. T. Mitchell, ed., *Landscape and Power* (Chicago, 1994), chap. 3.

56. Gerry's quartet was sold by Christie's in New York City on May 28, 1992.

57. Miller, *Empire of the Eye*, 87; Thoreau, "A Winter Walk," 222; entry for Jan. 7, 1852, in Blake, ed., *Winter: From the Journal of Thoreau*, 128. See also the entry for Oct. 9, 1857, in H. G. O. Blake, ed., *Autumn: From the Journal of Henry David Thoreau* (Boston, 1892), 89.

58. Quoted in Lebeaux, *Thoreau's Seasons*, 24.

59. Flagg, *Studies in the Field and Forest*, 23–25.

60. Harry Penciller [pseud. for Henry Carmer Wetmore], *Rural Life in America; or, Summer and Winter in the Country*, 2nd ed. (New York, 1856), 136, 222.

61. James J. Farrell, *Inventing the American Way of Death, 1830–1920* (Philadelphia, 1980); Blanche Linden-Ward, *Silent City on a Hill: Landscapes of Memory and Boston's Mount Auburn Cemetery* (Columbus, Ohio, 1989); David Charles Sloane, *The Last Great Necessity: Cemeteries in American History* (Baltimore, 1991).

62. Franklin B. Hough, *Census of the State of New-York for 1855 . . .* (Albany, 1857), 207; Stockton is quoted in Garry Wills, *Lincoln at Gettysburg: The Words That Remade America* (New York, 1992), 77.

63. Ellen M. Litwicki, *America's Public Holidays, 1865–1920* (Washington, D.C., 2000), chap. 1; David W. Blight, *Race and Reunion: The Civil War in American Memory* (Cambridge, Mass., 2001), esp. chaps. 1 and 3.

64. Diana Nemiroff et al., *Land, Spirit, Power: First Nations at the National Gallery of Canada* (Ottawa, 1992), 149, esp. for the work of Hachivi Edgar Heap of Birds; Lawrence Abbott, ed., *I Stand in the Center of the Good: Interviews with Contemporary Native American Artists* (Lincoln, Nebr., 1994), 29–54. See also the children's book by Joanna Troughton, *How the Seasons Came: A North American Indian Folk Tale* (New York and London, 1992).

65. William Cronon, *Changes in the Land: Indians, Colonists, and the Ecology of New England* (New York, 1983), 37, 42–43, 53. For occasional references to seasonal conditions and a section devoted to "The Four Winds," see Henry Wadsworth Longfellow, "Hiawatha," in *The Complete Poetical Works* (Boston, 1902), 144–46.

66. Cronon, *Changes in the Land*, 40. For the Iroquois, see Michael Kammen, *Colonial New York—A History* (New York, 1975), 8, 13.

67. Mary Hunter Austin, *The Land of Little Rain* (Garden City, N.Y., 1903), 106–7.

68. Information on the "winter count" from the Detroit Institute of Arts. There is a similar artifact, but made earlier, on buffalo hide, in the Rockwell Museum of Western Art in Corning, New York.

69. Desley Deacon, *Elsie Clews Parson: Inventing Modern Life* (Chicago, 1997), 176, 199–200. In the *Seasons of Our Story* sculpture (1993) located in Salt Lake City (see the Introduction), which is based upon Ute cultural traditions, the stones are placed in such a manner as to mark the shadows cast by the setting sun at the summer and winter solstices.

70. Mable Dodge Luham, *Winter in Taos* (New York, 1935), 52, 62, 65, 84, 97, 108–9, 112, 127, 130, 144–46, 149–50, 170–71, 191, 224–25, 230–31.

71. Church visited by the author, June 23, 2000.

72. Sarah F. McMahon, "A Comfortable Subsistence: The Changing Composition of Diet in Rural New England, 1620–1840," *William and Mary Quarterly* 42 (Jan. 1985): 26–65; McMahon, " 'All Things in Their Proper Season,' " 130–51.

73. I am grateful to Georgia B. Barnhill of the American Antiquarian Society for sharing this unusual and rare sheet with me.

74. Susan Fenimore Cooper, *Rural Hours* (1850; Athens, Ga., 1998), 209; Blake, ed., *Autumn: From the Journal of Thoreau*, 181 (Oct. 29, 1858). See also Rochelle Johnson, "*Walden*, *Rural Hours*, and the Dilemma of Representation," in *Thoreau's Sense of Place: Essays in American Environmental Writing*, ed. Richard J. Schneider (Iowa City, 2000), 179–93.

Chapter Three

1. Bradford Torrey, ed., *The Writings of Henry David Thoreau: Journal* (Boston, 1906), 6:96.

2. H. G. O. Blake, ed., *Autumn: From the Journal of Henry David Thoreau* (Boston, 1892), 153–54.

3. Henry David Thoreau, *Walden* (Princeton, 1971), 81, 131.

4. *N.Y. Herald Tribune*, Oct. 28, 1928, 12; Donald Culross Peattie, *An Almanac for Moderns* (New York, 1935), 122–23; Carson to Teale, 1951 Christmas card, Teale Papers, box 150, DLUC; *Chicago Sunday Tribune*, July 14, 1957; Leonard Hall, *Country Year: A Journal of the Seasons at Possum Trot Farm* (New York, 1957), 70–75; Charles B. Seib, *The Woods: One Man's Escape to Nature* (Garden City, N.Y., 1971), 2; Maxine Kumin, *In Deep: Country Essays* (New York, 1987), 174.

5. Brian F. LeBeau, *Currier and Ives: America Imagined* (Washington, D.C., 2001), 187–90; Peter C. Marzio, *The Democratic Art: Chromolithography, 1840–1900* (Boston, 1979), 59–63.

6. Walt Whitman, *Leaves of Grass*, ed. Emory Holloway (Garden City, N.Y., 1948), 37. See also the line in "When Lilacs Last in the Dooryard Bloom'd," where Whitman wrote, "Over the breast of the spring, the land, amid cities . . . ," in ibid., 277.

7. "Sketchings," *The Crayon*, May 16, 1855, 314.

8. "The Four Seasons," *Putnam's Monthly Magazine of American Literature, Science, and Art* 9 (Apr. 1857): 368.

9. Wilson Flagg, *Studies in the Field and Forest* (Boston, 1857), 274; *North American Review* 84 (Jan. 1857): 274.

10. Harry S. Stout, *New England Soul: Preaching and Religious Culture in Colonial New England* (New York, 1986), 91; Robert A. Gross, *The Minutemen and Their World* (New York, 1976), 7–8, 16; Charles E. Rosenberg, *The Care of Strangers: The Rise of America's Hospital System* (New York, 1987), 92, 259.

11. Ray Allen Billington, ed., *"Dear Lady": The Letters of Frederick Jackson Turner and Alice Forbes Perkins Hooper, 1910–1932* (San Marino, Calif., 1970), 18–19.

12. Ernest Samuels, ed., *The Education of Henry Adams* (1907; Boston, 1973), 9, 15, 39.

13. Roy Rosenzweig and Elizabeth Blackmar, *The Park and the People: A History of Central Park* (Ithaca, 1992), 184–85.

14. Morse-Libby House visited by the author in July 1993; Bruce T. Sherwood to the author, Aug. 16, 1993.

15. See Nancy Finlay, *Inventing the American Past: The Art of F. O. C. Darley* (New York, 1999).

16. See *Currier and Ives: A Catalogue Raisonné* (Detroit, 1984), 2 vols.

17. Oliver Wendell Holmes Sr., "The Seasons," *The Atlantic Almanac for 1868* (Boston, 1868), 2, 9–11; Flagg, *Studies in the Field and the Forest*, 284.

18. Donald G. Mitchell, "A Talk About the Year," *Atlantic Almanac for 1868*, 15, 31.

19. "The Moral Power of Poetry," *The Brunonian* 3 (Oct. 1869): 1; Waldo H. Dunn, *The Life of Donald G. Mitchell, Ik Marvel* (New York, 1922), 227–35; William B. Rhoads, "Donald G. Mitchell and the Colonial Revival before 1876," *Nineteenth Century* 4 (Autumn 1978): 76–83. For representative reviews, see *Democratic Review* 30 (Feb. 1852): 191–92, and *Atlantic Monthly* 72 (July 1893): 127–28. Mitchell's papers are located at BLYU and the New Haven Colony Historical Society, primarily the former.

20. Donald Grant Mitchell, *Dream Life: A Fable of the Seasons* (New York, 1851), 83; John Burroughs, *Signs and Seasons* (Boston, 1914), 251.

21. R. W. Franklin, ed., *The Poems of Emily Dickinson* (Cambridge, Mass., 1998), 1:320, 3:1461.

22. Harry Penciller [pseud. for Henry Carmer Wetmore], *Rural Life in America; or, Summer and Winter in the Country*, 2nd ed. (New York, 1856), 47, 122, 136.

23. Marzio, *The Democratic Art*, 94–106; Larry Freeman, *Louis Prang: Color Lithographer, Giant of a Man* (Watkins Glen, N.Y., 1971); Leigh Eric Schmidt, "The Commercialization of the Calendar: American Holidays and the Culture of Consumption, 1870–1930," *Journal of American History* 78 (Dec. 1991): 887–916.

24. Howard S. Merritt, "Thomas Cole's List 'Subjects for Pictures,'" *The Baltimore Museum of Art: Annual II (Studies on Thomas Cole, An American Romanticist)* (Baltimore, Md., 1967), 91, 98–99.

25. The McEntee painting, which came from John Hay's Euclid Avenue mansion in Cleveland, belongs to the Western Reserve History Museum in Cleveland.

26. Peter Bermingham, *Jasper F. Cropsey: A Retrospective View of America's Painter of Autumn* (College Park, Md., 1968, ex. cat.). Mr. Stuart P. Feld, former president of Hirschl & Adler Galleries in New York, owned the 1859–61 set until 2001 and kindly shared information and photographs with me in May 1992.

27. The most important and accurate source of information about Cropsey's work is Kenneth W. Maddox, historian at the Newington-Cropsey Museum in Hastings-on-Hudson, New York, the site of Cropsey's last home. Dr. Maddox has been invaluable in sharing materials with me. See also William S. Talbot, *Jasper F. Cropsey, 1823–1900* (New York, 1977).

28. Christopher Kent, "Spectacular History as an Ocular Discipline," *Wide Angle* 18, no. 3 (1996): 1–21, drawing upon *The Era*, Dec. 29, 1867, 7; Karen Halttunen, *Confidence Men and Painted Women: A Study of Middle-Class Culture in America, 1830–1870* (New Haven, 1982), 177.

29. Linda Merrill, *An Ideal Country: Paintings by Dwight William Tryon in the Freer Gallery of Art* (Washington, 1990), 51–61; Kathleen Pyne and David C. Huntington, *The Quest for Unity: American Art Between the World's Fairs, 1876–1893* (Detroit, 1983), 222–24. The Tryon-Dewing triptych now belongs to the Detroit Institute of Arts, and Tryon's quartet is located at the Freer Gallery in Washington, D.C.

30. Polly Longsworth, *Austin and Mabel: The Amherst Affair and Love Letters of Austin Dickinson and Mabel Loomis Todd* (New York, 1984), 56.

31. LaFarge's windows for the Lake George home are now located at the Hunter Museum in Chattanooga, Tenn., and his large *Spring* (plate 22) is permanently installed in the Philadelphia Museum of Art. For the Lamb ad, see *The Cornellian* yearbook for 1883–84 (no. 16). Tiffany windows of *Spring* and *Autumn*, designed in 1892 by Lydia Field Emmet, are in the Delaware Art Museum, Wilmington.

32. I am indebted to Lesley M. Leduc, public affairs coordinator at Yaddo, for sending me photographs and information, Mar. 12, 2001. There is also a set of four seasons statues in the garden of James K. Polk's ancestral home in Columbia, Tenn. Three of them are located in the boxwood garden, and "Spring" is in the contiguous azalea garden. Very neoclassical in design, they, too, were likely made by a craftsman of European origin.

33. See Faith Andrews Bedford, *Frank W. Benson: American Impressionist* (New York, 1994), 66–71; Sarah J. Moore, "In Search of an American Iconography: Critical Reaction to the Murals at the Library of Congress," *Winterthur Portfolio* 25 (Winter 1990): 231–39. For the most important review at the time, see Royal Cortissoz, "Painting and Sculpture in the New Congressional Library," Part X, *Harper's Weekly* 41 (Feb. 27, 1897): 201.

34. Lisa N. Peters, *John Henry Twachtman: An American Impressionist* (New York, 1999); Deborah Chotner et al., *John Twachtman: Connecticut Landscapes* (New York, 1989); Francis Murphy, *J. Francis Murphy: The Landscape Within, 1853–1921* (Yonkers, N.Y.: Hudson River Museum, 1982, ex. cat.).

35. Angela Miller, *The Empire of the Eye: Landscape Representation and American Cultural Politics, 1825–1875* (Ithaca, 1993), 216. Vedder's painting is in the Yale Univer-

sity Art Gallery. Gustin's paintings are privately owned by a descendant, Robert Gustin, in Preston Park, Pa.

36. The Gorham bowl is in a private collection, but see Christie's auction catalogue for Jan. 23, 1988, item 12. But while the concept of seasonality had staying power in terms of beauty for social display, it also served functional purposes as well. We have long since forgotten about the role of seasonally designed trolley cars in urban and suburban America. At the start of the twentieth century most trolley-car firms ordered two sets of cars: one equipped with windows for fall and winter use, and the others lacking sides altogether for spring and summer. See John R. Stilgoe, *Metropolitan Corridor: Railroads and the American Scene* (New Haven, 1983), 299.

37. Blake, ed., *Autumn: From the Journal of Thoreau*, 181 (Oct. 29, 1858); Holmes, "The Seasons," 9; Muir to A. H. Sellers, June 24, 1898, Muir Papers, ALUVA. There are countless references to Indian summer in Thoreau's journals. Cropsey's painting is in the Detroit Institute of Arts, and Richards's is in the Metropolitan Museum of Art, New York City.

38. Flagg, *Studies in the Field and Forest*, 299; Bartlett Cowdrey, *George Henry Durrie, 1820–1863: Connecticut Painter of American Life* (Hartford: Wadsworth Atheneum, 1947, ex. cat.); James Russell Lowell, "A Good Word for Winter," in *The Complete Works of James Russell Lowell: Literary Essays* (Boston, 1910), 3:286.

39. Murphy to Burroughs, Dec. 15, 1879, Burroughs Papers, box 66, Vassar College Library, Poughkeepsie, N.Y.; Burroughs, "A Bunch of Herbs," in Burroughs, *Pepacton* (New York, 1881), 207–35; Burroughs, *Signs and Seasons*, 65–66.

40. Whitman's letters to Burroughs, most of them incompletely dated, are in the Whitman Collection, box 1, ALUVA.

41. The seven-page manuscript, headed "The Interesting," is in Burroughs Papers, box 6, and the question and reply in ibid., box 8, fol. 475, ALUVA.

42. See Edward J. Renehan, *John Burroughs: An American Naturalist* (Post Mills, Vt., 1992), 205–6, 267–70; Stephen Fox, *The American Conservation Movement: John Muir and His Legacy* (Madison, 1981), 82. James reviewed *Winter Sunshine* in *The Nation*, Jan. 27, 1876.

43. Burroughs, *Signs and Seasons*, 3–4, 17, 241–42; John Burroughs, "The Spring Bird Procession," in Burroughs, *Field and Study* (New York, 1919), 17.

44. Burroughs, "Spring Bird Procession," 7. For the recent revelation of Burroughs's affair and child born out of wedlock, see Edward Kanze, *The World of John Burroughs* (New York, 1993), 63–64.

45. See Clara Barrus, *The Life and Letters of John Burroughs* (Boston, 1925), 2 vols.

46. Frederic T. Edwards to Burroughs, Oct. 20, 1916, and Herbert D. Miles to Burroughs, Jan. 12, 1920, Burroughs Papers, box 66, Vassar College Library, Poughkeepsie, N.Y.

47. Doolittle's "almanac" of Burroughs's seasonal observations is in the Burroughs Papers, folder 29, Hartwick College Library, Oneonta, N.Y.; obituary of Farida Wiley, *NYT*, Oct. 19, 1986, D7; Farida A. Wiley, ed., *John Burroughs' America: Selections from the Writings of the Naturalist* (New York, 1951), 84–140, on the four seasons.

48. Peattie, *Almanac for Moderns*, 16–17.

49. Ibid., 36.

50. See Peter J. Schmitt, *Back to Nature: The Arcadian Myth in Urban America* (New York, 1969); and Nathaniel S. Shaler, "The Landscape as a Means of Culture," *Atlantic Monthly* 82 (Dec. 1898): 777–85.

51. Mabel Osgood Wright, *The Friendship of Nature: A New England Chronicle of Birds and Flowers* (1894; Baltimore, 1999), 115.

52. Blake, ed., *Autumn: From the Journal of Thoreau*, 158. For an explicit echo, see Robert Frost's poem, "My November Guest," in *Complete Poems of Robert Frost, 1949* (New York, 1949), 8.

53. Gladys Taber, *Stillmeadow Daybook* (Philadelphia, 1955), 13.

54. "An Amateur's Walk Around His Garden," *American Gardening* 16 (June 22, 1895): 231.

55. James Wood, "Planting a Country Place for Winter," *The Garden Magazine* 1 (Dec. 1905): 219–22; "The Pussy Willow's Neglected Beauty," *The Guide to Nature* 8 (Aug. 1915): 73–75. I am indebted to John T. Fitzpatrick for these references.

56. Deborah Pickman Clifford, *The Passion of Abby Hemenway: Memory, Spirit, and the Making of History* (Hanover, N.H., 2001), 43; and see Thomas S. Edwards and Elizabeth A. De Wolfe, eds., *Such News of the Land: U.S. Women Nature Writers* (Hanover, N.H., 2001). Thoreau is quoted in Richard Lebeaux, *Thoreau's Seasons* (Amherst, 1984), 194.

57. Fox, *The American Conservation Movement*, 56–57; Henry Beston, *The Outermost House: A Year of Life on the Great Beach of Cape Cod* (1928: New York, 1949), 82–89; *Complete Poems of Frost, 1949*, 314. See also John R. Knott, *Imagining Wild America* (Ann Arbor, 2002).

58. H. G. O. Blake, ed., *Summer: From the Journal of Henry David Thoreau* (Boston, 1888), 212–13; Muir to A. H. Sellers, Dec. 28, 1898, Muir Papers, ALUVA; and see James Henry, "Pennsylvania Forest Scenery," *The Crayon*, Feb. 28, 1855, 131.

59. See William Cronon, *Nature's Metropolis: Chicago and the Great West* (New York, 1991), 57, 59, 166–67, 298, 230–32, 248.

60. This information and what follows draws upon the phenomenal Ethel Z. Bailey Horticultural Catalogue Collection of American seed catalogues located at the Liberty Hyde Bailey Hortorium Herbarium of Cornell University, carefully researched for this project by Alicia K. Anderson.

61. Comstock, Ferre & Co., *Descriptive Catalogue of Garden Seeds Cultivated and Sold at the Wethersfield Seed Garden* (Wethersfield, Ct., 1853), 10–11, Bailey Hortorium, Cornell University.

62. *Annual Catalogue of Fruit and Ornamental Trees, Shrubs, Roses . . . by John Donellan & Co.* (Rochester, 1857), 6–7; Johnson & Stokes, *Seed Catalogue* (Philadelphia, 1889 and 1890), 43, 31–33, Bailey Hortorium, Cornell University.

63. See *American Agriculturist*, Feb. and May 1869, Feb. 1870, Oct. 1876, Bailey Hortorium, Cornell University.

64. The Bailey Hortorium, Cornell University, has a complete run of catalogues for *Flower Seeds from Miss C. H. Lippincott* ("Season" 1896 to 1918). See especially the covers for 1896 and 1899 for feminization, and 1904 for "cold season" flowers.

65. Owen Wister, *The Virginian* (1902; New York, 1988), 322, 377.

66. A. B. Frost and E. S. Martin, "The Farmer's Seasons: Four Pictures in Colors,"

Scribner's Magazine 40 (Aug. 1906): 215–23. Between the 1880s and 1910 a symptomatic debate took place throughout much of rural France. The Angelus had traditionally been rung on church bells at different times in summer and winter, marking the times to start and stop work. Controversy arose when some officials proposed setting a consistent time throughout the year because of a wish to be "modern"— once again an attempt to defy custom by "flattening" the seasons. See Alain Corbin, *Village Bells: Sound and Meaning in the 19th-Century French Countryside* (New York, 1998), 115–17.

67. Cleota Reed, *Henry Chapman Mercer and the Moravian Pottery and Tile Works* (Philadelphia, 1987), 159–60, 163, and pl. 10.

68. Both paintings, with helpful wall texts, are located in the Art Institute of Chicago.

Chapter Four

1. Eugen Neuhaus, *The Art of the Exposition* (San Francisco, 1915), 5–11, 38, the quotation at 11–12.

2. Clara Barrus, "With John O'Birds and John O'Mountains in the Southwest," *The Century* 80 (Aug. 1910): 521–28; John Muir, *My First Summer in the Sierra* (Boston, 1911), 3.

3. From Thomas Wolfe, *Of Time and the River* (1935), in *Country Matters: An Anthology*, ed. Barbara Webster (Philadelphia, 1959), 238–39.

4. Wilson Flagg, *Studies in the Field and Forest* (Boston, 1857), 302; Maxine Kumin, *In Deep: Country Essays* (New York, 1987), 162.

5. Elizabeth de Veer and Richard J. Boyle, *Sunlight and Shadow: The Life and Art of Willard J. Metcalf* (Boston, 1987), 225, 244–45.

6. Ibid., esp. 149–51, and 191, 200–206, 213, 220, 225–30, 233–35; Barbara J. MacAdam, *Willard Metcalf in Cornish, New Hampshire, 1909–1920* (Hanover, N.H., 1999), 29–30.

7. Bruce Robertson, *Marsden Hartley* (New York, 1995), 19–34; Barbara Haskell, *Marsden Hartley* (New York, 1980), 14–16, 23; *Robert Emmett Owen: The Seasons of New England* (New York: Spanierman Gallery, 2000, ex. cat.).

8. Beston to Richards, Nov. 30, 1935, Beston Papers, Houghton Library, Harvard University, Cambridge, Mass.; Beston to Arthur Stanley Pease, n.d., ibid.; Donald Culross Peattie, *An Almanac for Moderns* (New York, 1935), 46; Gladys Taber, *Stillmeadow Daybook* (Philadelphia, 1955), 144.

9. Henry Beston, *The Outermost House* (1928; New York, 1949), 58.

10. *NYT*, Dec. 9, 1928, 5; *New York Herald Tribune*, Oct. 28, 1928, 12; *The Nation*, Nov. 14, 1928, 522. Beston's obituary appears in *NYT*, Apr. 17, 1968, 47.

11. Henry Beston, *Northern Farm: A Chronicle of Maine* (Camden, Me., 1948), 185; Carson to Beston, May 14, 1954, Carson Papers, box 102, BLYU.

12. John Burroughs, *Signs and Seasons* (Boston, 1914), 56, 71, 230–31; Sara G. Allaben to Burroughs, Dec. 10, 1884, Burroughs Papers, box 66, Vassar College Library, Poughkeepsie, N.Y.; Herbert D. Mills to Burroughs, Jan. 12, 1920, ibid.

13. William M. S. Rasmussen, "Making the Confederate Murals: Studies by

Charles Hoffbauer," *Virginia Magazine of History and Biography* 101 (July 1993): 433–56; *United Daughters of the Confederacy Magazine* 33 (Oct. 1970): 37.

14. Edward J. Renehan, *John Burroughs: An American Naturalist* (Post Mills, Vt., 1992), 24, 29–30; Donald Hall, *Seasons at Eagle Pond* (Boston, 1987), esp. 43–65.

15. Harvey Levenstein, *Revolution at the Table: The Transformation of the American Diet* (New York, 1988); Henry F. May, *Coming to Terms: A Study in Memory and History* (Berkeley, 1987), 7; Leigh Eric Schmidt, *Consumer Rites: The Buying and Selling of American Holidays* (Princeton, 1995), 27, 39; C. Wright Mills, *The Power Elite* (New York, 1956), 92.

16. See Paul A. Carter, *The Spiritual Crisis of the Gilded Age* (DeKalb, Ill., 1971); Henry F. May, *Protestant Churches and Industrial America* (New York, 1949).

17. John Fitzmier, *New England's Moral Legislator: Timothy Dwight, 1752–1817* (Bloomington, Ind., 1998), 19, 73, 145; Wilson Flagg, *A Year with the Birds: or, The Birds and Seasons of New England* (Boston, 1875), 304; Steven J. Holmes, *The Young John Muir: An Environmental Biography* (Madison, 1999), 182–83; Burroughs to May Cline, Nov. 27, 1891, Burroughs Papers, box 1, ALUVA; John Burroughs, *Time and Change* (Boston, 1912), 243–73, for his "Gospel of Nature."

18. Muir to A. H. Sellers, Mar. 8, 1902, Muir Papers, ALUVA; Frances E. Burnett to Burroughs, Nov. 9, 1907, Burroughs Papers, box 1, ALUVA.

19. Samuel C. Schmucker, *Under the Open Sky* (Philadelphia, 1910), 19; reviewed in *The Dial*, Dec. 16, 1910, 521; obituary in *NYT*, Dec. 28, 1943, 17.

20. Joseph Hergesheimer, *From an Old House* (New York, 1926).

21. Robert C. Bannister, *Ray Stannard Baker: The Mind and Thought of a Progressive* (New Haven, 1966), chaps. 6, 8, and 11; *American Chronicle: The Autobiography of Ray Stannard Baker* (New York, 1945). *Adventures of David Grayson* (Garden City, N.Y., 1928), contains the first four volumes of Baker's story of a New England farmer. For praise of the simple life, see John Burroughs, "What Life Means to Me," *Cosmopolitan* 40 (Apr. 1906): 654–58.

22. H. G. O. Blake, ed., *Autumn: From the Journal of Henry David Thoreau* (Boston, 1892), 129; H. G. O. Blake, ed., *Winter: From the Journal of Henry David Thoreau* (Boston, 1887), 103; Gladys Taber, *Stillmeadow Seasons* (Philadelphia, 1950), 68.

23. Renehan, *John Burroughs*, 231. See also Ralph H. Lutts, *The Nature Fakers: Wildlife, Science, and Sentiment* (Golden, Colo., 1990).

24. Flagg, *Studies in the Field and Forest*, 23–25, 88; James Buckham, *Afield with the Seasons* (New York, 1907), 60. Cf. Alain Corbin, *Village Bells: Sound and Meaning in the 19th-Century French Countryside* (New York, 1998).

25. Gladys Taber, *Stillmeadow Calendar* (Philadelphia, 1967), 92; Sheldon Nodelman, *Marden, Novros, Rothko: Painting in the Age of Actuality* (Seattle: Institute for the Arts at Rice University, 1978, ex. cat.), 46–47, 50–51, 60–61. Marden's paintings are at the Menil Collection and Museum in Houston, Tex. For another example of a quartet of colored panels (1955), equally minimalist, by an American artist, see Yves-Alain Bois, *Ellsworth Kelly: The Early Drawings, 1948–1955* (Chicago, 1999), pl. 184.

26. Farida A. Wiley, ed., *John Burroughs' America: Selections from the Writings of the*

Naturalist (New York, 1951), 99; Mabel Osgood Wright, *The Friendship of Nature: A New England Chronicle of Birds and Flowers* (1894; Baltimore, 1999), 88; Beston, *Northern Farm*, 212–13.

27. Edwin Way Teale, *A Naturalist Buys an Old Farm* (New York, 1974), 20.

28. Malcolm Rohrbough, *Days of Gold: The California Gold Rush and the American Nation* (Berkeley, 1997); Joseph A. Smith, *Reminiscences of Saratoga, or, Twelve Seasons at the "States"* (New York, 1897); Jacquelyn Dowd Hall, *Revolt Against Chivalry: Jessie Daniel Ames and the Women's Campaign Against Lynching* (1973; New York, 1993), 137, 140.

29. For the older usage of "progressive" see John Mitchell, *Derwent; or Recollections of Young Life in the Country* (New York, 1872), 67, 70; Michael Kammen, "Charles Burchfield and the Procession of the Seasons," in *North by Midwest: The Paintings of Charles Burchfield*, ed. Nannette V. Maciejunes and Michael D. Hall (New York, 1996), 38–49, the quotations at 38, 39.

30. Borland's columns in *The Progressive* 27 (Oct. 1963): 22; and 32 (Oct. 1968): 36. For his use of "sequence" as an alternative, see ibid. 30 (July 1966): 21.

31. Blake, ed., *Autumn: From the Journal of Thoreau*, 74 (Oct. 6, 1840); John Burroughs, "Autumn Tides," in *Winter Sunshine* (Boston, 1895), 97–111; Rachel Carson, *Under the Sea-Wind* (New York, 1941), 106; Edwin Way Teale, *North with the Spring* (New York, 1951), 1–2.

32. Flagg, *Studies in the Field and Forest*, 60; Wright, *The Friendship of Nature*, 87–88; J. Benjamin Townsend, ed., *Charles Burchfield's Journals: The Poetry of Place* (Albany, 1993), 238; Hal Borland, "September: A Time to Come Home," *The Progressive* 39 (Sept. 1975): 46.

33. Stephen Kern, *The Culture of Time and Space, 1880–1918* (Cambridge, Mass., 1983), 14; "A Rational Calendar," *The New Republic*, July 21, 1926, 257.

34. Geneviève Moreau, *The Restless Journey of James Agee* (New York, 1977), 194–95; E. B. White, *Writings from the New Yorker, 1927–1976* (New York, 1990), 4, 7, 8, 74–75; Grace Metalious, *Peyton Place* (New York, 1956), 1, 264, 289.

35. Lincoln Kirstein, *Elie Nadelman* (New York, 1972), 296 and pl. 46. In 1911–13 Nadelman also made a seasonal plaque in bronze for Rubinstein's billiard room in London.

36. Kenneth Lindsay, "Kandinsky in 1914 New York: Solving a Riddle," *Art News* 55 (May 1956): 32–33, 58–60. At the Lenbach Haus art museum in Munich there are three small studies for the Campbell commission dated 1914 and explicitly labeled Summer, Autumn, and Winter; they correspond closely in color and design to the final panels installed in New York. See also Hans K. Roethel and Jean K. Benjamin, *Kandinsky: Catalogue Raisonné of the Oil Paintings*. Vol. 1, *1900–1915* (Ithaca, 1982), 493–501; Will Grohmann, *Wassily Kandinsky: Life and Work* (New York, 1958), 142–44. For many years the Guggenheim Museum in New York City owned two and the Museum of Modern Art in New York City owned two. A deal was finally arranged, and the four have been reunited at the Museum of Modern Art at last.

37. Lowery Stokes Sims, ed., *Stuart Davis: American Painter* (New York, 1991); Dove's painting is in the Museum of Fine Arts, Boston, and Pollock's and Cornell's works are in the Museum of Modern Art, New York City.

38. Susan Teller, ed., *Grant Wood: The Lithographs* (New York, 1984).

39. Howard E. Wooden, "Grant Wood: A Regionalist's Interpretation of the Four Seasons," *American Artist* 55 (July 1991): 58–64, is somewhat misleading. More reliable and useful is James M. Dennis, *Grant Wood: A Study in American Art and Culture* (New York, 1975).

40. Creekmore Fath, *The Lithographs of Thomas Hart Benton* (Austin, Tex., 1979), nos. 27, 28, and 31. See Henry Adams, *Thomas Hart Benton: An American Original* (New York, 1989).

41. Townsend, ed., *Charles Burchfield's Journals*, 501.

42. Kammen, "Burchfield and the Procession of the Seasons," 43–45, 48.

43. Quoted in ibid., 45.

44. Townsend, ed., *Charles Burchfield's Journals*, 3, 7.

45. Krasner's painting is in the Whitney Museum of American Art, New York City.

46. The entire project has been archived at the Smithsonian Institution in record unit 290, and in 1992 it was located in the Arts and Industries Building, room 2135. I am grateful to Libby Glen for her help in making the full collection available.

47. See *Arts and Activities: Creative Activities for the Classroom* 41, no. 5 (June 1957), which includes forty pages of selected images from the exhibition, prefaced by an introduction from Otto Kallir, director of the Galerie St. Etienne.

48. Renehan, *John Burroughs*, 8; Buckham, *Afield with the Seasons*, 129.

49. Late in 2001, when sixth-grade children in Ithaca, N.Y., were invited to contribute to a community diary project by writing pieces on any subject in any format, prose or poetry, a number chose to write poems about the four seasons. These are located in the Archives of the Tompkins County historian.

50. James R. Mellow, *Walker Evans* (New York, 1999), 119.

51. Lea Rosson DeLong, *Christian Petersen: Sculptor* (Ames, Iowa, 2000), 64–67; Patricia L. Bliss, *Christian Petersen Remembered* (Ames, Iowa, 1986), 77–83.

52. Geoffrey J. Martin, *Ellsworth Huntington: His Life and Thought* (New York, 1973); Ellsworth Huntington, *Season of Birth* (New York, 1938), 1, 219, 236.

53. Huntington, *Season of Birth*, 7–8, 25–26.

54. Ibid., 13, 24, 26.

55. Renehan, *John Burroughs*, 11–12; Wiley, ed., *John Burroughs' America*, 85; Flagg, *A Year with the Birds*, 33.

56. John Keats, "To Autumn," in *Complete Poems*, ed. Jack Stillinger (Cambridge, Mass., 1982), 360; Flagg, *Studies in the Field and Forest*, 149.

57. T. S. Eliot, *Collected Poems, 1909–1962* (New York, 1963), 182–83.

58. Allen Tate, "Seasons of the Soul," first appeared in the *Kenyon Review* 6 (Winter 1944): 1–9. It appears in Allen Tate, *Poems* (New York, 1960), 27–39. "Mother of silences" may also be an ironic allusion to Tate's own mother, who smothered him with devoted attention during his boyhood. See Thomas A. Underwood, *Allen Tate: Orphan of the South* (Princeton, 2000), chaps. 1–2.

59. *The Collected Poems of Wallace Stevens* (New York, 1967), 9–10.

60. Ibid., 372–78. See Helen Vendler, *On Extended Wings: Wallace Stevens' Longer Poems* (Cambridge, Mass., 1969), 231–68, esp. 235 and 246.

61. *Collected Poems of Stevens*, 411–21.

62. Vendler, *On Extended Wings*, 246; David M. LaGuardia, *Advance on Chaos: The Sanctifying Imagination of Wallace Stevens* (Hanover, N.H., 1983), 128–41, and the quotation at 162. Also helpful in understanding these challenging poems is Gyorgi Voros, *Notations of the Wild: Ecology in the Poetry of Wallace Stevens* (Iowa City, 1997).

63. William Carlos Williams, *Imaginations*, ed. Webster Schott (New York, 1970), 82.

64. Christopher MacGowan, ed., *The Collected Poems of William Carlos Williams*, (New York, 1988), 2:386–90.

65. Bernard Mergen, *Snow in America* (Washington, D.C., 1997), 61–62, 87–93; Mergen, "Climate, Identity and Winter Carnivals in North America," in *Celebrating Ethnicity and Nation: American Festive Culture from the Revolution to the Early 20th Century*, ed. Jürgen Heideking et al. (New York, 2001), 222, 225.

66. See Gunther Barth, "Demopiety: Speculations on Urban Beauty, Western Scenery, and the Discovery of the American Cityscape," *Pacific Historical Review* 52 (Aug. 1983): 249–66. For Stieglitz's photographic vision of New York City in the years 1893–1903, see Dorothy Norman, *Alfred Stieglitz: An American Seer* (New York, 1960), pls. 5–7, 9, 18 ("Old and New New York" [1910]), and 24. Sarah Greenough, comp., *Alfred Stieglitz: The Key Set* (Washington, D.C., 2002), 2 vols., is now *the* compendium devoted to Stieglitz's photography. The index lists seven works titled "Winter" with a New York location, four for "Spring," only one for "Autumn," and none for summer.

67. John Van Dyke, *The New New York: A Commentary on the Place and the People* (New York, 1909), 45.

68. Ibid., 49–50, 52, 54, 56–57. For an example of the ambivalent feelings expressed at this time, see Nathaniel S. Shaler, "The Landscape as a Means of Culture," *Atlantic Monthly* 82 (Dec. 1898): 782–84.

69. Frederick T. Edwards to Burroughs, Feb. 20, 1917, Burroughs Papers, box 66, Vassar College Library, Poughkeepsie, N.Y.

70. John Kieran, *A Natural History of New York City* (Boston, 1959), 397–406, the quotation at 397; Mireille Johnston, *Central Park Country: A Tune Within Us* (San Francisco, 1968), 19.

71. Henry Beston, essays collected in *Northern Farm*, 112. For comparisons with the earlier transformation in Europe, see André Guillerme, "La Disparition des Saisons dans la Ville: Les Années 1830–1860," in *Les Annales de la Recherche Urbain* 61 (1994): 8–14.

72. Leonard Hall, *Country Year: A Journal of the Seasons at Possum Trot Farm* (New York, 1957), 11.

73. *NYTBR*, June 2, 1957, 18; *Chicago Sunday Tribune*, July 14, 1957, 3; *San Francisco Chronicle*, July 28, 1957, 20.

Chapter Five

1. Obituaries in *NYT*, Apr. 22, 1948, 27 (Leopold), and May 23, 1970, 23 (Krutch).

2. Obituaries in *NYT*, Nov. 17, 1964, 41 (Peattie), and Oct. 21, 1980, 10 (Teale). See also Frank Graham Jr., "The Last Naturalist," *Audubon*, Jan. 1981, 8, 10. A one-volume condensation of Teale's quartet appeared in 1976 as *The American Seasons*.

3. For Taber, see *Who Was Who in America* (St. Louis, 1981), vol. 7; Borland obituary in *NYT*, Feb. 24, 1978, sec. 2, p. 1.

4. Paul Brooks, *The House of Life: Rachel Carson at Work* (Boston, 1972); *Who Was Who in America* (St. Louis, 1968), vol. 4.

5. Teale to Brooks, Oct. 2, 1977, Teale Papers, box 149, DLUC. See Robert Henry Welker, *Natural Man: The Life of William Beebe* (Bloomington, Ind., 1975), 175.

6. Joseph Wood Krutch, *More Lives Than One* (New York, 1962); Donald Culross Peattie, *The Road of a Naturalist* (Boston, 1941); Edwin Way Teale, *Days Without Time: Adventures of a Naturalist* (1948); Hal Borland, *Country Editor's Boy* (Philadelphia, 1970).

7. Edwin Way Teale, ed., *The Wilderness World of John Muir* (Boston, 1954); Teale, ed., *Thoughts of Thoreau, Selected with a Biographical Foreword* (New York, 1962).

8. Peterson review in the *NYTBR*, Oct. 24, 1965, 1; Teale review in the *New York Herald Tribune*, Mar. 2, 1952, 4; Krutch to Teale, Mar. 24, 1953, Teale Papers, box 152, DLUC.

9. Sarton review in the *NYTBR*, May 18, 1969, 23; Borland review in ibid., May 15, 1949, 3.

10. Peattie review in *Saturday Review of Literature*, Nov. 17, 1956, 25; Borland to Reginald Cook, Dec. 9, 1967, Borland Papers, box 7, BLYU; Borland to Teale, Apr. 18, 1968, Teale Papers, box 149, DLUC.

11. *NYT*, Mar. 1, 1952, 13; Krutch to Teale, Nov. 21 and Dec. 4, 1953, Teale Papers, box 152, DLUC. See Herbert W. Gleason, *Through the Year with Thoreau* (Boston, 1917).

12. Dorothy G. Thorne to Teale, Apr. 13, 1961, Teale Papers, box 166, DLUC; Paul H. Love to Teale, Feb. 15, 1961, ibid., box 161; Edwin and Theta Minnis to Teale, Feb. 2, 1966, ibid., box 166.

13. Borland to Peter Farb, Oct. 10, 1964, Borland Papers, box 47, BLYU; Borland to Angus Cameron, Jan. 11, 1975, ibid., box 9; Gladys Taber, *Stillmeadow Calendar* (Philadelphia, 1967), 195, 255.

14. John Burroughs, "The Heart of the Southern Catskills," in Burroughs, *Riverby* (New York, 1896), 42–43, 56; Edward J. Renehan, *John Burroughs: An American Naturalist* (Post Mills, Vt., 1992), 162–63; Edwin Way Teale, *North with the Spring* (New York, 1951), 175–76, 184, 323–32.

15. Edwin Way Teale, *North with the Spring*, 272–73; Teale, *Journey into Summer* (New York, 1960), 20, 248; Teale, *A Naturalist Buys an Old Farm* (New York, 1974), 16.

16. Leonard Hall, *Country Year: A Journal of the Seasons at Possum Trot Farm* (New York, 1957), 135; Donald Hall, *Seasons at Eagle Pond* (Boston, 1987), 86.

17. Hall, *Country Year*, xiv, 11, 70–75, 85–86, 127.

18. Teale to Carson, Nov. 14, 1951, Carson Papers, box 106, BLYU; Taber, *Stillmeadow Calendar*, 152, 169; Kieran to Borland, Mar. 11, 1962, Borland Papers, box 48, BLYU; Kieran to Teale, Apr. 15, 1964, Teale Papers, box 152, DLUC.

19. Teale to Krutch, Nov. 4, 1962, Teale Papers, box 152, DLUC; Krutch to Teale, Dec. 7, 1962, ibid.; Kieran to Teale, Sept. 6, 1965, ibid.

20. Borland to Teale, Apr. 8, 1965, Teale Papers, box 149, DLUC; Teale to Borland, Mar. 14, 1968, Borland Papers, box 49, BLYU.

21. Joan Mills to Borland, July 30 and Sept. 7, 1977, Borland Papers, box 48, BLYU; Borland to Mills, Sept. 7, 1977, ibid.; Hal Borland, *Homeland: A Report from the Country* (Philadelphia, 1969), 54–55. The italics in Borland's quotation are mine.

22. John Skow, "Naturalists Follow Turn of the Seasons," *Los Angeles Times*, [1976], clipping, Borland Papers, box 9, BLYU.

23. *San Francisco Chronicle*, Nov. 27, 1949, 28; *Chicago Sunday Tribune*, Dec. 25, 1949, 3; *The Nation*, Dec. 24, 1949, 628.

24. *New York Herald Tribune*, Apr. 22, 1949, 19, sec. 2, p. 21; *Chattanooga Times*, May 22, 1949; Halle in *Saturday Review of Literature*, May 21, 1949, 9–10. Krutch confessed in his autobiography that he wrote the book in thirty days! See *More Lives Than One*, 295.

25. *New York Herald Tribune Book Review*, Mar. 2, 1952, 4; *Saturday Review of Literature*, Apr. 19, 1952, 50; *NYTBR*, Mar. 16, 1952, 3.

26. See Robert Rowley, "Joseph Wood Krutch: The Forgotten Voice of the Desert," *American Scholar* 64 (Summer 1995): 440–41.

27. *NYTBR*, July 21, 1946, 5; *Saturday Review of Literature*, Aug. 3, 1946, 9.

28. *NYTBR*, Apr. 26, 1964, 2; ibid., May 18, 1969, 12.

29. See *New York Herald Tribune Book Review*, May 11, 1952, 33; *Christian Science Monitor*, Apr. 10, 1952, 15; *Chicago Sunday Tribune*, Apr. 6, 1952, 3.

30. *Christian Science Monitor*, Nov. 29, 1951, 14; *Chicago Sunday Tribune*, Nov. 25, 1951, 3; *New York Herald Tribune Book Review*, Nov. 11, 1951, 1; *Saturday Review of Literature*, Nov. 3, 1951, 11.

31. *Saturday Review of Literature*, Nov. 17, 1956, 25; *NYTBR*, Oct. 14, 1956, 6; *New York Herald Tribune Book Review*, Oct. 14, 1956, 1; *Atlantic Monthly* 198 (Dec. 1956): 84.

32. *NYTBR*, Oct. 30, 1960, 6; *Library Journal* 85 (Oct. 15, 1960): 3670; *Christian Science Monitor*, Oct. 20, 1960, 13.

33. See R. T. Bond to Teale, Feb. 6, 1956, Teale Papers, box 174, DLUC; Dodd to Teale, Mar. 6, 1961, and July 5, 1962, ibid.; Teale to Dodd, July 19, 1962, ibid.

34. *NYTBR*, Oct. 24, 1965, 1; *Christian Science Monitor*, Oct. 2, 1965, 9; *America*, Oct. 2, 1965, 375; *Library Journal* 90 (Oct. 1, 1965): 4098.

35. *New York Herald Tribune Book Review*, Nov. 1, 1953, 6; *NYTBR*, Nov. 8, 1953, 34; *Christian Science Monitor*, Dec. 17, 1953, 13.

36. Jean Crothers to Teale, Dec. 7, 1967, Teale Papers, box 161, DLUC; Muir to A. H. Sellers, Nov. 22 and Dec. 13, 1898, Muir Papers, ALUVA; Maude L. Lee to Teale, Mar. 24, 1955, Teale Papers, box 160, DLUC.

37. Dorothy Warren to Teale, Aug. 25, 1955, Teale Papers, box 165, DLUC; Ruth (and Frank) Morris to Teale, Mar. 21, 1966, ibid., box 166; [name not legible] to Teale, Dec. 29, 1965, ibid.; L. W. Affolter to Teale, Jan. 3, 1979, ibid., box 161.

38. Earl W. Browning to Teale, Aug. 20, 1954, Teale Papers, box 160, DLUC; Katherine Buxbaum to Teale, Oct. 22, 1957, ibid.; Bettina Hunter Shears to Teale, Apr. 14, 1965, ibid., box 161; Harry C. Pifer to Teale, Nov. 1, 1966, ibid.; Phoebe Way to Teale, Dec. 29, 1960, ibid.; Mary Daly to Teale, Jan. 3, 1967, ibid.

39. William C. Happe to Teale, July 13, 1961, ibid.; Mildred M. Boese to Teale, Apr. 10, 1978, ibid.; Louise T. Haney to Teale, Mar. 18, 1955, ibid., box 166; Lucile

Gundel to Teale, Jan. 22, 1956, ibid., box 165; Mary Hughes Smith to Teale, Feb. 3, 1954, ibid., box 166; Margaret Gunn to Teale, Apr. 15, 1961, ibid.

40. Evelyn Gundy to Teale, Jan. 1, 1954, ibid.

41. E. L. Vinton to Teale, Jan. 20, 1954, ibid.; Gordon Wilson to Teale, Feb. 12, 1966, ibid.; Carl A. Wagner to Teale, May 27, 1969, ibid.

42. Peggy Mauss to Teale, Jan. 29, 1952, ibid., box 165; Ruby C. Eldredge to Teale, June 22, 1955, ibid.; Jean M. Crothers to Teale, Dec. 7, 1967, ibid., box 161.

43. Adelaide R. Penders to Teale, Mar. 12, 1952, ibid., box 160; Ellis Lucia, May 3, 1966, ibid., box 161; Mrs. James L. Respers to Teale, Mar. 1, 1967, ibid., box 167; William A. Turnbaugh, July 30, 1967, ibid., box 161; Miss Gretchen Schuh to Teale, Nov. 16, 1966, ibid.

44. Mr. and Mrs. Riley D. Kaufman to Teale, Nov. 20, 1960, ibid.; June Johnston to Teale, Apr. 4, 1954, ibid., box 160; autobiographical notes (1958) in ibid., box 174; Edwin Way Teale, *Wandering Through Winter* (New York, 1965), 346.

45. Margaret Cornwell to Teale, Mar. 2, 1966, Teale Papers, box 166, DLUC; Rudolf G. Hosse to Teale, Dec. 27, 1965, ibid.; Swiggett to Teale, Oct. 26, 1956, ibid., box 161. See also Hosse to Teale, Dec. 10, 1960, ibid., box 166.

46. See Teale, *Journey into Summer*, 333–35; David Rains Wallace, *Idle Weeds: The Untamed Garden and Other Personal Essays* (Columbus, Ohio, 1986), 27.

47. Mrs. Henry A. Hespenheide to Teale, July 2, 1957, Teale Papers, box 166, DLUC; Ralph H. Leffler to Teale, Jan. 19, 1970, ibid., box 165.

48. James Kieran to Teale, Apr. 30, 1957, ibid., box 166; Tommy Gassiot to Teale, Apr. 9, 1969, ibid.

49. See Natalie Bowen to Teale, Feb. 13, 1961, ibid.

50. Emma Speer to Borland, June 24, 1945, Borland Papers, box 49, BLYU; Mrs. Michael Drury to Borland, Jan. 15 and July 24, 1967, and Borland to her, Jan. 22, 1967, ibid. For Borland's belief that his *Book of Days* (New York, 1976) was "philosophical," see Borland to Mignon G. Eberhart, Aug. 6, 1976, ibid., box 47.

51. Letters to the editor from Edward Truth, Feb. 24, 1978; Theodore Mazaika, Feb. 27, 1978; Barbara Whitcomb, Feb. 27, 1978; and Margaret Trevor Pardee, Feb. 26, 1978, all in ibid., box 36.

52. Wyeth to John B. Oakes, Jan. 14, 1964, ibid., box 49; Borland to Wyeth, Jan. 30, 1964, ibid.

53. For the hearses, see Mary Frances Williams, *Catalogue of the Collection of American Art at Randolph-Macon Woman's College* (Charlottesville, 1977), 182; Andrew Wyeth, *The Four Seasons: Paintings and Drawings* (New York, 1963); Richard Meryman, *Andrew Wyeth: A Secret Life* (New York, 1996), 47.

54. Gottscho to Teale, Dec. 28, 1965, Teale Papers, box 151, DLUC. Harding's biography was published in November 1965. Gottscho's intended "autobiography" was titled *Seventy-One Years: Or, My Life with Photography* but was never published. His set of four seasons images was made between 1932 and 1965. Division of Prints and Photographs, Library of Congress, Washington, D.C.

55. Ruth Bonner to Borland, Mar. 25, 1964, Borland Papers, box 7, BLYU; The one-day-at-a-time approach was recommended in Wes Lawrence's review in the *Cleveland Plain Dealer*, Mar. 24, 1964, a sentiment echoed exactly by Victor P. Hass

in the *Omaha World Herald*, Oct. 4, 1964, both clippings in ibid.; Borland, "Summer: A Time for Perspective," *The Progressive* 34 (July 1970): 24.

56. John Burroughs, *Winter Sunshine* (1875; New York, 1917), 41–42.

57. *New Yorker*, Nov. 21, 1953, 222; *America*, Oct. 2, 1965, 375.

58. Taber, *Stillmeadow Calendar*, 229; Susie and Bryson Ahlers to Teale, July 4, 1967, Teale Papers, box 166, DLUC.

59. *The Progressive* 33 (Jan. 1969): 26; 34 (July 1970): 23; 35 (May 1971): 25; 37 (Nov. 1973): 26. See Robert McHenry and Charles Van Doren, eds., *A Documentary History of Conservation in America* (New York, 1972).

60. Beston to Teale, Nov. 17, 1947, Teale Papers, box 160, DLUC. For constant reiterations in this vein, see Beston's letters in Houghton Library, Harvard University, Cambridge, Mass., especially to Oswald Garrison Villard and Rosalind Richards, as well as his "Country Chronicle" columns, which appeared in *The Progressive* from 1945 until 1957.

61. William E. Buckley to Teale, Feb. 2, 1957, Teale Papers, box 166, DLUC; Mona R. Trigg to Teale, Oct. 14, 1959, ibid., box 165; Borland, "Autumn and the Forgotten Certainty," *The Progressive* 31 (Oct. 1967): 27–28.

62. See chapters 3 and 4, and "The Four Seasons," *Putnam's Monthly Magazine* 9 (Apr. 1857): 368–74; James Buckham, *Afield with the Seasons* (New York, 1907), 70; Louise Antrim to Burroughs, Oct. 5, 1913, Burroughs Papers, box 66, Vassar College Library, Poughkeepsie, N.Y.; Louise Bacon Buck to Burroughs, n.d., ibid.

63. Joseph Wood Krutch, *The Twelve Seasons: A Perpetual Calendar for the Country* (New York, 1949), 102; Gladys Taber, *Stillmeadow Seasons* (Philadelphia, 1950), 62, 161, 254.

64. Edward W. Isakson to Teale, Apr. 15, 1953, Teale Papers, box 165, DLUC; Ruth Wilson to Teale, Nov. 18, 1957, ibid., box 166. See also Daniel K. Steinway to Teale, Oct. 13, 1967, ibid., box 161.

65. Hal Borland, "The Solstice and the Certainty," *The Progressive* 30 (Jan. 1966): 12; Borland, "The Solstice: Still a Miracle," ibid. 39 (Dec. 1975): 53. See also his very last essay, published posthumously, "Spring and Beginnings," ibid. 42 (May 1978): 34, in which he remarked poignantly that city folks "too often have only the sketchiest idea of the elaborate interplay of natural factors that govern the seasons."

66. Janet Baldwin Kroll to John B. Oakes, Mar. 4, 1973, Borland Papers, box 36, BLYU; Borland to Kroll, Mar. 17, 1973, ibid.

67. Borland, "January: Winter and the Totals," *The Progressive* 31 (Jan. 1967): 16.

68. Gladys Taber, *Stillmeadow Daybook* (Philadelphia, 1955), 15; Hal Borland, "April and the Challenges," *The Progressive* 27 (Apr. 1963): 16; Borland, *Homeland*, 82.

69. Frankel to Borland, Jan. 11, 1977, Borland Papers, box 36, BLYU; Borland to Frankel, Jan. 14, 1977, ibid.

70. Wilson Flagg, *A Year with the Birds: or, The Birds and Seasons of New England* (Boston, 1875), 245, 266, 300; Flagg, *Studies in the Field and Forest* (Boston, 1857), 211–12; Hamil Dellenbough to Burroughs, Nov. 16, 1907, Burroughs Papers, box 1, ALUVA; Burroughs to Ethel Doolittle, Jan. 11, 1908, Burroughs Papers, box 1, fol. 28, Hartwick College Library, Oneonta, N.Y.

71. Krutch, *The Twelve Seasons*, 148–49; Teale, *Wandering Through Winter*, 3, 32;

Hal Borland, "Winter: Down to Earth," *The Progressive* 32 (Jan. 1968): 20–21; Borland, *Homeland*, 71.

72. Bradford Angier to Teale, Mar. 16, 1962, Teale Papers, box 161, DLUC; Katharine W. Baldwin to Teale, Mar. 5, 1958, ibid., box 160; Marie Armstrong to Teale, Jan. 12, 1967, ibid., box 161.

73. Arnold and Yvonne Anderson to Teale, Sept. 18, 1960, ibid.; Helen Clark Grimes to Teale, Mar. 21, 1961, ibid., box 167; Virgil, *The Georgics*, ed. and trans. L. P. Wilkinson (London, 1982), 63. For anticipations of Grimes's feelings, see H. G. O. Blake, ed., *Winter: From the Journal of Henry David Thoreau* (Boston, 1887), 132, 163, 247.

74. Joseph Wood Krutch, "How Spring Comes to America," *Family Weekly*, May 17, 1968, 4–5; Hall, *Country Year*, 27–28; Edwin Way Teale, *A Walk Through the Year* (New York, 1978), 34, 378–79, 397; Hal Borland, "The Turning Year: Springsong," *The Progressive* 22 (Apr. 1958): 19.

75. Barbara Arguimbeau to Teale, Apr. 10, 1962, Teale Papers, box 165, DLUC; Virginia R. Crocker to Teale, Nov. 28, 1968, ibid.; Margaret Leahy to Teale, Mar. 20, 1966, ibid., box 161; David O. Mocine to Teale, Apr. 18, 1970, ibid., box 165.

76. Hal Borland, *Sundial of the Seasons* (Philadelphia, 1964), 94; Borland, "October—and Answers," *The Progressive* 30 (Oct. 1966): 25.

77. Donovan Richardson, "On Tour with the Teales," *Christian Science Monitor*, Oct. 2, 1965, 9; Teale, *North with the Spring*, 188, 333; Teale, *Journey into Summer*, 345; Teale, *Autumn Across America* (New York, 1956), 2, 108.

78. Charles B. Seib, *The Woods: One Man's Escape to Nature* (Garden City, N.Y., 1971), 102.

Chapter Six

1. Teale to Rachel Carson, Jan. 4, [1954], and Dec. 16, 1960, Carson Papers, box 106, BLYU.

2. Ron Powers, *White Town Drowsing* (Boston, 1986), 175–76; Mary Taylor Simeti, *On Persephone's Island: A Sicilian Journal* (San Francisco, 1986), 78.

3. Stephen King, *Different Seasons* (New York, 1982), 526.

4. See Rudolf and Margot Wittkower, *Born Under Saturn: The Character and Conduct of Artists. A Documented History from Antiquity to the French Revolution* (London, 1963), 8–22.

5. Wendell Berry, *Collected Poems* (San Francisco, 1985), 212. See also "An Autumn Burning," in ibid., 212–13, and Herman Nibbelink, "Thoreau and Wendell Berry: Bachelor and Husband of Nature," *South Atlantic Quarterly* 84 (Spring 1985): 127–40.

6. Charles Frazier, *Cold Mountain* (New York, 1997), 276, and see 330. For the problem of defining popular culture, see Michael Kammen, *American Culture, American Tastes: Social Change and the Twentieth Century* (New York, 1999), chap. 1.

7. Hannah Tillich, *From Time to Time* (New York, 1973), 235.

8. For an overview, see Lawrence Buell, *The Environmental Imagination: Thoreau, Nature Writing, and the Formation of American Culture* (Cambridge, Mass., 1995), and Peter A. Fritzell, *Nature Writing and America: Essays Upon a Cultural Type* (Ames, Iowa, 1990).

9. For a superb anthology of seasonal writing relating to a single region, see Michael P. Branch and Daniel J. Philippon, eds., *The Height of Our Mountains: Nature Writing from Virginia's Blue Ridge Mountains and Shenandoah Valley* (Baltimore, 1998).

10. John Janovy Jr., *Keith County Journal* (New York, 1978), 197–99.

11. Donald Hall, *Seasons at Eagle Pond* (Boston, 1987), 19, 23, 59, 77–78, 82–83. For a fair review, see the *Washington Post Book World*, Dec. 17, 1987, C17.

12. John Keats, *Of Time and an Island* (Syracuse, 1987), 245.

13. Sue Hubbell, *A Country Year: Living the Questions* (New York, 1986), 210; *NYTBR*, Apr. 13, 1986, 20. See also *Los Angeles Times*, Apr. 13, 1986, p. 3 of the book review section; *Washington Post Book World*, Apr. 27, 1986, 11.

14. Simeti, *On Persephone's Island*, 35, 47; *NYTBR*, Apr. 20, 1986, 14; and see *Washington Post*, Mar. 25, 1986, C10.

15. Ann Haymond Zwinger, *Beyond the Aspen Grove* (New York, 1970), 3–4.

16. Annie Dillard, *Pilgrim at Tinker Creek* (1974; New York, 1999), 13, 76.

17. See Gary McIlroy, "*Pilgrim at Tinker Creek* and the Social Legacy of *Walden*," *South Atlantic Quarterly* 85 (Spring 1985): 111–22; Philip Yancey, "A Face Aflame: An Interview with Annie Dillard," *Christianity Today*, May 5, 1978, 16; and for a diverse array of initial responses, Hayden Carruth, "Attractions and Dangers of Nostalgia," *Virginia Quarterly Review* 50 (Autumn 1974): 637–40; Eudora Welty, "Meditation on Seeing," *NYTBR*, Mar. 24, 1974, 4–5; *America*, 130 (Apr. 20, 1974): 312–14.

18. Dillard, *Pilgrim at Tinker Creek*, 73–76, 83, 184, 186.

19. In addition to the *Helliconia* series, all published by Cape in London and Atheneum in the United States, see the very useful study by Michael R. Collings, *Brian Aldiss* (Mercer Island, Wash.: Starmont House, 1986).

20. Tracy Kidder, *Among Schoolchildren* (Boston, 1989), 271; H. G. Bissinger, *Friday Night Lights* (Reading, Mass., 1990), 255.

21. Jack H. Pollock, "Norman Rockwell: The People's Painter," *Coronet* 21 (Apr. 1947): 170–76; R. W. Holmquist to Rockwell, Apr. 18, 1947, Rockwell Papers, box 1, Rockwell Museum and Archives, Stockbridge, Mass.; Mildred E. Bittingham to Rockwell, Dec. 31, 1947, ibid.; Effie J. Bengston to Rockwell, Nov. 9, 1961, ibid.

22. See Laurie Norton Moffatt, *Norman Rockwell: A Definitive Catalogue* (Hanover, N.H., 1986), 1:309–11; Mrs. Boyd O. Burkey to Rockwell, Mar. 17, 1964, Rockwell Papers, box 14, Rockwell Museum and Archives, Stockbridge, Mass.; Alta Moorman Gavin to Rockwell, Oct. 24, 1965, ibid.; Kenneth E. Pifer to Rockwell, Nov. 17, 1965, ibid.; Marion L. Crawley (Athletic Director at Jefferson High School in Lafayette, Ind.) to Rockwell, Apr. 22, 1966, ibid.

23. Mrs. Harry Plumaker to Rockwell, Jan. 4, 1951, ibid.; Mrs. C. D. Foss to Rockwell, Jan. 8, 1951, ibid.; Ted Stillwell (Ephrata) to Rockwell, Jan. 29, 1951, ibid.; Dorothy Helmer (Brown & Bigelow) to Rockwell, Oct. 5, 1960, ibid.

24. See Moffatt, *Rockwell: A Definitive Catalogue*, 301, 305–17; Oris C. Fairhurst to Rockwell, Easter 1952, Rockwell Papers, box 1, Rockwell Museum and Archives, Stockbridge, Mass.

25. Rockwell as told to Nanette Kutner, "All Kinds of Love," *American Weekly*, Oct. 24, 1954, 16–19.

26. The B&B in-house magazines are not dated, but sheets pertaining to Rockwell's calendars are with his fan mail in Rockwell Papers, box 14, Rockwell Museum and Archives, Stockbridge, Mass. Beverley Freeman to Rockwell, ca. 1960, ibid.; Helen G. Taylor to Rockwell, Dec. 4, 1965, ibid.

27. Clair V. Fry (art director at B&B) to Rockwell, July 12 and 17, 1962, ibid.

28. Janet Scheuneman to Rockwell, Oct. 5, 1962, ibid.; John R. Owen to Rockwell, Aug. 9, 1963, ibid.; Bob Hoff to Rockwell, Aug. 17, 1963, ibid.; Mrs. J. W. Needham to Rockwell, n.d., ibid.; Mrs. J. Valluzzo to Rockwell, Nov. 29, 1961, ibid.; Grace B. Stafford to Rockwell, Jan. 11, 1966, ibid.

29. See George Mendoza, *Norman Rockwell's Four Seasons* (New York, 1982).

30. Summer 1999 newsletter from Literacy Volunteers of Tompkins County, Inc., 124 West Buffalo St., Ithaca, N.Y. 14850.

31. All of Caygill's papers and seminar videos have been deposited in Special Collections at Cornell University Library, Ithaca, N.Y. See Carole Jackson, *Color Me Beautiful* (New York, 1980), and Richard Martin, *The Four Seasons* (New York: Metropolitan Museum of Art, The Costume Institute, 1987, ex. cat.).

32. Maxine Kumin, "The Country Kitchen," in *In Deep: Country Essays* (New York, 1987), 96–99.

33. Obituary of Edith McClain, *Ithaca Journal*, May 17, 2001, 4A.

34. See Cass Peterson, "Plants That Speak for Their Seasons," *NYT*, Apr. 16, 2000, sec. 9, p. 9; "Shedding Light on Evening Gardens," *Los Angeles Times*, Nov. 4, 1993, J2. See Brian Mathew, *Bulbs: The Four Seasons: A Guide to Selecting and Growing Bulbs All Year Round* (London, 1998).

35. John Hay, *Nature's Year: The Seasons of Cape Cod* (Garden City, N.Y., 1961), 13.

36. For the ad see *Preservation* (magazine of the National Trust for Historic Preservation), Sept. 2001, 3; "Long Island," *Look*, Sept. 7, 1965, pp. 61–69.

37. I am grateful to Professor Michele Bogart of SUNY, Stony Brook, for bringing this monument to my attention.

38. Eliot Porter and Henry David Thoreau, *In Wildness Is the Preservation of the World* (San Francisco, 1962). The Sierra Club had started to publish handsome coffee table books glorifying the wonders of nature in 1960. Porter's project began with a photographic exhibition, "The Seasons," which traveled from Santa Fe to Baltimore, Kansas City, San Francisco, and eventually the George Eastman House Museum of Photography in Rochester, N.Y., in 1959–1960. See Finis Dunaway, "Remembering Nature: Environmental Images and the Search for American Renewal, 1890–1970" (Ph.D diss., Rutgers University, 2001), chap. 6.

39. Hal Borland and Les Line, *Seasons* (Philadelphia, 1973); George Stevens to Borland, Sept. 3, 1973, Borland Papers, box 49, BLYU. Material pertaining to the book in ibid., box 7.

40. Joellyn Duesberry, Pattiann Rogers, David Park Curry, *A Covenant of Seasons* (New York: Hudson Hills Press, 1998).

41. Ronald Blythe, *England: The Four Seasons* (London, 1993), 6.

42. Steven Watts, *The Magic Kingdom: Walt Disney and the American Way of Life* (Boston, 1997), 67–68, 87–89, 113–17, 122, 186–87; Robin Allan, *Walt Disney and Europe: European Influences on the Animated Feature Films of Walt Disney* (Bloomington,

Ind., 1999), 97–170, esp. 97, 99, 101, 119, 151–52; Matt Cartmill, *A View to a Death in the Morning* (Cambridge, Mass., 1993), for seasonality and the appeal of *Bambi*.

43. Gregg Mitman, *Reel Nature: America's Romance with Wildlife on Film* (Cambridge, Mass., 1999), 125–28.

44. Arlene Alda, *On Set: A Personal Story in Photographs and Words* (New York, 1981), 11; John O'Connor, "Alan Alda's New Series Is Off to a Hilarious Start," *NYT*, Feb. 5, 1984, H5. In 2001 Diane Kitchen made a seventeen-minute silent film titled "Wot the Ancient Sod," which is supposed to follow the four seasons through close-ups and dissolves of leaves changing color, dying, and being "re-born." One San Francisco–based critic called it a "tour-de-force." When I saw it in March 2002, the audience was uninspired.

45. Stephen Holden, "The Elaborate Fantasies of Love and Longing," *NYT*, Oct. 2, 1998, E22; Dana Thomas, "A Student of Young Love Turns to Middle Age," *NYT*, July 4, 1999, sec. 2, p. 7.

46. David Heineman, "Reinventing Romance: Eric Rohmer's *Tales of the Four Seasons*: Freedom, Faith, and the Search for the Grail," *Film Comment* 36 (Sept. 1998): 50–54; David Denby, "French Connections," *New Yorker*, Feb. 19, 2001, 230–32.

47. See A. O. Scott, "A Book of Love, a Chapter at a Time," *NYT*, Feb. 11, 2001, sec. 2, p. 13.

48. Woody Guthrie, *Bound for Glory* (New York, 1943), 37–38.

49. Tony Scherman, "Fiddling While the Old Barriers Burn," *NYT*, Apr. 2, 2000, sec. 2, p. 37. O'Connor's composition was performed on New Year's Day, 2002, by the Buffalo Symphony and broadcast on National Public Radio.

50. Iris Fanger, "To Dance Vivaldi, Just Ask Vivaldi," *NYT*, Sept. 24, 2000, sec. 2, p. 6.

51. In 2001 another Australian, poet John Tranter, wrote a sequence of four haibun devoted (roughly) to the four seasons theme. The "haibun" is a form developed in seventeenth-century Japan that usually consists of a page or so of prose followed by a haiku. Tranter's seasonal qualities are somewhat reversed because he is Australian. They have not yet been published. Communication from Tranter to the author by e-mail, Jan. 15, 2002, with texts of the haibun, which begin with Spring and conclude with Winter.

52. Gene Hill, *Hill Country* (New York, 1978), 115–18; John Ed Pearce, *Seasons: A Collection of Essays, Vignettes and Random Thoughts* (Louisville, Ky., 1983), 59, 81–83, 84–86, 104–6, 113–15.

53. Mike Royko, "Ah Me, the Blessings of Our Four Seasons," *Ithaca Journal*, Nov. 8, 1986, 10A.

54. Rachel Dickinson, "Seasons Aren't All That Change," ibid., Sept. 20, 1999, 3A. See also the collected essays of an upstate New York journalist, Rick Marsi, *Wheel of Seasons* (Binghamton, N.Y.: Bufflehead Books, 1988).

55. Joseph Wood Krutch, "How Spring Comes to America," *Family Weekly*, Mar. 17, 1968, 4–5.

56. JoAnn Wypijewski, ed., *Painting by Numbers: Komar and Melamid's Scientific Guide to Art* (New York, 1997), 94. An exhibition based upon Vitaly Komar and Alexander Melamid's survey but with more information about seasonal preferences

in the United States, "The People's Choice: An Art Project," was installed at the Santa Barbara Museum of Art during the spring and summer of 1999.

57. *Wizard of Id* in the *Ithaca Journal*, Aug. 20, 2001; Sarah Boxer, "Jules Feiffer, at 71, Slows Down to a Gallop," *NYT*, June 17, 2000, B11; *New Yorker*, July 7, 1997, 55.

58. Verlyn Klinkenborg, "The Blockbuster Culture of Summer," *NYT*, Aug. 19, 2001, E12; "The Seasonal Threshold," ibid., Sept. 26, 2001, p. A18. And see Verlyn Klinkenborg, *The Rural Life* (Boston, 2003).

59. See Matthew Dennis, *Red, White, and Blue Letter Days: An American Calendar* (Ithaca, 2002), 9–10; *Washington Post and Times Herald*, June 20, 1959, A5.

Chapter Seven

1. Harold Altman and William Styron, *The Four Seasons* (University Park, Pa., 1965), unpaginated essay; Styron to the author, Feb. 23, 2000.

2. Frank Anderson Trapp, *Peter Blume* (New York, 1987), 117; obituary in *NYT*, Dec. 1, 1992, B12. As early as 1927 Blume completed *Winter, New Hampshire* (located in the Museum of Fine Arts, Boston), evoking a traditional farmscape. Seasonality had obviously been gestating in his mind for more than thirty-five years.

3. Trapp, *Peter Blume*, 118–20, 128–29. I am indebted to Blume's erstwhile dealer, Terry Dintenfass, for providing me with an image of *Spring*, which was painted after Trapp's book had been published.

4. See John House, *Monet: Nature into Art* (New Haven, 1986), 196–201, 215–16, 220–25; Paul Hayes Tucker, *Monet in the Twentieth Century* (New Haven, 1998), 8, 17, 24.

5. Five-page press release from the First Chicago National Bank, Sept. 24, 1974, and three pages in Sept. 1996. For public reactions, see the *Chicago Tribune*, Sept. 18, 1974, 14; Charles-Gene McDaniel, "Chicago's Outdoor Sculpture," *The Progressive* 39 (Feb. 1975): 53; James L. Riedy, *Chicago Sculpture* (Urbana, 1981), 256–58.

6. *James McGarrell: Recent Paintings* (New York: Frumkin/Adams Gallery, 1992, ex. cat.); McGarrell to the author, Apr. 14, 1992.

7. *James McGarrell: Ten Years of Big Paintings* (Springfield, Mo.: Springfield Art Museum, 1994, ex. cat.). To see all of McGarrell's *Redwing Stanza*, along with his own notes about the paintings and an essay about them by writer Allan Gurganus, go to McGarrell's website, ‹www.redwingstanza.com›.

8. David Campbell to the author, Apr. 4, 1992; Campbell also sent me an essay he wrote subsequently, "Looking at Trees," that appeared in *The Sun: A Magazine of Ideas*, issue 203 (Nov. 1992), 7–15.

9. Welliver's work is in many museums and can be viewed at the Alexandre Gallery in New York City; and see Neil Welliver, *Prints* (Camden, Me., 1996), 71. Robert Stacey, *The View from Tabor Hill: Paintings and Drawings by Glenn Priestley* (Waterloo, Ont.: University of Waterloo Art Gallery, n.d., ex. cat.). Freed's work can be seen at the Reynolds Gallery in Richmond; Haley's work is handled by the Randall Beck Gallery in Boston; Masur's suite of the *Seasons* is handled by the Barbara Krakow Gallery in Boston.

10. All five paintings remain in private collections, but see Lincoln Kirstein, *Paul Cadmus* (San Francisco, 1992), 138.

11. *Painting in Poetry, Poetry in Painting: Wallace Stevens and Modern Art* (New York: Sidney Mishkin Gallery of Baruch College, 1995, ex. cat.), 13–14; Barbara Bertozzi, *Jasper Johns: "The Seasons"* (Milan, 1996), 12–17.

12. Barbara Rose, "Jasper Johns: The Seasons," *Vogue*, Jan. 1987, 193–99, 259–60.

13. Hart Crane, *Complete Poems*, ed. Brom Weber (Newcastle upon Tyne, U.K., 1984), 53.

14. See John Russell, "'The Seasons': Forceful Paintings from Jasper Johns," *NYT*, Feb. 6, 1987, C1; Michael Brenson, "Jasper Johns Shows the Flag in Venice," *NYT*, July 3, 1988, sec. 2, p. 27; Deborah Solomon, "The Unflagging Artistry of Jasper Johns," *NYT Magazine*, June 19, 1988, 20–23, 63–65; Sotheby's sale catalogue no. 6774, "Contemporary Art," Nov. 15, 1995, item 36; James Fenton, "A Banner with a Strange Device," *New York Review of Books*, Dec. 19, 1996, 61–67, an essay-review of the major Jasper Johns retrospective exhibition at the Museum of Modern Art in 1996–97.

15. Paul Taylor, "Jasper Johns," *Interview*, July 1990, 123.

16. Georges Boudaille, *Jasper Johns* (New York, 1989), 26.

17. In 1992 these paintings were acquired by the Portland Museum of Art in Portland, Maine.

18. Thomas Cornell, *Paintings: The Birth of Nature* (Brunswick, Me.: Bowdoin College Museum of Art, 1990, ex. cat.), 12, 13. For a lengthy review of the exhibition, see the *Maine Sunday Telegram*, May 27, 1990.

19. Robert Jessup, *The Four Seasons and Drawings in Anticipation of Spring* (New York: Ruth Siegel and Michael Walls Gallery, 1987, ex. cat.), 1–2; Julia W. Boyd in *Robert Jessup: Paintings* (Richmond: Virginia Museum of Fine Arts, 1989, ex. cat.), unpaginated. I am grateful to Jessup for several very helpful conversations during January 2002.

20. Donald Kuspit, "Lisa Zwerling's Seasonal Dreams," brochure for the initial exhibition of these pictures at the First Street Gallery in New York City, Apr. 1–19, 1997. Jed Perl also wrote for this "handout," but more briefly.

21. *Lisa Zwerling: Primitive Mysteries* (Seattle: Frye Art Museum, 2000, ex. cat.), with an essay by Robert Rosenblum; typescript of Zwerling's Frye lecture, Mar. 9, 2000, courtesy of Lisa Zwerling.

22. Barnet's oil paintings are located at the Whitney Museum of American Art in New York City. See Robert Doty, *Will Barnet* (New York, 1984), 86, 104–7, 137.

23. See *The Art of William Harper: Enameled Jewelry and Objects* (New York: Kennedy Galleries, 1981, ex. cat.); *Saints, Martyrs, and Strangers: Enameled Jewelry by William Harper* (New York: Kennedy Galleries, 1983, ex. cat.). I am indebted to Martha Fleischman, president of the Kennedy Galleries in New York City, for calling Harper's work to my attention and making transparencies of the goblet in each of its seasons available to me.

24. Sue Scott and Richard S. Field, *Jennifer Bartlett: A Print Retrospective* (Orlando, Fla.: Orlando Museum of Art, 1993, ex. cat.), 9–10.

25. Ibid., 10–11.

26. E-mail messages from Abrons to the author, May 30 and June 2, 2002.

27. Announcement and leaflet sheets from the Michael Walls Gallery, Inc., New

York City, Feb. 1992. I am grateful to Abrons and Sharpe for providing me with slides of all eight paintings as well as slides of Abrons's previous ones from the 1980s after I attended the exhibit in March 1992.

28. Interview with Anne Abrons and David Sharpe, Nov. 19, 1992.

29. Letter from Anne Abrons to the author, Feb. 7, 2002; and see *Anne Abrons* (Chicago: Sonia Zaks Gallery, 2000, ex. cat.).

30. Kirk Varnedoe, *Cy Twombly: A Retrospective* (New York, 1994), 50. In Greek mythology Silenus was a rural god, one of the retinue of Bacchus, usually shown with drinking cups and bunches of grapes.

31. Jed Perl, "Twombly Time," *New Republic*, Nov. 14, 1994, pp. 28–32.

32. *Felix de la Concha: Gates of Darkness as Mirrors of Light* (Columbus, Ohio: Columbus Museum of Art, 1998, ex. cat.), unpaginated.

33. Press release from Annegreth Hill, Columbus Museum of Art, Columbus, Ohio, May 25, 1998; Nancy Gilson, "Former Columbus Painter Reflects Changing World Around Him," *Columbus Dispatch*, June 18, 1998, E8.

34. Quoted in Richard Lebeaux, *Thoreau's Seasons* (Amherst, Mass., 1984), 233; John Burroughs, *Signs and Seasons* (Boston, 1914), 37.

35. See Joanne Gill, "Someone Else's Misfortune: The Vicarious Pleasures of the Confessional Text," *Journal of Popular Culture* 35 (Summer 2001): 81–93; David Haven Blake, "Public Dreams: Berryman, Celebrity, and the Culture of Confession," *American Literary History* 13 (Winter 2001): 716–36.

36. William D. Snodgrass, *Selected Poems, 1957–1987* (New York, 1987), 29.

37. Ibid., 35.

38. Ibid., 36, 47.

39. Antonio Vivaldi, *The Four Seasons*, trans. W. D. Snodgrass (New York, 1984). It is not entirely clear whether Vivaldi composed the sonnets himself or had them written by one of his regular librettists under his supervision.

40. I am indebted here to the brilliant essay by Fred Chappell, "The Music of 'Each in His Season,'" in Philip Raisor, ed., *Tuned and Under Tension: The Recent Poetry of W. D. Snodgrass* (Newark, Del., 1998), 72–87, the quotation at 74–75.

41. Ibid., 75.

42. W. D. Snodgrass, *Each in His Season* (Brockport, N.Y., 1993), 55–76.

43. Ibid., 56, 63, 73.

44. Ibid., 76. Cf. "Vivaldi's *La Primavera* Breaks Down," by Daryl Ngee Chinn, in Chinn's *Soft Parts of the Back: Poems* (Orlando, 1989), 58–59. Other seasonal poems by Chinn appear on 60–64.

45. Chappell, "The Music of 'Each in His Season,'" 82. In 2000 the Nashville Public Library commissioned Snodgrass to write four seasonal sonnets as companion pieces to four pairs of seasonal chairs painted by DeLoss McGraw. The chairs were inaugurated in 2001, and the sonnets, titled "Well-Seasoned Chairs for a Child," were completed in time for that occasion.

46. Mary Oliver, *Twelve Moons* (Boston, 1979), 72–73; John Janovy Jr., *Keith County Journal* (New York, 1978), 112–13.

Conclusion

1. Mary Rogers Miller, *The Brook Book: A First Acquaintance with the Brook and Its Inhabitants Through the Changing Year* (New York, 1902), 166; Edwin Way Teale, *Journey into Summer* (New York, 1960), 336.

2. Anthony Smith, *The Seasons: Life and Its Rhythms* (New York and London, 1970); Richard Adams and Max Hooper, *Nature Through the Seasons* (London and New York, 1975).

3. Natalie Angier, "Seasons Sway Human Birth Rates," *NYT*, Oct. 2, 1990, C6.

4. Ibid.

5. Sandra Blakeslee, "Men's Scores Linked to Hormone," *NYT*, Nov. 14, 1991, B14. See also Natalie Angier, *Woman: An Intimate Geography* (Boston, 1999), esp. 267–86 on testosterone in female physiology. Unfortunately this fascinating book does not discuss seasonality, circadian rhythms, and several other topics that Angier has covered in her science reporting.

6. Natalie Angier, "Modern Life Suppresses an Ancient Body Rhythm," *NYT*, Mar. 14, 1995, C1; Thomas A. Wehr et al., "Suppression of Men's Responses to Seasonal Changes in Day Length by Modern Artificial Lighting," *American Journal of Physiology* 269 (July 1995, pt. 2): R173–78. For James Agee, according to his biographer, "winter brought on sadness and fits of masochism"; see Geneviève Moreau, *The Restless Journey of James Agee* (New York, 1977), 48.

7. Shankar Vedantam, "Did a Bipolar Trait Bring a Turn for the Verse?," *Washington Post*, May 14, 2001, A7. For discussions of seasonal affective disorder and its manifestations in different parts of the northern United States, see Winifred Gallagher, *The Power of Place: How Our Surroundings Shape Our Thoughts, Emotions, and Actions* (New York, 1993), 27–39, 41–43, 61, and T. Partonen and A. Magnusson, eds., *Seasonal Affective Disorder: Practice and Research* (New York, 2001).

8. See Farida A. Wiley, ed., *John Burroughs' America: Selections from the Writings of the Naturalist* (New York, 1951), 84, 93, 118; Samuel C. Schmucker, *Under the Open Sky, Being a Year with Nature* (Philadelphia, 1910), 46–47, 240–42; Edwin Way Teale, *North with the Spring* (New York, 1951), 171.

9. *Seasons of Light* is located in the Metropolitan Museum of Art, New York City, and is reproduced in Lowery Stokes Sims, *Richard Pousette-Dart (1916–1992)* (New York, 1997), pl. 4. See Michael Kammen, "Charles Burchfield and the Procession of the Seasons," in *The Paintings of Charles Burchfield: North by Midwest*, ed. Nannette V. Maciejunes and Michael D. Hall (New York, 1997), 43–46.

10. H. G. O. Blake, ed., *Early Spring in Massachusetts: From the Journal of Henry David Thoreau* (Boston, 1881), 79, 159; John Burroughs, *Signs and Seasons* (Boston, 1914), 149–50; Wiley, ed., *John Burroughs' America*, 88; Leonard Hall, *Country Year: A Journal of the Seasons at Possum Trot Farm* (New York, 1957), 205–6; Donald Culross Peattie, *An Almanac for Moderns* (New York, 1935), 387; Teale, *North with the Spring*, 40, 171, 127–28; Bernd Heinrich, *A Year in the Maine Woods* (Reading, Mass., 1994), 221, 240.

11. Hall, *Country Year*, 7; John Burroughs, "The Spring Bird Procession," in Burroughs, *Field and Study* (New York, 1919), 3, 17, 22; Mabel Osgood Wright, *The Friendship of Nature: A New England Chronicle of Birds and Flowers* (1894; Baltimore,

1999), 105–6; Peattie, *Almanac for Moderns*, 50; Edwin Way Teale, *Autumn Across America* (New York, 1956), 120. See also Teale, *North with the Spring*, 209–10; Teale, *Journey into Summer* (New York, 1960), 318; Rachel Carson, *Under the Sea-Wind: A Naturalist's Picture of Ocean Life* (New York, 1941), 211–31.

12. Blake, ed., *Early Spring in Massachusetts: From the Journal of Thoreau*, 217; H. G. O. Blake, ed., *Summer: From the Journal of Henry David Thoreau* (Boston, 1884), 41.

13. Blake, ed., *Summer: From the Journal of Thoreau*, 37, 40, 42–43, 66, and the extract at 57. See Sharon Cameron, *Writing Nature: Henry Thoreau's Journal* (New York, 1985), esp. 140.

14. H. G. O. Blake, ed., *Autumn: From the Journal of Henry David Thoreau* (Boston, 1892), 233, 279; Wilson Flagg, *A Year with the Birds: or, The Birds and Seasons of New England* (Boston, 1875), 187. See also Cameron, *Writing Nature*, 62; Richard Lebeaux, *Thoreau's Seasons* (Amherst, Mass., 1984), 140–41, 185–86; Blake, ed., *Early Spring in Massachusetts: From the Journal of Thoreau*, 154.

15. Wiley, ed., *John Burroughs' America*, 121; Teale, *North with the Spring*, 8, 321; Teale, *Autumn Across America*, 42; Edwin Way Teale, *Wandering Through Winter* (New York, 1965), 3, 133–34; *NYT*, Mar. 11, 1987, A26; Diane Ackerman, *Cultivating Delight: A Natural History of My Garden* (New York, 2001), 190.

16. Blake, ed., *Autumn: From the Journal of Thoreau*, 88, 91, 159–60; Miller, *The Brook Book*, 189–90.

17. Wilson Flagg, *Studies in the Field and Forest* (Boston, 1857), 274–75; Edith Wharton, *Summer* (New York, 1917), 164–65, 182, 203–4, 208; Teale, *Autumn Across America*, 88. The complete title of Hardy's novel is *Under the Greenwood Tree, or The Mellstock Quire: A Rural Painting of the Dutch School* (1872; London, 1974).

18. Lawrence Buell, *The Environmental Imagination: Thoreau, Nature Writing, and the Formation of American Culture* (Cambridge, Mass., 1995), 228; John Burroughs, "Spring Relish," in Burroughs, *Signs and Seasons*, 175, 178; Wiley, ed., *John Burroughs' America*, 95; Frances Theodora Parsons, *According to Season: Talks about the Flowers in the Order of Their Appearance in the Woods and Fields* (1894; New York, 1902), 57. See Scott Slovic, *Seeking Awareness in American Nature Writing: Henry Thoreau, Annie Dillard, Edward Abbey, Wendell Berry, and Barry Lopez* (Salt Lake City, 1992), 47.

19. Aldo Leopold, *A Sand County Almanac and Sketches Here and There* (1949; New York, 1968), 54; Hal Borland, "Autumn and the Color," *The Progressive* 27 (Oct. 1963): 23, reprinted in Borland, *Homeland: A Report from the Country* (Philadelphia, 1969), 37. See also Borland, "Winter: Down to Earth," *The Progressive* 32 (Jan. 1968): 20–21, where he goes on at some length about the meaninglessness of calendars and almanacs; and Teale, *Autumn Across America*, 188, and *Journey into Summer*, 210.

20. Edward J. Renehan Jr., *John Burroughs: An American Naturalist* (Post Mills, Vt., 1992), 126; Fredric Klees, *The Round of the Year: An Almanac* (New York, 1963), 119.

21. Robert A. Rosenstone, *Mirror in the Shrine: American Encounters with Meiji Japan* (Cambridge, Mass., 1988), 100; Tim O'Brien, *Going After Cacciato* (New York, 1978), 48–49.

22. Lebeaux, *Thoreau's Seasons*, 44–45; Slovic, *Seeking Awareness in American Na-*

ture Writing, 27; Buell, *The Environmental Imagination*, 245; Wright, *The Friendship of Nature*, 22; Edwin Way Teale, *Circle of the Seasons* (New York, 1953), 293.

23. Flagg, *Studies in the Field and Forest*, 88; Flagg, *A Year with the Birds*, 113, 266–67.

24. Hal Borland, "July: Summer and Reality," *The Progressive* 31 (July 1967): 12; Borland, "April: Springtime and Belief," ibid., 32 (Apr. 1968), 23. See Slovic, *Seeking Awareness in American Nature Writing*, 24.

25. Virgil, *The Georgics*, ed. and trans. L. P. Wilkinson (London, 1982), 20.

26. Leopold, *Sand County Almanac*, 23, 27, 83, 87. I am indebted to Erica K. Anderson for calling these passages to my attention.

27. Burroughs to Johnson, Oct. 20, 1913, Burroughs Papers, box 1, American Academy of Arts and Letters, New York City; Johnson to Burroughs, Oct. 23, 1913, ibid.

28. Borland, *Homeland*, 9, 131–32. Discussions of the meaning and causes of alienation were very much in the air in the 1960s. See Joseph Wood Krutch, *More Lives Than One* (New York, 1962), 355–57, 363–64; David M. Potter, *History and American Society*, ed. Don E. Fehrenbacher (New York, 1973), chaps. 14–15, on alienation, written in 1963 and 1969.

29. See Teale, *Circle of the Seasons*, 24; Franklin Russell's review of Teale, *A Walk Through the Year* in *The Nation*, Nov. 11, 1978, 502; Hayden Carruth, "Attractions and Dangers of Nostalgia," *Virginia Quarterly Review* 50 (Autumn 1974): 637–40; Philip Yancey, "A Face Aflame: An Interview with Annie Dillard," *Christianity Today*, May 5, 1978, 16.

30. Krutch to Teale, Feb. 3, 1951, Teale Papers, box 152, DLUC; William H. Carr to Borland, Mar. 25, 1967, Borland Papers, box 47, BLYU.

31. Flagg, *Studies in the Field and Forest*, 150, 181, 273–75, 276–77; Blake, ed., *Autumn: From the Journal of Thoreau*, 390; Heinrich, *A Year in the Maine Woods*, 230; Teale, *Wandering Through Winter*, 346.

32. Edward Kennedy Ellington, *Music Is My Mistress* (Garden City, N.Y., 1973), 467.

33. Henry David Thoreau, *Walden* (1854; Princeton, 1971), 165.

34. "'A Sand County Almanac' at 50," *NYT*, Nov. 13, 1999, A4. See also William K. Stevens, "Celebrating an Ecologist's Eloquence and Vision," *NYT*, Oct. 19, 1999, F4. It needs to be acknowledged that not all naturalists and conservationists are of one mind on the matter of mankind's relationship to the land and nature. For a different perspective, which has been controversial itself, see William Cronon, "The Trouble with Wilderness: Or, Getting Back to the Wrong Nature," in William Cronon, ed., *Uncommon Ground: Toward Reinventing Nature* (New York, 1995), 69–90. Cronon contends: "To the extent that we celebrate wilderness as the measure with which we judge civilization, we reproduce the dualism that sets humanity and nature at opposite poles" (81) and "Idealizing a distant wilderness too often means not idealizing the environment in which we actually live, the landscape that for better or worse we call home" (85).

INDEX

Abbey, Edward, 217

Abrons, Anne, plate 36, 240, 256–58

According to Season: Talks about the Flowers in the Order of Their Appearance in the Woods and Fields (Parsons), 134

Ackerman, Diane, 8, 272

Adams, Charlotte, 225

Adams, Henry, 128; seasonal residences of, 114

Adirondacks, as symbol of wildness, 136

Advertising, seasonal art in, 224–27

Affluence, effect on seasonal images, 113–15

Africa, seasons of, 30

African Americans, seasonal work of, 75–77

Agee, James, 155

Agriculture, seasonal images from, 43, 44

Alda, Alan, 231–32

Alda, Arlene, 231, 232

Aldiss, Brian, 218

Aldrich, Thomas Bailey, 119

Alemanni, Luigi, 44

Allegories, of seasons, 45, 58, 66, 140

Allegory of Spring and Summer (Tintoretto), 37

Allegory of the Four Seasons (Manfredi), 58

Allegory of Winter and Autumn (Tintoretto), 37

Allen, Francis H., 184

Allston, Washington, 88

An Almanac for Moderns (Peattie), 20, 110

Almanacs, calendrical, 2, 18–19

Altman, Harold, 241–42, 245

America: contemporary art in, 240–60; contemporary poetry in, 260–64; early seasonal images of, 73–107; nostalgia and nationalism in, 108–39; seasonal diversity in, 141–51; seasonal iconography of, 6, 7, 8, 9, 12, 16, 97–98; seasonal writing in, 98; transitions in seasonality in, 140–74; Victorian seasonal art of, 122–27

An American Year: Country Life and Landscapes Through the Seasons (Borland), 155, 188

Anderson, Jon, 246

Antimodernism, 26, 265

Antiquity, seasonal icons in, 37, 38–45, 50

Appleton, William Sumner, 114

Aratus, 50

Arcimboldo, Giuseppe, 58, 61

Aristophanes, 39

Art: contemporary, in America, 240–60; mid-nineteenth-century, 90–95, 100–102, 115–17; seasonal imagery in, 8; twentieth-century, 155–64; in Victorian America, 121–27. *See also* individual artists and forms of art

Ashmore, Lawrence, 235

Asia, seasons of, 31

Astrological symbols. *See* Zodiac

Atkinson, Brooks, 145

The Atlantic Almanac, 117, 119, 128

Audubon, John James, 190

Augustine, Saint, 41

Austin, George, 32–33

Austin, Mary, 105

Australia, seasonal phases in, 71

Austria, seasonal art of, 59–60

Automobile, seasonal effects of, 27
Autumn Across America (Teale), 176, 180, 181, 189, 195, 196, 200, 201–2, 207, 272
Autumn/fall: American writing on, 98–99; flower representations of, 31, 55; fruit representations of, 37, 38; iconography of, 1, 6, 44, 54, 91, 122; landscape representations of, 33, 94
Avercamp, Hendrick, 56

Bacon, Henry, 141
Baker, Ray Stannard, 150–51
Ball, Charles, on slave life, 76–77
Bamboo, as seasonal icon, 31
Baptismal fonts, seasonal icons on, 47
Barbizon school, 115
Barker, Cicely Mary, 218
Barnet, Will, plate 33, 252–54
Barrus, Clara, 131, 141
Bartlett, Jennifer, plate 43, 3, 241, 254–55
Bartram, John, 182, 190
Bartram, William, 212
Bassano family, seasonal art of, 51
Bastien-LePage, Jules, 142, 195
Beattie, Ann, 229
Beebe, William, 179
Bees and beekeeping, as seasonal symbols, 18, 43, 44
Bellows, George Wesley, plate 24, 139
Bening, Simon, 6, 49, 50, 54
Bennett, William, 92
Benson, Frank, 2, 125, 142
Benton, Thomas Hart, 100, 158
Berry, Wendell, 211
Berryman, John, 260
Beston, Henry, 18, 26, 43, 110, 136, 143, 144–45, 150, 174, 179, 181, 182, 188, 194, 265, 270; Borland and, 200; on country living, 145–46; *Outermost House* of, 18, 26, 110, 145, 146, 182; on seasonal aromas, 152
Bible, 132; seasonal images in, 38
Birds and bird-watching, as seasonal symbols, 3, 19, 31, 32, 34, 99, 104, 131, 134, 149, 151, 237, 242, 269–70, 274

Birth. *See* Conception and childbirth, seasonality of
Bishop, Emily Clayton, 21
Bishop, John Peale, 167
Blake, H. G. O., 132
Blume, Peter, plate 32, 4, 101, 242
Blythe, Ronald, 230
Boar, as seasonal symbol, 40, 41
Bol, Hans, 52, 54
Bonner, Ruth Hard, 198
Book clubs, nature book selections of, 209
Book of Days (Borland), 154–55, 182, 185, 186
The Book of the Seasons; or The Calendar of Nature (Howitt), 88–89
Books, calendrical, 18–19
Books of days, 49
Books of hours, calendars in, 47
Borland, Barbara, 184, 197
Borland, Hal, 3, 9, 18, 19, 20, 21, 23, 26–28 (photo), 29, 32, 49, 150, 151, 181, 184; Beston and, 200; as professional nature writer, 176, 177, 179, 182, 185–86, 188, 199–200, 206, 209, 213, 229, 237, 238, 273, 274–75, 277, 279; readers' responses to, 192, 197–99, 202–4, 278; reviews of, 180, 184, 186, 188; on seasonal changes, 154–55
Bosschaert, Ambrosius, 56
Bosse, Abraham, 58
Botany, role in seasonal art, 123
Boucher, François, 2, 69
Boudaille, Georges, 249
Boudinot, Mrs. Elias, IV, 79, 80
Bowen, Keith, 229
Bowles, Carrington, 81
Boyle, Richard, 142
Bradstreet, Anne, 86–87
Brooks, Paul, 179, 180
Brown, John, 77
Brown & Bigelow, seasonal calenders of, 219, 221–23
Bruegel, Pieter, the Elder, 241; seasonal

art of, plate 3, 2, 3, 11, 51–52, 54, 71, 170, 171, 257, 276

Bruegel, Pieter, the Younger, seasonal art of, 54

Brunton, Richard, 83

Buckham, James, 18, 19, 134, 162, 201

Bucolics (Virgil), 43

Buechner, Thomas, plate 48, 254

Buell, Lawrence, 272

Bui, Tony, 233

Bunrin, Shiokawa, 33

Burchfield, Charles, plates 28 and 29, 3, 21, 28, 32, 36, 153, 159 (photo), 165, 241, 244, 265, 268, 274; on seasonal changes, 154, 158–60

Burne-Jones, Edward, 43

Burroughs, John, 3, 5, 14, 15 (photo), 19, 26, 43, 112, 120, 129–31, 133, 148, 149, 150, 192, 276; calendars of, 223–24; nature writing of, 162, 166, 182, 199, 260, 268, 269, 273; readers' responses to, 146, 173, 194, 201, 204; reviews of, 180; on seasons, 153; on sham nature writing, 151; Thoreau and, 3, 5, 14, 15, 19, 26, 43, 112, 120, 129–31, 149

Cadmus, Paul, plate 35, 101, 240, 246, 260

Calendars: American, 74; early, 73n; modern, 141; Rockwell art for, 219–24; seasonal divisions of, 154; seasonal iconography of, 2, 10, 18–19, 48–50, 121, 210; treatises based on, 45

California, seasons of, 3, 30

Campbell, David, plate 41, 244–45

Campbell, Edwin R., 156

Canova, Antonio, 84

The Canterbury Tales (Chaucer), 2, 46

Cape Cod, seasonal travel to, 227

Caravaggio, 58

Caribbean islands, perceived seasonal absence in, 30–31

Carmina Burana, seasonal motifs in, 47

Carson, Rachel L., 6, 18, 32, 110, 146,

147 (bust), 184, 276; on ocean seasons, 153–54; as professional nature writer, 176, 178, 179, 181, 200, 209, 270; reviews of, 189

Cartoons, seasonal, 235–39

Catacombs, seasonal icons in, 39

Catalogues: seasonal art in, 224–25; for seeds and plants, 136–37

Caterpillar Tractor Company, on snow removal, 27

Catholicism, 167

Catlin, George, 182

Cats, Jacob, 54

Cattle, as seasonal images, 51, 54

Caudle, Todd, 229

Cave, Edward, 65

Caygill, Suzanne, 225

"Celadon and Amelia" (graphic), 79

Celadon and Amelia (Mount), 66, 68

Celadon and Amelia (Thomson), 100

Central Park (New York City), 114–15, 173

Century Magazine, 141

Ceramics, seasonal icons on, 31, 59

Cereals, as seasonal images, 43

Ceres, 16

Cézanne, Paul, 115

Chagall, Marc, plate 34, 240, 242–43, 245

Champney, Benjamin, 274

Chapman, Arthur D., 172

Chapman, Otto, 124

Chappell, Fred, 262, 264

Chardin, Jean, 91

Chaucer, Geoffrey, 2, 73, 230; seasonal motifs in *The Canterbury Tales* of, 46

Childbirth. *See* Conception and childbirth, seasonality of

Children: nature writing for, 218; as seasonal images, 116, 125, 218–24. *See also* Conception and childbirth, seasonality of

Children's art, modern changes in, 141, 161–63, 218

China, seasons of, 31

Christianity, seasonal iconography and, 16, 39, 41, 47, 49, 73, 88–90

Christmas, seasonal imagery of, 9, 162

Church, Frederic E., 122

Circadian rhythms, seasonal changes in, 268

Circle of seasons, 12–16, 32

Circle of the Seasons: The Journal of a Naturalist's Year (Teale), 12, 19, 155, 191, 192–94, 199, 209

City life, seasonal images of, 25–30, 171–74

City readers, of nature writing, 199–204

Civil life, seasonal creativity and, 275–79

Civil War, 103, 104, 137, 212, 276; sentimental seasonality after, 115–20

Clare, John, 230

Clarke, Thomas Shields, plate 21, 29

Clocks, seasonal icons on, 83

Clothing, as seasonal symbols, 1, 50, 58, 59, 70, 83, 84

Coca-Cola, seasonal advertising for, 224–25

Cock, Hieronymous, 52

Coffee-table books, seasonal motifs in, 173, 229–30

Coins, seasonal icons on, 39

Cold War, 239

Cole, Thomas, 24, 32, 34, 43, 65, 90, 121, 123

Colombe, Jean, *Très Riches Heures* of, 48

Color lithography, effects on seed catalogues, 138

Colors, seasonal, 140, 151–52, 225

Conception and childbirth, seasonality of, 71, 75, 164–66, 267

confessional poets, 260–61

Connick, Charles, 165

Conservation movement, nature writers in, 200, 276, 279

Consumerism, role of four seasons in, 224–27

Contemporary art: in America, 240–60; symbolic serialism in, 253–55

Conyngham, Barry, 235

Cookbooks, four seasons themes in, 225

Cooper, Hester, 81

Cooper, James Fenimore, 3, 86

Cooper, Susan Fenimore, 2, 18, 106 (photo), 107, 181, 213

Copernicus, 61, 62, 65

Copland, Aaron, 235

Corn, as seasonal motif, 165

Cornell, Joseph, 157

Cornell, Thomas, plate 39, 249–50, 251

Coronet magazine, Rockwell art for, 219

Cort, Anne Quinn, 225

Cortissoz, Royal, 142

Cosmology, role in seasonal perceptions, 21–22

Cosmopolitanism, in seasonal art, 126

Country Year (Hall), 183

Court of the Four Seasons (Panama-Pacific Exposition, San Francisco, 1915), 141

Courtship, as seasonal symbol, 1, 54, 59, 69, 116

Crane, Hart, 247, 255

The Crayon, 86, 99, 112

Creativity, manic depression and, 268

Crete, Minoan, seasonal icons of, 38

Cronon, William, on New England Indians, 104–5

Cropsey, Jasper, 3, 20, 34, 94, 99, 100, 128, 241; seasonal art of, plates 14–18, 122–23

Cultivation, seasonal, 133–39

Cupples House (St. Louis, Mo.), seasonal icons in, 43

Currier and Ives, seasonal lithographs of, 2, 4, 22, 23, 24, 25, 80, 94, 95, 96, 97, 111–12, 116, 121, 201, 209

Curry, David Park, 229

Curtis, George William, 94

Damon and Musidora, 65–66

Daphnis and Chloë (Longus), 49

da Ponte, Francesco, 51

da Ponte, Leandro, 51, 52

Darley, Felix Octavius Carr, seasonal lithographs of, 115–16, 121

Davidson, Laura Lee, 32, 153

Davis, Stuart, 157

Day, seasons compared to segments of, 24, 39

Death, as seasonal symbol, 103–4, 167, 168

"Deaths Classified by Months and Seasons" (New York State census, 1855), 103

de Berri, Duc Jean, 48

Decorative arts, seasonal motifs in, 3–4, 124, 127

Deities, in seasonal art, 42

de la Concha, Felix, plate 47, 258–60

Delacroix, Eugène, 36, 115

Delius, Frederick, 35

Demopiety, seasons in the city and, 171–74

Demuth, Charles, 170

Denby, David, 233

de Passe, Magdalena, 57

Deseasonalization: of American cities, 27; of diet, 148

The Desert Year (Krutch), 19, 180, 181, 188

DeVoto, Bernard, 141

Dewing, Thomas Wilmer, 123

Dickinson, Emily, 120, 268

Dillard, Annie, 4, 5, 21, 32, 36, 101, 216–17 (photo)

Disney, Walt, seasonal films of, 230–31, 235

Diversity and seasonal perception, in America, 141–51

Dodd, Edward H., Jr., 190–91, 198

Donne, John, 61

Doolittle, Ethel, 132

Dorame, Anthony, 106

Doty, Robert, 253–54

Doughty, Thomas, 36, 86, 87

Douglass, Frederick, 75

Dove, Arthur, 157

Dream Life: A Fable of the Seasons (Mitchell), 117, 119, 120, 150

Drinker, Elizabeth, seasonal poetry of, 74

Dryden, John, 44

du Cerceau, Jean Androuet, 59

Duesberry, Joellyn, 229

Dumbarton Oaks Sarcophagus, seasonal symbols on, 40, 41

Duncan, Henry, 16, 89–90, 201

Durand, Asher B., 34, 86, 94, 101

Durrie, George Henry, plate 12, 95, 128

Dwight, Timothy, 96, 149

East Asia, seasonal icons of, 31

"East Coker" (Eliot), 167

Eastman, George, 83

Ecclesiastes, 38, 234

Eckert, Allan W., 217

Edison, Thomas, 131–32

The Education of Henry Adams, 128

Edwards, Samuel, 65

Egypt, ancient, seasonal symbols of, 38

Elements, iconography of, 2, 58

Eliot, T. S., 167, 240

Ellington, Duke, 278

Ely, Catherine Beach, 143

Emerson, Ralph Waldo, 87, 129, 131, 148, 275; on seasons, 12

Enamelware, seasonal motifs on, 254

Engravings, seasonal images on, 55, 57, 58, 83, 92

Enkvist, Nils Erik, 46, 49–50

Eugenics, seasonality and, 164–66

Euripides, 39

Europe: Renaissance in, humanistic motifs of, 48; seasonal iconography of, 37–71

Evangelism, 89, 90

Fall. See Autumn/fall

Family Circle, 176, 209

Family life, in seasonal symbols, 82

Fantasia, seasonal themes and music of, 230–31

Feiffer, Jules, 238

Females and female beauty: in Currier

and Ives prints, 117; as seasonal symbols, plate 21, 2, 37, 38–39, 40, 51, 54, 57, 65–66, 69, 70, 81, 115, 124, 125, 127, 155–56

Fertility: seasonal effects on, 266; seasonal symbols of, 40, 164–66

Films, seasonal themes in, 224, 230–35

Firestone, Harvey, 131

Fishing, as seasonal icon, 86

"Fishing season," of American slaves, 76

Flagg, Wilson, 22, 113, 118, 120, 128, 129, 142, 149, 151, 154, 166, 204, 272, 274, 275, 278; seasonal writing of, 102–3, 166–67; on the seasons, 113

Flasks, seasonal motifs on, 95

Flemish art, seasonal images in, 51–54

Flinck, Govaert, 17

Flowers, as seasonal images, 1, 31, 37, 38, 39, 44, 50, 55–56, 66, 84, 101, 125, 127, 134–35, 158, 257, 265

Food consumption, seasonality of, 148–49

Foods, as seasonal symbols, 8, 106–7

Ford, Henry, 131, 148

Fountains, seasonal motifs on, 2, 163–66

Four Quartets (Eliot), 167

Four Seasons (Poussin), 24, 35

The Four Seasons of Life (Currier and Ives), 22–25, 121

Four seasons quartet (Millet), 7, 130

Francavilla, Pietro, 37

France, seasonal art of, 6, 59, 65, 69

Francis, John F., plate 11, 91, 92, 101

Frankel, Max, 204

Franklin, Benjamin, 78

Frazier, Charles, 212, 213

Freed, David, 245

Freer, Charles, 123, 143

Freneau, Philip, 87, 91

Frost, Robert, 129, 136

Fruits, as seasonal symbols, 16, 37, 39, 57, 58, 59, 91, 101, 102, 116, 127, 265

Frye, Northrop, 61, 62–63

Fuller, Margaret, 94

Furniture, seasonal motifs on, 83

Gainsborough, Thomas, 66

The Galaxy, 120, 129

Galle, Cornelis, 57

Gannett, Lewis, 187

Gardens and gardening, seasonal symbols in, 99–100, 135, 226

Gentlemen's Magazine, 65

Georgics (Virgil), 11, 16, 43–44, 86, 115, 217, 275, 279

Gérome, Jean Léon, 2

Gerry, Samuel Lancaster, 100, 116

Gerrytsz, Hessel, 56

Gignoux, Regis, 34, 128

Gissing, George, 35

Glacier National Park, seasons of, 9

Glassware, seasonal motifs on, 95, 254

Glasunov, Alexander, 35

Gleason, Herbert W., 181

Gobelins Manufactory, seasonal tapestries of, 59

Golden Age, myth of, plate 5, 21, 43

Goliardic songs, seasonal motifs in, 47

Goltzius, Hendrick, 54

Goodenough Erwin R., on zodiac art, 42

Goodrich, Lloyd, 198

Gorham Manufacturing Company, 127

Gottscho, Samuel H., 198

Gould, Jay, 131

Goya, Francisco, plate 7, 69–71

Graham, Nan Wood, 158

Grains, as seasonal symbols, 40, 44, 49

Grapes and grape vines, as seasonal symbols, 43, 44, 47, 50, 51, 58, 60, 70, 83, 84, 87, 125

Grayson, David, 150, 151, 194. See also Baker, Ray Stannard

Great Britain: coffee-table book on, 230; early calendars of, 73n; seasonal art of, 6, 59–62, 65; seasonal marriage in, 71

Greece, ancient, seasonal icons of, 38–39, 42, 43

"Greenfield Hill" (Dwight), 97, 149

Greenwood, F. W. P., 89

Greeting cards, seasonal motifs on, 121

Gregorian calendar, 19

Grief, seasonal aspects of, 88

Griffin, Arthur, 229

Griffis, William E., 273

Grimmer, Abel, 54

Grimmer, Jacob, 54

Grinnell, George Bird, 182

Gustin, George Wilmont, 126, 127

Guthrie, Woody, 233–34

Haley, Stephen, 245

Hall, Donald, 183, 214, 217

Hall, Isabella, "Spring" needlework of, 81

Hall, Leonard, 110, 174, 183–84, 205–6, 217

Halle, Louis J., 184, 187

Hammerstein, Oscar, II, 233

Hampton Institute, freed slaves at, 77

Hanbury, Una, 147

Hanfmann, George M. A., 41

Harding, Walter, 189, 198

Hardy, Thomas, 272

Harper, William, plate 37, 254

Harper's magazine, 129, 272

Harrington, James, 100

Hart, William, 116

Hartley, Marsden, plate 23, 143

Harvest, as seasonal symbol, 1, 16, 39, 46, 49, 50, 52, 61, 74, 117

Harvey, George, plate 10, 92, 100

Hassam, Childe, 142

Hay, John, 227

Haydn, Franz Josef, 4, 35

"Heart's Needle" (Snodgrass), 261–62

Hecker, Frank J., 123

Heckman, Hazel, 213, 214

Heineman, David, 232–33

Heinrich, Bernd, 36, 218, 269, 278

Hemenway, Abby Maria, 135

Hergesheimer, Joseph, 150

Hesiod, 17, 31, 38, 43, 44, 137, 139, 211, 214, 218

Hicks, Edward, 92

Hill, Gene, 236

Hippocrates, on Asiatic seasons, 31

Hitchcock, Edward, 90–91

Hoefnagel, Jacob, 54

Hoffbauer, Charles, 146

Hoffmann, Hans, 157

Holidays: calendar divisions for, 154; children's art based on, 162; commercialization of, 109; role in seasonal imagery, 8; symbolism of, 149

Hollar, Wenceslaus, 57, 59

Holmes, Martha, 225

Holmes, Oliver Wendell, Sr., 6, 117–19; on Indian summer, 128; "The Seasons" of, 117–19, 128

Homeland: A Report from the Country (Borland), 27–28, 155, 186, 188

Homer, 38

Homer, Winslow, 122

Hooper, Alice Forbes Perkins, 114

Horace, 67

Horae, 38–39, 41, 45, 47

Horgan, Paul, 188

Hospitality industry, seasonal motif use in, 226–27

Houses, seasonal icons on, 39

Howitt, William, 88–89

Hubbell, Sue, 18, 215, 217

Humanistic motifs, in Renaissance Europe, 48

Human life cycle: cemetery rituals of, 103; contemporary views of, 266–68; depiction in American art, 245–53; Rockwell paintings of, 218–27; seasonal images and, 1, 2, 4–5, 11, 23–25, 45, 54, 57, 58, 59, 66, 84, 89, 116, 135; Thoreau on, 108

Humors, iconography of, 2

Hunting, as seasonal symbol, 1, 50, 52

Huntington, Ellsworth, on seasons of birth, 164–65

Hurd, Peter, 30

Illinois Central Railroad, seasonal art of, 224

Imagery, American transitions in, 140–74
Impressionism, 115
Indians. *See* Native Americans, seasonal symbols of
Indian summer, 104, 107, 128, 143, 155
Inness, George, 122, 126
Internet, seasonal topics on, 211
Italy, seasonal art of, 51
Ithaca, N.Y., 10, 98
Ives, Charles, 128
Ives, Frederick. *See* Currier and Ives

Jackson, Carole, 225
James, Henry, 130
Janovy, John, 213–14, 264
Japan, seasons of, 31
Jaudon, D., 81
Jefferson, Thomas, 19, 74, 78
Jennings, Samuel, 79
Jeremiah, 38
Jessup, Robert, plate 40, 18, 249–51
Jesus Christ, 47, 49, 104
Johns, Jasper, plate 38, 3, 4, 11, 12, 150, 240, 246–47, 249–50, 254–55, 260
Johnson, Robert Underwood, 276–77
Johnston, Frances Benjamin, 77, 78
Jones, John Paul, 78
Jongelinck, Nicolaes, II, 52
Journalism, seasonal, 235–39
Journey into Summer (Teale), 176, 182, 190, 193, 195, 207, 209
Judaism, seasonal iconography and, 42

Kachina dances, of Zunis, 105–6
Kakadu (Australia), six seasons of, 30
Kalendrier des Bergers, 49
Kandinsky, Wassily, plate 25, 156–57, 245
Kaplan, Justin, 229
Karasz, Ilonka, 163
Keats, John (1795–1821), 4–5, 166, 167
Keats, John (1920–), 214–15
Kent, William, 100
Kerchiefs, seasonal symbols on, 83, 84
Kidder, Tracy, 218–19

Kieran, John, 3, 19, 173, 179, 184, 189–90, 191
King, Stephen, 211
Kirchwey, Freda, 145
Kirstein, Lincoln, 165
Kitchens, seasonal motifs in, 225–26
Klees, Fredric, 14, 16, 213, 214, 273
Klinkenborg, Verlyn, 19, 217, 238, 272, 279
Kost (American painter), 101
Krasner, Lee, 160
Kroll, Janet, 204
Krutch, Joseph Wood, 3, 19, 26, 155, 167, 177 (photo), 184, 190, 191, 265, 277–78; as professional nature writer, 176, 180, 181, 187, 190, 200, 201, 204, 205, 217, 228, 237; reviews of, 180, 186–87, 188
Kumin, Maxine, 110, 142, 225–26, 229
Kuspit, Donald, 251

Labors, seasonal, 48–50
Ladies' Home Journal, 176
LaFarge, John, plate 22, 2, 124, 142
LaGuardia, David, 169
Lamb, J. & R., 124
Landscapes: in contemporary American art, 241–45; as seasonal icons, 92, 94, 99, 112, 123, 126, 128, 143
Lanman, Charles, 94
Lauder, Evelyn, 229
Lawrence, D. H., 106
Lawrence, Frieda, 106
Leaves of Grass (Whitman), 112
Lee, Robert E., 146–47
"The Leiden Aratea," 50
Leonardo da Vinci, 247
Leopold, Aldo, 3, 6, 11, 19, 20, 31, 136, 177 (photo), 265; as professional nature writer, 176, 179, 183–84, 186, 194, 200, 217, 273, 276, 278–79; reviews of, 180, 186–87, 279
Lester, Terrell S., 229
Levinson, Daniel J., 24
Lewis and Clark, 182

Library of Congress, 125
Light, seasonal transitions of, 140
Limbourgs, calendars made by, 48
Lincoln, Frances, 230
Lindsay, Vachel, 150
Line, Les, 229
Lippincott, Carrie H., 138
Little, Phillip, 235
Lodge, Henry Cabot, 229
London, Jonathan, 218
Longus, 49
Loomis, Eben, 124
Loomis, Mabel, 124
Lorrain, Claude, 99
Low Countries, seasonal art of, 51–52, 54–57, 111
Lowell, James Russell, 98, 129, 166; on Thomson, 98
Lowell, Robert, 260
Ludi, based on seasons, 46–47
Luhan, Mabel Dodge, 106
Lyttelton, Lord, 99, 100

Ma, Yo-Yo, 234
Macdonald, R. H., 229–30
MacLeish, Archibald, 150, 229
Male hormones, seasonal fluctuations in, 267
Manet, Edouard, 249
Manfredi, Bartolomeo, 58
Manic depression, creativity and, 269
Marden, Brice, 152
Marriage, seasonality of, 71, 74–75, 121, 164–66
Marsi, Rick, 27
Martineau, Harriet, 74
Marvel, Ik, 22, 119, 120. *See also* Mitchell, Donald Grant
Mary, 47
Mascarons, seasonal icons on, 58–59
Masur, Kurt, 235
Masur, Michael, 245
May, Henry F., 149
McDermott, John F., 268
McEntee, Jervis, 122

McGarrell, James, plates 44 and 45, 24–25, 240, 243–44
Medical practice, seasonal influences on, 113–14
Medici, Piero de, 48
Medieval period: calendars of, 19, 47; seasonal icons in, 41, 45–47, 50, 131
Melatonin, secretion variations in, 267, 268
Memorial Day, seasonal images of, 104
Mercer, Henry Chapman, 139
Metalious, Grace, 155
The Metamorphoses (Ovid), 16, 22, 43, 44
Metaphors, in seasonal writing, 151–55
Metcalf, Willard Leroy, 3, 36, 128, 142–43, 144, 241
Michelangelo, 38
Middle English, seasonal motifs in poetry of, 45, 46
Midwestern values, in Wood art, 157–58
Miller, Alfred Jacob, 95
Miller, Angela, 101, 126
Miller, Mary Rogers, 134, 265
Millet, Jean-François, 3, 6, 7, 36, 115, 130, 142, 195
Mills, C. Wright, 149
Mills, Joan, 185, 186
Milton, John, 61, 65
Mind, seasons of, 166–67
Mirabelli Garden (Salzburg), 59–60
Mitchell, Donald Grant, 117, 118 (portrait), 119–20, 174, 265
Mitchell, Joni, 234
Mitman, Greg, 231
Modernism: artistic, 155–64; literary, 166–67, 171, 260–64; seasonal imagery of, 9, 140–41
Mondrian, Piet, 160
Monet, Claude, 142, 230, 255
Montgomery, Janet Livingston, 83–84
Montgomery, Richard, 83–84
Montgomery, Sy, 229
Moore, Marianne, 173
Morgan, Matthew Somerville, 123
Mormons, historic preservation by, 227

Morris, William, 6

Morse, Ruggles, 115

Mosaics, seasonal images on, 37, 39, 42, 47, 243

Motherhood, as seasonal symbol, 54

"Mother of silences," in death symbolism, 167

Mould, Jacob Wrey, 115

Mount, William Sidney, 66, 68

Moussorgsky, Modest, 231

Mucha, Alphonse, 2, 6

"Mud March," as Vermont season, 30

Muir, John, 15 (photo), 32, 130, 132–33, 136, 149, 180, 186, 191, 276; camping trip with Burroughs, 141; on Indian summer, 128

Murphy, J. Francis, 126, 129

Murphy, Robert Cushman, 189, 198

Music, seasonal motifs in, 34–35, 117, 128, 210, 230–35

Musidora, 89; depiction of, 79

Musidora (Sully), 66, 67

My First Summer in the Sierra (Muir), 132, 141

Mythology, seasonal symbols in, 21, 36, 43

Myths, seasonal allegories and, 62–63

Nadelman, Elie, 155–56

The Nation, 162, 186

Nationalism: American seasons and, 108–39; seasonal symbols and, 6–7, 9, 107

Native Americans, seasonal symbols of, 104–7, 165–66

Naturalists, 265; seasonal imagery of, 5, 6, 9, 10, 15, 19–20, 21, 26, 30, 34, 36, 62, 110, 112–13, 129, 134

Natural theodicy, seasonal change and, 11

"Natural Theology," 89

Nature: cultural constructions of, 21–25; "rediscovery" of, 140; seasonal imagery of, 9, 10, 242–45; sham writing about, 151

Nature writers: amateur vs. professional, 175–76; American, 174, 175–207

Nature writing: anthologies, 180; book club selections of, 209; for children, 218; city readers of, 199–204; illustrations for, 217–18; readers' responses to, 191–99; reviews of, 174, 180, 186–91

Needlework, seasonal motifs in, 225

Neoplatonism, seasonal art in, 42

Netherlands, seasonal art of, 54, 55. *See also* Low Countries, seasonal art of

Neumayr, Christoff, 59, 60

New England: Metcalf landscapes of, 143; seasonal motifs in, 73, 104, 115, 144

Newton, Isaac, 32, 65

New York City, four seasons in, 171–73

The New Yorker, 165, 199

New York Herald Tribune, 110, 145, 190

New York State, Cropsey paintings of, plates 14–17, 122–23

New York Times, 18, 26, 124, 145, 174, 177, 187, 190, 197, 198, 202, 204, 238, 272, 279

New York Times Book Review, 189, 191, 215

Nightingale, as seasonal symbol, 47

Nile River, seasons of, 30

North American Review, 113

Northeast (U.S.), seasonal imagery of, 9, 142–46

Northup, Solomon, 76

North with the Spring (Teale), 110, 176, 182, 185, 189, 206, 207

Nostalgia: American seasons and, 108–39, 148; seasonal icons and, 6–7, 8, 25, 26, 107

Novelty, seasonal imagery and, 9

Oakes, John, 198, 202, 204

O'Brien, Tim, 229–30, 273

Oceans, seasons of, 153–54

Ochs, Adolph, 124

O'Connor, John, 232

O'Connor, Mark, seasonal music of, 234–35

Old age, as seasonal symbol, 37, 38, 43, 60

Olive harvest, as seasonal phase, 39, 41, 43

Oliver, Mary, 264

Olmsted, Frederick Law, landscape architecture of, 114–15

Osage tribe, seasonal motifs from, 165–66

Ouray Ute tribe, sculpture images of, 29–30

The Outermost House: A Year of Life on the Great Beach of Cape Cod (Beston), 18, 26, 110, 145, 146, 182

Overton, Henry, 81

Ovid, 49, 67; *The Metamorphoses* of, 16, 22, 43, 44

Owen, Robert Emmet, 143

Owl, as seasonal icon, 47

Painting. *See* Art; individual painters

Paiute tribe, 105

Palazzo Vecchio (Florence), seasonal art in, 38

Palmer, Frances F., 94, 116

Palmer, Potter, Mrs., 243

Panther, as seasonal symbol, 40

Parade Magazine, Rockwell art for, 220–21

Paradise Lost (Milton), 61, 65

Parsons, Charles R., 116

Parsons, Elsie Clews, 105–6

Parsons, Frances Theodora, 26, 134, 273

Passages: Predictable Crises of Adult Life (Sheehy), 24

The Passing of the Seasons: Winter into Spring (Bishop), 21

Pastoral icons, of seasons, 36, 49, 50

Patel, Pierre-Antoine, 65

Paul, Ann Whitford, 225

Peale, Charles Willson, 79, 80, 91

Pearce, John Ed, 236

Pearsall, Derek, 48

Peasants, as seasonal figures, 51, 54, 70

Peattie, Donald Culross, 20, 35–36, 49, 110, 132–33, 144, 145 (photo), 154, 189, 269–70; as professional nature writer, 176, 179, 181, 182, 218

Penciller, Harry, 103, 121, 201. *See also* Wetmore, Henry Carmer

Perkins, Charles Elliott, 114

Perl, Jed, 259

Perrin, Noel, 30

Persephone, 16, 215–16

Petersen, Christian, plate 27, 2, 164, 165

Peterson, Roger Tory, 180, 191

Petrarch, 44

Peyton Place (Metalious), 155

Phaedrus (Plato), 58

Picasso, Pablo, 247

Pierson, George W., 27

Pilgrim at Tinker Creek (Dillard), 4, 36, 101, 216, 217, 277

The Pioneers (Cooper), 3, 86

Pitt, William, the Elder, 100

Place, seasonal sense of, in America, 140–74

Plantations, slave life on, 76–77

Plasterwork, seasonal motifs on, 83

Plath, Sylvia, 260

Plato, 58

Plowing, as seasonal symbol, 1, 51, 111

Plum blossoms, as seasonal symbol, 31

Pluto, 16

"Pocket books," in early America, 80–81

Poetry: contemporary, in America, 260–64; seasonal images in, 4–5, 17, 31, 32, 35–36, 45, 50, 86–88, 107, 117, 120, 149, 167–68, 170

Politian, 44

Political conflict, seasonality and, 275–76

Pollock, Jackson, 157, 160

Pomona, 16

Ponchielli, Amilcare, 231

Ponte Santa Trinita (Florence), seasonal statues on, 37–38

Poor Richard's Almanack (Franklin), 78, 139, 200, 209

Pope, Alexander, 50

Popular culture: American, 209–19; seasonality in, 141

Popular Science Magazine, 176

Porcelain, seasonal symbols on, 66, 69

Porter, Eliot, 228

Postmodernism, social change and, 25

Pousette-Dart, Richard, 268

Poussin, Nicolas, 6, 24, 35, 39, 40, 57, 268

Powers, Ron, 209–11

Poyet, Jean, 59

Prang, Louis, and Company, seasonal items made by, 121

Prehistory, seasonality in, 21

The Prelude (Wordsworth), 123

Presley, Elvis, 224

Priestley, Glenn, 245

Prince, William Wood, 243

The Private Papers of Henry Ryecroft (Gissing), 35

The Progressive, 18, 26, 174, 177, 188, 199

"Prospect" (Dwight), 97

Ptolemy, 21, 61

Punch, 119

Puritans, 86; marriage season of, 74

Putnam's Monthly Magazine, 112, 201

Putti, as seasonal symbols, 29, 37, 41, 51, 127

Pythagoras, 22

Quakers: conception and childbirth among, 75; marriage season of, 74; seasonal ideas of, 88–89

Quilts, seasonal motifs on, 127

Radnitzky, Emmanuel. *See* Ray, Man

Raeburn, Henry, 80

Raphael, seasonal art of, 51, 52

Ray, Cuba, plate 1

Ray, Man, 139

Reader's Digest, 185, 194, 195, 209

Regionalism, in seasonal art, 126, 140–48

Religion: effect on marriage seasons, 74; nature writing and, 196; seasonal motifs of, 32, 61, 86–95, 132, 149, 150, 167

Renaissance era: *Georgics in*, 44; humanistic motif in, 48; seasonal art of, 42, 50–63, 131, 211, 250, 251

Reproduction (human), periodicity in, 266

Retirement, concept of, 150, 151

Richards, Rosalind, 144

Richards, William Trost, 116, 128

Robbins, Jerome, 235

Robusti, Jacopo. *See* Tintoretto

Rockefeller, John D., Sr., 124

Rockwell, Norman, 3–4, 10, 141, 184; calendar art of, plate 30, 218–27; paintings of, 218–27

Roesen, Severin, 101

Rogers, Pattiann, 229

Rohmer, Eric, 3, 4, 232–33

Romance, as seasonal symbol, 49, 165

Rome, ancient: calendars of, 49; seasonal icons of, 37, 39, 41

Roosevelt, Theodore, 131

Rosa, Salvatore, 99

Rose, Barbara, 247

Roses, as summer symbol, 134–35

Roundels, seasonal symbols on, 54, 60, 77–78, 84, 165

Rousseau, Henri, 195

Rowe, Samuel Worcester, 14

Royko, Mike, 236

Rubinstein, Helena, 155–56

Rucella, Giovanni, 44

Rural life: American changes in, 108; American icons of, 116

Rural Life (Klinkenborg), 19, 217

Rural Life in America; or, Summer and Winter in the Country (Wetmore), 103

Rush, William, 92

Ruskin, John, 35

Russell, Vivian, 230

Ryder, Albert Pinkham, 122

Sackville-West, Victoria, 17

Sacred Philosophy of the Seasons; Illustrating the Perfections of God in the Phenomena of the Year (Duncan), 16, 89, 201

Saenredam, Jan, 54

Saftleven, H., 57

Saint Lambert, Jean-François, Marquis de, 66–68

Salter, Elizabeth, 48

A Sand County Almanac (Leopold), 11, 19, 20, 179, 180, 183, 276, 278; reviews of, 186

Sarton, May, 153, 188–89

Saturday Evening Post, Rockwell covers for, 219, 221

Savage, Eugene F., plate 26, 12

Sawin, Martica, 249

Sayer, Robert, 81

Schilling, Johannes, 164

Schlesinger, Arthur, Jr., 229

Schmolze (artist), 80

Schmucker, Samuel C., 26, 150, 268

Science (human biology), seasons and, 265–79

Science fiction, seasonal motifs in, 218

Scotland, seasonal art of, 61

Scribner's Magazine, 138, 139

Scrolls, seasonal symbols in, 31

Sculpture, seasonal imagery in, 21, 37, 92, 155–56, 164–65, 228

The Sea Around Us (Carson), 178–79, 189

Seasonal affective disorder (SAD), 267

Seasonal art: artistic modernism of, 155–64, 240–60; for consumer sales, 224–27; literature and, 101–4; mid-nineteenth-century, American, 91–95, 100; in Victorian America, 116, 121–27

Seasonal iconography, 1; American and European compared, 100–101; in antiquity, 37, 38–45; in calendars and books, 2; in medieval times, 45–47

Seasonal processions, 25–30

Seasons: American cycles of, 209–18;

American writing on, 86–90, 96–99, 106–7, 112–14, 117–20, 128–31, 141–46, 150–55, 164–207, 212–18, 260–64; anxieties with, 31–36; areas with depictions of, 30–31; cartoons based on, 235–39; changing attitudes toward, 204–7; continuity and change in responses to, 16–21; cycles and sequences of, 11–36, 272–75; as journalism theme, 235–39; perceptions of, 21–25; personal preferences for, 237–38, 278; personifications of, 2; psychological, 153; science and, 265–68; sentimental icons of, 2–3; statuettes of, 82–83; urban responses to, 256–57

The Seasons (Haydn oratorio), 4

The Seasons (Thomson poem), 2, 4, 11, 14, 32, 35, 65–66, 67, 78, 79, 80, 86, 89, 96–98, 99–100, 107, 132, 136, 182, 209, 263, 265

Seed catalogues, 136–37

Seeger, Pete, 234

Seib, Charles, 27, 110, 207

Sentiment, seasonal, in America, 141–51

Sepulchral iconography: in America, 103–4; in early Rome, 39–41, 42; in Scotland, 61

Serialism, symbolic, in contemporary art, 253

Sexton, Anne, 260

Sexuality, seasonal images and, 240, 246, 251–52, 266

Shakespeare, William, 233

Shapero, Janet, 21

Sharpe, David, plate 42, 256, 257, 258

Sheehy, Gail, 24

Sheep shearing, as seasonal symbol, 1

Shenstone, William, 100

Shephearde's Calendar (Spenser), 36, 49, 50

Shepherds, as seasonal symbols, 49

Sherman, Roger, 151

Sierra Club, 132, 181, 228

Silver, seasonal motifs on, 127

Simeti, Mary Tyler, 210, 215–16
Sistine Chapel, seasonal art in, 51
Slavery, seasonality and, 75–77
Smells, seasonal, 140, 152
Snodgrass, William D., 3, 260–62 (photo), 263–64
Social change: in America, 140; seasonal motifs and, 25–30, 113–15, 119; seasonal responses to, 109–13
Social stratification, in seasonal images, 54, 57, 79, 84, 100
The Song of Solomon, 38
Sounds, seasonal, 140, 151
Southwest (U.S.): nature writing on, 181, 187–88; seasonal travel to, 228; seasons of, 3, 30, 181
Spenser, Edmund, 36, 49, 50, 73
Spiritualism, 89
Sports, in seasonal images, 165
Spring: colors of, 157; flower symbols of, 31, 37, 39, 55, 57, 58; iconography of, 1, 54, 91, 121, 187; landscape images of, 33, 92; perceived sounds of, 151
Stained glass, seasonal motifs on, 124, 165
Starrett, George, 124
Statuary, seasonal symbols and, 29–31, 35, 82, 124–25, 155–56
Sternberg, Harry, 165
Stevens, Wallace, 4, 14, 167, 168–69, 246
Stieglitz, Alfred, 171–72
Stillmeadow series (Taber), 201
Stockton, T. H., 103–4
Stokowski, Leopold, 231
Stonehenge, seasonal meaning of, 42
Storms, as seasonal phenomena, 94, 136
Stravinsky, Igor, 231, 259
Studies in the Field and Forest (Flagg), 113, 129
Styron, William, 241–42
Sully, Thomas, 66, 91
Summer: flower symbols of, 31, 55; iconography of, 1, 6, 37, 39, 44, 49, 54, 57, 58, 91; landscape icons of,

92–93; medieval motifs of, 45; perceived sounds of, 151; poetic renderings of, 35, 168–69
Sun, role in seasonal changes, 14, 21–22, 268
Sundial of the Seasons (Borland), 155, 188, 198–99
Swedenborgianism, 275
Swiggett, Howard, 195
Switzerland, seasonal art of, 59

Taber, Gladys, 134, 135 (photo), 144, 151, 152, 184, 199; as professional nature writer, 176–77, 182, 201, 203
Taos Pueblo (N.Mex.), seasonal rituals of, 106
Tapestries, seasonal symbols in, 42, 51, 60, 70
Tasmania, seasonal phases in, 71
Tate, Allen, 167–68
Taylor, Paul, Johns interview by, 248–49
Tchaikowsky, Peter I., 35
Teale, Edwin Way, 4, 9, 12, 19, 20, 21, 30, 110, 134, 150, 154, 155, 178 (photo), 179, 180, 181, 192, 201, 269, 270, 272, 277; as professional nature writer, 176, 178, 181, 182–83, 184, 185, 187–88, 189, 190, 198, 200, 205, 206, 209, 213, 237, 266; readers' responses to, 192–97, 199, 200, 201–2, 205, 206–7; reviews of, 180, 186, 189–91, 199; on seasonal aromas, 152
Teale, Nellie, 176, 182, 183, 189, 192, 201
Television, seasonal characters in, 224
Terra-cotta, seasonal motifs on, 48, 225
Testa, Pietro, 57
Tesuque Pueblo (N.Mex.), seasonal rituals at, 106
Thaxter, Celia, 167
Thayer, Abbott, 125
Theodicy: natural, 11, 86–90; of Thomson, 277
Thomas, Isaiah, 79
Thompson, Ernest Seton, 151

Thompson, Jerome, 94

Thomson, James, 2, 4, 6, 11, 32, 73, 86, 91, 132, 149, 230, 277; American rejection of, 96–101; poetic influence of, 65–71, 77–86; portrait of, 64; *The Seasons* of, 65–66, 78–81, 89, 96, 97, 99–100, 136, 182, 209, 263, 265

Thoreau, Henry David, 2, 14 (portrait), 26, 28, 29, 32, 35, 88, 91, 98–99, 102, 107, 129–30, 132, 134, 151, 180, 182, 185, 271 (photo), 274; on art, 35, 101; literary influence of, 110–11, 134, 144, 145, 155, 181, 182, 184, 186, 188, 194, 199, 204, 265; on seasons, 12, 20, 36, 109, 120, 128, 135, 151, 153, 159, 166, 268, 269, 270–73, 278; on Thomson, 98; on urbanization, 108; *Walden* of, 3, 5, 11, 13, 20, 21, 22–23, 109–11, 113, 120–21, 134, 159, 182, 199, 274, 276, 278, 279; on wildness, 136, 183

Thorvaldsen, Bertel, 84, 125

"Throne Baldachin," 51, 53

Tiffany, Louis Comfort, 3, 124

Tileworks, seasonal motifs on, 139

Tillich, Hannah, 212

Time magazine, 155

Tintoretto, 37

Torke, Michael, 235

Torrey, Bradford, 182

Trade cards, seasonal motifs on, 121

Trask, Katrina, 124–25

Trask, Spencer, 124–25

Travel, seasonal, 227–30

Travels (Bartram), 212

Travels (Dwight), 96–97

Troilus and Criseyde (Chaucer), 46

Très Riches Heures (Colombe), 48

Tryon, Dwight William, plate 19, 123, 126

Turner, J. M. W., 35, 123

Twachtman, John Henry, plate 20, 125–26, 128, 241

Twelve Moons of the Year (Borland), 19, 155, 209

Twelve Seasons: A Perpetual Calendar for the Country (Krutch), 26, 155, 180, 186, 187, 201

Twombly, Cy, 240, 258–59, 268

Udechukwu, Obiora, African seasonal paintings of, 30

Uintah tribe, sculpture images of, 29

Under the Sea-Wind: A Naturalist's Picture of Ocean Life (Carson), 18, 146, 178, 189

Updike, John, 229

Urbanization: seasonal images and, 27, 174; seasonal responses to, 106–7, 108, 109–13, 134, 138. *See also* City life, seasonal images of; City readers, of nature writing

Utagawa, Kunitsuru, 124

Valentines, seasonal motifs on, 121

van Aelst, Pieter Coecke, 51–52

van Almeloven, Jan, 57

van Blarenberghe, J., 56–57

van de Pass, Crispin, 55–56

van der Ast, Balthasar, 56

Vanderbank, John, 80

van der Heyden, Pieter, 54

van de Venne, Adriaen, 54, 57

Van Dyke, John, 172, 173

Van Gennep, Arnold, 58

van Goyen, Jan, 54

van Huysum, Jan, plate 6, 56, 101

van Leyden, Lucas, 59

van Schoel, Hendrick, 54

Vedder, Elihu, 14, 15, 126

Vegetables, as seasonal symbols, 61, 158, 257

Vendler, Helen, 169

Verdi, Giuseppe, 35, 235

Vermont, perceived seasons of, 30

Versailles, four seasons fountains of, 59

Vertumnus, 16

Vertumnus and Pomona (Flinck), 17

Victorian era: in America, 116–35; seasonal imagery in, 6, 14, 16, 43, 139

Vier Jahreszeiten (fountain), 164

Vietnam, 273, 274, 275

Vintage, as seasonal icon, 39, 40

Virgil, 31, 35, 49, 61, 67, 73, 211, 214, 275–76; *Georgics* of, 11, 16, 43–44, 86, 115, 217, 275, 279

Vivaldi, Antonio, 6, 35, 232, 235, 262

von Wiegand, Charmion, 160

The Voyage of Life (Cole), 65, 90

Walden (Thoreau), 3, 5, 11, 13, 20, 21, 22–23, 109–11, 113, 120–21, 130, 134, 182, 199, 276, 278, 279; seasonal references in, 109–11, 159

Wallace, David Rains, 196

Wandering Through Winter (Teale), 176, 180, 182, 184, 192–93, 195, 198, 199, 205, 206, 278

Ward, Lynd, 218

Washington, George, 83; as slave owner, 75–76

Webster, James C., 47

A Week on the Concord and Merrimack Rivers (Thoreau), 20, 134

Weeks, Edward, 190

Welker, Robert Henry, 179

Wertinger, Hans, 50

West, Benjamin, 66

Wetmore, Henry Carmer, 103

Wharton, Edith, 272

Wheat, as seasonal symbol, 37, 51, 58, 60, 70, 79, 125, 127, 158

Wheeldon, Christopher, 235

White, E. B., 150, 155

White, Gilbert, 34, 181–82

Whitman, Walt, 112, 129

Whitney, William, 124

Whittier, John Greenleaf, 151

Widowhood, as seasonal symbol, 54

Wilbur, Richard, 229

Wilder, Laura Ingalls, 165

Wildness, seasonal, 133–39

Wiley, Farida, 132

Williams, William Carlos, 167, 170

Wilson, Alexander, 182, 194

Wilson, Woodrow, 150

Wine making, as seasonal symbol, 1, 70, 87

Winter: American images of, 98; American writing on, 98, 129; flower symbols of, 31, 55; iconography of, 1, 16–17, 36, 37, 44, 54, 56, 57, 82–83, 94; medieval motifs of, 45; perceived sounds of, 151

Winter Carnival (St. Paul, Minn.), 171

"Winter count," of Yankton Sioux, 105

Wister, Owen, 138

Wolfe, Thomas, on seasonal diversity, 141–42

Women: seasonal affective disorder in, 267. *See also* Females and female beauty

Wood, Grant, 100, 157–58

Woodblocks, seasonal art in, 65

Works and Days (Hesiod), 18, 43, 139

World War II: role in seasonal imagery, 7, 8, 167, 205, 211, 213; urban changes after, 27, 192

Wright, Mabel Osgood, 134, 152, 154, 274

Wtewael, Joachim, plate 5

Wyeth, Andrew, 10, 198

Wyeth, Betsy, 198

Wysocki, Charles, 225

Yaddo (Saratoga Springs, N.Y.), 124–25

Yankton Sioux tribe, "count keeper" of, 105

Yellowstone National Park, seasons of, 9

Young people, Rockwell paintings of, 218–27

Zodiac: early depictions of, 42; as seasonal icons, 43, 48, 54, 157

Zuni tribe, seasonal rituals of, 105–6

Zwerling, Lisa, plate 46, 240, 251–52

Zwinger, Ann, 5, 216, 217

DATE DUE